THE ART INSTITUTE OF CHICAGO

W9-AYN-670

THE ESSENTIAL GUIDE

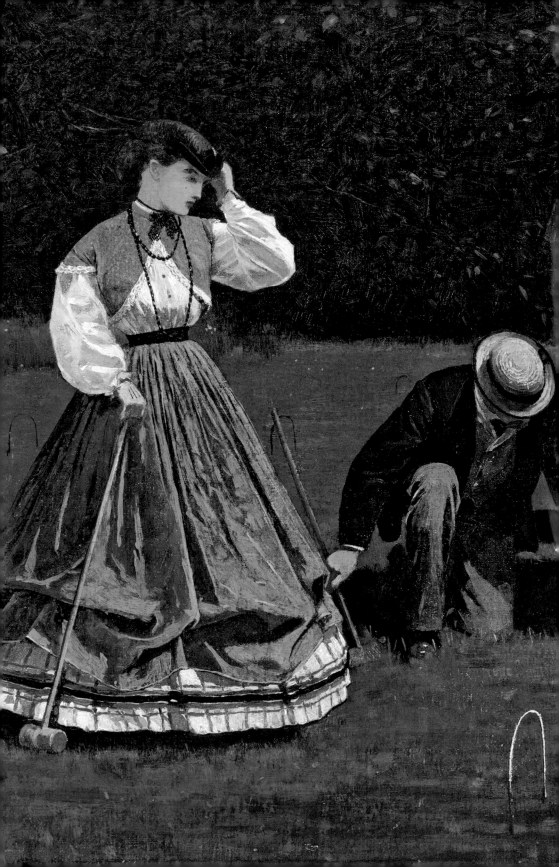

THE ART INSTITUTE OF CHICAGO

THE
ESSENTIAL
GUIDE

Foreword by
Douglas Druick

THE ART INSTITUTE OF CHICAGO

The Art Institute of Chicago gratefully acknowledges the Elizabeth F. Cheney Foundation for its early support of this publication.

© 2013 The Art Institute of Chicago

All rights reserved. No part of this publication may be reproduced, transmitted, or utilized in any form or by any means, electronic or mechanical, including photocopy, digital recording, or any other information storage and retrieval system, without prior written permission from the Publications Department of the Art Institute of Chicago, except by a reviewer who may quote brief passages.

Fourth edition
Printed in China
Library of Congress Control Number: 2012955102
ISBN: 978-0-86559-255-1

Published by
The Art Institute of Chicago
111 South Michigan Avenue
Chicago, Illinois 60603-6404
www.artic.edu

Produced by the Publications Department of the Art Institute of Chicago, Robert V. Sharp, Executive Director
Entries written by the curatorial staff of the Art Institute of Chicago
Edited by Robert V. Sharp and Wilson McBee
Production by Sarah E. Guernsey and Joseph Mohan
Photography research by Lauren Makholm
Photography by the Department of Imaging, Christopher Gallagher, Director (and additional photography credits on pages 351–52)
Third edition designed and typeset by Jena Sher
Revisions for the fourth edition executed by Hey J Min
Separations by Professional Graphics, Rockford, Illinois
Printing and binding by Oceanic Graphics, China

Front cover: Edward Hopper, *Nighthawks* (detail), 1942 (see p. 58).
Back cover: *Bishamon*, Japanese, 11th century (see p. 106).
Frontispiece: Winslow Homer, *Croquet Scene* (detail), 1866 (see p. 35)

This book has been printed on paper sourced in accordance with sustainable forest management.

CONTENTS

"To the east were the moving waters as far as the eye could follow. To the west a sea of grass as far as wind might reach." The Chicago writer Nelsen Algren began his portrait of the city with these words, locating it in the heart of the continent, bordered by the Great Lakes and the Great Plains.

As the metropolis expanded, so too did its cultural ambitions. In 1879 the Chicago Academy of Fine Arts was established to accomplish "the founding and maintenance of schools of art and design, the formation and exhibition of collections of objects of art, and the cultivation and extension of the arts by any appropriate means." In December 1882 the Academy of Fine Arts changed its name to the Art Institute of Chicago and moved from rented rooms into a building that it soon purchased on the southwest corner of Michigan Avenue and Van Buren Street. Five years later, it commissioned Burnham and Root to design an entirely new structure on the same site. The museum soon outgrew these quarters, however, and in 1893 it moved into a building designed by Shepley, Rutan and Coolidge on Michigan Avenue at Adams Street, which it continues to occupy to this day. Built in concert with the World's Columbian Exposition, the building served as a hall for the World's Congresses during the fair; the Art Institute officially opened there on December 8, 1893.

Civic leaders and museum patrons alike saw the arts as an essential aspect of an urban center that would be not only a manufacturing center and transportation hub, a city of livestock and grain, but also a center of culture and learning. As the very form of the modern city was reinvented across Michigan Avenue in the towering skyscrapers of Chicago, the Art Institute set in motion its dual commitment to collect the art of the past and the present while training and inspiring the artists of the future. Once settled into its new home, the museum began an ambitious campaign to fill its galleries with original works of art. The museum's leaders aspired to a grand collection and made their intentions evident to all by carving the names of great artists—Praxiteles, Apelles, Cimabue, Giotto, and more—on the outside of the building. At that time, the museum was a hope chest waiting to be filled. In the succeeding 130 years, works of art of every kind, place, time, and style have taken residence in our galleries.

What makes the Art Institute's early history unique, what cannot be said about other major American museums, is that the acquisition of historical works of art was accompanied by an equally aggressive acquisition of contemporary art at the hands of forward-thinking Chicago collectors. These men and women were deeply invested in the artistic avant-garde, and they introduced Chicagoans to works unfamiliar to American audiences—paintings by Georges Seurat, Vincent van Gogh, and Claude Monet. Eventually these pioneering collectors gave their paintings to the Art Institute and thus formed one of the finest collections of Impressionist and Post-Impressionist paintings in the world.

The Art Institute continues to be a lively home for the best new art of each subsequent generation. With the opening of the Modern Wing in May 2009, the museum was able to fully present its collections of modern and contemporary

paintings, sculptures, photography, film and video, and architecture and design in a new building designed by the prominent architect Renzo Piano. This addition—the largest made to the Art Institute since the opening of its Michigan Avenue building in 1893—along with the renovations and reinstallations of the galleries throughout all other parts of the museum's buildings, marked an exciting new phase in the Art Institute's evolution.

Visitors are often surprised by Chicago's cultural wealth and architectural impact; for its citizens, the Art Institute is both a familiar local museum and, thanks to its size and the diversity of its holdings, a constant source of discovery. Indeed, the range and vitality of our collections demonstrate the museum's commitment to preserve for the public representative examples of the world's artistic legacy in order to foster an atmosphere of education and understanding. One of the many pleasures of visiting the Art Institute is the possibilities for discovery: of archaic Chinese jades and Japanese prints; extraordinary Peruvian ceramics; collections of European and American paintings, sculptures, and works on paper that are among the finest of their kind; the arts of Africa; and Indian art of the Americas. These collections, and much more, are presented in a variety of contexts intended to provide the viewer with a direct and meaningful experience. Distinguished collections of textiles, photography, prints and drawings, and architectural renderings—materials sensitive to light and atmosphere—have their own galleries and study facilities where changing selections of their holdings can be enjoyed by all.

Discovery, no matter how confident the explorer, can be enhanced by a knowledgeable and sympathetic guide. It is our hope that this new edition of *The Art Institute of Chicago: The Essential Guide* will be just such a companion, providing introductions to many of the museum's most celebrated inhabitants and encouraging you to strike out on your own to explore secondary trails that stimulate your imagination. It is both a survey of the collections and a record of more than one hundred years of collecting. We take great pleasure in sharing a collection that, spanning much of our human history, brings art to life. In Sir Kenneth Clark's words, a museum visit brings us face to face with "the work of artists of genius who have been absorbed by the spirit of the time in a way that has made their individual experiences universal."

An endeavor such as this book is realized only with the participation of more people than can be named here—with the efforts, direct and indirect, of the entire museum staff. In particular, we have relied upon the extensive documentation and writings of many members of the curatorial departments, present and former, whose efforts at understanding and maintaining every aspect of our collections are the cornerstone of this institution. We hope that this guide to the collection will help you to make this museum your own and to recall favorite works once you have departed. More importantly, we hope that the information it contains and the firsthand experience of original works of art at the Art Institute will stimulate you to return and to seek out new experiences.

Douglas Druick
President and Eloise W. Martin Director
The Art Institute of Chicago

AFRICAN ART AND
INDIAN ART OF THE AMERICAS

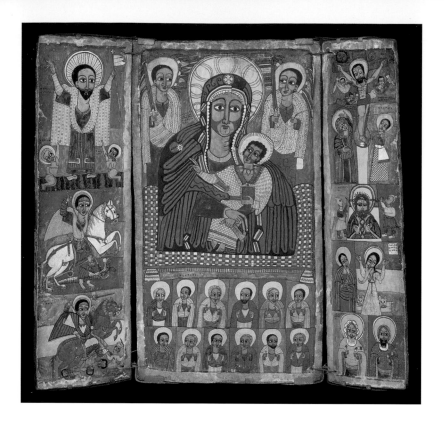

TRIPTYCH ICON WITH CENTRAL IMAGE OF THE VIRGIN AND CHILD
Central Ethiopia
Late 17th century, reign of Iyyasu I (1682–1706)

Tempera on linen, mounted on wood and bound with cord; 67 x 74 cm (26 ³/₈ x 29 ¹/₈ in.)
Director's Fund, 2006.11

In the highlands of Ethiopia, Orthodox Christianity stretches in an unbroken line of practice from the fourth century to the present day. Although painted icons are known from the late fourteenth century, demand for such objects increased greatly in the mid-fifteenth century, when the worship of Mary was formalized in the Ethiopian Orthodox liturgy. Considered sacred, icons were venerated in weekly services and on special feast days.

The central image of this large, finely rendered triptych presents Mary with the young Jesus on her lap. She grasps a handkerchief in her left hand, while her son blesses her with his right hand and holds a book in his left. This depiction derives from a painting of the Virgin long held in the Basilica of Santa Maria Maggiore, Rome. Reproduced in portable paintings, the image was disseminated throughout Christendom by missionaries beginning in the early seventeenth century. Upon its arrival in Ethiopia by the mid-seventeenth century, it revolutionized the representation of the Virgin and Child. Here Christ is delicately portrayed wearing a checkered robe and a beautifully detailed cowrie-shell necklace. He and Mary sit enthroned on an Ethiopian-style bed, flanked by the archangels Gabriel and Michael. This image is surrounded by secondary themes, including the Crucifixion at top right, the Ascension at top left, and Saint George slaying the dragon at center left.

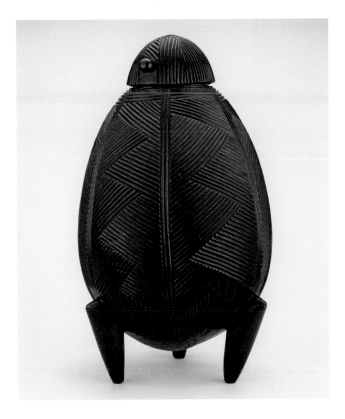

CONTAINER WITH LID

Northern Nguni, possibly Zulu
Swaziland or KwaZulu-Natal, South Africa
Mid-/late 19th century
Wood; 46 x 27.9 cm (18 ⅛ x 11 in.)
Ada Turnbull Hertle Fund, 1979.539

The graceful ovoid form of this container and the precisely aligned and executed fluted lines that embellish it, articulating alternating triangles, display great artistry. A closely related work acquired by the British Museum in the 1860s, during a period of growing pressure from the British on the Zulu Kingdom, helps to pinpoint a date for the Art Institute's container. They are part of a small group of highly decorative vessels, made in the mid- to late nineteenth century, that are widely admired but not well understood. Also tied to this group are several neckrests that have similarly shaped legs and various miniature containers, some with fluted decoration, supported at either end. While scholars have speculated on their possible uses, the virtuoso sculptural quality of this container and its related works indicates that they were held in high esteem. Deeply incised fluting also embellishes more familiar status objects from the region, including meat platters, neckrests, snuff containers, and staffs. It is possible that these were all prestige objects intended for high-ranking members of society. Another intriguing possibility is that artists within the Zulu Kingdom made these extraordinary works of art for sale to a growing foreign clientele that included European merchants, military personnel, missionaries, settlers, and travelers.

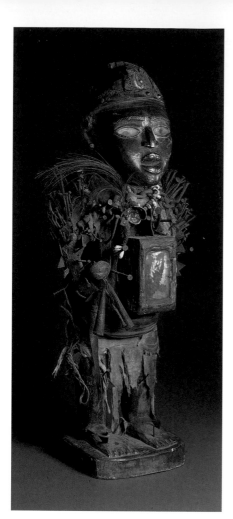

POWER FIGURE (*NKISI NKONDI*)
Vili; Republic of the Congo
Early/mid-19th century
Wood, metal, glass, fabric, fiber, cowrie
shells, bone, leather, gourds, and feathers;
h. 72 cm (28 ³/₈ in.)
Ada Turnbull Hertle Endowment, 1998.502

This striking figure, with its serenely
rendered face and violently pierced
body, was made to contain and direct a
spirit in order to assist people in need.
Nkondi means "hunter" in the Kongo
language and refers to the spirit's
power to track down the source of
trouble. The figure's cap and asser-
tive pose, with hands on hips and chin
thrusting forward, suggest those of
a chief, and like a chief, the figure and
its associated spirit were called on to
enforce laws and exact punishment.
The spirit was drawn into the sculpture
through the application of medicinal
ingredients packed in resin on its
head and in the projecting box, sealed
by a mirror, on its abdomen. These
ingredients were selected for their
associations with the ancestral world
(such as earth from graves) and for
their metaphorical associations with
the spirit's powers. Medicines may also
have been related directly to the
figure's function; for instance, the
chain may refer to the spirit's ability
to immobilize its victims. A nail or
a blade was driven into the sculpture
each time its force was invoked
through ritual, thereby provoking
the spirit into action.

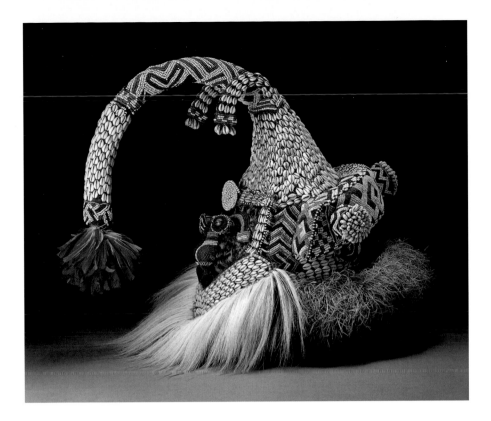

MASK (*MUKENGA*)

Kuba; Western Kasai region, Democratic Republic of the Congo
Late 19th/mid-20th century
Wood, glass beads, cowrie shells, feathers, raffia, fur, fabric, thread, and bells; h. 57.5 cm (22 ⅝ in.)
Laura T. Magnuson Fund, 1982.1504

Formed in the seventeenth century, the Kuba Kingdom unites an ethnically diverse
population across the Western Kasai region of today's Democratic Republic of the
Congo. This mask, called *mukenga*, is a regional variant of a Kuba royal mask that
is made only in the northern part of the kingdom. The mask's form and lavish em-
bellishment are associated with wealth and status. Cowrie shells and glass beads, once
highly valued imports, cover much of its surface. A stylized elephant trunk and tusks
rise from the top, evoking the powerful animal and the wealth accrued by the Kuba
in the nineteenth century through control of the ivory trade. The tuft of red parrot
feathers that is suspended from the tip of the trunk and the spotted cat fur on the
mask's face are insignias of rank.

 During the funerals of titled aristocrats, a member of the men's initiation society
may dance wearing the *mukenga* mask and an elaborate costume that includes many
layers of woven raffia skirts and cowrie- and bead-laden belts, gloves, bracelets, and
anklets. The deceased is laid out in identical attire, underscoring the association
between the spirit, which is manifested through the performance of the mask, and
the realm of the ancestors.

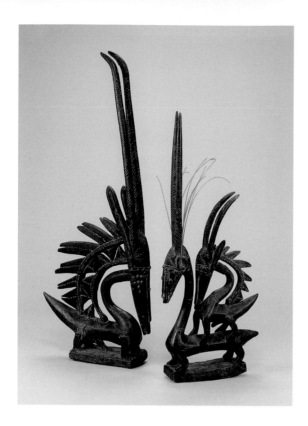

PAIR OF HEADDRESSES (*CI WARA KUNW*)

Bamana; Baninko region, Mali
Mid-19th/early 20th century
Wood, metal, brass tacks, and grasses; left: 98.4 x 40.9 x 10.8 cm (38 ³/₄ x 16 ¹/₈ x 4 ¹/₄ in.); right:
79.4 x 31.8 x 7.6 cm (31 ¹/₄ x 12 ¹/₂ x 3 in.)
Ada Turnbull Hertle Endowment, 1965.6–7

Among the Bamana of central Mali, farming is an ancient and noble profession that is entwined with religious beliefs and ritual practices. The invention of agriculture is credited to a mythical hero named Ci Wara, literally "farming animal," who was half human and half beast. A Bamana men's association named for Ci Wara is dedicated to the practical aspects of farming and the social and ritual structures that support it. Among its activities, the association sponsors masquerade performances that take place as farmers work together in communal fields. The performances encourage the farmers as they labor, inspiring them to work even harder while also celebrating their agrarian heritage. These Ci Wara headdresses combine the graceful head, neck, and horns of the antelope with the short legs, compact body, and tough, pointed nose (used to dig into hard, dry ground) of the pangolin, or scaly anteater. Viewed from the side, the figures' silhouettes are enlivened by the articulation of positive and negative space. Such headdresses, in male and female pairs, are worn in ceremonial performances, though few pairs remain united in museum collections today, making this outstanding twosome all the more remarkable. The female carries a spry young male on her back, suggesting the fertile union of men and women and of earth, water, seeds, and sun.

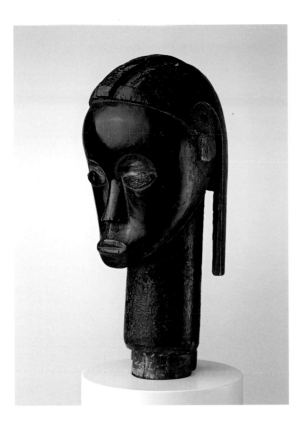

RELIQUARY HEAD

Fang; Gabon

Mid-/late 19th century

Wood and copper; h. 39.4 cm (15 ½ in.)

Frederick W. Renshaw Acquisition Fund; Robert Allerton and Ada Turnbull Hertle endowments; Robert Allerton Income Fund; Gladys N. Anderson Endowment, 2006.127

Communion with the ancestral dead is an important focus of art and ritual for the Fang people of southern Cameroon and northern Gabon. This large, beautiful head was made to sit with its neck inserted into the lid of a bark reliquary box that held the selected remains, most often skull fragments, of an honored ancestor. Kept in a dark corner of a man's sleeping room, the head and box protected the remains and embodied the deceased, keeping his or her force available to the living. This reliquary head's almond-shaped eyes were embellished with copper-alloy inserts, one now missing, that would have reflected light in a startling manner, adding to the work's mysterious aura. The wide-eyed stare also lends an infantile quality to the ancestral likeness that would have been appreciated by the Fang. Within their worldview, the balance of opposing elements—infant and ancestor, birth and death—is considered a fundamental aspect of human existence. The sleek and refined features of this sculpture, including a high domed forehead, a jutting chin, and an elongated nose that is visually balanced by a plaited coiffure, highlight classic qualities of Fang abstraction that likewise embody opposition. These stylistic elements had a strong influence on the work of early-twentieth-century artists such as Paul Klee, Henri Matisse, and Pablo Picasso.

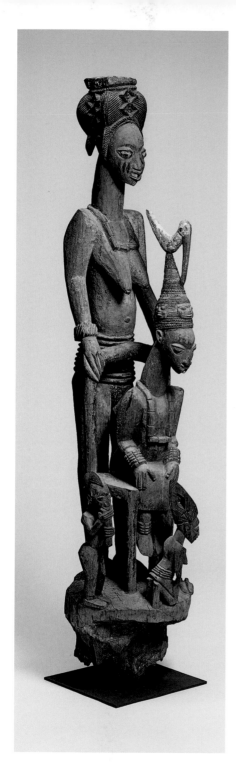

VERANDA POST OF ENTHRONED KING AND SENIOR WIFE (*OPO OGOGA*)

Olowe of Ise (died 1938)
Yoruba; Ikere, Ekiti region, Nigeria
From the palace of the *ogoga* (king)
of Ikere
1910/14
Wood and pigment; 152.5 x 31.75 x 40.6 cm
(60 x 12 ½ x 16 in.)
Major Acquisitions Centennial Fund, 1984.550

This veranda post is one of four that were sculpted for the palace at Ikere by the renowned early-twentieth-century Yoruba artist Olowe of Ise. It is considered among the artist's masterpieces for the way it embodies his unique style, including the interrelationship of figures, their exaggerated proportions, and the open space around them. The composition and iconography of the work also masterfully reflect Yoruba concepts of divine kingship. Although the king is the focal point of the sculpture, his portrayal suggests a ruler's dependence on others. He sits with a lowered gaze and dangling legs and is weighed down by his beaded crown, the ultimate source of his authority. Such crowns are spiritually charged accessories that confer power to a ruler. The stately female figure behind the king represents his senior wife. Her large scale and pose, with hands on the king's throne, underscore her importance; she had the critical role of placing the power-invested crown on the king's head during his coronation. Moreover, the senior wife used political acumen and spiritual knowledge to protect the king's interests during his reign. The small figures at the king's feet represent a kneeling woman, the flute-playing trickster god Esu, and a fan bearer, now missing.

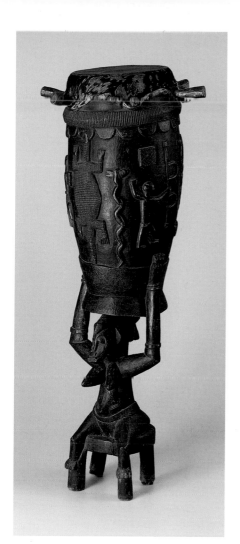

CEREMONIAL DRUM (*PINGE*)

Senufo; Côte d'Ivoire
1930/50

Wood, hide, and applied color; 122.9 x 49.2 cm
(48 ³/₈ x 19 ³/₈ in.)
Robert J. Hall, Herbert R. Molner Discretionary,
Curator's Discretionary, and African and
Amerindian Art Purchase funds; Arnold Crane,
Mrs. Leonard Florsheim, O. Renard Goltra,
Holly and David Ross, Departmental Acquisi-
tions, Ada Turnbull Hertle, and Marion and
Samuel Klasstorner endowments; through prior
gifts of various donors, 1990.137

This elaborate ceremonial drum takes the form of a seated woman gracefully balancing a load on her head. The figure's stylized features are characteristic of Senufo figural art, in particular that of the hereditary Kulebele woodcarvers, a group of artists who have historically traveled widely to work on location for patrons who commission their work. The strong and dignified female figure that holds this drum aloft evokes the Senufo ideal of women as family founders and spiritual mediators and guardians. Her composed expression projects a sense of inner calm that belies the great weight she carries, while her seated pose reflects a position of honor within the community. The drum's hide-covered resonating chamber is embellished with motifs that allude to conflict and competition, including warriors, a snake devouring a fish, and a crocodile biting into the decorative edge of the drum itself. These motifs emphasize the importance of knowledge and power in a world of competing spiritual and temporal forces.

In some Senufo communities, men play ceremonial drums during agricultural competitions or initiation rituals. Women may also play them during commemorative funerals for women of status.

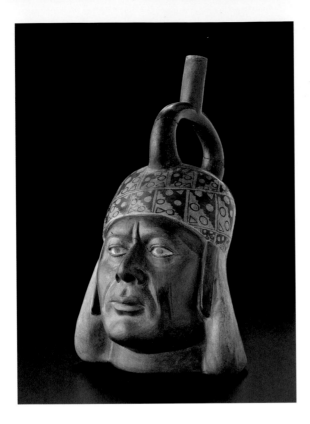

PORTRAIT VESSEL OF A RULER

Moche; north coast, Peru

100 B.C. / A.D. 500

Ceramic and pigment; 35.6 x 24.1 cm (14 x 9 ½ in.)

Kate S. Buckingham Endowment, 1955.2338

Among the most distinctive art objects of the ancient Peruvians were ceramic vessels produced by the artists of the Moche culture, which flourished on the north coast between about 100 B.C. and A.D. 500. Remarkable for their sculptural naturalism, these stirrup-spout bottles were molded without the aid of a potter's wheel and painted in earth tones. Moche potters represented everything about their world, from domestic scenes to architecture, ritual events and royal personages, and animals and plants. This portrait vessel portrays individual characteristics—the furrowed brow and full, slightly protruding upper lip—as well as general features recognizable among Peruvian Indians today. With his commanding expression and proud bearing, the depicted ruler conveys an indelible sense of the power of Moche leaders. His elite status is further indicated by his fine headdress, decorated with the geometric motifs of Moche textiles, and by his elongated ear ornaments and the traces of facial paint on his forehead and cheeks. Vessels such as this were placed in burials as funerary offerings, but before they accompanied an individual to the grave, they may also have been sent as emblems of royal authority from a center of power to neighboring districts along with gifts of textiles and other ceremonial presents.

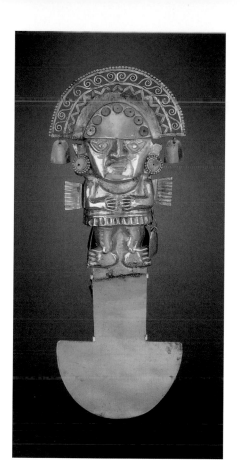

CEREMONIAL KNIFE (*TUMI*)
Chimú; north coast, Peru
A.D. 1100/1450

Gold with turquoise inlay; 34 x 12.7 cm
(13 ³/₈ x 5 in.)

Ada Turnbull Hertle Endowment, 1963.841

Naymlap, the heroic founder-colonizer of the Lambayque valley on the north coast of Peru, is thought to be the legendary figure represented on the top of this striking gold *tumi* (ceremonial knife). The knife would have been carried by dynastic rulers during state ceremonies to represent, in a more precious form, the copper knives used for animal sacrifices. Here Naymlap stands with his arms to his abdomen and his feet splayed outward. His gold headdress has an elaborate open filigree design. Turquoise—for the peoples of ancient Peru, a precious gem related to the worship of water and sky—is inlaid around the headdress cap and in the ear ornaments. The *tumi* was made with diverse metalworking techniques. Solid casting was used to produce the blade. The face and body were created with annealing (heating, shaping, and then cooling) and repoussé, in which the relief design is hammered into a mold from the reverse side. Finally, the small ornaments around the top of the headdress were separately hammered or cast, then soldered into place. This *tumi* and many other gold, silver, and textile objects were made in royal workshops and ceremonially presented to high officials as emblems of rank and authority.

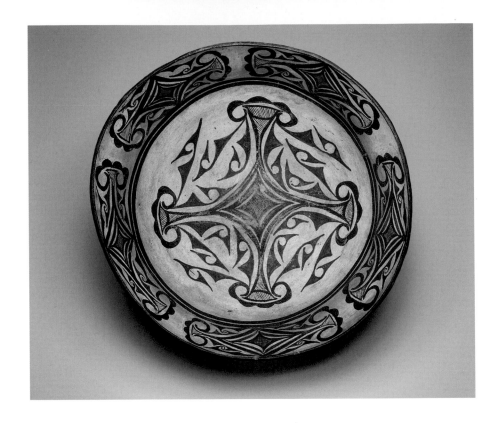

POLYCHROME BOWL
Probably We'wah (c. 1848–1896)
Zuñi
Zuñi Pueblo, New Mexico, United States
c. 1890
Ceramic and pigment; 16.5 x 42 cm (6 ½ x 16 ½ in.)
Gift of Charles and Marjorie Benton, 2010.550

Toward the end of the nineteenth century, an artistic renewal occurred throughout the Southwest as centuries-old styles and techniques were recast in response to increasing public interest in Native American art and culture. Potters from several pueblos (towns) developed innovative vessel forms and designs by adapting and adding to the achievements of their ancestors. The styles and symbolic forms expressed each community's particular historical identity and sense of place. The interior of this bowl is filled with a large, X-shaped symbol with arms emerging from a crosshatched diamond—a reference to the four sacred directions of the Zuñi world. The red, hooked motifs between the arms represent *pahos*, prayer sticks with attached feathers that were placed at sacred locations to petition for rain. On the exterior, zigzag lines flanked by red and black triangles signify lightning and rainfall. Many features of this vessel are characteristic of ceramics made by We'wah, one of the most renowned Zuñi artists, who held a special status within his community as one of their *lhamanas*. These highly respected individuals typically were born male, but followed traditional female gender roles, including pottery-making and weaving, and served as mediators with special ceremonial and spiritual responsibilities.

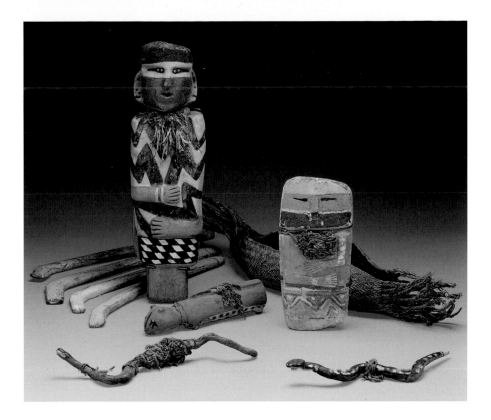

RITUAL CACHE

Salado branch of the Mogollon; southeastern Arizona, United States
A.D. 1300/1400

Wood, stone, plant fibers, cotton, feathers, hide, and pigment; male figure: h. 64 cm (25 ¼ in.);
female figure: h. 36 cm (14 ³⁄₁₆ in.)

Major Acquisitions Centennial Endowment, 1979.17.1–11

Discovered wrapped and hidden in a remote, dry cave, this cache of ritual figures comes
from the Salado culture, which flourished in the mountains of southwestern New
Mexico and southeastern Arizona between the fourteenth and fifteenth centuries.
Brilliantly colored and adorned with flicker feathers and dyed cotton string, these
effigies once formed an altar as agents for communion with the life-giving spirits of the
earth and sky. The large male figure, with his feather necklace and bold black-and-tur-
quoise zigzag pattern, features sky symbolism. The smaller female figure is a more
self-contained form, probably corresponding to the earth. Her ocher color probably
refers to maize and pollen, symbols of sustenance and fertility. The accompanying fig-
ures are a mountain lion (the chief predator in the region) and two serpents (carved
from cottonwood roots), representing agents of communication with the earth and
the seasonal cycle of fertility. Curved wooden throwing sticks for rabbit hunting com-
plete the ensemble. Testimony to the antiquity and endurance of the worship of earth
and sky, and to the spiritual bonds between people and animals, these objects bear
close resemblance to ritual figures and implements still used today among the diverse
Pueblo peoples.

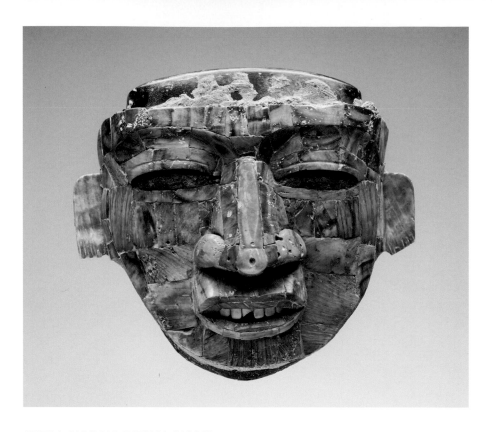

SHELL MOSAIC RITUAL MASK
Teotihuacan; Teotihuacan, Mexico; A.D. 300/600

Stone and *Spondylus* (spiny oyster) shell with stucco; 18 x 21 x 11 cm (7 ⅛ x 8 ¼ x 4 ⁵⁄₁₆ in.)

Through prior gifts of Mr. and Mrs. Arthur M. Wood and Mr. and Mrs. William E. Hartmann; Robert Allerton Trust; through prior gifts of Ethel and Julian R. Goldsmith and Mr. and Mrs. Samuel A. Marx; Morris L. Parker Fund; restricted gifts of Cynthia and Terry Perucca and Bill and Stephanie Sick; Wirt D. Walker Trust, Bessie Bennett, and Elizabeth R. Vaughn funds; restricted gifts of Rita and Jim Knox and Susan and Stuart Handler; Edward E. Ayer Fund in memory of Charles L. Hutchinson and Gladys N. Anderson Fund; restricted gift of Terry McGuire; Samuel P. Avery and Charles U. Harris Endowed Acquisition funds, 2012.2

Teotihuacan, whose ruins are located near Mexico City, was one of the largest and most complex cities in the world during the first millennium A.D. Although this mask shares features common to others from the city—a broad forehead, prominent nose, receding chin, and widely spaced cheekbones—it is subtly unique, indicating that it represents a stylized portrait. Tied to wooden armatures adorned with feathers, jewelry, and garments, such masks were displayed in residential compounds and temples where they were the focus of rituals commemorating ancestors who acted as intermediaries between the living community and the deified forces of nature. An older, recut stone mask was covered with mosaic tiles made from the inner layer of *Spondylus* shell imported from the Pacific coast. The use of this exotic material suggests the far-reaching power, authority, and wealth of Teotihuacan. *Spondylus* was also considered sacred, associating this mask and the individual it honors with the generative power of lakes, rivers, and the sea.

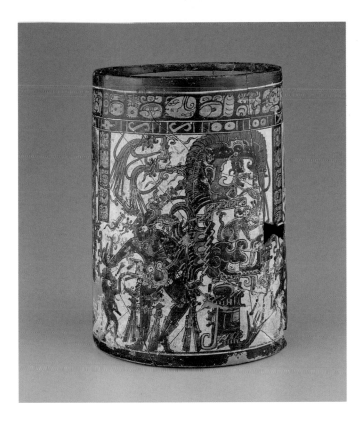

VESSEL OF THE DANCING LORDS

Ah Maxam (active mid-/late 8th century)
Late Classic Maya; vicinity of Naranjo, Petén region, Guatemala
A.D. 750/800
Ceramic and pigment; 24 x 15.8 cm (9 ½ x 6 ¼ in.)
Ethel T. Scarborough Fund, 1986.1081

According to ancient Maya belief, after several failed attempts the gods succeeded in populating the earth when they created humanity out of maize, the staff of life. In the *Popol Vuh*, a sixteenth-century epic of the K'iche' Maya, the death and resurrection of the maize god was likened to seed corn that sprouted and produced new life. This vessel from the Late Classic period (A.D. 600–800) depicts a Maya ruler attired as the maize god in three almost-identical panels. On his back, the ruler wears an enormous rack containing brilliant feathers, heraldic beasts, and related emblems. Just as maize plants sway to and fro, the maize god dances to the rhythm of life—often, as seen here, in the company of a dwarf. Among the Maya, dwarfs were seen as special beings with powerful spiritual connections to the earth and the interior world below. This vase refers to a rite of passage in which dwarfs assist the soul of the deceased into the domain of the dead, from which it would be eventually reborn in the royal lineage, just as maize sprouts again in the cycle of nature's renewal. This vase of the Dancing Lords appears to have been painted as a funerary offering for a noblewoman with dynastic connections in the city of Naranjo, where it was made.

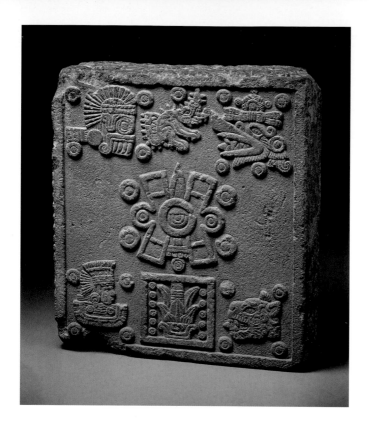

CORONATION STONE OF MOTECUHZOMA II (STONE OF THE FIVE SUNS)

Aztec (Mexica); Tenochtitlan, Mexico

1503

Basalt; 55.9 x 66 x 22.9 cm (22 x 26 x 9 in.)

Major Acquisitions Fund, 1990.21

This stone, commemorating the beginning of the reign of Emperor Motecuhzoma II, was originally located within the ritual center of Tenochtitlan, the capital of the extensive empire conquered by the Aztecs between 1428 and 1519. The ruins of Tenochtitlan lie beneath downtown Mexico City. Known as the *Stone of the Five Suns*, this monument draws connections between Aztec history and the cosmic scheme. The quadrangular block is carved with the hieroglyphic signs of five successive cosmic eras, called "suns" in the language of the Aztecs. These eras were mythic cycles of creation and destruction that began in the time of genesis and continued with the birth of humankind and the period of Aztec rule. From "4 Jaguar-sun" in the lower-right corner, the eras proceed counterclockwise through "4 Wind-sun," "4 Rain-sun," and "4 Water-sun." The X carved in the center represents "4 Movement-sun," the sign of the present era for the Aztecs. The year "11 Reed" in the square cartouche refers to 1503, the year of Motecuhzoma's coronation, while the day listed above it—"1 Crocodile"—corresponds to July 15, when the ceremony probably occurred. On the underside, the hieroglyphic date "1 Rabbit" denotes the beginning of things in the distant mythological past. The sculpture thus legitimizes Motecuhzoma's rule as a part of the larger cycles of birth, death, and renewal and shows him as heir to the world in the present era of creation.

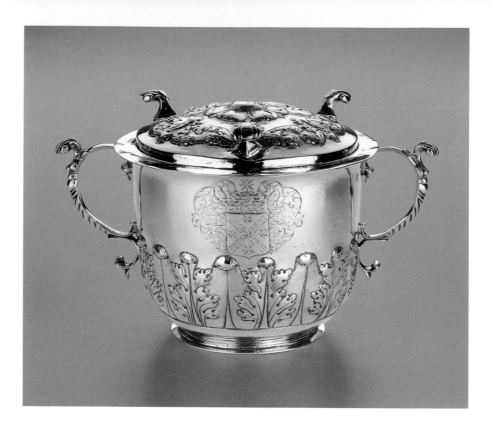

CORNELIUS KIERSTEDE American, 1675–1757
Two-Handled Covered Cup, 1698/1720
New York, New York
Silver; 14 x 22.9 x 14.1 cm (5 ½ x 9 x 5 ⁹/₁₆ in.)
Restricted gift of Mrs. James W. Alsdorf, Pauline Seipp Armstrong, Marshall Field, Charles C.
Haffner III, Mrs. Burton W. Hales, Mrs. Harold T. Martin, Mrs. C. Phillip Miller, Mr. and Mrs. Milo
M. Naeve, Mrs. Eric Oldberg, and Mrs. Frank L. Sulzberger; Ethel T. Scarborough Fund, 1984.1132

This luxurious vessel, by one of New York's foremost early silversmiths, was used
to serve syllabub, a sweetened or flavored wine, cider, beer, or ale into which milk was
whipped. The cover helped preserve the frothy drink and also, using its three equi-
distant handles as legs, could be inverted into a stand for the cup. The cup bears the
mark *CK*, standing for Cornelius Kierstede, a third-generation New York silversmith
of Dutch descent. Kierstede opened a shop around 1698 in New York, where he worked,
off and on, until moving to New Haven, Connecticut, in the early 1720s. Like the
Van Cortlandt family, who commissioned this cup and whose coat of arms it bears,
and the Stuyvesant family, whose descendants owned the cup until the Art Institute
acquired it, the majority of Kierstede's patrons were wealthy Dutch colonists. This cup
is one of four nearly identical vessels made during the same period by Kierstede and
two other well-known New York silversmiths. Evolved from English prototypes, all
these cups have the same nearly straight sides, scroll-like handles, and slightly domed
cover, as well as variations of the embossed acanthus-leaf ornament.

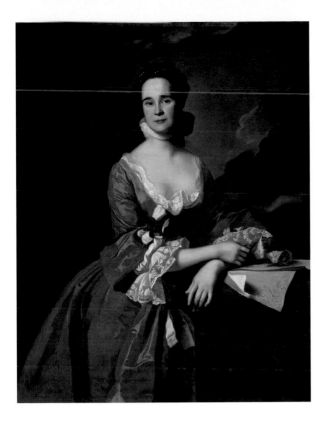

JOHN SINGLETON COPLEY American, 1738–1815

Mrs. Daniel Hubbard (Mary Greene), c. 1764

Oil on canvas; 127.6 x 100.9 cm (50 ¼ x 39 ¹¹/₁₆ in.)

The Art Institute of Chicago Purchase Fund, 1947.28

America's foremost portrait painter before the Revolutionary War, John Singleton
Copley had completed his first portraits by the age of fifteen. Largely self-taught, the
Boston painter often relied, as did English artists, on European prints for composi-
tional models and, in particular, on the print collection of his stepfather and teacher,
Peter Pelham, a mezzotint engraver. For this portrait of a wealthy merchant's wife,
Copley emulated the pose, gown, and background of an English noblewoman in a
mezzotint portrait. Standing on a balcony or terrace, Mrs. Hubbard rests her arm
on an embroidered cloth placed over a pedestal. As in the print, draperies and clouds
billow behind her. Even the cherub carved in relief on the parapet is borrowed from
the mezzotint. Nevertheless, the penetrating directness, vigorous execution, and
precision of detail are Copley's own; this particular indigenous sensibility was much
appreciated throughout the colonies. The wealthy merchants and professionals Copley
painted included Mrs. Hubbard's husband (whose portrait is also in the Art Institute's
collection), as well as some of the colonies' most influential personages, such as the
patriots Samuel Adams, John Hancock, and Paul Revere. Copley left America for
England on the eve of the American Revolution and never returned.

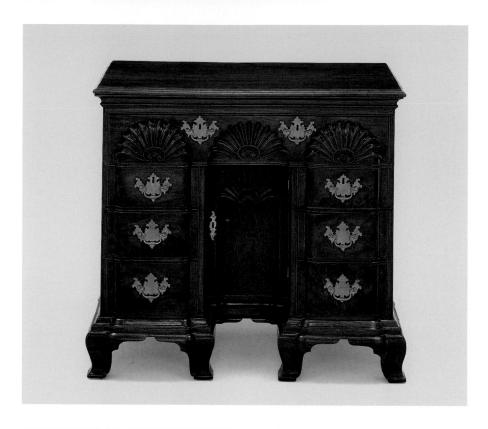

ATTRIBUTED TO JOHN TOWNSEND American, 1732–1809
Bureau Table, 1780/90
Newport, Rhode Island
Mahogany, with maple, chestnut, and white pine; 86.6 x 93.4 x 58 cm (34 ⅛ x 36 ¾ x 20 in.)
Gift of Jamee J. and Marshall Field, 1984.1387

This elegant piece epitomizes the late Baroque style that flourished in Newport, Rhode Island. It is one of six bureaus that can be attributed to the master cabinetmaker John Townsend on the basis of similar construction and design features in labeled pieces by the maker. For example, the carved shells have central C-scrolls featuring petals and crosshatched baskets, all motifs that are indicative of Townsend's work. In addition, the top is integrated into the case by cove-and-bead molding, with smaller cavetto molding underneath. The blocking of the upper drawer continues through the side drawers and into the graceful double scroll of the bracket feet, creating an unbroken visual plane that unifies the design elements.

Kept in bedchambers, bureau tables most likely functioned as dressing tables. They were particularly popular among the Quaker citizens of Newport, who appreciated the wide array of storage possibilities they offered. According to oral tradition, Samuel Fowler originally owned this bureau. A successful merchant, Fowler frequently conducted business with the Townsend family. In 1786 and 1787, John Townsend purchased hinges, nails, and sundries from Fowler. This relationship bolsters the argument that Fowler owned this bureau, since patronage loyalty resulting from familial, religious, or trading ties was typical in eighteenth-century Newport.

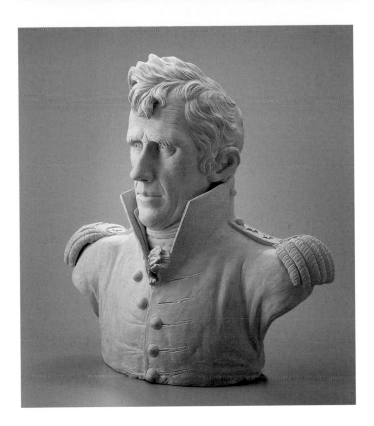

WILLIAM RUSH American, 1756–1833
General Andrew Jackson, 1819
Terracotta; 50.5 x 47.9 x 22.2 cm (19 ⅞ x 18 ⅞ x 8 ¾ in.)
Restricted gift of Jamee J. and Marshall Field; the Brooks and Hope B. McCormick
Foundation; and the Bessie Bennett, W. G. Field, Ada Turnbull Hertle, Laura T. Magnuson, and
Major Acquisitions funds, 1985.251

Andrew Jackson was described by a contemporary as having "an erect military bearing, and a head set with considerable *fierté* [pride] upon his shoulders. . . . His eye is of a dangerous fixedness; . . . [and] the instant his lips close, a visor of steel would scarcely look more impenetrable." William Rush rendered a remarkably similar depiction of the general. Demonstrating a blend of naturalism, subtlety, and strength, Rush avoided grandiosity in this terracotta portrait bust of the fifty-two-year-old military hero, who, ten years later, would begin to serve the first of two consecutive terms as president of the United States. The artist's only concession to idealization was the replacement of the general's well-known stiff, wiry hair with the soft curls that signify noble qualities in Neoclassical sculpture. Since there is no documentation that Jackson formally posed for Rush, the artist, a prominent resident of Philadelphia, may have observed the general during his three-day visit to the city in 1819. This sculpture achieved critical and commercial success, with one reviewer ranking it as "Rush's masterpiece." Hoping to benefit from Jackson's popularity, Rush followed the European custom of producing plaster replicas of the bust.

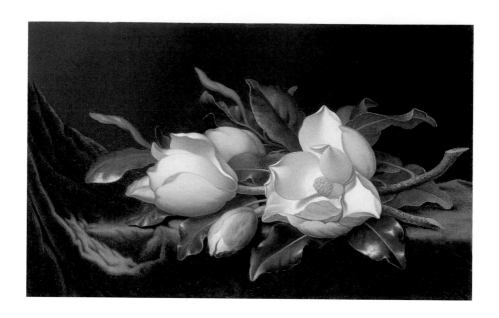

MARTIN JOHNSON HEADE American, 1819–1904
Magnolias on Light Blue Velvet Cloth, 1885/95
Oil on canvas; 38.6 x 61.8 cm (15 ³/₁₆ x 24 ⁵/₁₆ in.)
Restricted gift of Gloria and Richard Manney; Harold L. Stewart Endowment, 1983.791

This sensuous and decorative image dates from the later part of Martin Johnson Heade's long, varied, and peripatetic career. Traveling through much of the United States, to England and continental Europe, and (three different times) to Brazil, he produced work ranging from pristine views of East Coast salt marshes and lush tropical landscapes to pictures of exotic hummingbirds and orchids. At the age of sixty-four, Heade settled in St. Augustine, Florida. There he began painting detailed arrangements of native flowers, including the Cherokee rose, orange blossom, and magnolia. Although the majority of his floral compositions were vertical, Heade chose a horizontal format to display the curvaceous magnolia. Stretched out like an odalisque on blue velvet cloth, the fleshy white flower is meticulously rendered in pale, subtle hues and illuminated by a light so sharp that the image evokes the hyper-intensity of a dream. The warm, steamy atmosphere is almost palpable, as is the blossom's heady, pungent scent. The Art Institute's *Magnolias* is one of a number of compositions by the artist featuring this dramatic yet delicate white flower.

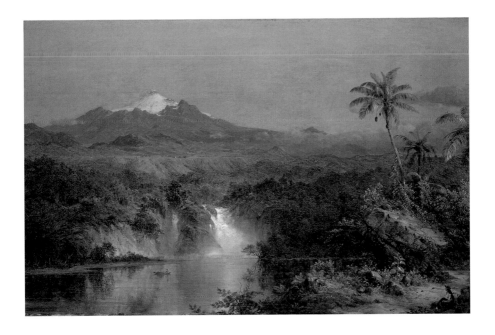

FREDERIC EDWIN CHURCH American, 1826–1900
View of Cotopaxi, 1857
Oil on canvas; 62.2 x 92.7 cm (24 ½ x 36 ½ in.)
Gift of Jennette Hamlin in memory of Mr. and Mrs. Louis Dana Webster, 1919.753

One of the leading American landscape painters in the mid-nineteenth century, Frederic Edwin Church approached his subject matter as both an artist and a scientist. Inspired by the writings of the German naturalist and explorer Alexander von Humboldt, Church visited the mountainous terrain of South America twice, in 1853 and 1857. In this untamed "New World"—and particularly in what was then the highest active volcano in the world, the mighty Ecuadorian Cotopaxi—Church saw the perfect symbol of primeval nature and the spiritual renewal it could bring to civilization. This view of the smoldering cone of Cotopaxi (which means "shining mass" in Incan) was completed after Church's first trip to South America. A dazzling compendium of minutely rendered wildlife, vegetation, and terrain, the canvas illustrates the fascinating contrasts indigenous to this locale: from the calm water to the explosive cascades and from the lush, green foliage to the frozen, barren peak. The elevated vantage point, which makes the viewer feel suspended in midair, heightens these evocative juxtapositions. One of at least ten finished canvases featuring the Andean volcano that Church executed over the course of almost two decades, this painting represents an intermediate vision between his more naturalistic early pieces and the dramatic, transcendental works of his mature career.

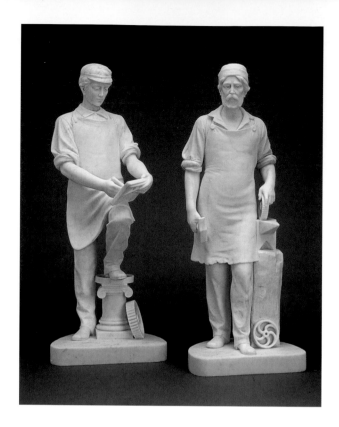

EMMA STEBBINS American, 1815–1882
Machinist and *Machinist's Apprentice*, c. 1859
Marble; 74.9 x 29.2 x 29.2 cm (29 ½ x 11 ½ x 11 ½ in.) and 74.9 x 29.9 x 22.9 cm (29 ½ x 11 ¾ x 9 in.)
Gift of the Antiquarian Society, 2000.13.1–2

Emma Stebbins was a member of the community of women sculptors in Rome. Like
their male colleagues, these women emulated the statues of antiquity, seeing in
them the highest form of art. This rare pair of marble statues portrays a laborer and
his apprentice, an unusual theme in mid-nineteenth-century American sculpture.
Stebbins's innovative conceit was to render a modern subject—the profession of the
machinist—in the refined, Neoclassical visual language traditionally used to depict
biblical, historical, or mythological subjects. Both figures can be identified as machin-
ists by their clothing: cap, work shirt, leather apron, and long pants. The senior
machinist holds a forging hammer and toothed gear, the means and ends of his labor;
the young apprentice demonstrates his ability to improve on his teacher's experience
with a compass and drawing stylus. By using a Neoclassical idiom to represent a new
machine-based profession practiced by two generations of workers, Stebbins
celebrated the possibilities of innovation and suggested the peaceful coexistence of
traditional labor and mechanization.

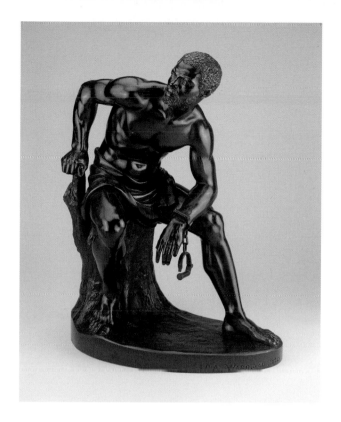

JOHN QUINCY ADAMS WARD American, 1830–1910
The Freedman, 1862–63
Bronze; 49.9 x 40 x 23.9 cm (19 ⅝ x 15 ¾ x 9 ⅜ in.)
Roger McCormick Endowment, 1998.1

A leader among the nation's second generation of sculptors, John Quincy Adams Ward played a significant role in elevating the medium in the United States, calling for a new realism to address moral concerns. Inspired by Abraham Lincoln's Emancipation Proclamation, announced in September 1862, *The Freedman* reflects not only Ward's aspiration to create relevant statements on pressing issues of the day, but also his abolitionist sentiments. Using antiquity as his inspiration, he depicted a seminude man seated on a tree stump who has just been liberated from the shackles that bound him to slavery. Ward broke artistic convention by showing the former slave as master of his own destiny, not reliant on white men for freedom. The vestiges of chains, potent symbols of his bondage, dangle from both wrists, and his muscular body, turned to look over his shoulder, is contained within a formal, triangular composition. *The Freedman* was modeled from life and is generally considered the first and most accurate sculptural representation of an African American. When *The Freedman* was first exhibited in 1864, the eminent art critic James Jackson Jarves effectively summarized the work's power: "We have seen nothing in our sculpture more soul-lifting or more comprehensively eloquent. It tells in one word the whole sad story of slavery and the bright story of emancipation."

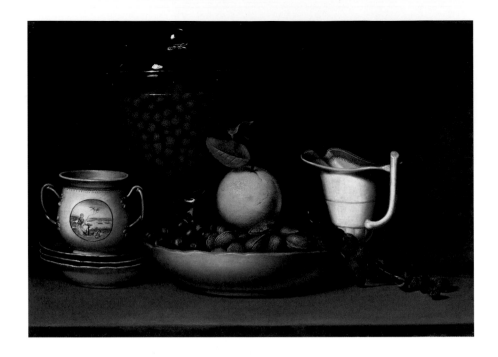

RAPHAELLE PEALE American, 1774–1825
Still Life—Strawberries, Nuts, &c., 1822
Oil on wood panel; 41.1 x 57.8 cm (16 ³/₁₆ x 22 ³/₄ in.)
Gift of Jamee J. and Marshall Field, 1991.100

Academic theory during Raphaelle Peale's time relegated still life to the bottom of the
hierarchy of painting subjects. Yet Peale ignored its low status and is now acknowl-
edged as America's first professional still-life painter and master of the genre. Born
into an artistic Philadelphia family, Raphaelle was the eldest son of Charles Willson
Peale and the nephew of James Peale, both artists; his siblings were, like him, named
after famous Old Master painters. (He had brothers named Rembrandt, Titian, and
Rubens, for example.) Characterized by crisp forms and serenely balanced composi-
tions, most of Peale's still lifes portray food (mainly fruit), crockery, and glassware
arranged on a plain shelf, parallel to the picture plane. In this particularly fine example,
the rhythmic balance of fruit, nuts, and Chinese export porcelain is enlivened by
the diagonal branch of raisins and orange leaf. These objects are brightly illuminated
against a bare, dark background, in the manner of the dramatic still-life composi-
tions of seventeenth-century masters such as the Spanish painter Juan Sánchez Cotán
(see p. 207). Peale may have seen Sánchez Cotán's work when it was shown at the
Pennsylvania Academy of the Fine Arts in 1818.

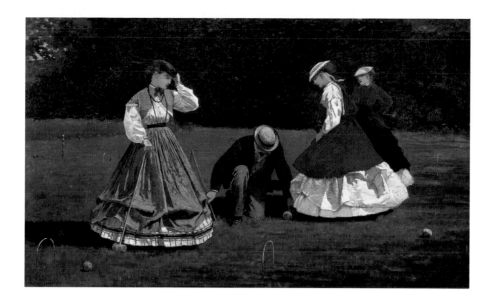

WINSLOW HOMER American, 1836–1910
Croquet Scene, 1866
Oil on canvas; 40.3 x 66.2 cm (15 ⁷/₈ x 26 ¹/₁₆ in.)
Friends of American Art Collection; Goodman Fund, 1942.35

One of America's master painters, Winslow Homer began his career as an illustrator during the Civil War. In the late 1860s, he turned his acute observational and technical skills toward oil painting, depicting figures bathed in sunlight out-of-doors. These early paintings, often executed in series, feature scenes of upper-class leisure pursuits—in this case, women and men competing with one another in the popular sport of croquet, which had recently been introduced to the United States from the British Isles. In *Croquet Scene,* one of five paintings Homer completed on the subject, progress on "the grand round" seems fairly advanced. The crouching male figure positions the ball belonging to the woman dressed in red. She is about to croquet (or "send up the country") another ball, probably belonging to the woman in the left foreground, who shields her eyes against the bright afternoon sun. Notable for its bold patterning, strong contours, and brilliant light effects, the painting epitomizes the spirit of a breezy summer afternoon.

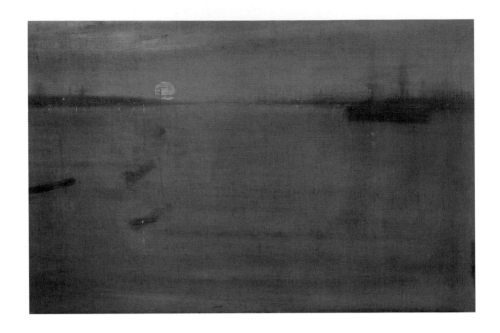

JAMES MCNEILL WHISTLER American, 1834–1903
Nocturne: Blue and Gold—Southampton Water, 1872
Oil on canvas; 50.5 x 76 cm (19 ⁷/₈ x 29 ¹⁵/₁₆ in.)
Stickney Fund, 1900.52

"Art should be independent of all clap-trap—should stand alone and appeal to the artistic sense of eye or ear," said the iconoclastic painter James McNeill Whistler. Born in the United States, Whistler spent most of his adult life in Paris and London. To emphasize that his paintings have no narrative overtones—that instead they are aesthetic arrangements of color and shape on flat surfaces—he gave them titles derived from music, such as *arrangements, symphonies*, and *nocturnes*. One of his first such paintings, *Nocturne: Blue and Gold—Southampton Water* depicts a hazy, moonlit night on an inlet of the English Channel, southwest of London. Although the work is based on his experience of the location, the specifics of place are inconsequential to it. Instead, Whistler was interested in the subtle harmony of shades of blue, punctuated by touches of gold. By blurring and obscuring the shapes of the distant boats, he made color and form the primary focus of the painting. Often misunderstood and sometimes openly ridiculed when they were first exhibited, Whistler's luminous nocturnal visions were forerunners of the experiments in abstraction that would follow in the next century.

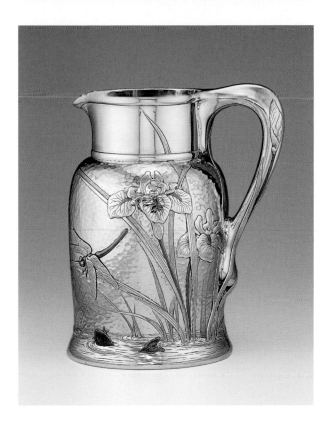

DESIGNED BY EDWARD C. MOORE American, 1827–1891
Pitcher, 1878
New York, New York
Made by Tiffany and Company
Silver, gold, and copper; 22.2 x 14 cm (8 ³/₄ x 5 ¹/₂ in.)
Restricted gift of Mrs. Frank L. Sulzberger, 1984.240

By the time this elegant pitcher was produced, Tiffany and Company had become one of the largest and most accomplished silver manufacturers in the world. Created by the company's chief designer, Edward C. Moore, the work reflects the late-nineteenth-century fascination with Japan, a nation that had resumed full trade with the outside world just two decades before. Moore formed one of the earliest collections of Japanese art in the United States; in this pitcher, he emulated both motifs found in Japanese woodblock prints and the multiple metals and hammered surfaces used in Japanese metalwork. Company records show that several dozen versions of this object were made during the 1870s and 1880s and sold as far away as Russia. An identical version received widespread acclaim when it was exhibited at the Exposition Universelle in Paris in 1878, where Moore received a gold medal and the company's founder, Charles Lewis Tiffany, was made a Knight of the French Legion of Honor. The London *Spectator* lamented, "We confess we were surprised and ashamed to find that a New York firm, Tiffany & Co., had beaten the old country and the old world in domestic silver plate."

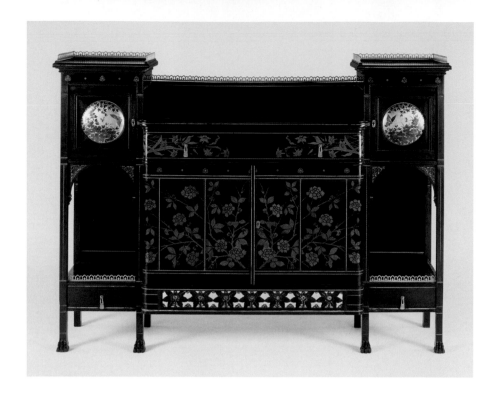

HERTER BROTHERS American, 1864–1906
Cabinet, 1878/80
New York, New York

Rosewood, cherry, maple, walnut, satinwood, marquetry of various woods, brass, gilding, and paint;
134.6 x 180.3 x 40.6 cm (53 x 71 x 16 in.)
Restricted gift of the Antiquarian Society through the Capital Campaign, 1986.26

Herter Brothers, one of New York's foremost decorating firms during the 1870s and
early 1880s, followed the lead of English designers intent on reforming an industry that
produced poorly conceived and constructed work by advocating designs that joined
the beautiful and the functional. Brothers Gustave and Christian Herter preferred bold,
rectilinear shapes, which they often enlivened, as in this case, with exquisite surface
decoration inspired by Japanese art, evidence of the Japanism that was prevalent
throughout the West at this time. Here the painted roundels featuring flowers and
insects on either side of the cabinet emulate Japanese lacquer, while the floral inlay
across the facade is reminiscent of patterns found in Japanese screen paintings and
textiles. Japanese family crests inspired the bands of inlay across the tops of the doors
and above the side compartments, and Japanesque plum blossoms were carved in
the arched spandrels on either side of the facade. Nevertheless, the overall form of
the cabinet is Western, and the piece also includes such non-Japanesque elements
as Egyptian-revival paw feet. Aesthetic movement designers such as Herter Brothers
readily combined such eclectic motifs as long as they achieved a sense of visual harmony.

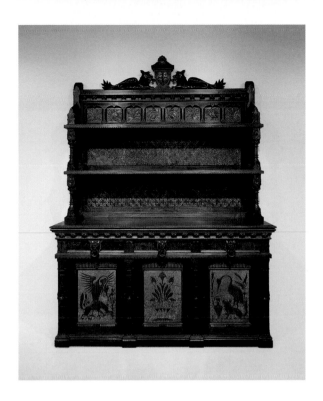

DANIEL PABST American, 1826–1910
Sideboard, c. 1870/80
Philadelphia, Pennsylvania
Walnut and burled elm; 256.5 x 185.4 x 62.2 cm (101 x 73 x 24 ½ in.)
Restricted gift of the Antiquarian Society, 2005.51

Marking the height of the "modern Gothic" style in Philadelphia, this sideboard
resembles the furniture designed by notable architect Frank Furness, who frequently
collaborated with cabinetmaker Daniel Pabst. Although details of the piece's carving
tie it unmistakably to Pabst, the design cannot be attributed conclusively to a particular
hand. The designer was influenced by the writings of Christopher Dresser and Charles
Eastlake, British reformers who advocated honesty of construction and convention-
alized ornament. Instead of carving the decoration deeply in order to achieve a
naturalistic effect, Pabst used a cameo technique, cutting through the burled elm veneer
to reveal the darker walnut beneath and creating a striking color contrast and flat-
tened style of decoration.

In the mid-nineteenth century, dining-room furniture typically featured ornament
that was intended to reinforce ideals of hospitality and gentility. Here the cabinet doors
display designs recounting Aesop's fable of the fox and the stork, a tale in which each
animal offers the other some food in a serving dish from which the guest cannot eat,
thus proving the importance of true hospitality. The panels are virtually identical to
images found on curtain designs illustrated in Eastlake's 1868 book *Hints on Household
Taste,* a text that was widely influential in the United States.

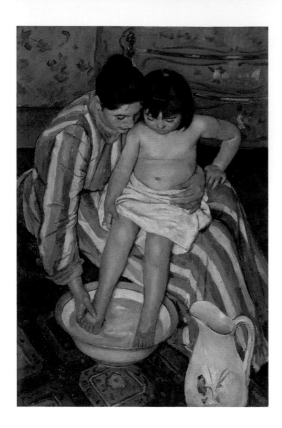

MARY CASSATT American, 1844–1926
The Child's Bath, 1893
Oil on canvas; 100.3 x 66.1 cm (39 ½ x 26 in.)
Robert A. Waller Fund, 1910.2

The only American artist to exhibit her work with the French Impressionists, Mary Cassatt was first invited to show with the group by Edgar Degas in 1877. By that time, she had become disenchanted with traditional academic painting. Like her friend Degas, Cassatt concentrated on the human figure in her Impressionist works, particularly on sensitive yet unsentimental portrayals of women and children. *The Child's Bath*, with its striking and unorthodox composition, is one of Cassatt's masterworks. In it she employed unconventional devices such as cropped forms, bold patterns and outlines, and a flattened perspective, all of which derived from her study of Japanese woodblock prints. The lively patterns play off one another and serve to accentuate the nakedness of the child, whose vulnerable white legs are as straight as the lines of the woman's striped dress. The elevated vantage point permits the viewer to observe, but not participate in, this most intimate scene. Cassatt's composition thereby reinforces her subject: the tender absorption of a woman with a child.

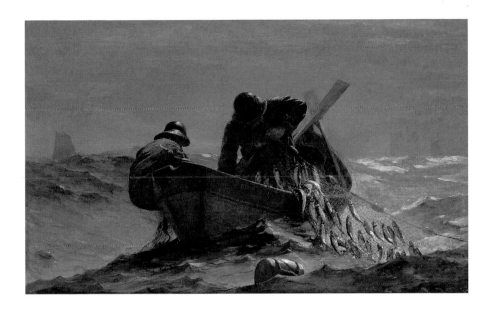

WINSLOW HOMER American, 1836–1910
The Herring Net, 1885
Oil on canvas; 76.5 x 122.9 cm (30 ⅛ x 48 ⅜ in.)
Mr. and Mrs. Martin A. Ryerson Collection, 1937.1039

In 1883 Winslow Homer moved to the small coastal village of Prouts Neck, Maine, where he created a series of paintings of the sea unparalleled in American art. Long inspired by the subject, Homer had spent summers visiting New England fishing villages during the 1870s, and in 1881–82, he made a trip to a fishing community in Cullercoats, England, that fundamentally changed his work and his life. The paintings he created after 1882 focused almost exclusively on humankind's age-old contest with nature. Here Homer depicted the heroic efforts of fishermen at their daily work, hauling in an abundant catch of herring. In a small dory, two figures loom large against the mist on the horizon, through which the sails of the mother schooners are dimly visible. While one fisherman hauls in the netted and glistening herring, the other unloads the catch. Utilizing the teamwork so necessary for survival, both strive to steady the precarious boat as it rides the incoming swells. Homer's isolation of these two figures underscores the monumentality of their task: the elemental struggle against a sea that both nurtures and deprives.

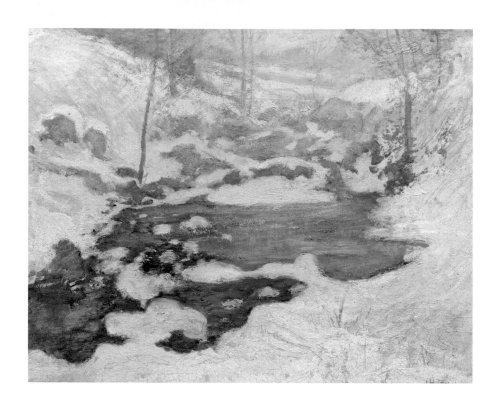

JOHN HENRY TWACHTMAN American, 1853–1902
Icebound, c. 1889
Oil on canvas; 64.2 x 76.6 cm (25 ¼ x 30 ⅛ in.)
Friends of American Art Collection, 1917.200

Around 1889, after years of training and travel, John Henry Twachtman purchased a seventeen-acre farm in Greenwich, Connecticut. During the next decade, he created some of his finest works there. Like the French Impressionists, whose style greatly influenced him, Twachtman found an inexhaustible source of subjects and inspiration in his local surroundings. *Icebound* illustrates a favorite theme: a stream descending from rocks to a serene pool surrounded by hemlock trees. In the hushed tranquility of this winter scene, Twachtman achieved a fine compositional balance between spontaneity and control. Movement is implied despite the frozen stillness suggested by the title and the muted tonal harmonies of the painting's limited white and blue palette. Sinuous arabesques of white snow against blue water accentuate the stream's descent. Thick brushstrokes of white and streaks of violet amid the blue of the water enliven the picture's surface. Vivid red-orange leaves serve both as distinctive accents against the dominant white and as reminders of an autumnal life that has not surrendered to the relentless change of seasons.

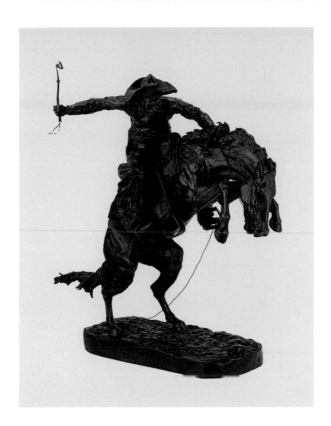

FREDERIC REMINGTON American, 1861–1909
The Bronco Buster, modeled 1895; cast 1899
Cast by Henry-Bonnard Bronze Company, New York
Bronze; 61 x 39.4 x 17.8 cm (24 x 15 ½ x 7 in.)
George F. Harding Collection, 1982.808

Although born, raised, and educated on the East Coast, Frederic Remington achieved considerable success as America's leading illustrator of life on the western frontier. In 1894 he turned his skill and energy to sculpture. This vigorous portrayal of a cowboy taming a wild horse was the artist's first effort in bronze, and with an illustrator's eye for drama, he captured the single most illuminating moment of the event. Although the horse and rider struggle against each other, they are pulled together at the instant of utmost exertion. As the bronco rears up, back arched and splayed tail snapping, the cowboy leans forward, his whip suspended in midair as he clutches the reins and horse's mane. This minutely rendered, instantaneously captured, and technically remarkable depiction of life in the Wild West became one of the most popular American bronzes of the early twentieth century. The Art Institute's version is one of nearly seventy made at the Henry-Bonnard Bronze Company of New York, using the French sand-casting method.

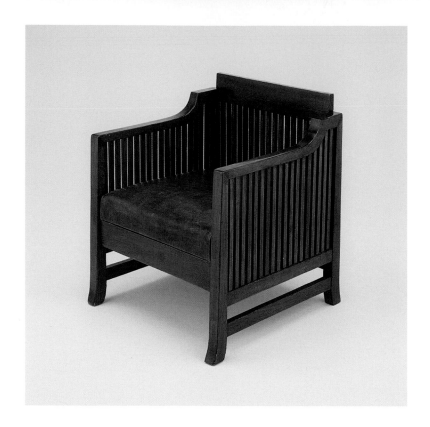

FRANK LLOYD WRIGHT American, 1867–1959
Spindle Cube Chair, 1902/06
Made for the Frank Lloyd Wright Home and Studio, Oak Park, Illinois
Poplar and leather; 73.7 x 73.7 x 73.7 cm (29 x 29 x 29 in.)

Restricted gift of the Antiquarian Society; Roger McCormick Purchase, Alyce and Edwin DeCosta and the Walter E. Heller Foundation, Robert Allerton Purchase Income, Ada Turnbull Hertle, Mary Waller Langhorne Memorial funds; Robert Allerton Trust; Pauline Seipp Armstrong Fund; bequest of Ruth Falkenau Fund in memory of her parents; Mrs. Wendell Fentress Ott, Bessie Bennett, Elizabeth R. Vaughn, and Gladys N. Anderson funds; estate of Stacia Fischer; the Goodman Fund; Maurice D. Galleher Endowment; Samuel P. Avery and Charles U. Harris Endowed Acquisition funds; estate of Cora Abrahamson; Charles R. and Janice Feldstein Endowment Fund for Decorative Arts, 2007.79

This elegant spindle cube chair is an early example from Frank Lloyd Wright's home and studio. In 1889 Wright built a house for his young family on Forest Avenue in Oak Park, a new suburb just west of Chicago; ten years later, he opened an attached studio and designed it and the home's interior in accordance with his philosophy of simplicity and the integrity of materials. Among his furniture experiments were heavy, solid cube chairs. By the first decade of the twentieth century, Wright had refined his early design into that of this chair, adding spindles, a subtly tapering crest rail, and gently curving leg ends to produce an effect that is equal parts sophistication and simplicity. The spindles themselves were a legacy of William Morris–inspired ladder-back dining chairs, as well as the Arts and Crafts approach of contrasting positive and negative space. This chair was also influenced by the reticulated ceilings and walls of Japanese homes.

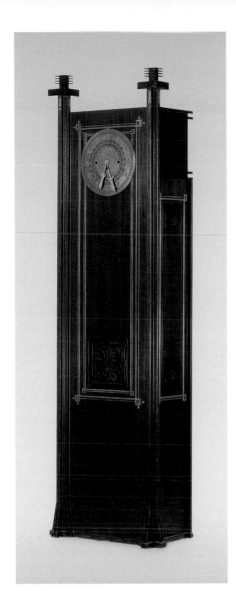

GEORGE GRANT ELMSLIE
American, born Scotland, 1871–1952
WILLIAM GRAY PURCELL
American, 1880–1965
Tall Clock, 1912
Made for the Henry Babson
House, Riverside, Illinois
Manufactured by Niedecken-
Walbridge Company, Milwaukee,
Wisconsin (1907–38)
Mahogany with brass inlay;
213.3 x 66 x 40 cm (84 x 26 x 15 ¾ in.)
Restricted gift of Mrs. Theodore D. Tieken,
1971.322

This handsome tall-case clock was
designed by the firm of George Grant
Elmslie and William Gray Purcell for
the Henry Babson House in Riverside,
Illinois. Although Louis Sullivan de-
signed the house in 1907, a large part of
the scheme—including the built-in
and freestanding furniture—was actu-
ally executed by Elmslie, who was then
working for Sullivan. In 1912 Elmslie
and his firm made additions to the
house, including eight pieces of furni-
ture. This elegant clock, whose works
and nine chimes were imported from
Germany, dates from this later commis-
sion. Its hands were executed by Chi-
cago metalsmith Robert Riddle Jarvie
according to Elmslie's design. In his
concern over creating an organic, har-
monious relationship between the
interior of a house and its exterior, the
Scottish-born Elmslie found a staunch
ally in designer George Niedecken,
president of the Milwaukee-based firm
of Niedecken-Walbridge, which made
the clock's mahogany case.

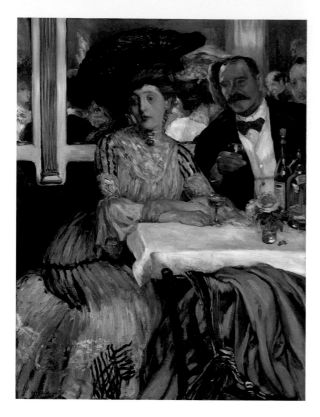

WILLIAM GLACKENS American, 1870–1938
At Mouquin's, 1905
Oil on canvas; 122.4 x 92.1 cm (48 ⅛ x 36 ¼ in.)
Friends of American Art Collection, 1925.295

William Glackens—a member of an association of artists called the Eight—was
at the center of avant-garde American painting at the turn of the twentieth century.
Rejecting the academic standards of the influential National Academy of Design in
New York, Glackens and his fellow urban realists focused unflinchingly on the city
around them, vividly recording the street life and leisure activities they encountered.
Mouquin's was a fashionable New York restaurant frequented by Glackens and mem-
bers of his circle. Combining portraiture with genre painting, he depicted the res-
taurateur James B. Moore sharing a drink with Jeanne-Louise Mouquin, the wife of
the proprietor. The artist's wife, Edith, and Charles Fitzgerald, a local art critic and
champion of Glackens's work, are reflected in the large wall mirror. Jeanne Mouquin
is the focal point of the composition; not only did Glackens render her dress and
cloak with fluid, eye-catching brushstrokes, but her mysterious, abstracted gaze also
creates an unresolved tension within the work. Perhaps Glackens intended to make
a social commentary; many contemporary writers maintained that anomie was one
of the psychological consequences of rapid change in European and American cities.
Criticized for its unabashed depiction of men and women drinking together, *At
Mouquin's* suggests the pleasures and the perils of modern life.

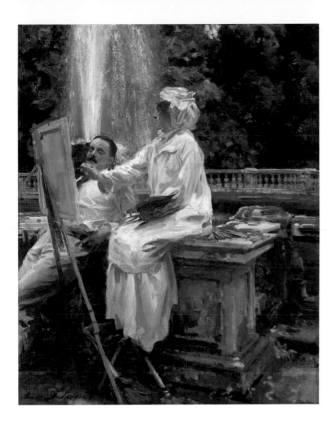

JOHN SINGER SARGENT American, 1856–1925
The Fountain, Villa Torlonia, Frascati, Italy, 1907
Oil on canvas; 71.4 x 56.5 cm (28 ⅛ x 22 ¼ in.)
Friends of American Art Collection, 1914.57

As one of the most sought-after and prolific portraitists of international high society,
American expatriate John Singer Sargent painted the cosmopolitan world to which
he belonged with elegance and a bravura touch. Born to American parents residing in
Italy, Sargent spent his early adult life in Paris, moving to London in the mid-1880s.
The artist traveled frequently, and it was during these trips that he experimented most
extensively with painting *en plein air*, or outdoors. Set in a sunlit garden in the central
Italian town of Frascati, this charming double portrait depicts Sargent's friends and
fellow artists Wilfrid and Jane Emmet de Glehn. The painting is filled with light,
displaying Sargent's characteristically dazzling surface articulated with thick impasto
and virtuoso brushwork. Jane described the work as a "most amusing and killingly
funny picture" in a letter to her sister Lydia. She continued: "I am all in white with a
white painting blouse and a pale blue veil around my hat. I look rather like a pierrot,
but have a rather worried expression as every painter should who isn't a perfect fool,
says Sargent. Wilfrid is in short sleeves, very idle and good for nothing, and our
heads come against the great 'panache' of the fountain."

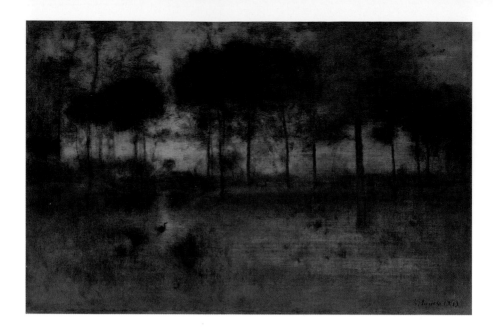

GEORGE INNESS American, 1825–1894
The Home of the Heron, 1893
Oil on canvas; 76.2 x 115.2 cm (30 x 45 5/16 in.)
Edward B. Butler Collection, 1911.31

The landscape painter George Inness once explained, "The true purpose of the painter is simply to reproduce in other minds the impression which a scene has made upon him . . . to awaken an emotion." Inness sought, particularly in his later years, to record not so much the appearance of nature as its poetry. To achieve this, he limited his subject matter to, in his words, "rivers, streams, the rippling brook, the hillside, the sky, the clouds." For half a century, the artist captured these moisture-laden subjects in all seasons, during all hours of the day and night. First he made small, quick sketches in the field or wood, and then, in the seclusion of his studio, he used them to create the more than one thousand oils credited to him.

The Home of the Heron was completed late in Inness's career, after he had finally achieved a degree of comfort and success. The painting is characteristic of his late work, with loosely rendered detail and dim objects that seem bathed in an almost incandescent glow. The picture's blurred outlines, broad handling, and delicate, subtle tonalities, as well as the solitary presence of the heron, masterfully evoke nature's stillness and mystery. With thirty-two canvases by Inness, the Art Institute has one of the most comprehensive collections of the painter's work.

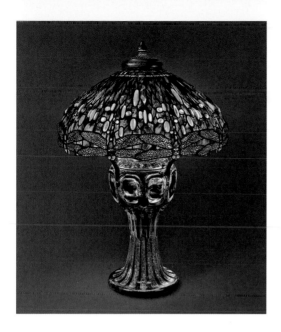

DESIGN ATTRIBUTED TO CLARA PIERCE WOLCOTT DRISCOLL
American, 1861–1944
Hanging Head Dragonfly Shade on Mosaic and Turtleback Base, by 1906
Made by Tiffany Studios, Corona, New York (1902–1932)
Favrile glass and bronze; 86.4 x 57.2 cm (34 x 22 ½ in.)

Roger and J. Peter McCormick endowments; Robert Allerton Purchase Fund; Goodman Endowment for the Collection of the Friends of American Art; Pauline S. Armstrong Endowment; Edward E. Ayer Endowment in memory of Charles L. Hutchinson; restricted gift of the Antiquarian Society in memory of Helen Richman Gilbert and Lena Turnbull Gilbert, Sandra van den Broek, Mr. and Mrs. Henry M. Buchbinder, Quinn E. Delaney, Mr. and Mrs. Wesley M. Dixon, Jamee and Marshall Field, Celia and David Hilliard, Elizabeth Souder Louis, Mrs. Herbert A. Vance, and Mr. and Mrs. Morris S. Weeden, 2006.2

In the 1890s, Louis Comfort Tiffany began using his opalescent Favrile glass to produce lamps, the decorative form for which he would become most famous. As the artistic director of Tiffany Studios, he approved all patterns but created relatively few lamps himself. Clara Driscoll, head of the Women's Glass Cutting Department, was likely responsible for this shade and base. Driscoll began working for Tiffany in 1888, and she designed the majority of the firm's lamps before she left the company in 1908 or 1909. Driscoll created at least eight dragonfly shades. Among these, this example is distinguished by its large size, glass cabochons, and the placement of insects' bodies along the lower edge. While Tiffany Studios mass-produced these shades and bases, the firm varied the color scheme of each object to heighten the sense of handcraftsmanship. This daring design became one of Tiffany's most popular and was made through 1924.

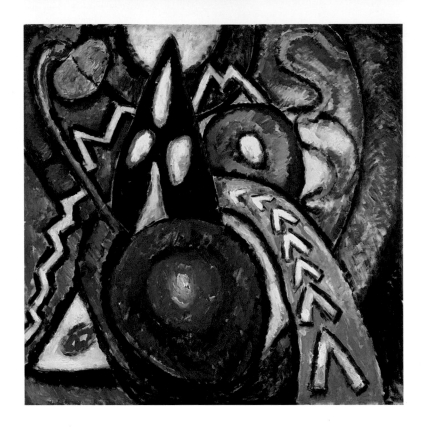

MARSDEN HARTLEY American, 1877–1943
Movements, 1913
Oil on canvas; 119.5 x 119 cm (47 x 46 ⅞ in.)
Alfred Stieglitz Collection, 1949.544

Marsden Hartley painted *Movements* while living in Berlin, where he met Vasily Kandinsky, whose abstract and highly spiritual art (see p. 254) influenced the American painter deeply. Hartley was a central figure of the American avant-garde that exhibited at Alfred Stieglitz's New York gallery 291 (see p. 287). The title of this intense, vividly colored canvas suggests a musical analogy for its nearly abstract forms, which are rhythmically orchestrated around the central red circle and black triangle. Yet Hartley also drew on his experience of Berlin in *Movements*; the vigorous forms in the composition, bursting and overlapping in a riotous array, suggest the fast pace of life in the German capital. Although Hartley's art underwent frequent changes in style and subject, the charged, romantic energy seen here remained a constant presence.

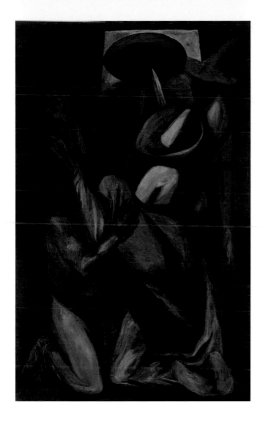

JOSÉ CLEMENTE OROZCO Mexican, 1883–1949
Zapata, 1930
Oil on canvas; 198.8 x 122.6 cm (78 ¼ x 48 ¼ in.)
Gift of the Joseph Winterbotham Collection, 1941.35

This dramatic canvas was painted during José Clemente Orozco's self-imposed exile in
the United States, where he moved in 1927, in part to escape political unrest, but also
because he felt that it was increasingly difficult to get commissions in his native land.
A leader of the Mexican mural movement of the 1920s and 1930s, Orozco claimed
to have painted *Zapata* to finance his trip back to New York after completing a mural
commission in California. For liberal Mexicans, Emiliano Zapata became a symbol
of the Mexican Revolution (1910–20) after his assassination in 1919. The charismatic
Zapata crusaded to return the enormous holdings of wealthy landowners to Mexico's
peasant population. Here his specterlike figure appears in the open door of a peasant
hut. Despite the drama before him, the revolutionary hero seems solemn and
unmoved. The painting is filled with menacing details—the bullets, the dagger, and
especially the sword aimed at Zapata's eye—and the somber palette of dark reds,
browns, and blacks further underscores the danger of the revolutionary conflict.

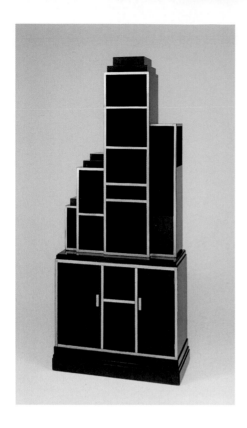

PAUL T. FRANKL American, born Austria, 1886–1958
Skyscraper Cabinet, c. 1927
New York, New York
Painted wood; 213.4 x 83.8 x 40 cm (84 x 33 x 15 ³/₄ in.)
Gift of the Antiquarian Society through Mr. and Mrs. Thomas B. Hunter III and Mr. and Mrs. Morris
S. Weeden, 1998.567

Trained as an architect in Vienna and Berlin, Paul T. Frankl immigrated to New York
City in 1914 and established his own gallery. There he began to design interiors and
champion the skyscraper as a source of a uniquely American Modernist vision. The
impetus behind the *Skyscraper Cabinet,* however, was distinctly rural. Frankl spent
the summer of 1925 in Woodstock, New York, sketching ideas for new furniture designs
and renovating his cabin. In an effort to organize his books, he fitted boards together
to create a cabinet with "a rather large, bulky lower section and a slender, shallow
upper part going straight to the ceiling. It had a new look; the neighbors came and
said, 'It looks just like the new skyscrapers.'" From then on, Frankl experimented
with spare, geometric furniture that mimicked the setback contours of New York
City's skyscrapers. By 1926 these pieces were touted in *Good Furniture* magazine as
the "sky-scraper type of furniture, which is as American and as New Yorkish as Fifth
Avenue itself." The Art Institute's monumental cabinet epitomizes Frankl's designs.
Its geometric form rests on a sharply molded base and consists of a bottom cabinet
section surmounted by a series of compartments and shelves arranged in a pyramid-
like fashion. Smooth, unadorned surfaces exemplify the tenets of Modernist design.

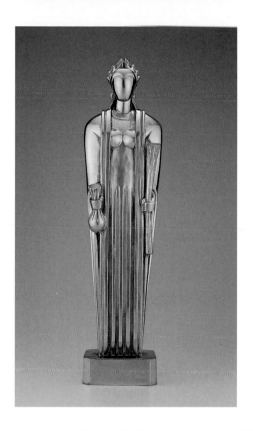

JOHN BRADLEY STORRS American, 1885–1956
Ceres, 1928
Copper alloy plated with nickel and then chrome; 67.3 x 16.2 x 12.4 cm (26 ½ x 6 ⅜ x 4 ⅞ in.)
Gift of John N. Stern, 1981.538

John Storrs was a leading American Modernist sculptor in the 1920s and 1930s.
Although he moved to Paris in 1911 and spent much of his career there, he grew up
in Chicago and studied at the Chicago Academy of Fine Arts and the School of the
Art Institute. *Ceres* is a smaller version of the figure Storrs designed for the top of the
Chicago Board of Trade Building. In his efforts to make the sculpture symbolic of the
building's purpose, Storrs turned to the Classical subject of Ceres, the Roman goddess
of grain, alluding to the board's activity as the world's biggest grain exchange. He
depicted Ceres holding a sheaf of wheat in one hand and a grain sample bag in the
other. Storrs also synchronized his sculpture with the building's Art Deco architec-
ture, emphasizing the figure's streamlined form and employing modern materials.
Ceres garnered a great deal of praise; a contemporary review stated that "this work
has been described by some of the nation's leading architects as one of the finest
pieces of architectural sculpture to be found in America." Perhaps in reaction to such
favorable notices, Storrs produced smaller versions of the sculpture, such as this one.

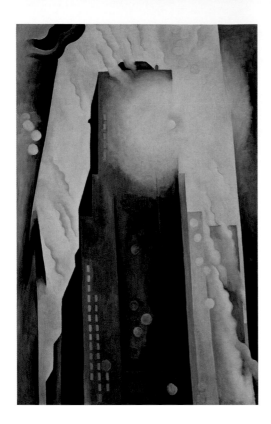

GEORGIA O'KEEFFE American, 1887–1986
The Shelton with Sunspots, N.Y., 1926
Oil on canvas; 123.2 x 76.8 cm (48 ½ x 30 ¼ in.)
Gift of Leigh B. Block, 1985.206

"I went out one morning to look at [the Shelton Hotel] and there was the optical illusion of a bite out of one side of the tower made by the sun, with sunspots against the building and against the sky," said Georgia O'Keeffe, recalling the precise moment that inspired her to paint *The Shelton with Sunspots*. Although her depictions of flowers and the southwestern landscape are powerful and evocative, O'Keeffe painted a group of cityscapes in the 1920s that are no less intriguing. She married the photographer and dealer Alfred Stieglitz in 1924, and the following year they moved into the Shelton, a recently completed skyscraper. O'Keeffe was fascinated by the soaring height of the building and emphasized its majesty in this painting by rendering it from the street below. In the glaring light of the emerging sun, the building becomes an abstracted series of rectangles arranged in the center of the composition. Yet the hard edges of the Shelton are softened by the numerous circular sunspots and wavy, flowing lines of smoke and steam, suggesting that despite her urban subject matter, O'Keeffe nevertheless sought to unify man-made and organic forms, just as she would in her southwestern paintings such as *Black Cross, New Mexico* (p. 55).

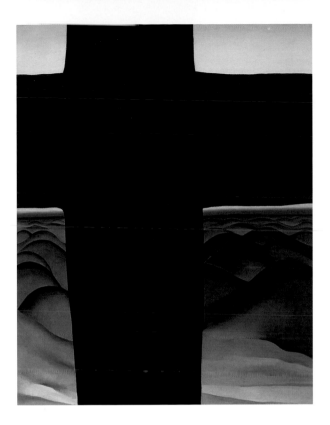

GEORGIA O'KEEFFE American, 1887–1986
Black Cross, New Mexico, 1929
Oil on canvas; 99.1 x 76.2 cm (39 x 30 in.)
Art Institute Purchase Fund, 1943.95

"I saw the crosses so often—and often in unexpected places—like a thin dark veil of the Catholic Church spread over the New Mexico landscape," said Georgia O'Keeffe about her first visit to Taos, New Mexico, in the summer of 1929. A member of the circle of avant-garde artists who exhibited at Alfred Stieglitz's gallery 291 in New York, O'Keeffe had married the progressive photographer and dealer in 1924 (see p. 287). What she encountered during late-night walks in the desert and then transformed into *Black Cross, New Mexico* were probably crosses erected near remote *moradas*, or chapels, by secret Catholic lay brotherhoods called Penitentes. As this pioneer of American Modernism approached all of her subjects, whether buildings or flowers, landscapes or bones, here O'Keeffe magnified shapes and simplified details to underscore their essential beauty. She painted the cross just as she saw it: "big and strong, put together with wooden pegs," and behind it, "those hills . . . [that] go on and on—it was like looking at two miles of gray elephants." For O'Keeffe, "painting the crosses was a way of painting the country," a beloved region where, in 1949, she settled permanently and worked almost until her death at the age of ninety-eight.

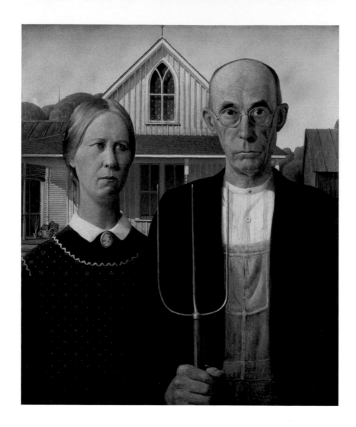

GRANT WOOD American, 1891–1942
American Gothic, 1930
Oil on beaverboard; 78 x 65.3 cm (30 ¹¹/₁₆ x 25 ¹¹/₁₆ in.)
Friends of American Art Collection, 1930.934

This familiar image was exhibited publicly for the first time at the Art Institute of Chicago, winning a three-hundred-dollar prize and instant fame for Grant Wood. The impetus for the painting came while Wood was visiting the small town of Eldon in his native Iowa. There he spotted a little wood farmhouse, with a single oversized window, made in a style called Carpenter Gothic. "I imagined American Gothic people with their faces stretched out long to go with this American Gothic house," he said. He used his sister and his dentist as models for a farmer and his daughter, dressing them as if they were "tintypes from my old family album." The highly detailed, polished style and the rigid frontality of the two figures were inspired by Flemish Renaissance art, which Wood studied during his travels to Europe between 1920 and 1926. After returning to settle in Iowa, he became increasingly appreciative of midwestern traditions and culture, which he celebrated in works such as this. *American Gothic,* often understood as a satirical comment on the midwestern character, quickly became one of America's most famous paintings and is now firmly entrenched in the nation's popular culture. Yet Wood intended it to be a positive statement about rural American values, an image of reassurance at a time of great dislocation and disillusionment. The man and woman, in their solid and well-crafted world, with all their strengths and weaknesses, represent survivors.

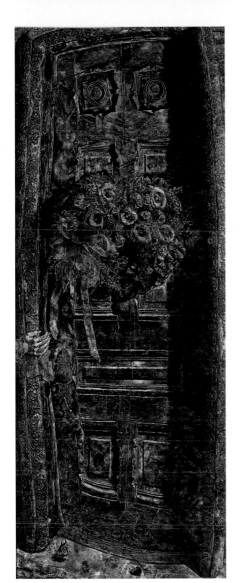

IVAN ALBRIGHT
American, 1897–1983
That Which I Should Have Done I Did Not Do (The Door), 1931–41
Oil on canvas; 246.4 x 91.4 cm (97 x 36 in.)
Mary and Leigh Block Charitable Fund,
1955.645

Replete with powerful imagery and bearing a long, philosophical title, *That Which I Should Have Done I Did Not Do (The Door)* is an evocative meditation on the choices and regrets in life. Ivan Albright considered *The Door* to be his most important picture, and he worked for ten years to achieve its mesmerizing effect. He spent weeks collecting props for the painting: a marred Victorian door found in a junkyard, a faded wax funeral wreath, and a tombstone for the door-sill. Once he arranged these objects, Albright completed an elaborate charcoal underdrawing that he then covered with the intricate and obsessively painted detail that characterizes most of his work. He would often finish no more than a quarter of a square inch a day. A wrinkled, aging woman's hand rests on the carved doorway, a faded blue handkerchief clenched between the fingers. The poignant placement of the hand, near but not touching the doorknob, only underscores the sense of remorse and mourning implied by the painting. With its profound themes of mortality and the passage of time, *The Door* is a modern memento mori that encourages a consideration of the brevity of human existence.

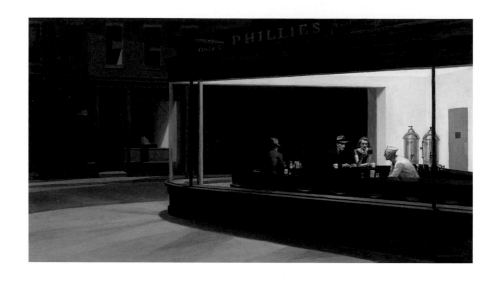

EDWARD HOPPER American, 1882–1967
Nighthawks, 1942
Oil on canvas; 84.1 x 152.4 cm (33 1/8 x 60 in.)
Friends of American Art Collection, 1942.51

Edward Hopper said that *Nighthawks* was inspired by "a restaurant on New York's Greenwich Avenue where two streets meet," but the image—with its carefully constructed composition and lack of narrative—has a timeless, universal quality that transcends its particular locale. One of the best-known images of twentieth-century art, the painting depicts an all-night diner in which three customers, all lost in their own thoughts, have congregated. Hopper's understanding of the expressive possibilities of light playing on simplified shapes gives the painting its beauty. Fluorescent lights had just come into use in the early 1940s, and the all-night diner emits an eerie glow, like a beacon on the dark street corner. Hopper eliminated any reference to an entrance, and the viewer, drawn to the light, is shut out from the scene by a seamless wedge of glass. The four anonymous and uncommunicative night owls seem as separate and remote from the viewer as they are from one another. (The red-haired woman was actually modeled by the artist's wife, Jo.) Hopper denied that he purposefully infused this or any other of his paintings with symbols of human isolation and urban emptiness, but he acknowledged that in *Nighthawks* "unconsciously, probably, I was painting the loneliness of a large city."

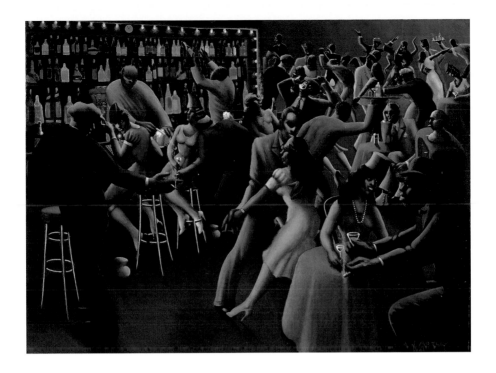

ARCHIBALD J. MOTLEY, JR. American, 1891–1981
Nightlife, 1943
Oil on canvas; 91.4 x 121.3 cm (36 x 47 ³/₄ in.)

Restricted gift of Mr. and Mrs. Marshall Field, Jack and Sandra Guthman, Ben W. Heineman, Ruth Horwich, Lewis and Susan Manilow, Beatrice C. Mayer, Charles A. Meyer, John D. Nichols, and Mr. and Mrs. E. B. Smith, Jr.; James W. Alsdorf Memorial Fund; Goodman Endowment, 1992.89

Chicago painter Archibald Motley represented the vibrancy of African American culture in his work, frequently portraying young, sophisticated city dwellers out on the town. *Nightlife* depicts a crowded cabaret in the South Side neighborhood of Bronzeville, with people seated around tables on the right and at a bar on the left. The clock reads one o'clock, yet the place is still hopping with drinkers and dancers. Two bartenders serve customers and restock the well-lit and plentiful display of liquor, and a number of couples dance furiously in the background to music provided by the jukebox at the right. The strange head atop the jukebox may be a peanut vending machine known as "Smilin' Sam from Alabam'"; when a coin was inserted into the head and the tongue was pulled, the machine would dispense peanuts. Motley unified the composition through his use of repeated forms and a pervasive burgundy tone that bathes the entire scene in intense, unnatural light. (The artist had seen Edward Hopper's *Nighthawks* at the Art Institute the year before and was intrigued by his use of artificial light.) The stylized figures are tightly interconnected; they are arranged along a sharp diagonal that compresses the space into a stagelike setting. The dynamic composition and heightened colors vividly express the liveliness of the scene, making *Nightlife* one of Motley's most celebrated paintings.

PETER BLUME American, born Russia (present-day Belarus), 1906–1992
The Rock, 1944–48
Oil on canvas; 146.4 x 188.9 cm (58 x 74 in.)
Gift of Edgar Kaufmann, Jr., 1956.338

When it was exhibited at the Carnegie International in Pittsburgh in 1950, *The Rock* was voted the show's most popular painting. Peter Blume's dramatic image of a shattered but enduring rock must have struck a responsive chord in many post–World War II viewers. Displaying a startling juxtaposition of images, the work evokes Surrealist dreamscapes made even more vivid by meticulous brushwork inspired by fifteenth- and sixteenth-century northern European painting. Although Blume's imagery resists easy interpretation, the work suggests a parable of destruction and reconstruction. The jagged rock looms at the center of the composition, still upright despite the removal of its base by workers below. On the right, smoke billows around the charred timbers of a house, an image that might allude to the bombing of London during World War II. On the left, a new building, encased in scaffolding, rises as laborers in the foreground cart slabs of stone toward it. The new structure recalls Frank Lloyd Wright's famous Fallingwater (1935–37), in southwestern Pennsylvania, the residence for which Liliane and Edgar Kaufmann commissioned the painting. Their son Edgar Kaufmann, Jr., donated *The Rock* to the Art Institute in 1956.

KOHL CONTAINER IN THE SHAPE OF A PALM COLUMN
Egyptian, late Dynasty 18 or 19, 1550/1202 B.C.

Glass; 8.2 x 3 x 3 cm (3 ¼ x 1 ⅛ x 1 ⅛ in.)

Gift of Theodore W. and Frances S. Robinson, 1941.1084

Glassworking in Egypt appeared suddenly as a fully developed industry under the pharaohs of the Eighteenth Dynasty (1550–1307 B.C.) and was most probably imported from the older glass centers of the Eastern Mediterranean. During this time glass production was restricted to a handful of workshops producing vessels and objects intended only for the pharaoh and his court. In addition to small glass objects such as beads, amulets, and inlays, the new industry produced a wide variety of glass vessels for unguents, incense, and cosmetics. Particularly popular were vessels like this example made to contain kohl, a black pigment used by both men and women to outline their eyes. The kohl was applied with a thin rod, and the vessels were sealed with stoppers made of linen and wax. The shape of this vessel recalls a palm column, a traditional element of Egyptian architecture. The bright, opaque colors of these early core-formed glass vessels—dark blue, turquoise blue, red, yellow, and white—seem to emulate semiprecious stones such as lapis lazuli, turquoise, and jasper. The rarity of these glass vessels (only some five hundred complete examples are known) indicates that they were precious commodities.

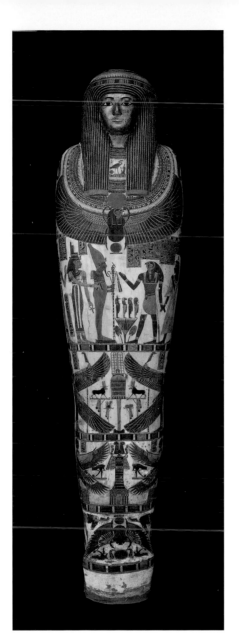

MUMMY CASE AND MUMMY OF PAANKHENAMUN

Egyptian, Third Intermediate
Period, Dynasty 22 (c. 945/715 B.C.)
Cartonnage (gum, linen, and papyrus, with
gold leaf and pigment) and human remains;
h. 170.2 cm (67 in.)
William M. Willner Fund, 1910.238

Mummification is the ancient Egyptian
funerary practice of drying out a corpse
for preservation. Anointed with oils
and spices and protected with amulets,
this linen-wrapped body was placed
in a series of nesting coffins; the vividly
painted cartonnage was the innermost
shell. Across the surface of the mummy
case, inscriptions and painted scenes
and symbols identify the deceased—
Paankhenamun (The One Who Lives for
Amun)—and proclaim his wish to live
well in the afterlife. Another inscription
records that he was the doorkeeper
of the temple of Amun. The names and
titles on the mummy case suggest that
Paankhenamun lived at Thebes. The cen-
tral scene depicts the presentation of
the deceased by the falcon-headed deity
Horus to Osiris, the ruler of eternity
(shown, as was common, as a mummy).
Other divinities help the deceased in his
journey to the afterlife. Despite the youth-
ful features of the gilt face, X-rays reveal
that Paankhenamun was middle-aged.

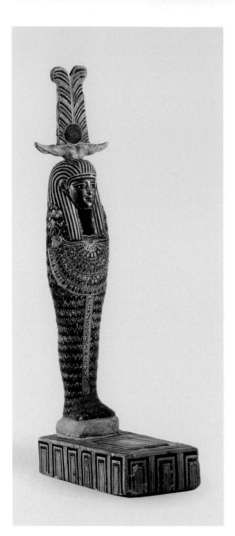

STATUE OF OSIRIS
Hellenistic, Egypt, 305/30 B.C.

Wood, preparation layer, pigment, gold, and textile; 62.9 x 12.7 x 27.3 cm (24 3/4 x 5 x 10 3/4 in.)

Gift of Phoenix Ancient Art, S.A., 2002.542

This beguiling statue represents the great god Osiris. He is shown here in the form of a mummy, recalling the pivotal story in Egyptian mythology when Orisis's body was reassembled with bandages by Isis, his wife and sister, after he had been murdered and thrown into the Nile River by his brother, Seth. Exceptionally well preserved, the statue was assembled from three pieces of wood, coated with a preparation layer, and then decorated with brilliant gold leaf and vivid polychromy. Osiris wears a headdress of feathers and horns, and a false beard is attached to his face, which is gilded, reflecting the belief that gods had skin of gold.

Equally striking are the hieroglyphs on the front and back of the statue indicating that it was made for a woman named Osiris-ir-des (Osiris Is the One Who Made Her). The text also asks the king to make offerings to Osiris, so that in return the god will provide the dead woman with "beer, bread, and every good and pure thing on which the god lives" to sustain her in the afterlife. Osirid figurines were often included among tomb furnishings to assist the dead on their journey into the afterlife.

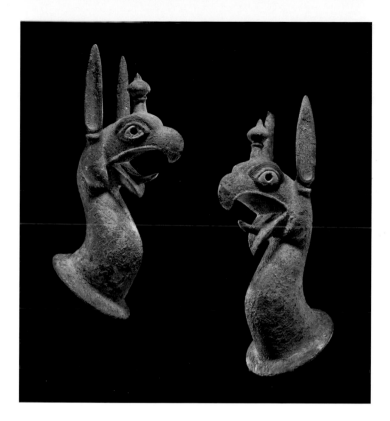

PAIR OF PROTOMES FASHIONED IN THE SHAPE OF
THE FOREPART OF GRIFFINS

Greek, probably Samos, 625/575 B.C.

Bronze and bone or ivory; *left*, 20.3 x 7.6 x 7.6 cm (8 x 3 x 3 in.); *right*, 21.6 x 8.3 x 7 cm (8 ½ x 3 ¼ x 2 ¾ in.)

Katherine K. Adler Memorial Fund, 1994.38.1–2

The great holy sites of ancient Greece, such as the sanctuary of Zeus at Olympia and the Heraion of Samos, functioned as repositories for gifts brought by believers seeking divine favor. The most impressive of these offerings were large bronze cauldrons, which were set on a conical stand or tripod base and embellished with cast-bronze attachments like these two griffins. These beasts, facing outward, would have been fastened to the vessel by means of the rivets still present on their collars. This hollow-cast pair is remarkable for the superb quality of their craftsmanship, their condition, and their partially preserved inlaid eyes.

A mythical creature revered for its protective powers, the griffin combined a feline body, an avian head, and tall, horse-like ears. It has been argued that the beaked *Protoceratops* dinosaurs that once roamed Central Asia were the iconographic inspiration for these ferocious beasts. Travelers may have seen the fantastic fossilized remains of the dinosaurs and then created stories to account for them. Meanwhile, local inhabitants may have spread tales about their ferocity as a way to discourage marauders from looting their wealth. These two griffins are highly agitated; their mouths are agape and their tongues curl up as they screech bloodcurdling warnings to ward off intruders.

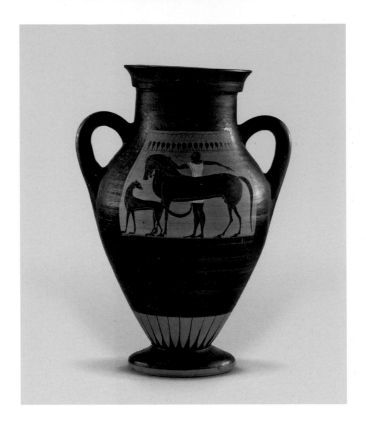

STORAGE JAR (AMPHORA)
Etruscan, 530/520 B.C.
Attributed to the Ivy Leaf Group

Terracotta, decorated in the black-figure technique; 38.7 x 27.9 cm (15 ¼ x 11 in.)

Katherine K. Adler Memorial Fund, 2009.75

During the sixth and fifth centuries B.C., the Etruscans, who lived north of Rome, increasingly imported Athenian ceramics decorated with scenes of Greek mythology, religion, and daily life. Made of fine, iron-rich clay that fired orange, decorated with a rich black gloss, and sometimes embellished with white and purple-red details, the ceramic vessels produced in Athens were the finest of Classical antiquity.

Etruscan artists, no doubt eager to capitalize on the high demand for Greek vases, and perhaps also hoping to attract customers unable to afford the imported wares, set up a workshop, probably at Vulci, to produce facsimiles of the Athenian vases. This vessel's attenuated proportions and symmetrical profile create an especially elegant shape that belies the somewhat coarse texture of the local Etruscan clay from which it is made. The clay's poor quality also stymied attempts to replicate the highly refined surface finishes of Athenian vases. Nevertheless, the painter of this vase skillfully composed his scenes within trapezoidal picture fields bounded above by a decorative pattern of interlacing lotus buds and dots and along its sides by a single line. On the front, a hound looks back at a horse and hunter, while a stag and hare flee for their lives on the back.

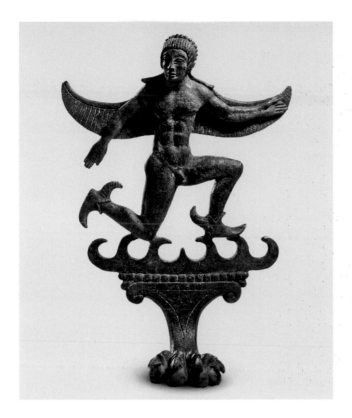

FOOT OF A CISTA
Etruscan, early 5th century B.C.
Bronze; 15.6 x 10.4 x 5.4 cm (6 ⅛ x 4 ⅛ x 2 ⅛ in.)
Katherine K. Adler Memorial Fund, 1999.559

With a bent-knee pose that connotes rapid movement, the Etruscan sun god Usil dashes across breaking waves, borne aloft by wings on his back and boots. Except for his footgear, he is nude. His arms extend away from his brawny body, which twists at the waist to face forward. This splendid figure was cast in one piece together with its support, which comprises stylized waves above a beaded band and a flat Ionic capital that tapers down to the paw of a feline creature that has unusually thick, fleshy pads.

With locally abundant sources of copper and modest amounts of tin, Etruscan metalsmiths excelled in fashioning a variety of beautiful bronze objects, including lamp stands, incense burners, mirrors, vessels, and containers. This remarkable object was one of three identical feet supporting a cista, or lidded chest, typically used by women to store their cosmetics and toiletries. The body of the chest was fashioned from a sheet of hammered bronze, and it was probably incised with intricate illustrations of mythological or other scenes. That part is now lost; only the solid-cast feet that once supported it survive. Its now-missing lid likely had an equally exquisite figural handle that would also have been solid-cast.

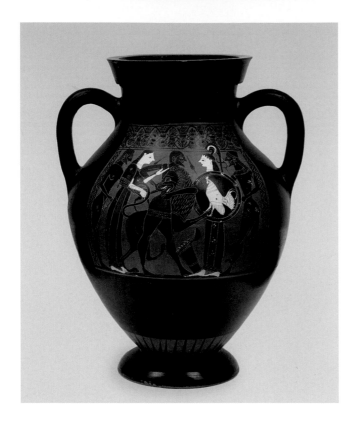

STORAGE JAR (AMPHORA)

Greek, near Athens, 550/525 B.C.

Attributed to the Painter of Tarquinia RC 3984

Terracotta, decorated in the black-figure technique; 28.2 x 21.1 cm (10 $^3/_4$ x 8 $^1/_4$ in.)

Katherine K. Adler Memorial Fund, 1978.114

Ancient artists frequently depicted events from the life of the demigod Herakles, especially the Twelve Labors he had to complete to attain immortality. On this amphora (storage jar) the great hero completes his first assignment—to kill a lion with an invincible hide that was terrorizing the village of Nemea. Here the contest has been decided; Herakles strangles the lion, whose jaws he has pried open with his bare hands. To one side stand Athena and Hermes; on the other stand a pair of balancing figures. In subsequent episodes, Herakles often wears the lion's head as a helmet and either wears or carries its pelt as a protective cloak.

These vases were used for the transport and storage of items such as wine and olives, and they were given as prizes in athletic competitions. Many vases have been broken, either in antiquity or in modern times, and repaired. However, this amphora remains intact, with only a few losses, like the chips on the rim, and some surface abrasion. The vivid white gloss that highlights the women's skin and the shield is especially well preserved.

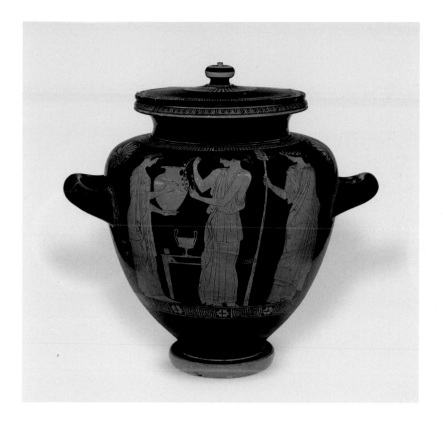

MIXING JAR (STAMNOS)
Greek, Athens, c. 450 B.C.
Attributed to the Chicago Painter
Terracotta, decorated in the red-figure technique; 37 x 41.9 cm (14 ⅝ x 16 ½ in.)
Gift of Philip D. Armour and Charles L. Hutchinson, 1889.22a–b

This refined Athenian stamnos was used to hold and mix wine. Also valued for its
beauty, this red-figure vessel (so called because the figures remain the natural color
of the clay) portrays maenads, women participants in rites celebrating Dionysos, the
god of wine. But unlike the frenzied and whirling figures of other Greek vases, these
women convey calmness, even elegance. This tender serenity, coupled with a softer,
somewhat freer form, is a hallmark of the artist (referred to as the Chicago Painter
because of this vase) and has been used to identify other works by him, principally
similar stamnoi. Working in the potter's quarter of Periclean Athens, the painter
was active during the construction of the Parthenon, the stylistic influence of which
can be seen here. He worked closely with a master potter whose vases were individu-
ally shaped in a prescribed range of configurations. With refined designs that are
gracefully adapted to its shape, this stamnos embodies the finest achievements of
red-figure pottery.

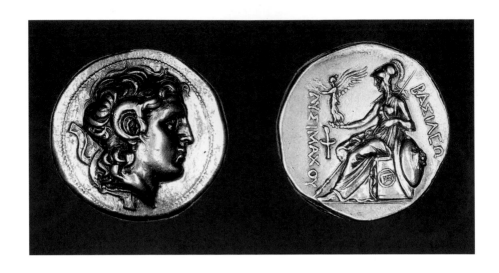

TETRADRACHM (COIN) PORTRAYING ALEXANDER THE GREAT
Greek, Ephesus, minted by Lysimachus of Thrace, 306/281 B.C.

Silver; 16.99 g

Gift of Martin A. Ryerson, 1922.4924

Following the untimely demise of Alexander the Great in 323 B.C., his generals, friends, and heirs engaged in forty years of wars over his empire. Lysimachus (r. 323–281 B.C.), one of Alexander's companions and bodyguards, used the king's image on his own coins in order to cast himself in the role of successor and legitimize his claim to the kingdom of Thrace. Alexander, responsible for establishing the conventions of royal portraiture, is depicted in his preferred manner: youthful and clean-shaven, with long locks of hair rising above his forehead and eyes cast heavenward. Additionally, he is shown with horns curling around his ears. These "horns of Ammon" symbolize Alexander's claim that he was the son of the Egyptian god Ammon—a claim that was confirmed by the oracle at the sanctuary of the composite god Zeus-Ammon at Siwa, Egypt.

On the reverse of the coin Lysimachus exerts his own royal autonomy by naming himself "king." The goddesses Athena and Nike (Victory) crown his name with laurels, which symbolized victory or honor. The lion on the shield at Athena's side references Lysimachus's famous exploit of killing a lion with his bare hands and reinforces his association with Alexander, who used the skin of the Nemean lion as a symbol of power and courage.

PAIR OF ATTACHMENTS FASHIONED IN THE SHAPE OF THE UPPER BODIES OF SILENOI

Roman, 1st century B.C./1st century A.D.

Bronze, silver, and copper; *left*, 17.8 x 14.6 x 8.6 cm (7 x 5 ³/₄ x 3 ³/₈ in.); *right*, 18.7 x 16.2 x 8.9 cm (7 ³/₀ x 6 ³/₈ x 4 ¹/₂ in.)

Katherine K. Adler Memorial Fund, 1997.554.1–2

The Greek imagination was populated with a number of strange creatures. When their thoughts turned to wine, Greeks pictured mischievous young satyrs, the half-human, half-horse creatures who frolicked, danced, and chased hapless maenads. Satyrs symbolized the suppressed hedonistic desires of mankind, which were unleashed by the intoxicating elixir of the wine god Dionysos. These creatures are mature satyrs, or silenoi, and they once decorated the sides of the curved headboard of an elaborate couch used by diners at the lavish banquets that were popular pastimes for privileged members of society. Because wine was served at these festive events, creatures from Dionysos's entourage were popular subjects for such furniture attachments.

The craftsmanship of this pair of attachments is superb. Each is made of two pieces that were cast separately and fastened together. The right arm of the left silenos is lost, but the right silenos retains his separately made left arm. It and the wineskin slung over the corresponding shoulder were molded as one piece. The sclerae, or whites of their eyes, are silver, as are their teeth; furthermore, their lips were once inlaid with copper. Their furrowed brows and slightly parted lips suggest that something troubles them.

CAMEO PORTRAYING A ROMAN EMPEROR AS JUPITER

Cameo: Roman, A.D. 41/54

Sardonyx

Frame: Italian, 16th century

Gold, enamel, and pearls

7.6 x 5.7 x 0.8 cm (3 x 2 ¼ x ⁵⁄₁₆ in.)

Gift of Marilynn B. Alsdorf, 1991.375

This exquisite cameo is thought to combine a portrait of the fourth Roman emperor, Claudius (r. A.D. 41–54), and the powerfully muscled body of Rome's supreme deity, Jupiter. The figure is nude, except for an aegis (protective garment) wrapped around his right thigh, modestly drawn across his body, and draped over his left arm. A laurel wreath, the symbol of the imperial office, is tied around his head. A long scepter rests against his left forearm, and he holds a thunderbolt in his right hand. An eagle watches him from the ground. The aegis, thunderbolt, and eagle are symbols of Jupiter; the scepter and laurel wreath are those of the emperor. Conjoined, they identify the emperor as the father-god, Jupiter, the supreme deity of the Roman pantheon.

A virtuoso gem engraver delicately coaxed his design from a single piece of sardonyx comprising four thin, horizontal layers of naturally occurring colors. He painstakingly removed the extraneous stone until he exposed very low-relief, but masterfully modeled, white figures against a dark gray-blue background, retaining a sufficient amount of stone around the perimeter to create a beveled border from the opaque layers of white and brown.

PORTRAIT OF EMPEROR HADRIAN
Roman, 2nd century A.D.

Marble; 36 x 27.5 x 27.3 cm (14 ¼ x 10 ⅞ x 10 ¾ in.)

Katherine K. Adler Memorial Fund, 1979.350

Of all the Roman emperors, Hadrian (r. A.D. 117–38) is the one whose portrait is most frequently found, all across the empire from Britain to Persia, from Asia Minor to Egypt. Furthermore, among all his portraits, few equal this likeness in conveying the complex character of the emperor who inherited the Roman world at its greatest extent from his fellow Spaniard Trajan (r. A.D. 98–117). Hadrian traveled widely, visiting most of the provinces during the twenty years of his reign, and commissioned buildings, aqueducts, and roads in many cities. Citizens responded to Hadrian's generosity by erecting numerous statues in his honor, and after his death they revered him as a god.

Hadrian greatly admired the Greeks. Unlike previous emperors, who were clean-shaven, Hadrian wore a beard, perhaps in emulation of the Greek philosophers whom he so revered. Here Hadrian's closely cropped beard contrasts with the thick, luxurious curls that frame his face. This sculpture also features an innovative trend in Roman portraiture: the artist carefully sculpted the irises and pupils of the eyes rather than rendering them in paint as was conventional.

PORTRAIT BUST OF A WOMAN
Roman, A.D. 140/50

Marble; 64.8 x 47.6 x 27.3cm (25 $\frac{1}{2}$ x 18 $\frac{3}{4}$ x 10 $\frac{3}{4}$ in.)

Restricted gift of the Antiquarian Society in honor of Ian Wardropper, the Classical Art Society, Mr. and Mrs. Isak V. Gerson, James and Bonnie Pritchard, and Mrs. Hugo Sonnenschein; Mr. and Mrs. Kenneth Bro Fund; Katherine K. Adler, Mr. and Mrs. Walter Alexander in honor of Ian Wardropper, David Earle III, William A. and Renda H. Lederer Family, Chester D. Tripp, and Jane B. Tripp endowments, 2002.11

This exquisite portrait bust depicts an elegant Roman matron of timeless beauty. The subject looks to her left, which affords a tantalizing glimpse of her complex coiffure. Her diadem, or crown, would have been fashioned in place by a thick fabric cord. Her crisply pleated, gap-sleeved tunic is so thinly carved that light passes through parts of the marble. For modesty's sake, she also wears an overgarment, its deep folds indicating a thick material, possibly wool. Draped low across her torso, the mantle reveals the gentle swell of her right breast, an unusual feature of Roman busts of this period. Although portraiture is one of ancient Rome's greatest contributions to the visual arts, the names of its practitioners remain unknown. This sculpture survives as an enduring testament to the extraordinary talent of its sculptor and as a tribute to his stately subject.

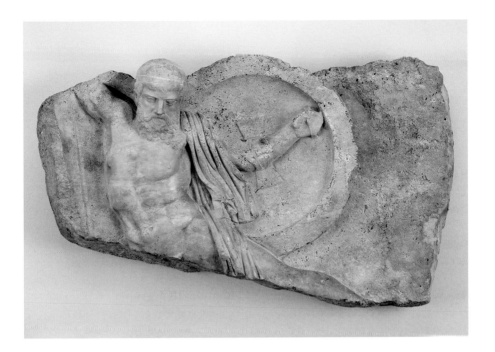

RELIEF OF A FALLING WARRIOR

Roman, 2nd century A.D., copy of a 5th century B.C. Greek original by Phidias

Marble; 53.3 x 78.7 x 15.2 cm (21 x 31 x 6 in.)

Gift of Alfred E. Hamill, 1928.257

Around 435 B.C., the Greek sculptor Phidias enriched the front of the shield at the side of his gold-and-ivory statue of Athena in the Parthenon with scenes of Greeks and Amazons battling in the Trojan War. In Roman times, certain figures from this complex struggle were lifted out of their original context and enlarged to become decorative reliefs for the walls of a colonnade or courtyard.

Here a wounded Greek warrior collapses to the ground after being struck a mortal blow from behind. The dying warrior's noble countenance, the fillet or ribbon tied around his forehead, and his powerful, athletic body epitomize what Phidias and his pupils sought to project as the ideal of mature male dignity in the decade when Athens was at the height of its power in the eastern Mediterranean world. Some five centuries later, collectors such as the Roman emperor Hadrian sought this Phidian style, translated from a circular golden shield to a rectangular marble relief, to decorate their palaces and villas. Athenian sculptors of the Roman Empire made a good living creating and exporting such memories of past glories. This relief and a number of others were found near Athens in the harbor of Piraeus, where they had been lost in a disaster, likely while awaiting shipment.

SOLIDUS (COIN) OF THE EMPEROR CONSTANTINE I

Roman, minted in Antioch,
A.D. 324/25

Gold; 4.49 g

Gift of Martin A. Ryerson, 1922.4903

In A.D. 313, Constantine I (c. 272–337, r. 306–37) and his coruler Licinius (c. 265–325, r. 308–24) jointly issued the Edict of Milan, which aimed to end religious intolerance by granting legal rights to Christians and ordering the return of their confiscated property. This solidus, bearing a large profile portrait of Constantine wearing a laurel crown, was issued during the period in which Constantine both defeated Licinius to become sole emperor and sponsored the First Council of Nicaea (A.D. 325), whose goal was to establish the nature of Jesus and his relation to God the Father. Baptized on his deathbed, Constantine is honored as the first Christian emperor, and his reign marks the beginning of the Christianization of the empire. He transferred the capital of the Roman Empire to ancient Byzantium, which was renamed Constantinople in his honor.

HISTAMENON (COIN) OF ROMANOS III ARGYROS

Byzantine, minted in Constantinople,
A.D. 1028/34

Gold; 4.4 g

Gift of Mrs. Emily Crane Chadbourne, 1940.25

Romanos III Argyros (c. A.D. 968–1034, r. 1028–34) was a later member of the dynasty founded by Basil the Macedonian. Marked for succession to the throne by his short-lived father-in-law, Romanos managed a six-year reign that was riddled with ill-conceived and poorly executed policies, including a disastrous attempt to reform taxation that left the empire's finances in disarray and drove the less fortunate into enforced servitude. In an effort to halt the growing threat posed by Arabs along the eastern frontier, Romanos personally led the army to confront them, only to be thoroughly routed in a surprise attack. Later conquests and victories did little to improve his reputation, and he died, possibly at the hands or order of his entirely disillusioned wife. On the front of this histamenon, the enthroned and haloed Jesus holds the Gospel book in his right hand. The inscription reads "Jesus Christ, King of Kings." On the reverse, his mother, Mary, crowns the richly bedecked Romanos, who holds a *globus cruciger*, indicating that the emperor wields earthly power on behalf of the Christian God.

ARCHITECTURE AND DESIGN

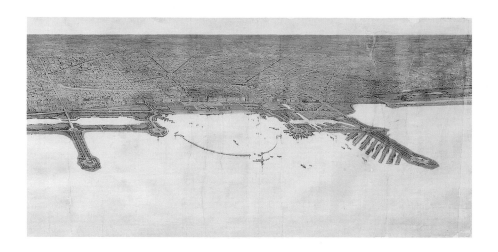

DANIEL H. BURNHAM American, 1846–1912
EDWARD H. BENNETT American, born England, 1874–1954
Plate 49 from the *Plan of Chicago* (1909): *View of the City from Jackson Park to Grant Park, Looking West* (detail), 1907
Rendered by Jules Guérin (American, 1866–1946)
Watercolor and graphite on paper; 103.5 x 480 cm (41 x 189 in.)
On permanent loan to the Art Institute of Chicago from the City of Chicago, 2.148.1966

"Make no little plans," Daniel H. Burnham reputedly exclaimed around the time he unveiled his *Plan of Chicago*, the first comprehensive metropolitan plan in the United States. Providing the vocabulary for Chicago architecture through the 1920s, the project was the legacy of Burnham, whose renown in large-scale city planning began when he was chief of construction for Chicago's 1893 World's Columbian Exposition. Commissioned by the Commercial Club of Chicago, the plan was developed with the assistance of architect Edward H. Bennett, who elaborated parts of it after Burnham's death in 1912 and was responsible for executing many of its recommendations. Emulating the grand classical design of European cities, Chicago was to become "a Paris by the Lake." Features included the development of Chicago's lakefront and Lake Shore Drive, the construction of Grant Park, and the transformation of Michigan Avenue into a premier commercial boulevard following the completion of the Michigan Avenue bridge. Eleven of the seventeen perspective views were rendered by Burnham's frequent collaborator, the Beaux-Arts-trained Jules Guérin. The draftsman's stunning, impressionistic views, with their unusual perspectives and dramatic use of color, bring the *Plan of Chicago* to life, imbuing it, as Burnham stated about his own aims, with the "magic to stir men's blood."

MARION MAHONY GRIFFIN American, 1871–1962
WALTER BURLEY GRIFFIN American, 1876–1937
Perspective Rendering of Rock Crest-Rock Glen, Mason City, Iowa, c. 1912
Lithograph and gouache on green satin; 59 x 201 cm (23 ¼ x 79 ⅛ in.)
Gift of Marion Mahony Griffin through Eric Nicholls, 1988.182

Walter Burley and Marion Mahony Griffin were exceptional figures in the Prairie
school, for they not only designed individual buildings but also planned housing
developments, universities, and entire cities. In their partnership (formed in 1911 at
the time of their marriage), Walter Burley Griffin was chief designer, while Marion
Mahony, one of the nation's first women to distinguish herself in architecture, contrib-
uted to design and produced the spectacular renderings for which the firm was
noted. In this exquisite work, she delineated the pair's major domestic work and the
most important planning scheme of the Prairie school: the Iowa housing develop-
ment Rock Crest–Rock Glen (begun in 1912). The vaguely Japanesque intertwining
of single-family dwellings within the eighteen-acre site is a perfect encapsulation of
the Prairie school's emphasis on the harmonious integration of suburban domesticity
and a tamed, almost pastoral, nature. Of the sixteen proposed houses, eight were
built, four by the Griffins. Just as construction began, the couple won the interna-
tional competition to plan Canberra, the new capital of Australia; the commission
allowed them to bring the Prairie style to an international audience.

FRANK LLOYD WRIGHT American, 1867–1959

Triptych Window from a Niche in the Avery Coonley Playhouse, Riverside, Ill., 1912

Leaded glass in oak frames; center panel: 89.5 x 109.2 cm (35 1/4 x 43 in.), side panels: each 91.4 x 19.7 cm (36 x 7 ³/₄ in.)

Restricted gift of Dr. and Mrs. Edwin J. DeCosta and the Walter E. Heller Foundation, 1986.88

This colorful, whimsical triptych window is from the Avery Coonley Playhouse, a small structure that Frank Lloyd Wright designed as an addition to the Coonleys' suburban Chicago estate, which he had previously completed in 1908. Louis Sullivan's foremost student, Wright continued his teacher's search for an indigenous American architecture. Like Sullivan, Wright drew inspiration from nature and natural forms, and both men were pioneers of the Prairie school of architecture, characterized by low-slung, horizontal lines and rambling, open spaces that reflect the gently rolling landscape of the Midwest. Odes to the middle-class American family at the turn of the century, Wright's residences are organic, designed not only to adapt to a family's changing structure but also to contain the sense of a unified and harmonious whole. Every detail of the Coonley complex, like all of Wright's projects, bore his personal imprint, down to the creation and placement of the furniture and the design of this window. Referencing such Americana as the flag and colored balloons, Wright explored the use of glass both as a transparent screen uniting exterior and interior and as a decorative element, the colors and design of which anticipate the later abstractions of Piet Mondrian (see p. 262).

LOUIS H. SULLIVAN American, 1856–1924
Impromptu, 1922, plate 16 from *A System of Architectural Ornament*, 1924
Graphite on Strathmore paper; 57.7 x 73.5 cm (22 ³/₄ x 29 in.)
Commissioned by the Art Institute of Chicago, 1988.15.16

In 1922 the Art Institute's recently opened Burnham Library of Architecture commissioned the aging and impoverished Louis H. Sullivan to make drawings illustrating his renowned theories of architectural ornament. These masterpieces were published together as *A System of Architectural Ornament, According with a Philosophy of Man's Powers* by the American Institute of Architects in 1924; this was Sullivan's final statement about the geometry underlying both natural and man-made forms. In his search for an original American architecture, Sullivan drew his inspiration from nature, not unlike the nineteenth-century American poets and writers whom he emulated. Like them, he intended ornament to function evocatively as well as to represent organic growth, evolving from closed geometric units to open, efflorescent forms. In *Impromptu,* the sixteenth of the twenty delicate drawings in his treatise, Sullivan produced one of his most open, vibrant, and fluent compositions. Giving free rein to expansive whiplash appendages and spiral stalks, the architect combined nature's infinite creative variation and incessant change with an intense emotional expressionism. To convey these poetic nuances, Sullivan's correlating notation describes the design as entering "the domain of Virtuosity, Romance and Symbolism."

LUDWIG MIES VAN DER ROHE American, born Germany, 1886–1969
Court House Studies: Interior Views Showing Steel Columns, c. 1931–38
Ink on paper, mounted on archival board; 21.4 x 29.9 cm (8 ⁷/₁₆ x 11 ³/₄ in.)
Gift of A. James Speyer, 1981.937

Ludwig Mies van der Rohe is widely recognized as one of the most influential figures in the development of modern architecture. Operating on a principle of "less is more," he utilized materials such as industrial steel and plate glass in his strikingly minimal designs, which are notably free of decorative forms. As director of the German Bauhaus during the early 1930s, Mies formalized his notion of unifying form with function. In 1937 he immigrated to Chicago, where he became director of the School of Architecture at the Armour Institute of Technology (later the Illinois Institute of Technology). His legacy is still felt in the school's program of stressing the fundamentals, materials, and function of architectural design. This *Court House Study* depicts a vast, open interior in which two slender columns provide the only visible means of support. The wide-angle perspective emphasizes the building's strong horizontal character. A nearly seamless wall of glass fills living areas with light and dissolves the boundary between interior and exterior.

RICHARD BUCKMINSTER FULLER American, 1895–1983
Dymaxion Car: Section, c. 1933
Ink on tracing paper; 34.2 x 91 cm (13 x 36 in.)
Through prior gift of Three Oaks Wrecking Company, 1990.167.1

Trained in engineering, Richard Buckminster Fuller made significant contributions to other disciplines including architecture, philosophy, industrial design, and social science. Central to all his endeavors was a holistic understanding of the universe and a desire to use science and technology in a sustainable manner to better serve mankind and the planet. Fuller coined the term *dymaxion* to label his inventions that provided the greatest possible efficiency with available technology. In 1927 he began investigating designs that would revolutionize transportation. Fuller used existing automotive parts and boat and airplane technology to design the *Dymaxion Car,* which debuted to an awed public at the 1933 Century of Progress Exposition in Chicago. The aerodynamic bullet shape and lightweight aluminum chassis enabled the car to reach speeds of 120 mph, and it had a fuel efficiency rate of thirty miles per gallon. The three-wheeled vehicle was driven by a single rear wheel, which offered exceptional maneuverability. Fuller refined the design in the 1940s, but a prototype proved too costly to manufacture. Although considered too radical to mass-produce at the time, Fuller's *Dymaxion Car* presaged many features considered standard in today's automobiles.

BERTRAND GOLDBERG American, 1913–1997
River City: Aerial Perspective, 1979
Ink and pencil on tracing paper; 45.6 x 57.9 cm (18 x 22 ³/₄ in.)
The Archive of Bertrand Goldberg, gifted by his children through his estate, Rx23664 /110.279

In 1932 eighteen-year-old Bertrand Goldberg left his native Chicago to study at the Bauhaus in Germany, becoming one of the first Americans to work under the guidance of Ludwig Mies van der Rohe. The next year, he returned home and was employed by various Chicago firms until he founded his own practice in 1937. He is best known for Chicago's Marina Towers, America's first mixed-use urban-housing complex, which he completed in 1967. Two decades later, Goldberg made plans for the even more ambitious River City. Conceived as part of a huge marina along the south branch of the Chicago River, the development was to consist of a vast complex of linked towers housing thousands of residents. Believing that architecture should address the needs of the many, Goldberg envisioned River City as a self-sufficient environment that would foster a sense of community. Six clusters of seventy-two-story buildings, featuring the architect's now trademark curvilinear concrete shell construction and cantilevered balconies, would wind a serpentine path along the river's edge. Although the full scope of River City was never realized, a scaled-back version was built in 1987. Despite its diminished proportions, River City drew high praise and was hailed by the *New York Times* as "a remarkable space, unusually lyrical and soft in feeling for a structure finished in harsh concrete."

STANLEY TIGERMAN American, born 1930
The Titanic, 1978
Photomontage on paper; approx. 28 x 35.7 cm (11 $\frac{1}{16}$ x 14 in.)
Gift of Stanley Tigerman, 1984.802

The groundbreaking innovations of Ludwig Mies van der Rohe left a lasting impact on both the practice and teaching of architecture in the United States, especially in Chicago. As director of the School of Architecture at the Illinois Institute of Technology, Mies stressed the importance of bold, clean designs based on structure, materials, and function. Stanley Tigerman was among the many architects schooled in the Miesian tradition, and he based much of his work in the 1960s and 1970s on the designs of the famed architect. Tigerman's restless curiosity and iconoclastic spirit, however, led him to question the authority and durability of Mies's program. *The Titanic* is a conceptual project that was meant to provoke architects to contend with the Mies legacy, challenging them to choose sides: move beyond Mies or remain cemented to the past. The photocollage pitches Mies's Crown Hall building (1950–56), one of the architect's most iconic and revered designs, into the deep. Tigerman mailed copies of the work to members of the architectural establishment, including an offer of a one-way ticket on the *Titanic.* Though the title of the work portends the end of Mies's dominance (he died in 1969), Tigerman acknowledged that many would see the building as rising back to the surface, ever triumphant.

GAROFALO ARCHITECTS American, 1993–2010
Markow House: Design Drawings, 1997–98
Color computer print on paper; 91.4 x 61.7 cm (36 x 24 ⁵/₈ in.)
Gift of Douglas Garofalo, 2000.471.2

The Chicago firm Garofalo Architects was an early leader in digital architecture. The firm's Markow House represents the studio's initial foray into digital production methods, and it is one of the first realized residences created through this new technology. Using animation software, principal Douglas Garofalo conceived a 2,000-square-foot addition that radically reworked the Markows' 1960s split-level home in suburban Chicago, allowing interior and exterior spaces to break free of compartmentalized conformity. This digital rendering, called an exploded axonometric diagram, shows the layers of forms and shapes that constitute the building. Rather than conceal the existing structure, Garofalo chose to maintain the twin-gabled rear and create a dramatically different front facade that emphasizes the home's hybrid nature. The angular, folding roof planes are visible from all sides, and the exterior walls are boldly painted purple, blue, gray, and yellow. In the interior, a network of glass walkways and ramps weaves in and out of the structure. Garofalo transformed this typical suburban Chicago residence into a spatially complex, dynamic structure that stands apart from the surrounding architecture.

TOKUJIN YOSHIOKA Japanese, born 1967
Honey-Pop Armchair, 2001
Honeycomb paper construction consisting of white wove, highly calendered paper; 79.4 x 81.3 x
81.3 cm (31 x 32 x 32 in.) (unfolded)
Restricted gift of Architecture and Design Society, 2007.111

Tokujin Yoshioka's unfettered creativity was greatly nurtured by fashion designer Issey
Miyake, who hired the young designer in 1988. His lack of specific fashion training
left him free to experiment with unexpected materials. The designer's *Honey-Pop
Armchair* defies the notion of furniture as merely functional. Both sculptural and
ethereal, the chair, made entirely of paper, plays upon the intangible idea of an object
and the materiality of its being. Without an underlying frame, the chair is like an
oversize, intricate work of origami, supported entirely by a complex of hexagons
made out of 120 layers of paper glued together. The name *Honey-Pop* refers not
only to its appearance as a giant honeycomb but also to the legacy of Pop Art, which
championed commonplace yet unorthodox materials. The *Honey-Pop Armchair*
debuted at the 2002 Milan International Furniture Fair. In assembly-line fashion,
Yoshioka laid out a thick roll of the layered paper, cutting out seat shapes, which
he opened up like a book to create the chair and reveal its seemingly insubstantial
honeycomb structure. To show its tensile strength, Yoshioka sat on the chair,
demonstrating how the weight of his body actually fixed the paper folds into place.

HELLA JONGERIUS Dutch, born 1963
Repeat Dot Textile, 2002
Commissioned by Maharam
Cotton, polyester, and rayon upholstery; 79.4 x 81.3 x
81.3 cm (31 x 32 x 32 in.) (unfolded)
Gift of Maharam Fabric Corporation, 2007.114.4

Collaboration with designers has become a hallmark of the New York–based textile firm
Maharam, adding dynamic partnerships with renowned contemporary designers to their
important archive of midcentury reissues. Maharam often commissions designs from
practitioners whose primary work lies outside of textile design—an approach that results
in a wide range of critical artistic engagements with the medium. Hella Jongerius's
2002 *Repeat Dot* takes inspiration from her close observation of the manufacturing
process in textile mills producing Maharam designs. Focusing on the technology and by-
products used to create woven fabrics, this work recalls the perforations of punch cards
used to program Jacquard weaving machines, overlaid with white screen-printing that
mimics the codes and handwritten notes used to make changes to fabric samples. Her
Repeat series also has a unique means of application as the repeats of different patterns
of the design occur at wide intervals, offering users a level of customization by choosing
to use one or more of the patterns in a single piece of fabric.

HERNAN DÍAZ ALONSO American, born Argentina 1969
Sur, Long Island City, New York, 2005
Acrylic and nylon; 7.6 x 61 x 33 cm (3 x 24 x 13 in.)
Department of Architecture and Design Purchase Fund, 2006.311

Since its inception in the early 1990s, digital architecture has moved into widening frontiers, fusing with other disciplines to enable unexpected formal explorations and generate new typologies that are changing the way in which structures are aestheticized and fabricated. As the field has matured, Hernan Díaz Alonso, principal architect of the Los Angeles firm Xefirotarch, has emerged as a significant figure; his studio's grotesque, animal-like forms exemplify just how far digital practice has evolved. Shown here is the model for *Sur,* the firm's winning entry for the Museum of Modern Art/P.S.1 Young Architects Program. The piece is composed of an acrylic surface that supports three-dimensional forms printed from nylon composite. The actual pavilion was constructed of bent aluminum tubing clad with reflective fabric sheathing and fiberglass benches and platforms painted Ferrari red. The title *Sur,* taken from a popular Argentine tango, refers to the rhythmic forms of the work. While Díaz Alonso draws freely from a wide range of visual-arts disciplines—especially film and video—he combines these influences with digital manipulation and distortion to explore the limits of beauty and scale. His constructions reintroduce an experimental notion of figuration to the pedagogy and practice of digital architecture.

JEANNE GANG American, born 1964
STUDIO GANG ARCHITECTS American, founded 1997
Aqua Tower, Chicago, Illinois, Presentation Model, 2005
Acrylic; 106.7 x 40.6 x 40.6 cm (42 x 16 x 16 in.)
Restricted gift of the Architecture and Design Society, 2011.115

Studio Gang's 82-story Aqua Tower is among Chicago's most important tall buildings of the last ten years. The tower's urban context helped determine its undulating surface, resulting in unique concrete balconies designed to contribute a graphic wave pattern to the building's façade, while controlling solar exposure and allowing for expansive views of the city and Lake Michigan. Inspired by the flow of wind, water, and topography, the Aqua Tower's facade was designed and fabricated with a combination of digital and analogue techniques to create mass-produced, yet custom-made, forms. Aqua Tower fuses Studio Gang's rigorous research process with a dedication to strong architectural imagery.

BRUCE MAU Canadian, born 1959

¡GuateAmala! Posters, 2006

Commissioned by Fundación Proyecto de Vida, Guatemala

Offset ink on paper; 91.4 x 61.7 cm (36 x 24 ⅝ in.)

Gift of Bruce Mau, 2009.62.1–10

Working across all fields of visual communications, Bruce Mau strives to make works of social significance and meaning. Invited by the Fundación Proyecto de Vida, a collective of Guatemalan leaders, to create a campaign that would encourage Guatemalans to think positively about their country's future, Mau's studio created ¡GuateAmala!, which translated from Spanish means "to love Guatemala." This attention-grabbing slogan began as the centerpiece of a series of projects launched in 2006 that included the posters shown here. Installed across the country, these vibrant works—featuring local inhabitants and portraying the rich culture and heritage of Guatemala—became a provocative communication tool.

GREG LYNN American, born 1964
Flatware, 2007
Commissioned by Alessi
Sterling silver; dimensions variable, length of knife, 23 cm (9 ¹/₁₆ in.)
Celia and David Hilliard Fund; restricted gift of the Architecture and Design Society, 2007.646.1–5

The flatware that architect and designer Greg Lynn created for Alessi is a brilliant reinterpretation of the figurative tradition in tableware design. With its sinuous lines, the flatware formally reflects Lynn's ongoing interest in Art Nouveau and the late-nineteenth-century designs of architect and designer Victor Horta. Beginning with the premise that the design of all flatware originates with the spoon, Lynn conceived of the cutlery as a kind of genetic system made up of stem, leaf, and flower, and capable of endless variations. Lynn produced the flatware out of layers of liquid metal using a three-dimensional digital-printing method. The result is that each piece is figuratively articulated and differentiated from the others by subtle mutations, as the basin and tines of the fork blend in surprising combinations.

HULGER English, founded 2005
SAMUEL WILKINSON DESIGN English, founded 2007
Plumen, 2010
Glass, ABS plastic, and metal; 7.6 x 61 x 33 cm (3 x 24 x 13 in.)
Gift of Hulger, 2011.784

Challenging the sterile functionalism of compact fluorescent lightbulbs, London design company Hulger and British product designer Samuel Wilkinson reimagined these devices as aesthetic objects in their own right. Wilkinson drew on the raw qualities of the glass tubing used in low-energy bulbs to create a dynamic sculptural form that is revealed through movement. Like the best high-tech retoolings of traditional designs, the *Plumen* lightbulb pays homage to history with references to the arching shape of the filaments in early incandescent bulbs, while promoting the cause of energy conservation for the future.

AARON KOBLIN American, born 1982
Flight Patterns, 2011
Animation
Restricted gift of Architecture and Design Society, 2011.275

Flight Patterns is a time-lapse animation that employs data visualization and Process-
ing, an open-source computer programming environment, in order to display Ameri-
can air-traffic patterns and densities over a twenty-four-hour period. Begun as a larger
project at UCLA with designers Scott Hessels and Gabriel Dunne, Aaron Koblin's
animations follow the routes of 140,000 airplanes crossing the United States begin-
ning at 5:00 PM Eastern time. Koblin uses variations of color and pattern to illustrate
a wide range of data and events, including aircraft type, alterations to routes, changes
in flight traffic over certain geographical areas, varying weather patterns, and no-fly
zones. As the animation reveals multiple iterations of flight patterns during the cycle,
the viewer experiences a changing, phantom geography of the country with airline
hubs appearing as bright points of diffusion in a complex web.

KNEELING FIGURE

Chinese, probably Sichuan Province, late 2nd millennium B.C.

Chlorite; 19.6 x 7 x 9.8 cm (7 ⁵/₈ x 2 ³/₄ x 3 ⁷/₈ in.)

Edward and Louise B. Sonnenschein Collection, 1950.671

This starkly poignant figure, probably a male, kneels with his hands bound behind him with two rounds of thick rope. Parted down the middle, his hair resembles an open book; finely incised parallel lines suggest that it has been meticulously combed, and a long double braid hangs down his back. His facial features are defined by raised eyebrows, high cheekbones, a tight mouth that curves slightly downward, and large pierced ears that project perpendicularly from his head. Evoking fierceness and shock, the man stares blankly ahead—like a subdued victim anticipating a terrifying, painful punishment. Figures with proportions and features similar to this sculpture have recently been unearthed at sites in southwestern Sichuan Province that date to the second millennium B.C. Whereas those images were carved from more roughly textured stones, and sometimes preserve traces of pigment, this example's smooth, blackish green surface appears unique. Scientific analyses indicate that the sculpture was probably darkened by burning before burial and, upon rediscovery, was polished and saturated with wax.

TRIPOD FOOD CAULDRON (*DING*)

Chinese, Western Zhou dynasty (c. 1050–771 B.C.), early 9th century B.C.

Bronze; 49 x 43 cm (19 3/8 x 16 15/16 in.)

Major Acquisitions Centennial Fund, 2005.426

As this monumental cauldron demonstrates, the most distinctive bronze vessels of early China represent important historical documents as well as stunningly powerful works of art. Designed to contain offerings of meat in ritual ceremonies, this vessel was cast with a lengthy inscription on its interior bowl. The text commemorates a solemn ritual ceremony at the imperial court of the Zhou, the second dynasty recorded in Chinese texts, and explains that Captain Wang, a noble official who had been rewarded for his loyal service to the Zhou king, commissioned this vessel to honor his deceased father and record the occasion for succeeding generations. Together with the inscription, the vessel's shallow profile and austere surface decor date it to the early ninth century B.C. Although the monsterlike masks that project from each leg display animal imagery common on older bronzes, the two registers of hooked, ribbonlike bands that encircle the bowl preserve only traces of early dragon or bird patterns. The transition from zoomorphic to abstract surface designs marks a significant turning point in the art of early Chinese bronzes. Recent archaeological discoveries of similar bronze vessels in China indicate that this cauldron was most likely buried as part of a large hoard.

PAIR OF DRAGON PENDANTS

Chinese, Eastern Zhou dynasty, Warring States period (475–221 B.C.),
4th/3rd century B.C.

Jade; 9.2 x 17 x 0.6 cm (3 ⁵/₈ x 6 ³/₄ x ¹/₄ in.); 8.6 x 16.5 x 0.6 cm (3 ¹/₂ x 6 ⁵/₈ x ¹/₄ in.)

Edward and Louise B. Sonnenschein Collection, 1950.640–41

These matching pendants are designed as serpentine dragons with backturned heads,
coiled tails, and small fins that project above and below their undulating trunks. The
rhythmic fluency of these creatures belies the unyielding quality of jade—a compact,
fine-grained stone that cannot be carved and must be worn away with abrasive paste ap-
plied to its surface with saws, grinders, and drills. The craftsman's remarkable dexterity
with this intractable material is displayed in smoothly rounded, heart-shaped units and
delicately incised spirals, striations, and cross-hatching that thoroughly enliven both the
front and back surfaces. Their substantial size and thickness, technical refinement, and
glossy polish point to aristocratic patronage. That these pendants were likely designed
to drape down the owner's shoulders or from a waistband is indicated by holes pierced
for suspension through the creatures' hindquarters. Toward the end of the Bronze Age
when these pendants were created, sinuously curved dragons had become prominent
motifs in many luxurious materials. Contemporary literature suggests that such dy-
namic creatures were not merely decorative, but also envisioned as supernatural beings.
When buried with the deceased, jade pendants like these may have reflected widely held
beliefs in the dragon as a vehicle that could transport the human soul on its journey to
the netherworld.

EQUESTRIENNE

Chinese, Tang dynasty (618–907), 725/50

Earthenware with traces of polychromy; 56.2 x 48.2 cm (22 1/8 x 18 15/16 in.)

Gift of Mrs. Potter Palmer Wood, 1970.1073

Chinese ceramic figures made exclusively for burial often vividly evoke the fashions and recreational activities of their aristocratic owners. This figure sensitively captures a quiet moment in the life of a matronly equestrienne, who gently guides her horse. The animal's powerful neck and flanks, long legs, trimmed mane, and decoratively tied tail are features distinctive to the handsome breeds that were brought to China from the empire's northwestern frontiers, as well as from sites as far west as the Aral Sea. Carefully twisted strands of clay realistically depict the furlike texture of the animal's saddle blanket. The woman's full proportions—evident in the folds of her flowing, wide-sleeved robe, as well as in her plump cheeks and double chin—are enhanced by her loosely gathered coiffure, which is topped with a dangling forehead bun. Her weight, costume, and hairstyle reflect early-to-mid-eighth-century ideals of feminine beauty. Stylistically, the woman closely resembles figures that archeologists have recently unearthed from the tombs of high-status individuals that are datable to about 740.

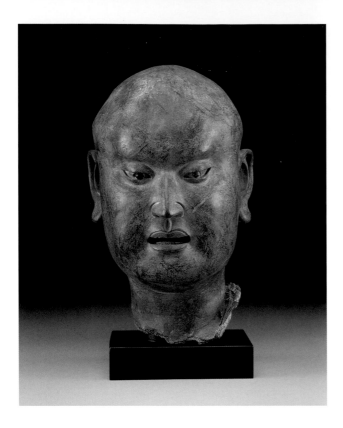

HEAD OF A *LUOHAN*

Chinese, Northern Song, Liao, or Jin dynasty, c. 11th century

Hollow dry lacquer; 28.6 x 18 x 20 cm (11 1/4 x 7 1/16 x 7 7/8 in.)

Gift of the Orientals, 1928.259

In traditional Buddhist belief, the *luohan* is a disciple who has attained enlightenment through intense personal effort. Beginning in the ninth century, the worship of *luohan*, and their depiction in art, evolved primarily in the context of the Chan (Zen), or "meditation," sect of Buddhism. This head was created in the delicate technique of hollow dry lacquer. The artisan first soaked layers of coarse cloth in lacquer (a thick sap tapped from a sumac tree) and applied these to a clay core formed over an armature of wood or another material. After allowing the work to dry, he applied a thick layer of lacquer paste to create the basic shape of the sculpture and a thinner coat into which he carefully modeled the eyes, high cheekbones, and other facial features. After removing the core and supporting armature, he set colored beads behind the eyes to represent irises and pupils. Finally, he painted the surface and perhaps applied gilding. Although these surface finishes have disintegrated over the centuries, the sensitively executed facial features preserve the *luohan*'s insightful expression.

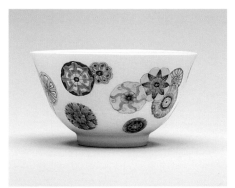
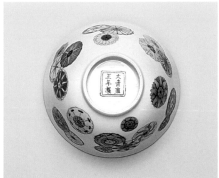

PAIR OF CUPS

Chinese, Qing dynasty (1644–1911), Yongzheng reign mark and period (1723–35)

Porcelain painted with underglaze blue and overglaze *doucai* enamels; 5.7 x 10.2 cm (2 ¼ x 4 in.)

Estate of Henry C. Schwab, 1941.701a–b

The emperors of China's last dynasty, the Qing, were enamored of exquisitely decorative objects and recruited remarkable craftsmen to serve their court. During his brief reign, the Yongzheng emperor, himself an artist and astute connoisseur, took a personal role in overseeing the imperial kilns. In their elegance and technical sophistication, these extraordinarily thin cups exemplify his exacting standards. Their floral medallions were delicately outlined in pale cobalt blue and, after glazing and firing, filled with soft, translucent enamels. So perfectly do these enamels fill the outlines that this technique is known as *doucai* (joined or dovetailed colors). Although quite different from the naturalistic floral motifs that characterize many Qing imperial porcelains, these medallions are also seen in rare examples of exquisite Yongzheng ware in the Palace Museum in Beijing. Their style may reflect the influence of Japanese lacquers, which were imported into China in the sixteenth and seventeenth centuries and subsequently inspired creative copies by Chinese palace craftsmen. The Yongzheng emperor is renowned for having encouraged innovative and sometimes foreign-inspired design in ceramics as well as other decorative arts.

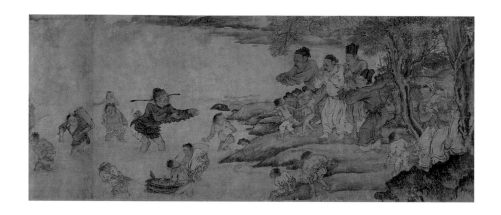

YANG PU MOVING HIS FAMILY (detail)
Chinese, Yuan dynasty (1279–1368), late 13th century
Handscroll; ink and light color on paper; 52.7 x 231.1 cm (20 ³/₄ x 91 in.)
Kate S. Buckingham Endowment, 1952.9

With a lively combination of realism and caricature, this detail of the painting *Yang Pu Moving His Family* depicts a group of peasants transporting a rustic scholar and his family across a stream. Distinguished by his official government cap, with its long streamers, the otherwise disheveled, bare-legged scholar bids farewell to his neighbors from the shallow water. Servants valiantly attempt to carry children and the family's belongings—scrolls, furniture, and dishes—through the water. The scholar depicted here may represent Yang Pu, a character described in stories of the Southern Song dynasty (1127–1279). According to folklore, Yang Pu initially declined, and then reluctantly accepted, his appointment to a government position in the capital city. As Chinese law forbade civil officials from working in their native districts, many were required to move to distant cities. Painters and poets frequently depicted the theme of farewell or "noble parting" exemplified by the story of Yang Pu. The twigs that protrude from the official caps of the men depicted here may allude to the ancient Chinese custom of presenting departing friends with small branches from a willow tree.

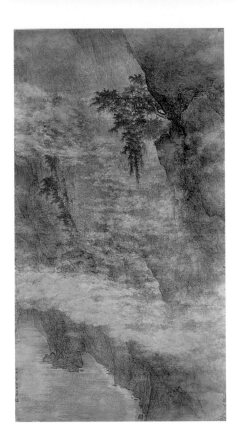

LI HUAYI

American, born China, 1948
Landscape, 2002
Ink and color on paper; 182 x 98.3 cm
(71 ¹¹/₁₆ x 38 ¹¹/₁₆ in.)
Comer Foundation Fund, 2004.450

Impressive in scale and refinement, this dramatic ravine evokes the monumental landscapes attributed to China's foremost painters of the tenth and eleventh centuries. Like those early masters, Li Huayi captured the continuous momentum and flux of nature. Steeply curving banks edged by windswept trees tower precariously over the water, whose receding flow is echoed by the cloudlike mist hovering above. This majestically dynamic image is rendered most remarkable by the artist's distinctively rigorous but expressive method of painting. After defining the composition with large areas of ink spilled onto the paper or worked with a broad brush, Li gradually rendered mass and solidity with denser layers and then allowed the paper to dry before adding details with a small, finely tapered brush.

Trained in Shanghai and San Francisco and now living in the United States, Li Huayi is one of the most creative and accomplished Chinese painters working today. By the artist's own account, powerfully fresh landscapes such as this do not reflect direct observation of nature but rather exist only in his mind.

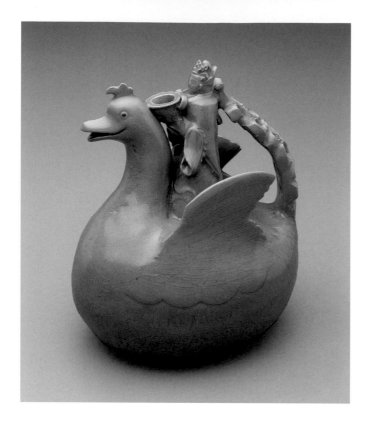

EWER

Korean, Goryeo dynasty (918–1392), 12th century

Stoneware with celadon glaze and underglaze carved and incised decoration;
21.4 x 17.7 x 13.2 cm (8 ¹/₂ x 7 x 5 ¹/₂ in.)

Bequest of Russell Tyson, 1964.1213

The prosperous Goryeo dynasty that gave its name to modern-day Korea produced some of the world's most esteemed ceramics. Preeminent among these are celadons, whose iron-rich glazes had been refined by Chinese potters to create a subtle range of gray and bluish green hues. Under the Goryeo court, Korean craftsmen drew upon the Chinese celadon tradition to create wares of unprecedented beauty and ingenuity. The technical refinement and stylistic naiveté of this intricately constructed bird-shaped ewer exemplify a distinctively Korean aesthetic. Whereas the creature's plump body resembles a duck's, its head is crowned with a cockscomb. Disproportionately small wings project out as if in flight, while the tail swoops upward to form a reticulated handle that supports a man who stands atop the bird's back, holding a bowl. His elaborate headdress and long, flowing robe suggest that this figure represents an immortal. Details of his garments, as well as of the bird's overlapping scales and layered feathers, were finely carved and incised into the clay body before glazing and firing; these areas appear a slightly deeper green where the glaze naturally pooled. As a final touch, dots of underglaze iron brown accent the eyes. Although wine or other liquids could be poured into the figure's bowl and out through the bird's smiling beak, this vessel may have been designed purely as an ingeniously whimsical work of art.

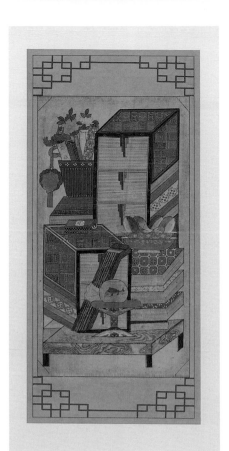

CHAEKKORI
Korean, Joseon dynasty (1392–1910),
19th century
One panel of an eight-panel screen; ink and
color on paper, mounted on silk brocade with a
wood frame; 162.5 x 415.2 cm (63 ¹⁵/₁₆ x 163 ⁵/₈ in.)
Wirt D. Walker Fund, 2006.3

Chaekkori are Korean still-life paintings
that were popular during the latter part
of the Joseon dynasty. Three-dimensional
effects were commonly used in *chaekkori*,
as was reversed perspective, in which
distant objects are shown larger than
those nearby, thus flattening the picto-
rial surface. These different treatments
of spatial illusion resulted in composi-
tions with a highly graphic feel that is
enhanced by the decorative pattern-
ing on the depicted objects. It is clear
that such still-life images did not have
realism as a goal. Instead, *chaekkori*
(defined as "painting[s] of books and
associated things") were seen as convey-
ers of cultural values. They were most
often displayed within studios or schools
and reflected reverence for scholarship
and learning. In this screen, scholarly
tools are depicted along with flowers,
plants, food, exotic imported objects,
and religious implements. These motifs
express varied meanings; for example,
eggplant represents the promise of a long
life, while musical instruments symbolize
harmony among people. Such a profusion
of auspicious meanings indicates that
chaekkori may not have been restricted
to the scholarly environment; they may
also have served as talismans ensuring
harmony within the home and beyond.

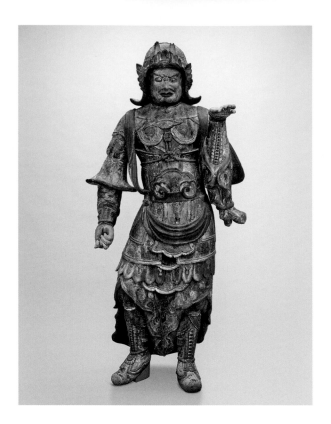

BISHAMON
Japanese, Heian period (794–1185), 11th century
Wood with traces of polychromy; h. approx. 135 cm (52 ³/₄ in.)
Robert Allerton Endowment, 1968.145

This is one of the Art Institute's most prized works of Japanese Buddhist sculpture. Bishamon (also known as Tamonten or Vaisravana) is the chief of the four guardian devas (or *shitennō*) who protect the four cardinal directions in a Buddhist sanctuary. Together they defend the entire world against evil and promote the seeking of enlightenment. Originally an Indian folk deity who was later adopted by Buddhism, Bishamon wards off harmful influences to the north.

Glaring at those who pose danger to the Buddhist law, Bishamon is clothed in full armor, ready to take on the Buddha's enemies. The figure is carved from wood in an intricate style that conveys action while also paying attention to the smallest details of his costume. The dynamic representation of Bishamon's figure—the sway of his hips and the opposing movements of his arms, with his sleeves swinging as if caught in a divine breeze—effectively expresses the guardian's strength and determination. His elaborate helmet is actually carved from the same piece of wood as the head. The plated armor was elaborately decorated with dragons, flowers, and other patterns depicted in gold and bright colors, ample traces of which remain. Bishamon once held a miniature reliquary in the upturned palm of his left hand and a sword in the right, symbolizing his duty to defend the Buddhist law.

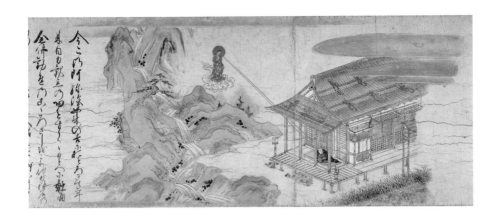

LEGENDS OF THE YŪZŪ NEMBUTSU SECT (detail)
Japanese, Kamakura period (1185–1333), mid-14th century
Handscroll; ink, color, and gold on paper; 30.5 x 1,176.9 cm (12 x 463 ³/₈ in.)
Kate S. Buckingham Endowment, 1956.1256

One of the most important and beautiful records of Amidism, a Buddhist salvation theology, is this rare narrative handscroll. It recounts details from the life of Ryōnin (1073–1132), a charismatic Tendai monk who founded the *yūzū* sect. The Buddhist concept of *yūzū* refers to the interrelationship or initial oneness of all things. The dynamically new approach to salvation that Ryōnin developed from *yūzū* reasoned that if all things are interrelated, the meritorious action of one individual benefits many. Followers of Amidism registered their names in a tally book, pledging to recite the brief *nembutsu* prayer, an invocation of the Amida Buddha, at specific times during the day. Contrasted with the dense and elite ritual of Buddhist teachings of the Heian period (794–1184), this simple, more populist approach to Buddhism had enormous appeal. Commissioned and executed in the mid-fourteenth century, during the revival of the *yūzū* sect, this lengthy horizontal scroll is unrolled from right to left and intended to be studied in successive sections approximately the width of the viewer's shoulders.

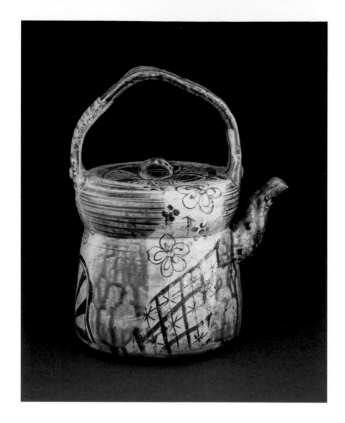

ORIBE-WARE EWER
Japanese, Momoyama period (1573–1615), early 17th century

Stoneware with copper-green and white glaze and underglaze iron-wash decoration; 26.7 x 21.6 cm (10 ½ x 8 ½ in.)

Gift of Robert Allerton, 1959.5

Furuta Oribe (1544–1615) was a military general–turned–tea aesthete whose style of presentation at tea gatherings catered to the samurai class and rulers of seventeenth-century Japan. In contrast to his predecessors, Oribe preferred tea wares that were bold and eccentric, rather than subtle and rustic. He was the first to recognize the beauty of artfully misshapen ceramics for use in tea gatherings. Ewers such as this were employed as water containers during the meal that preceded the tea service. Their distinctive glaze contains copper and thus turned green in the firing process. This glaze, along with slightly off-kilter or distorted shapes, became trademarks of Oribe ware produced in the Mino region of Japan (today, Gifu prefecture).

This vessel features drawings of plum blossoms, wheels, a hexagonal tortoise-shell pattern, and a lattice, all done in an underglaze iron wash. This is typical of such wares, which most often do not have a single decorative theme, but rather depict a mélange of almost abstract motifs akin to the popular patterning on textiles of the period.

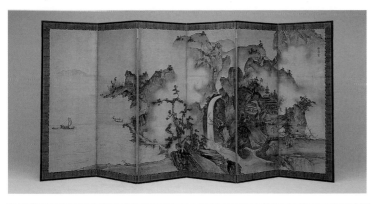

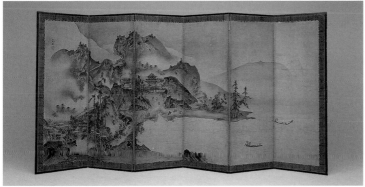

SESSON SHŪKEI Japanese, c. 1490–after 1577
Landscape of the Four Seasons, c. 1560
Pair of six-panel screens; ink and light color on paper; each 174.2 x 357.2 cm (68 ⁵/₈ x 140 ⁵/₈ in.)
Gift of the Joseph and Helen Regenstein Foundation, 1958.167–68

Sesson Shūkei was a Zen Buddhist monk and painter who achieved his idiosyncratic painterly style during an itinerant career in eastern Japan, seemingly without traveling to Kyoto, Japan's cultural and political capital at the time. Sesson's dreamlike Chinese landscape expands before our eyes in understandable spatial depth, an effect that is enhanced by the folds of the screen. We read the composition like the Japanese language, from right to left, and follow the flow of the seasons from the first red plum blossoms of the year, depicted on the right side of the right screen (seen here at top), all the way across to the snow-covered mountains on the far left side of the left screen. A mountain temple on the right and a village on the left enclose an inlet upon which boats come and go. People bustle about in activity, geologically impossible rock formations twist and turn, and water splashes out from the bottom of a waterfall like reaching fingers.

For adherents of Zen Buddhism, a sect with origins in China, idealized landscapes described a world akin to paradise, in which intellectual and religious activities could be pursued unhindered and the cycle of the seasons symbolized the harmony and rebirth inherent in the natural world.

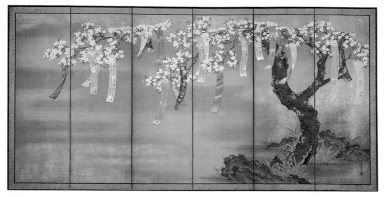

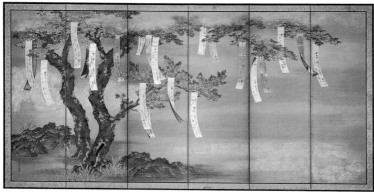

TOSA MITSUOKI Japanese, 1617–1691
Flowering Cherry and Autumn Maples with Poem Slips, 1654/81
Pair of six-panel screens; ink, color, gold, and silver on silk; each 144 x 286 cm (51 ⁹/₁₆ x 100 ¹³/₁₆ in.)
Kate S. Buckingham Endowment, 1977.156–57

Japanese aristocrats engaged in the elegant custom of recollecting classical poetry while viewing spring and autumn foliage. In these delicate screens, premier court painter Tosa Mitsuoki meditated on the inevitable passage of beauty by depicting the melancholy hours after the departure of reveling courtiers. A cherry tree bursts into bloom on the right screen (seen here at top), while its mate displays the brilliant red and gold foliage of maples in autumn. Slips of poetry, called *tanzaku*, waft from the blossoming limbs, the remaining evidence of a human presence. Courtiers (whose names are recorded in a seventeenth-century document) assisted Mitsuoki by inscribing the narrow strips with quotations of appropriate seasonal poetry from twelfth- and thirteenth-century anthologies. The screens were either commissioned by or given to Tōfukumon'in (1607–1678), a daughter of the Tokugawa shogun who married the emperor Gomizunoo (1596–1680). In an era otherwise marked by increasing control of the feudal shogunate over imperial prerogatives, this royal couple encouraged a renaissance of courtly taste that nostalgically evoked the past glories of early-medieval aristocratic life.

IKE TAIGA Japanese, 1723–1776
Group Pilgrimage to the Jizō Nun, 1755/65

Hanging scroll; ink on paper; 54.9 x 123.2 cm (21 ⅝ x 48 ½ in.)

Kate S. Buckingham Endowment; Margaret Gentles Fund; restricted gift of Roger L. Weston, George and Roberta Mann, Harlow and Susan Higinbotham, Charles C. Haffner III, and James M. and Carol D. Trapp, 2005.168

Ike Taiga was a revolutionary known for revitalizing Japanese painting traditions in the eighteenth century. He infused the Chinese-inspired ink painting (*nanga*) that was gaining favor among intellectuals in Kyoto with a purely Japanese aesthetic and humor. *Group Pilgrimage to the Jizō Nun* is a snapshot of contemporary life in Japan presented from Taiga's unique perspective. The print depicts pilgrims making offerings to the Jizō nun, a holy woman believed to be able to communicate with the bodhisattva Jizō, who had the power to save souls in the afterlife.

 Group Pilgrimage contains an inscription relating the story of the Jizō nun. Taiga was a master calligrapher, poet, and seal carver and was well versed in all forms of writing, from ancient seal script to cursive kana. Here he rendered the inscription in a cursive, informal style very much in keeping with the spontaneity of the painting itself. Taiga was also renowned for his use of finger painting and other odd techniques. Although opinions vary as to whether or not this work is a finger painting, it is clear that Taiga did not use a traditional brush. It seems likely that this could be a "paper twist painting," in which the artist worked with scraps of twisted paper charged with ink.

SUZUKI HARUNOBU Japanese, 1724–1770
Evening Snow on the Floss Shaper, from the series *Eight Parlor Views
(Zashiki hakkei),* 1766
Color woodblock print; *chūban*; 28.7 x 21.6 cm (11 ⁵/₁₆ x 8 ¹/₂ in.)
Clarence Buckingham Collection, 1928.903

The famous series *Eight Parlor Views* was produced in 1766, around the time of the birth of the full-color print in Japan. The series contains eight prints that were housed together in a fanciful wrapper, all of which are now in the Art Institute's collection. These eight views present visual puns based on well-known themes of the Xiao and Xiang rivers in China, each of which has its own poetic title. For this print, the scene represented is *Evening Snow.* Rather than showing snow-covered hills, however, Suzuki Harunobu depicted silk floss as snow and the floss shaper as the mountain.

Such witty visual riddles would have been appreciated by the audience of these prints—wealthy, well-educated townsmen who participated in poetry circles. One such figure was Ōkubo Jinshirō Tadanobu, whose pseudonym was Kyosen. It is thought that he produced this set, engaging Harunobu's services as well as those of the printer. In fact, this image contains Kyosen's handwritten signature, leading scholars to believe that the Art Institute's set is the first edition. Sets with Harunobu's signature exist in other collections.

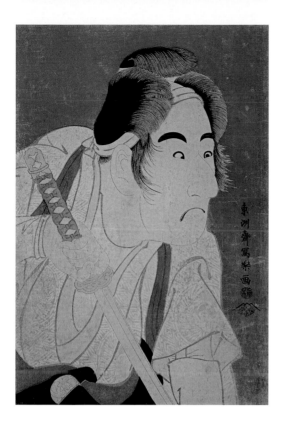

TŌSHŪSAI SHARAKU Japanese, active 1794–95
The Actor Bandō Mitsugorō as Ishii Genzō, 1794/95
Color woodblock print; *ōban*; 37.5 x 24.7 cm (14 ³/₄ x 9 ³/₄ in.)
Clarence Buckingham Collection, 1940.1086

Almost nothing is known of the life of Tōshūsai Sharaku, whose entire oeuvre of
bold portraits of Kabuki actors was produced during a ten-month period from 1794
to 1795. Sharaku's prints are frank and piercing, combining satire with decorative
power. His aggressive style is made all the more dramatic by his use of a dark mica
background, which throws the silhouette of the posturing actor into strong relief.
Depicted here is the actor Bandō Mitsugorō portraying the character Ishii Genzō at
the peak dramatic moment of the play *The Iris Soga of the Bunroku Era (Hanaayame
Bunroku Soga)*. With a look of intense fury, Genzō draws his sword to aid his two
brothers-in-law in avenging their father's murder. The play is based on an event that
occurred in 1701, disrupting the civil order of the Tokugawa shogunate and scandal-
izing the population of Edo. Commentary on contemporary issues was discouraged
by the Japanese government, however, so the play was disguised as a literary recounting
of a famous twelfth-century act of filial revenge that occurred in the Soga family.
Unlike the elite and highly stylized Nō theater, Kabuki was a popular form of drama
that reflected and catered to the tastes and pleasures of the emerging merchant class.

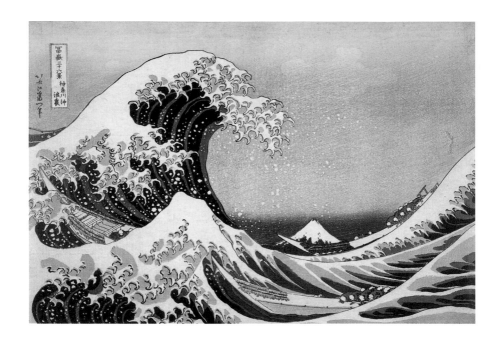

KATSUSHIKA HOKUSAI Japanese, 1760–1849
The Great Wave off Kanagawa, from the series *Thirty-Six Views of Mount Fuji,* c. 1831
Color woodblock print; *ōban*; 25.4 x 37.6 cm (10 ⅛ x 14 ¾ in.)
Clarence Buckingham Collection, 1925.3245

In the early nineteenth century, the pigment known as Berlin or Prussian blue (*bero*) became more widely available and affordable, inspiring a new flourishing of landscape imagery in print design that could make the most of the strong color. Produced between the late 1820s and early 1830s, Hokusai's series of prints studying the ancient pilgrimage site of Mount Fuji is among the most celebrated and majestic art of the nineteenth century. Whether the volcano is visually dominant, as in many of the prints, or reduced in scale, as it is here, the series is a virtuoso display of Hokusai's compositional skill. With its bold linear design, striking juxtapositions, and careful use of color, *The Great Wave* is one of the most compelling images of the mountain. Not only do the surging breakers seem to swamp the boaters, but—to the Japanese eye, accustomed to reading from right to left—the great claw of a wave appears almost to tumble into the viewer's face. Even Mount Fuji appears fragile, about to be engulfed by the uncontrollable energy of the water. This iconic image has been used widely in contemporary designs, ranging from comics and advertisements to book jackets and record covers.

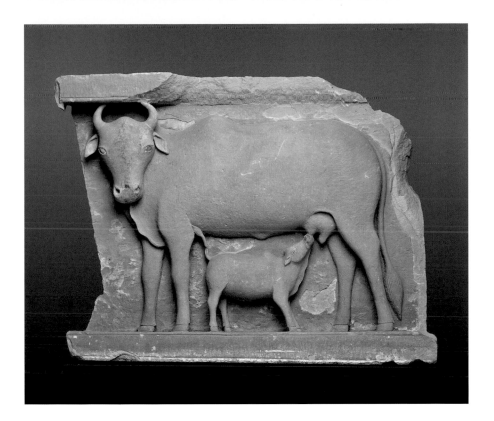

COW SUCKLING A CALF

India, Madhya or Uttar Pradesh, c. 9th century

Pinkish sandstone; 55.3 x 73.7 x 9.6 cm (22 ³/₄ x 29 x 3 ³/₄ in.)

James W. and Marilynn Alsdorf Collection, 2006.180

This naturalistic relief panel depicts a calf sucking milk from his mother while she stands patiently looking out at the viewer. Her placid eyes, floppy ears, undulating dewlap, small upwardly curving horns, and hump help identify her as belonging to the distinctive breed of Brahman cattle originally bred in India. Cows hold a respected place in India: they are regarded as the nourishing mother, as portrayed in this frieze, and even their waste is used in purification rituals and for fuel.

In the medieval period in India, the cow came to be particularly associated with Krishna, an incarnation of the Hindu god Vishnu, who grew up in Vrindavan (near Mathura) among the cowherds, a theme much celebrated in art. Less common are individual portrayals of a cow and calf, like this relief, which most likely came from the walls of a Hindu temple, possibly from central India, and can be dated around the ninth century. It is possible that this relief was once part of a larger narrative scene on a temple wall, perhaps depicting Krishna among cows and cowherds.

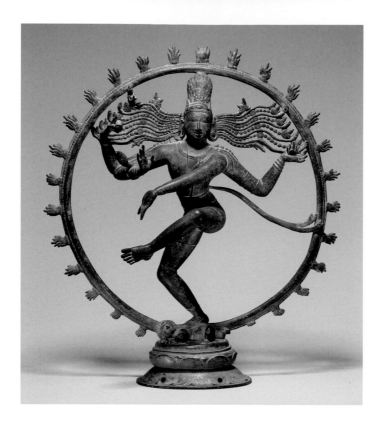

SHIVA AS LORD OF THE DANCE (*NATARAJA*)
India, Tamil Nadu, Chola period, 10th/11th century
Bronze; 69.3 x 61.8 x 24.1 cm (27 $\frac{1}{4}$ x 24 $\frac{1}{4}$ x 9 $\frac{1}{2}$ in.)
Kate S. Buckingham Fund, 1965.1130

Shiva, one of the most important Hindu divinities, is here depicted as the Lord of the Dance (*nataraja*), an iconic image in Indian art. Shiva's cosmic dance sets in motion the rhythm of life and death; it pervades the universe, as symbolized by the ring of fire that is filled with the loose, snakelike locks of the god's hair. One pair of his arms balances the flame of destruction and the hand drum (*damaru*) that beats the rhythm of life while another performs symbolic gestures: the raised right hand means "fear not," and the left hand (*gajahasta*) pointing down toward his raised left foot signifies release from the ignorance that hinders realization of the ultimate reality. Shiva is shown perfectly balanced, with his right leg planted on the demon of darkness (*apasmara*), stamping out ignorance. The tiny figure of the personified river goddess, Ganga, is caught up in his matted flowing locks. Hindus believe that Shiva breaks the fall of the great Ganges River as it descends from the Himalayas by standing beneath the waters, which divide over his hair, becoming the seven holy rivers of India. This classic bronze comes from the Chola period in the south of India. Icons such as this were carried in procession during religious ceremonies.

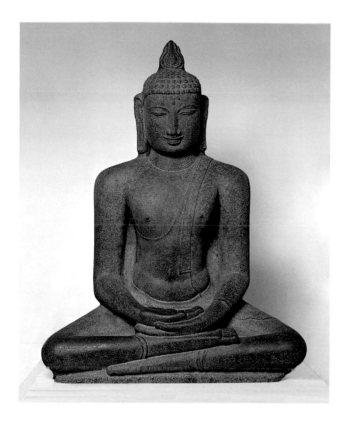

BUDDHA SEATED IN MEDITATION (*DHYANAMUDRA*)

India, Tamil Nadu, Nagapattinam, Chola period, c. 12th century

Granite; 160 x 120.2 x 56.3 cm (63 x 47 ⁵/₁₆ x 22 ³/₁₆ in.)

Restricted gift of Mr. and Mrs. Robert Andrew Brown, 1964.556

This meditating Buddha comes from the coastal town of Nagapattinam in southern India, which was, as a result of settlers from Srivijaya (Indonesia), one of the few places where Buddhism was still flourishing in the twelfth century. The Buddha—with his elongated earlobes, the wheel marks on his palms, the *urna* between his brows, and the cranial protuberance covered with snail-shell curls—is seated in the posture of meditation, with his hands resting on his lap (*dhyanamudra*), wearing a seemingly diaphanous monastic garment. As in other images from Nagapattinam, a flame emerges out of the Buddha's cranial protuberance, probably signifying wisdom. This monumental sculpture carved out of granite originally would have graced a monastic site at Nagapattinam, which is also well known for its Buddhist bronzes. The Tamil inscription covering its back is now no longer legible.

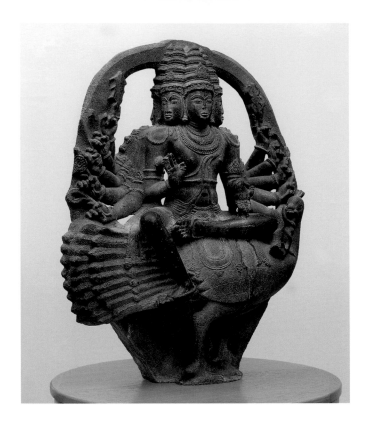

KARTTIKEYA, GOD OF WAR, SEATED ON A PEACOCK

India, Andhra Pradesh, Madanapalle, Ganga period, c. 12th century

Granite; 150.5 x 121 x 39 cm (59 ¹/₁₆ x 47 ⁵/₈ x 15 ³/₈ in.)

Restricted gift of Mr. and Mrs. Sylvain S. Wyler, 1962.203

Karttikeya, the god of war, is known by various names, including Skanda, Kumara, and Shanmukha, as well as Murugan in southern India, where he is very popular. This monumental granite sculpture is probably from the Madanapalle region of Andhra Pradesh. Carved in the round and riding a peacock, the commander of the gods is shown with six heads (*shanmukha*) and twelve arms, ten of which hold aloft weapons. The multiple arms and heads of Hindu deities usually denote their super-human power. According to legend, Karttikeya was born from the spilt seed of the Hindu divinity Shiva. He developed his six heads in order to nurse from his six mothers, the Pleiades (or Krittikas—hence his name, Karttikeya), a constellation of stars. The complex accounts of his miraculous birth and heroic exploits indicate that his character combines several streams of folk belief.

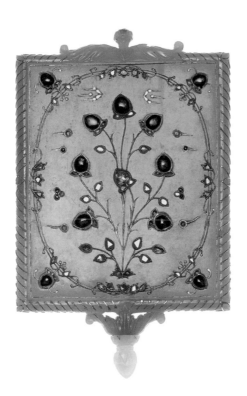

MIRROR FRAME WITH TREE OF LIFE MOTIF

India, Mughal period, 17th/18th century

Nephrite jade, gold, rubies, emeralds, and diamonds inset in the *kundan* technique; 16.4 x 10.2 x 1 cm
(6 7/16 x 4 x 3/8 in.)

Gift of Mr. and Mrs. Chester D. Tripp, 1970.474

This exquisite Mughal mirror frame of pale green nephrite jade is inlaid with rubies, emeralds, and diamonds in the *kundan* technique, a quintessentially Indian method of gem setting. The motif of this luxury item designed for the Mughal court is a Tree of Life with inlaid gold stems and leaves and buds of rubies, diamonds, and emeralds. Above the naturalistically depicted plant are two abstracted Chinese-style clouds in gold. Acanthus-leaf motifs adorn the top and bottom of the frame, while the mirror handle is in the shape of an unopened flower bud.

Jade was imported into India from the Khotan region of China. The owner of the jade concession there, the merchant Khwaja Mu'in, visited the Mughal emperor Akbar's court in 1563 and presented him with jade pieces. The earliest Mughal jades reflect Timurid, Ottoman, Safavid, and Chinese influences, and the finest jade objects were produced during the Jahangir and Shah Jahan periods in the seventeenth century. Jade was used for eating and drinking vessels, jewelry, sword hilts and scabbards, belt buckles, mirrors, and hookah parts. Inlaying jade with gold and setting it with gems was a popular Mughal technique derived from earlier Timurid traditions in Iran and Central Asia. This frame is a fine example of the union of various cultural motifs in a single object—a hallmark of Mughal art.

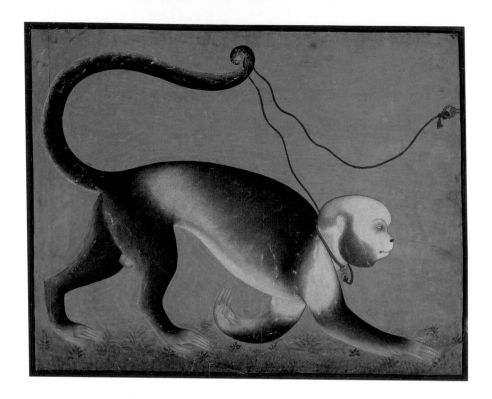

A MONUMENTAL PORTRAIT OF A MONKEY

India, Rajasthan, Mewar, Udaipur, 1705/10

Attributed to the Stipple Master (Indian, active c. 1692–c. 1715)

Opaque watercolor and gold on paper; 48.5 x 58.7 cm (19 x 23 in.)

Lacy Armour Fund and James and Marilynn Alsdorf Acquisition Fund, 2011.248

Except for depictions of the monkey-god Hanuman, monkeys are rarely the subject of portraits in India. In this monumental portrait of a monkey, therefore, we are looking not only at an unusual subject matter but also at a study of an extraordinary simian: one with human features, complete with a beard, pale eyes, and long slender hands. The inscription on the back of this work, written in Devanagari, states that the monkey is named Husaini and "comes from" Nawab Davad (or Daud) Khan. This name most likely refers to Daud Khan Panni, a powerful nobleman and a *faujdar* (a military commander and territorial administrator) who served the Mughal emperors from Aurangzeb (r. 1658–1707) through Farrukhsiyar (r. 1713–19), in various parts of India. The painting has been dated to 1705/10, and is attributed to the anonymous artist now called the Stipple Master. Working in tandem with his patron Maharana Amar Singh II of Mewar (r. 1698–1710), this artist was the initiator of a new painting style in Mewar in the late seventeenth and early eighteenth centuries. A group of about forty-six paintings, including the present work, has now been attributed to this artist-patron duo.

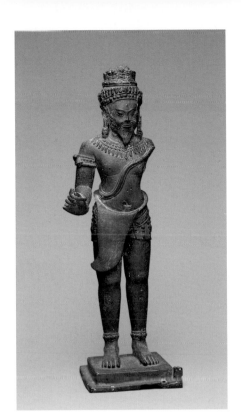

GOD SHIVA AS A DEIFIED KING

Southern Vietnam or Cambodia
Angkor period, 13th century

Bronze; 65.8 x 21.3 x 20.3 cm (25 ⁷/₈ x 8 ³/₈ x 8 in.)
James W. and Marilynn Alsdorf Collection,
1998.752

This bronze icon of the Hindu god
Shiva comes from Vietnam or Cambodia
and differs in several aspects from his
original renditions in India. Here, for
example, Shiva is identifiable by his
snake armband and the presence of
his third eye, with his long hair tied up
in a topknot like that of an ascetic. In
India, on the other hand, he is usually
shown as a smooth-faced youth in one
of his several guises: as a wild yogi; as
a young husband and family man ac-
companied by his bull, Nandi; as Lord
of the Dance; or as an abstract symbol
of creation. In this image, he appears
with all the weight and importance of a
mature, distinguished royal personage.
Around the neck and shoulders he bears
a multistrand necklace; in his ears are
massive, pendant earrings; and around
the hips he wears a brief, patterned sam-
pot with a long ornamental panel falling
in a point over his thigh.

This sculpture was discovered in
Vietnam, although it may have been
moved there from elsewhere in the
Khmer kingdom. It may have served
the dual purpose of a religious icon as
well as a memorial statue dedicated by
a king. The unusual ethnicity of the
facial features reinforces the idea that
this is a portrait as well as an image of
a deity, possibly representing a deified
royal guru figure identifying himself
with Shiva.

MILAREPA ON MOUNT KAILASH

Tibet, c. 1500

Pigment and gold on cotton; 45.5 x 30 cm (17 $^7/_8$ x 11 $^{13}/_{16}$ in.)

Asian Purchase Campaign Endowment and Robert Ross Fund, 1995.277

A beloved Tibetan singer-poet, mystic, teacher, and saint, Milarepa (1040–1123), whose name means "cotton-clad," is usually shown clothed in thin white cotton and cupping a hand to his ear—a gesture typical of singers in India and the Himalayas—to enhance his hearing while blocking out extraneous noise. In this *thangka*, a painted cloth that can be rolled up for portability, Milarepa sits in a cave on Mount Kailash, which is sacred to both Buddhists and Hindus. In front of him, Lake Manasarovar (Marpam) flows by in wavy blue and green bands. Milarepa is flanked by his disciples, and his teacher, Marpa, appears in a medallion above him. The dazzling white snow-covered peaks frame each of the central figures, and below them multicolored foothills appear as prismatic spikes refracting the sun's rays like jewels. Along the perimeter of the *thangka*, the five sisters of long life ride their mounts, accompanying Milarepa wherever he preaches his doctrine. The sacred peaks and lakes of the Himalayas have inspired numerous works of art—Milarepa, for example, wrote one hundred thousand songs about them. The other side of this textile contains a long inscription in Tibetan that demonstrates that this is one of the earliest representations of Milarepa.

NECKLACE INSCRIBED WITH THE NAME OF KING PRATAPAMALLADEVA

Nepal, Kathmandu Valley, c. 1650

Gilt copper with semiprecious stones; 36.2 x 35.6 x 8.9 cm (14 ¼ x 14 x 3 ½ in.)

Gift of the Alsdorf Foundation, 2010.575

This ornament may have been given by King Pratapamalla (r. 1641–74), ruler of the Malla dynasty of Nepal, to Taleju Bhavani, the revered patron goddess of the old palace in Kathmandu and the chief protective deity of Nepal and its royal family. King Pratapamalla may also have worn this collar when he participated in rituals. This complex piece is composed of five principal strands and bears the inscription: "Victory to the Mother-Goddess [*Bhagavati devi Janani*]. Hail! [This] is the necklace of the king of kings, lord of kings, lord of the poets, the victorious Pratapamalladeva (may it be) auspicious!"

The two innermost strands resemble rudraksha beads, made from the seeds of a large evergreen tree whose berries are commonly made into rosaries of 108 beads. Such prayer beads are most often worn by Shaivite ascetics, either around the neck or woven into their topknots. The third and fourth strands consist of tubular forms in a crescent shape known as *hansuli*. Each terminates in elaborate clasps, with the inner strand attached to a central amulet case. The outermost ring contains thirteen images of deities, including roundels of the eight mothers (*ashtamatrikas*), each depicted as the goddess Durga slaying the buffalo demon (Mahishasura). As this necklace was a royal commission, the finest Newari artists would have crafted it.

TWO TILES IN THE *SAZ* STYLE
Turkey, Ottoman period, Iznik, c. 1560

Fritware with underglaze painting in blue, turquoise, green, black, and red slip;
27.9 x 22.2 cm (11 x 8 ³/₄ in.)
Mary Jane Gunsaulus Collection, 1917.219a–b

During the sixteenth and seventeenth centuries, at the height of the Ottoman
empire, ceramic vessels and tiles of remarkable artistic and technical quality were
produced at Iznik, a city in northwestern Anatolia. The middle of the sixteenth cen-
tury was an important moment in the evolution of Iznik wares. To the existing blue-
and-white palette was added color: first turquoise, green, and purple, then a red slip.
The earlier focus on tableware was supplemented by a new demand for architectural
tilework. Also at this time a new style emerged that emphasized floral motifs, such
as familiar flowers (roses, carnations, tulips, etc.), as well as compositions of leaves
and palmettes. The enduring quality of Iznik at its best and most representative is
the effect of bold patterning in brilliant polychrome set against a pure white ground.

The design here consists of elaborate palmettes and sinuously writhing leaves
with serrated edges. Rosettes are half-covered by leaves, which, in turn, are pierced
by stems. This pattern is typical of the so-called *saz* style, a term that derives from
the words *saz kalem*, or "reed pen." The style developed in album drawings in black
ink executed in Turkey during the second half of the sixteenth century and became
widely popular in various media. The two tiles in the Art Institute's collection can be
dated to about 1560, the apogee of Iznik tile production. The tiles were meant to be
contiguous since the pattern continues effortlessly from one to the other.

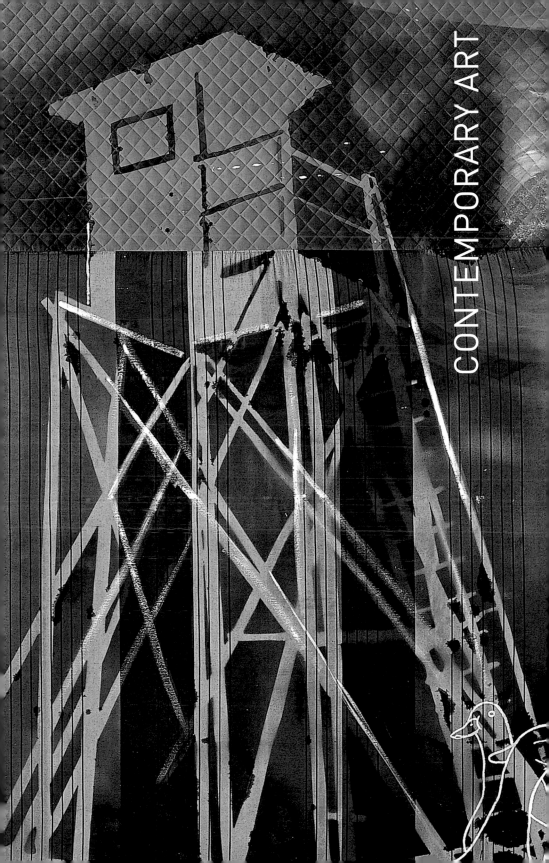

CONTEMPORARY ART

JOSEPH CORNELL American, 1903–1972
Untitled (Butterfly Habitat), c. 1940
Stained wood box with glass front, paper, screws, colored-paper butterflies, string, wood shavings, hollowed reeds, plaster fragments, and paint; 30.5 x 23.2 x 7.9 cm (12 x 9 ⅛ x 3 ⅛ in.)
Lindy and Edwin Bergman Joseph Cornell Collection, 1982.1845

For approximately thirty years, Joseph Cornell worked in relative obscurity in the basement of his home in Queens, New York, creating a multitude of wondrous miniature worlds within his boxed constructions. Poetic mélanges of found objects and materials, his deeply personal and elusive work (which also includes many collages on paper) combines the enthusiasms of his childhood—butterflies, marbles, seashells, sky charts, stamps—with adult fascinations such as ballerinas, empty cages, and movie stars. Cornell's boxes often prompt a dizzying series of associations; in *Untitled (Butterfly Habitat)*, these include Christmas decorations, collector's cabinets for specimens, microscopes, natural history displays, sailor's boxes, and windows. Some of these references are contradictory, reinforcing the work's ambiguity. Ideas linked to flight, voyages, and the exotic are countered by the rigid and symmetrical organization of the display. The butterflies are not, however, pinned as they would be on a specimen board. Each pane of paint-spattered glass encloses a small compartment with white wood walls in which a cutout of a paper butterfly is suspended with string, allowing for some movement as the box is handled.

ARSHILE GORKY American, born Turkish Armenia (present-day Turkey), 1904–1948
The Plow and the Song II, 1946
Oil on canvas; 132.7 x 156.2 cm (52 ¼ x 61 ½ in.)
Mr. and Mrs. Lewis Larned Coburn Fund, 1963.208

Born in Turkish Armenia, Arshile Gorky immigrated to the United States in the 1920s and became an influential member of the New York art scene. Profoundly interested in avant-garde European art, he experimented with a variety of styles. Young artists working in New York were particularly stimulated by the European Surrealists, many of whom moved to the city before and during World War II and whose circle Gorky joined. The 1940s, especially the years 1944–47, marked the creation of his most important work, produced in a kind of stream-of-consciousness or "automatic" manner of painting. *The Plow and the Song II* reflects the artist's indebtedness to the lyrical Surrealism of Joan Miró; but the sketchy handling of paint, translucent color, and tumbling pile of shapes are hallmarks of Gorky's mature work. A delicate contour line delineates the biomorphic forms in the center of the composition, in marked contrast to the loose brushwork that defines the background. The title signals Gorky's nostalgia for his heritage, as the artist wrote in 1944: "You cannot imagine the fertility of forms that leap from our Armenian plows. . . . And the songs, our ancient songs of the Armenian people, our suffering people. . . . So many shapes, so many shapes and ideas, happily a secret treasure to which I have been entrusted the key." Deeply earthbound and poetic, *The Plow and the Song II* is at once a still life, a landscape, and a fantasy.

BARNETT NEWMAN American, 1905–1970
The Beginning, 1946
Oil on canvas; 101.6 x 75.6 cm (40 x 29 ³/₄ in.)
Through prior gift of Mr. and Mrs. Carter H. Harrison, 1989.2

A key figure in the Abstract Expressionist movement, Barnett Newman is widely considered one of the most innovative and influential painters of the twentieth century. A brilliant colorist and a master of expansive spatial effects, he pioneered a new pictorial language that was at once emphatically abstract and powerfully emotive. For Newman, the spiritual content of abstract art was of paramount importance. Although his works seem largely focused on the formal qualities of painting, he insisted that they possessed symbolic meaning. For Newman, this meaning was never explicit; but he often alluded to it in the titles of his works, as with *The Beginning.* In the mid-1940s, Newman became preoccupied with the Old Testament story of Creation and began selecting titles in reference to the Book of Genesis. In this painting, the bands of paint that emerge from the base of the canvas interrupt a richly variegated field of color, a sort of primordial fog. The artist created these three stripes with the aid of masking tape, which he applied to the canvas as a guideline before adding the surrounding color. This work is an important precursor to Newman's mature paintings, which are characterized by a single vertical band, or "zip," that divides the composition.

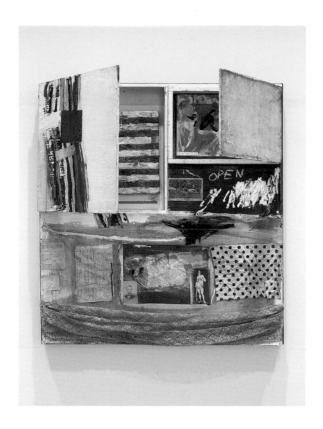

ROBERT RAUSCHENBERG American, 1925–2008
Short Circuit (Combine Painting), 1955

Oil, fabric, and paper on wood supports and cabinet with two hinged doors containing a painting by
Susan Weil and a reproduction of a Jasper Johns Flag painting by Sturtevant

Through prior purchase of the Grant J. Pick Purchase Fund; through prior bequest of Sigmund E.
Edelstone; Frederick W. Renshaw Acquistion Fund; Estate of Walter Aitken; Alyce and Edwin De-
Costa, Walter E. Heller Foundation, and Ada Turnbull Hertle funds; Wirt D. Walker Trust; Marian and
Samuel Klasstorner, Mrs. Clive Runnells, Alfred and May Tiefenbronner Memorial, Boles C. and Hya-
cinth G. Drechney, Charles H. and Mary F. Worcester Collection, Mary and Leigh Block Endowment,
Gladys N. Anderson, Benjamin Argile Memorial, Director's, and Joyce Van Pilsum funds, 2011.247

Robert Rauschenberg, along with Jasper Johns, charted a viable path out of Ab-
stract Expressionism, the predominant artistic practice when he emerged during the
1950s. Rauschenberg is best known for the "combine," a hybrid form of painting and
sculpture that integrates humble materials, found images, and paint to bridge what
he called "the gap between art and life." He submitted the combine *Short Circuit* to
an exhibition at Stable Gallery in 1955, inviting friends to produce small pieces that
could be smuggled into the show via his cabinet-shaped construction. A painting by
his former wife, artist Susan Weil, appears behind the right door, and a flag composi-
tion by Jasper Johns, later replaced by a facsimile, once sat behind the left door. The
work also includes a Judy Garland autograph, an image of Abraham Lincoln, and a
postcard of grazing cows, among other items.

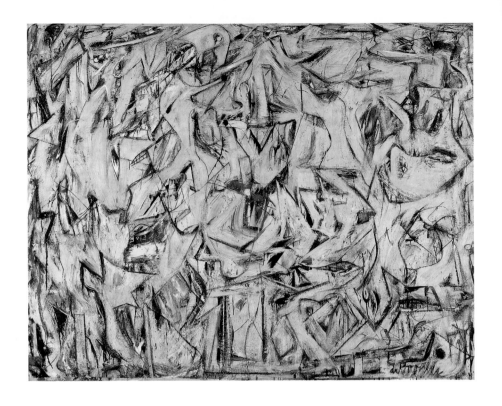

WILLEM DE KOONING American, born Netherlands, 1904–1997

Excavation, 1950

Oil on canvas; 205.7 x 254.6 cm (81 x 101 ¼ in.)

Mr. and Mrs. Frank G. Logan Purchase Prize Fund; restricted gift of Edgar J. Kaufmann, Jr., and
Mr. and Mrs. Noah Goldowsky, Jr., 1952.1

Willem de Kooning was a central figure in Abstract Expressionism, an art movement
that espoused the painterly actions of the artist as a sign of his or her emotions.
De Kooning completed *Excavation* in June 1950, just in time for it to be exhibited in
the twenty-fifth Venice Biennale. His largest painting up to that date, the work exem-
plifies the Dutch-born innovator's style, with its expressive brushwork and distinc-
tive organization of space into loose, sliding planes with open contours. According
to the artist, the point of departure for the painting was an image of women working
in a rice field in *Bitter Rice*, a 1949 Neorealist film by the Italian director Giuseppe
de Santis. The mobile structure of hooked calligraphic lines defines anatomical parts—
bird and fish shapes, human noses, eyes, teeth, necks, and jaws—that seem to dance
across the painted surface, revealing the particular tension between abstraction and
figuration that is inherent in de Kooning's work. The original white pigment has
yellowed over the years, diluting somewhat the flashes of red, blue, yellow, and pink
that punctuate the composition. Aptly titled, the painting reflects de Kooning's tech-
nically masterful painting process: an intensive building up of the surface and scraping
down of its paint layers, often for months, until the desired effect was achieved.

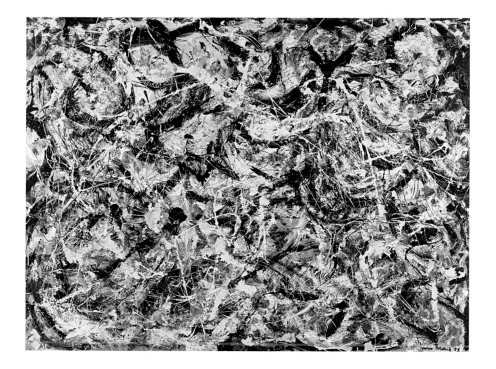

JACKSON POLLOCK American, 1912–1956
Greyed Rainbow, 1953
Oil on linen; 182.9 x 244.2 cm (72 x 96 ⅛ in.)
Gift of Society for Contemporary American Art, 1955.494

In the late 1940s, Jackson Pollock developed a revolutionary form of Abstract
Expressionism by dripping, pouring, and splashing paint onto large-scale canvases.
Pollock emphasized the expressive power of the artist's gestures, materials, and
tools, often applying paint with sticks, trowels, and palette knives instead of brushes.
He also challenged the concept of easel painting by working on canvases placed
either on the floor or fixed to a wall. With no apparent beginning or end, top or bottom,
his paintings imply an extension of his art beyond the edges of the canvas, engulfing
the viewer. Among the last great purely abstract paintings Pollock made before his
untimely death in 1956, *Greyed Rainbow* is a quintessential example of action painting.
The paint application ranges from thick chunks squeezed directly from a tube to
thin, meandering lines poured from a container with a small hole or squirted from
a baster. The work is predominantly black, white, gray, and silver; in the bottom
third of the canvas, however, Pollock thinly concealed orange, yellow, green, blue,
and violet. The title of the work presumably refers to these grayed sections of
hidden color.

ELLSWORTH KELLY American, born 1923
Red, Yellow, Blue, White, and Black, 1953
Oil on canvas, seven joined panels; 99.1 x 350.2 cm (39 x 138 in.)
Anstiss and Ronald Krueck Fund for Contemporary Art, 2001.157

Emphasizing the basics of line, shape, and color, Ellsworth Kelly's exquisitely spare paintings and sculpture influenced the development of Minimalist art and affected the course of color-field painting, hard-edge painting, and post-painterly abstraction. Among the Art Institute's rich holdings of Kelly's works, *Red, Yellow, Blue, White, and Black* stands apart: with startling clarity, this painting marks the moment at mid-century when Kelly's pure abstraction emerged in its mature form. After serving in World War II, the artist returned to Europe in 1948, living and working in France for the following six years. While abroad, Kelly expanded his practice of direct observation of nature and architectural forms into an experimental, rigorous study of abstraction. He made *Red, Yellow, Blue, White, and Black* in 1953 while still in France, creating it just as he was beginning to uncover the nearly infinite possibilities of monochrome, color spectrum, chance ordering, and multipanel composition. In the painting, Kelly centered the black panel so that it both divides and joins the three panels on either side of it, while the white panels simultaneously separate colors and pair them off. The blue panels at either end close and unify the sequence. Kelly's multipanel monochromes rely on the edges where sections meet, instead of handmade marks, to express their form. This seven-panel painting is the largest in a sequence of Paris-based works widely considered to be the artist's finest and most influential early statements on canvas.

MARK ROTHKO American, born Russia (present-day Latvia), 1903–1970
Untitled (Painting), 1953–54
Oil on canvas; 265.1 x 298.1 cm (104 ³/₈ x 117 ³/₈ in.)
Friends of American Art Collection, 1954.1308

Known for an impassioned form of painting predicated on the poetics of color,
Mark Rothko was one of the leading proponents of color field painting, a type of
nongestural Abstract Expressionism that entailed large canvases distinguished
by monumental expanses of form and tone. The canvas of *Untitled (Painting)* burns
with subtle variations of orange and yellow hues. The painting follows the character-
istic format of Rothko's mature work, according to which stacked rectangles of color
appear to float within the boundaries of the canvas. By directly staining the fabric of
the canvas with many thin washes of pigment and by paying particular attention to the
edges where the fields interact, he achieved the effect of light radiating from the image
itself. This technique suited Rothko's metaphysical aims: to offer painting as a door-
way into purely spiritual realms, making it as immaterial and evocative as music, and
to communicate directly the most essential, rawest forms of human emotion. Rothko
described his art as the "elimination of all obstacles between the painter and the
idea, between the idea and the observer." In place of overt symbolism, he used color,
overwhelming scale, and surface luminosity to elicit an emotive, profound response
from the viewer.

JOAN MITCHELL American, 1925–1992
City Landscape, 1955
Oil on linen; 203.2 x 203.2 cm (80 x 80 in.)
Gift of Society for Contemporary American Art, 1958.193

Joan Mitchell's large, vibrant paintings have always been anchored in the particularities of place. The artist settled in New York City in 1950 and became an active member of the first generation of Abstract Expressionists. The gestural brushwork of Willem de Kooning (see p. 130) particularly impressed her. Soon Mitchell was painting big, light-filled abstractions, animated by loosely applied skeins of bright color, infused with the energy and excitement of a large metropolis. In *City Landscape,* a tangle of pale pink, scarlet, mustard, sienna, and black hues threatens to coagulate or erupt. The painting's title suggests that this ganglia of pigments evokes the nerves or arteries of a city. Stabilizing this energized center are the roughly rectangular white forms of fore- and background, modulated with touches of gray and violet. The sense of spontaneity conveyed in *City Landscape* belies Mitchell's painting methods. Unlike many of her contemporaries, who were dubbed action painters, Mitchell worked slowly and deliberately. "I paint a little," she said. "Then I sit and look at the painting, sometimes for hours. Eventually, the painting tells me what to do."

CLYFFORD STILL American, 1904–1980
Untitled, 1958 (PH-774)
Oil on canvas; 292.2 x 406.4 cm (114 ¼ x 160 in.)
Mr. and Mrs. Frank G. Logan Purchase Prize Fund; Roy J. and Frances R. Friedman Endowment;
through prior gift of Mrs. Henry C. Woods; gift of Lannan Foundation, 1997.164

In the late 1940s, Clyfford Still, along with Barnett Newman and Mark Rothko, orig-
inated the type of Abstract Expressionism known as color-field painting, a term
used to describe very large canvases dominated by monumental expanses of intense,
homogeneous color. Like most of Still's mature work, *Untitled* is a sheer wall of
paint, imposing and self-sustaining, that makes no concessions to conventional notions
of beauty or pictorial illusionism. This painting's textural effects give it an insistent,
complex materiality. Dominated by blacks that the artist applied with both a trowel
and brushes, the surface is by turns reflective and chalky, granular and smooth,
feathery and leaden. These variegated black surfaces are even more emphatic because
their continuity is broken by areas of blank canvas and white paint. Like veins in
igneous rock, streaks of orange, yellow, and green paint are embedded in the black
voids. Mediating between the light and dark masses are areas of crimson, height-
ened at the edges, as if enflamed, by bright orange.

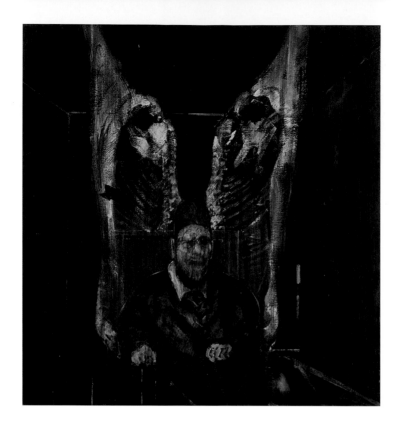

FRANCIS BACON English, born Ireland, 1909–1992
Figure with Meat, 1954
Oil on canvas; 129.9 x 121.9 cm (51 ⅛ x 48 in.)
Harriott A. Fox Fund, 1956.1201

Permeated by anguished visions of humanity, Francis Bacon's paintings embody the existential ethos of the postwar era. In his powerful, nihilistic works, tormented and deformed figures become players in dark, unresolved dramas. Bacon often referred in his paintings to the history of art, interpreting borrowed images through his own bleak mentality. *Figure with Meat* is part of a now-famous series he devoted to Diego Velázquez's *Portrait of Pope Innocent X* (c. 1650; Galleria Doria-Pamphili, Rome). Here he transformed the Spanish Baroque artist's iconic portrayal of papal authority into a nightmarish image, in which the blurred figure of the pope, seen as if through a veil, seems trapped in a glass-box torture chamber, his mouth open in a silent scream. Instead of the noble drapery that frames Velázquez's pope, Bacon framed his figure with two sides of beef, quoting the work of the seventeenth-century Dutch artist Rembrandt van Rijn and the twentieth-century Russian artist Chaim Soutine, both of whom painted brutal and haunting images of raw meat. Framed by the carcass, Bacon's pope can be seen alternately as a depraved butcher, or as much a victim as the slaughtered animal hanging behind him.

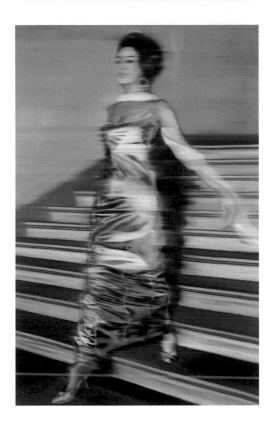

GERHARD RICHTER German, born 1932
Woman Descending the Staircase, 1965
Oil on canvas; 198 x 128 cm (79 x 51 in.)
Roy J. and Frances R. Friedman Endowment; gift of Lannan Foundation, 1997.176

Throughout his career, Gerhard Richter has alternated between figuration and abstrac-
tion. *Woman Descending the Staircase* is one of Richter's photo paintings, figurative
works in which the artist transferred found photographs, such as personal snapshots
or media images, onto canvas and then dragged a dry brush through the wet pigment,
thus blurring the image and making the forms appear elusive. Here, the slightly out-
of-focus quality reinforces the motion of an unknown, glamorously dressed woman
descending a set of stairs. The work's silver-blue brushwork suits the elegance of the
subject with her glistening evening gown and diaphanous scarf. The composition's
subject and title evoke Marcel Duchamp's famous work *Nude Descending a Staircase*
(1912; Philadelphia Museum of Art). When it was exhibited in the United States at
the 1913 Armory Show, Duchamp's painting shocked Americans for its radical ab-
straction. Rather than honoring this Modernist icon, Richter protested it, stating
that he "could never accept that it had put [an end], once and for all, to a certain kind
of painting." Indeed, in the Art Institute's work, Richter produced a hauntingly
sophisticated image that floats between reality and illusion.

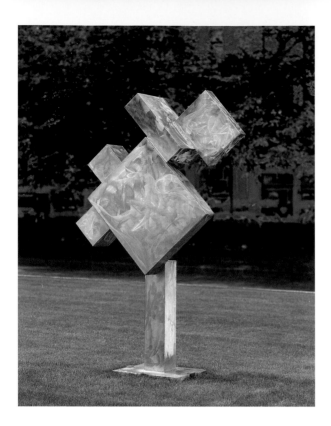

DAVID SMITH American, 1906–1965
Cubi VII, 1963
Stainless steel; 281.9 x 175.3 x 58.4 cm (111 x 69 x 23 in.)
Grant J. Pick Purchase Fund, 1964.1141

David Smith was among the first American artists to master the use of steel and other industrial materials. After many years of working metal into evocative linear compositions, he forged a new, formal language for sculpture through increased focus on shape, volume, surface, and structure. *Cubi VII* is part of a larger series executed in the four years that preceded his untimely death in 1965; the twenty-eight sculptures are most known for their use of industrial stainless steel. While the spare, sleek forms of the Cubi series relate them to Minimalist sculpture of the 1960s, the works also reflect the artist's connection to Abstract Expressionism in the gestural quality of their wire-brushed surfaces and their attendant emotive power. Its abstract qualities intact, *Cubi VII* also seems to allude to the human figure. Indeed, the large, central form and adjacent shapes evoke a torso with limbs. Yet when one walks around the sculpture, it becomes less a symbol of the human form than a vehicle for exploring the relationship between architectonic volumes and the space surrounding them. Despite its solidity, the piece appears to have no fixed center, and its elements seem precariously positioned, challenging accepted notions of balance. The reflective, burnished surfaces of *Cubi VII* pick up the shifting light of its outdoor site—the Art Institute's north garden on Michigan Avenue.

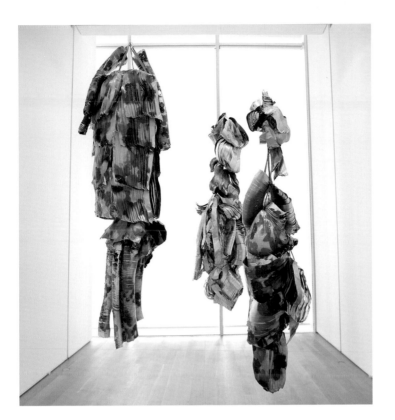

MARISA MERZ Italian, born 1931
Living Sculpture, 1966
Aluminum and paint; 351.2 x 264.2 x 180.3 cm (138 ¼ x 104 x 71 in.)
Through prior gifts of Adeline Yates and Fowler McCormick; Wilson L. Mead Fund, 2011.52

In the late 1960s, the term Arte Povera was coined to describe the radical emergent style of a group of Italian artists who began to engage everyday materials. Marisa Merz was included in the important *Arte Povera + Azioni Povere* exhibition in 1968 as one of the movement's leading practitioners. She spent the majority of her career, however, retreating from the public sphere, creating works in intimate settings such as her home. Merz has in fact stated, "There has never been any division between my life and my work." This three-part work belongs to the larger series *Untitled (Living Sculptures)*, begun in 1965. These extraordinary objects, crafted from thin folds of pliant, layered sheet metal, were made to hang from the ceiling of her Turin apartment. Her living and working spaces became, to varying degrees, a forest, a hive, a cave, and a womb. Merz's process turned simple industrial materials into fluid, organic forms. Removed from any social or narrative context, her abstract, formal inventions operate within their own temporal logic, reflecting the artist's belief in the enduring effect of each artwork beyond its material realization and the constraints of time and place.

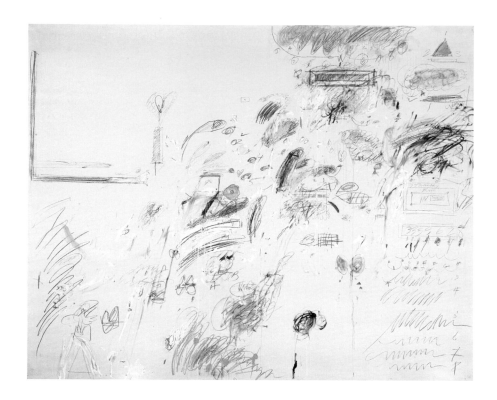

CY TWOMBLY American, 1928–2011
The First Part of the Return from Parnassus, 1961
Oil paint, lead pencil, wax crayon, and colored pencil on canvas; 240.7 x 300.7 cm (94 ³/₄ x 118 ³/₈ in.)
Through prior gift of Mary and Leigh Block, the Marian and Samuel Klasstorner Fund, Major Acquisitions Endowment Income Fund, Wirt D. Walker Trust, Estate of Walter Aitken, Director's Fund, Helen A. Regenstein Endowment, and Laura T. Magnuson Acquisition Fund, 2007.63

Cy Twombly's distinctive canvases merge drawing, painting, and symbolic writing in the pursuit of a direct, intuitive form of expression. More performative than illustrative in nature, the artist's inimitable visual language of scribbles, scratches, and scrawls is employed to both suggestive and sublime effects. Twombly's works from the early 1960s are florid evocations of art, myth, and allegory. *The First Part of the Return from Parnassus* refers to Mount Parnassus, the fabled home of Apollo and the Muses that became known as the center of poetry, music, and learning in ancient Greece. The title is likely taken from one of the *Parnassus Plays*, a series of sixteenth- and seventeenth-century theatrical performances that presented a satirical look at the adventures of two disillusioned graduates troubled by the lack of both employment opportunities and respect for learning in the larger world. Mixing visual references to corporeal processes with schematic forms and numbers, this painting is part of a general practice in which Twombly juxtaposes motifs of the irregular, organic, and intuitional with marks connoting the systematic, unyielding, and cerebral. A related work, *The Second Part of the Return from Parnassus* (1961), is also in the museum's collection.

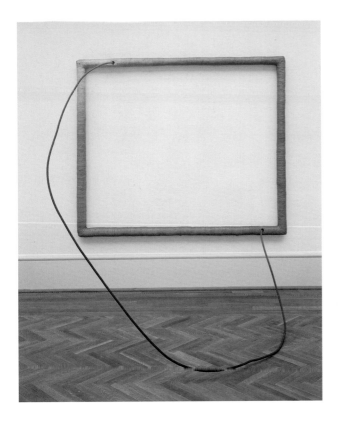

EVA HESSE American, born Germany, 1936–1970
Hang Up, 1966
Acrylic paint on cloth over wood and acrylic paint on cord over steel tube; 182.9 x 213.4 x 198.1 cm
(72 x 84 x 78 in.)
Through prior gifts of Arthur Keating and Mr. and Mrs. Edward Morris, 1988.130

Eva Hesse produced an extraordinarily original, influential body of work in her short
career, pioneering the use of eccentric materials and idiosyncratic sculptural forms.
Hesse considered *Hang Up* among her most important works because it was the first
to achieve the level of "absurdity or extreme feeling" she intended. Produced at the
height of Minimalism and the Pop Art movement but belonging to neither, the piece
was fabricated by her friend the artist Sol LeWitt, and her husband, Tom Doyle, who
wrapped the wood stretcher with bed sheets and attached the cord-covered steel tub-
ing. Sealed with acrylic, the object is subtly shaded from pale to dark ash gray. It is
an ironic sculpture about painting, privileging the medium's marginal features: the
frame and its hanging device, represented by the cord that protrudes awkwardly into
the gallery. The title might be understood as a humorous instruction for the sculpture's
display, but also acts on a more psychological level. Collapsing the space between
the viewer and the artwork, *Hang Up* creates a sense of disorientation and toys with
our ability to discern a clear demarcation between painting and sculpture.

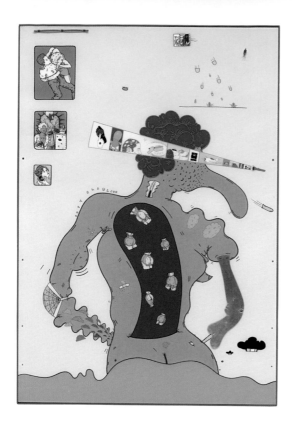

JIM NUTT American, born 1930
Miss E. Knows, 1967
Acrylic on Plexiglas, aluminum, rubber, and enamel on wood frame; 192.1 x 131.1 cm (75 ⅝ x 51 ⅝ in.)
Twentieth-Century Purchase Fund, 1970.1014

Jim Nutt is a principal member of the Hairy Who, an irreverent group of artists that emerged in Chicago during the late 1960s. Exhibiting Surrealist-inspired work aimed at subverting artistic conventions and standards of taste, these artists became part of the Chicago Imagist movement. Although each member developed a distinct style, collectively they shared an emphasis on intuition and spontaneity and an affection for wordplay and humor. In his earliest paintings, Nutt referenced popular culture, particularly painted store windows and pinball machines, through his choice of medium and support—acrylic paint on Plexiglas. In addition, many elements of his early style relate to the comic strip: hard, crisp forms stand out boldly against simple backgrounds. In *Miss E. Knows*, he also appropriated a sequential format, incorporating small, framed images in the upper-left corner of the painting. The work depicts a grotesquely imagined, highly sexualized female figure—Nutt's satire of ideal beauty. The artist included the cartoonish light beam across her eyes as a reference to the cinema. By attaching objects such as rubber tubing and a coat hook to its surface, Nutt heightened the Surrealist effect of this image.

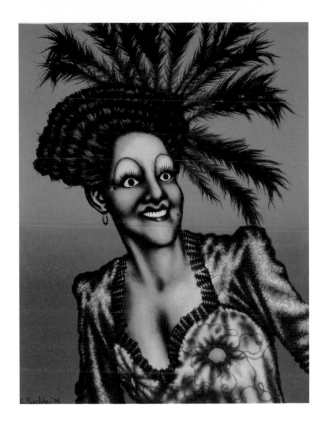

ED PASCHKE American, 1939–2004
Minnie, 1974
Oil on linen; 128 x 96.5 cm (50 ³/₈ x 38 in.)
Gift of the Robert A. Lewis Fund in memory of William and Polly Levey, 1982.397

Ed Paschke is celebrated as one of the leading figures of the Chicago Imagist move-
ment, a group of late-1960s artists whose expressive style of figurative painting was
rooted in outsider art, popular culture, and Surrealism. Drawing inspiration from New
York–based Pop Art, Paschke often culled his subjects from newspapers, tabloid
magazines, and television, producing work that taps into the movement's kitsch aes-
thetic. Although his paintings depict representational imagery, they play heavily upon
expressionist distortion, particularly in his use of psychedelic, inharmonious colors.
Paschke's love of urban subcultures and his interest in the underbelly of American
society translated into a penchant for sensational subject matter. In his early works,
Paschke painted circus freaks and other marginal figures, in marked contrast to,
for example, Andy Warhol's (see p. 150) overriding concern with mainstream celebrity.
Minnie, which depicts a now-anonymous individual silhouetted against a back-
ground of emanating light, is typical of his artistic production from this period. With
her theatrical costume, elaborate hairdo, and bizarre cosmetic application, this larger-
than-life figure becomes a grotesque. By painting a flamboyant, overtly sexualized
underworld character in a peculiar mixture of electric hues, Paschke added heat to
Pop Art's cool aesthetic.

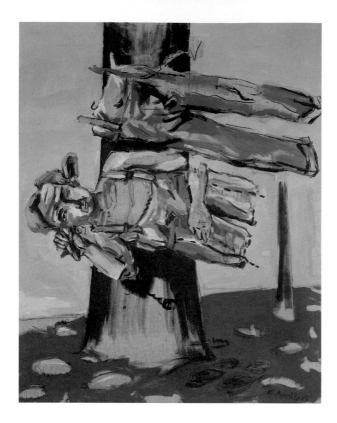

GEORG BASELITZ German, born 1938
Woodman, 1969
Charcoal and synthetic resin on linen; 250 x 200 cm (98 ½ x 78 ¾ in.)
Restriced gift of Mrs. Frederic G. Pick; Walter Aitken Fund, 1987.14

During the early 1960s, at a time when the art world was still propounding the virtues
of abstraction, a group of German artists turned their attention to the figure. Along
with such artists as Anselm Kiefer and A. R. Penck, Georg Baselitz began producing
representational images that drew inspiration from Germany's artistic and cultural
heritage. These so-called Neo-Expressionist works are further characterized by thickly
painted surfaces and often emotional and/or tragic themes. Between 1967 and 1969,
Baselitz executed a series of *Fracture Paintings*, in which he segmented his subjects—
animals, shepherds, and woodsmen—into horizontal bands or irregular fragments.
Strung up sideways against a massive tree trunk, this woodman heralds the artist's
trademark inverted figures, which first appeared soon after this painting's completion.
Conjuring up a world gone mad, *Woodman* evokes the psychic and physical disorient-
ation Germans experienced after their nation was partitioned in 1946. Indeed, Baselitz
created the work after he left a divided Berlin to reside in a small village.

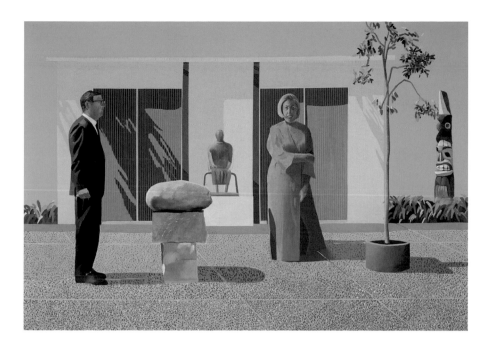

DAVID HOCKNEY English, born 1937
American Collectors (Fred and Marcia Weisman), 1968
Acrylic on canvas; 213.4 x 304.8 cm (83 ⅞ x 120 in.)
Restricted gift of Mr. and Mrs. Frederic G. Pick, 1984.182

One of England's most versatile and inventive artists of the postwar era, the painter, printmaker, set designer, and photographer David Hockney settled in Los Angeles in 1964. His work since then has often reflected, with wit and incision, the sun-washed flatness of the Southern California environment. Perhaps the most iconic example from a group of double portraits of friends and associates from the 1960s, this large painting depicts contemporary-art collectors Fred and Marcia Weisman in the sculpture garden of their Los Angeles home. As Hockney said, "The portrait wasn't just in the faces, it was in the whole setting." As relentlessly stiff and still as the objects surrounding them, the couple stands apart, his stance echoed in the totem pole to the right, hers in the figurative sculpture behind her. Mrs. Weisman's distorted mouth also mirrors that of the totem pole. Mr. Weisman's shadow falls possessively over the abstract sculpture at his feet. His hand is clenched so tightly it seems as if he were squeezing paint out of his fist (Hockney deliberately left the drips). Brilliant, raking light flattens and abstracts the scene. This pervasive aridity is reinforced by the segregation of living, green foliage, including the lonely potted tree, to the edges of the painting. Unsurprisingly, the Weisman's did not favor Hockney's harsh portrayal and did not keep the painting.

ROY LICHTENSTEIN American, 1923–1997
Mirror #3 (Six Panels), 1971
Oil and Magna on canvas; 304.8 x 335.3 cm (120 x 132 in.)
Anstiss and Ronald Krueck Fund for Contemporary Art, facilitated by the Roy Lichtenstein Foundation,
2005.18

Roy Lichtenstein was perhaps the most consistently inventive artist among the
group of individuals who rose to prominence as the progenitors of American Pop Art
in the early 1960s. Throughout his career, he explored the functional simplicity
and visual clichés that characterize processes of mechanical reproduction. Initially
preoccupied with the visual immediacy of cartoons, Lichtenstein embraced the
technical constraints of graphic illustration, applying them to painting. *Mirror #3
(Six Panels)* is among the most ambitious, summarizing canvases in the artist's Mirror
series (1969–72). Like his famous cartoon images, these paintings were inspired by
sources in popular culture. Studying illustrations from furniture- and glass-company
catalogs, Lichtenstein familiarized himself with pictorial conventions used to repre-
sent reflections. The work also references the long tradition of rendering mirrors in
art, a theme that was explored by artists from Diego Velázquez to Pablo Picasso.
Lichtenstein was perhaps most invested, however, in broadly generic questions of
surface and support. Only stylized gleam and shadow are reflected in his mirror;
thus, the puzzling, fragmented, even conceptual abstraction becomes the real subject
of the work.

BRICE MARDEN American, born 1938
Rodeo, 1971
Oil and wax on two canvases; 243.8 x 243.8 cm (96 x 96 in.)
Ada S. Garrett Prize Fund; estate of Katharine Kuh; through prior gift of Mrs. Henry C. Woods; gift of
Lannan Foundation, 1997.160

During the past four decades, Brice Marden has played a key role in maintaining
the vitality of abstract painting. *Rodeo*, a work of imposing scale and stark presence,
represents a high point of his early career. Two rectangular canvas panels—one yellow,
the other gray—are joined to form an eight-foot square. Each canvas is pulled across
a deep (two and one-eighth-inch) stretcher and painted with a combination of oil and
beeswax. The stretchers and thick, opaque pigment give *Rodeo* a sense of weight and
a sculptural presence. Like all of Marden's paintings, *Rodeo* is insistently handmade.
The artist laid multiple layers of the medium over his canvas panels, adding an extra-
ordinary sense of tactility to this relatively simple composition. The line joining the
two panels may suggest a horizon line, and thus a landscape. The juxtaposition of two
rectangular fields also recalls the work of Mark Rothko (see p. 133). In contrast to
Rothko's luminous, floating fields of color, Marden's twin panels seem determinedly
earthbound, presented as physical facts rather than as expressions of spiritual aspiration.

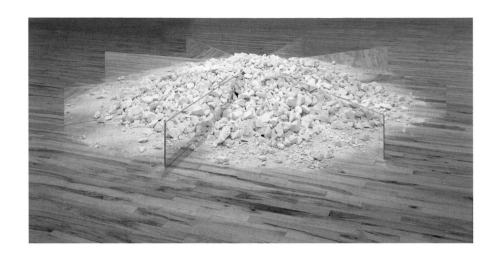

ROBERT SMITHSON American, 1938–1973
Chalk-Mirror Displacement, 1969
Eight mirrors and chalk; diam. approx. 3.1 m (10 ft.)
Through prior gift of Mr. and Mrs. Edward Morris, 1987.277

The painter, sculptor, theorist, filmmaker, and photographer Robert Smithson helped pioneer the Earthwork movement of the late 1960s and 1970s, which took as its subject the artistic reordering of the American landscape in its many varied forms. *Chalk-Mirror Displacement* belongs to a series of works, executed in 1968 and 1969, that combine mirrors and organic materials. Eight double-sided mirrors radiate like spokes from the center of a chalk pile located on the gallery floor. As they slice through the pile, the mirrors separate the chalk into almost identical wedge compartments. The double reflection in each compartment preserves the illusion of the whole pile, making the mirror dividers appear nearly invisible. This work is also one of Smithson's *Site/Nonsite* pieces. The artist referred to the first stage of the work as a "Site Incarnation," which he created for a particular outdoor location: in this case, a chalk quarry in Oxted, York, England. After setting up and photographing the Site piece, Smithson then dismantled it. The materials were subsequently reinstalled in the Nonsite location, the seminal 1969 exhibition *When Attitude Becomes Form* at the Institute of Contemporary Arts in London. This process purposefully blurred the boundaries between art and its environment, within and without gallery walls.

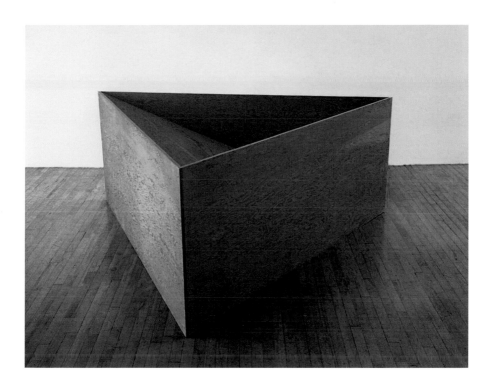

DONALD JUDD American, 1928–1994
Untitled, 1976
Douglas fir plywood; 91.5 x 233 x 214.6 cm (36 x 91 ³/₄ x 84 ¹/₂ in.)
Through prior gift of Adeline Yates, 2008.11

A key exponent of Minimalism, Donald Judd is celebrated as one of the most signifi-
cant American artists of the postwar period. By the mid-1960s, he had developed
a rigorous visual vocabulary involving simple geometric forms made of a range of
industrial materials including anodized aluminum, stainless steel, and Plexiglas.
To obtain a perfect finish without having to rework the material, Judd had his pieces
made in a factory. Presented as single works or combined serially into greater
wholes, these sculptures—which Judd termed "specific objects"—explore the physical
properties of color, shape, and space. In 1972 the artist began working with un-
painted plywood, for both practical and aesthetic reasons. Because it was a relatively
inexpensive material, it enabled Judd to experiment freely with proportion, scale,
and composition. Unlike many of his plywood sculptures, which are serial in nature,
Untitled is the only indoor triangular piece in Judd's oeuvre. In this work, an in-
terior plane bisects the structure. Investigations of the diagonal division of internal
space were an abiding formal concern that had occupied Judd's attention since 1974.

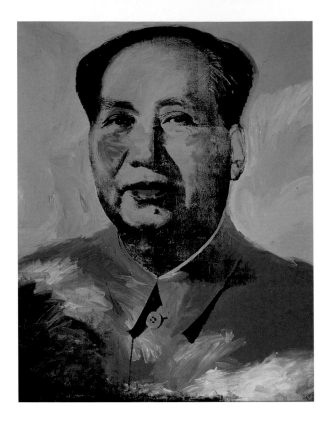

ANDY WARHOL American, 1930–1987
Mao, 1973
Synthetic polymer paint and silkscreen ink on canvas; 448.3 x 346.7 cm (176 ¹/₂ x 136 ¹/₂ in.)
Mr. and Mrs. Frank G. Logan Prize and Wilson L. Mead funds, 1974.230

The most influential of Pop artists, Andy Warhol cast a cool, ironic light on the pervasiveness of commercial culture and contemporary celebrity worship. Early in his career, he began to utilize the silkscreen process to transfer photographed images to canvas, creating multiple portraits of celebrities including Marilyn Monroe, Elvis Presley, and Jacqueline Kennedy, as well as duplicated images of mass-produced products such as Campbell's soup cans and Coca-Cola bottles. In this example from his *Mao* series, Warhol melded his signature style with the scale of totalitarian propaganda to address the cult of personality surrounding the Chinese ruler Mao Zedong (1893–1976). Nearly fifteen feet tall, this towering work mimics the representations of the political figure that were ubiquitously displayed throughout China. Warhol's looming portrait impresses us with the duality of its realistic qualities and its plastic artificiality. In contrast to the photographic nature of the image, garish colors are applied to Mao's face like makeup. The gestural handling of color in the portrait shows Warhol at his most painterly.

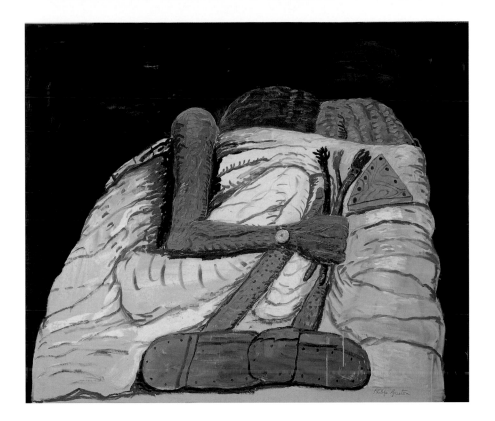

PHILIP GUSTON American, born Canada, 1913–1980
Couple in Bed, 1977
Oil on canvas; 206.2 x 240.3 cm (81 1/8 x 94 5/8 in.)
Through prior bequest of Frances W. Pick, and memorial gift from her daughter, Mary P. Hines, 1989.435

An established painter of some of the most poetic Abstract Expressionist work of the late 1950s, Philip Guston gradually abandoned abstraction in the 1960s in favor of seemingly crude, cartoonish images drawn from memory. For the artist, these new paintings represented a return to his creative beginnings. From 1934 to 1940, he had worked on Works Progress Administration murals in Los Angeles and New York, bringing to bear upon these projects such wide-ranging interests as cartoons, Cubist innovations, Italian Renaissance painting, and leftist politics. The radical stylistic shift Guston recaptured in the final decade of his life is fully evident in *Couple in Bed*. Here the artist employed a gritty, graphic imagery to explore the ongoing conflicts between his marriage and his all-consuming preoccupation with painting. In bed with his wife, he wears work shoes and grasps three paintbrushes that point to her tawny halo of hair. Missing its hands, and thus unable to track time, the artist's wristwatch symbolizes the enduring nature of his and his wife's love for each another, as well as their ongoing conflict over his priorities. Head to head, they huddle under a pale gray blanket in an inky-black cosmos that surrounds but does not envelop them.

TAKEN FROM HERE TO WHERE IT CAME FROM AND TAKEN TO A PLACE AND USED IN SUCH A MANNER THAT IT CAN ONLY REMAIN AS A REPRESENTATION OF WHAT IT WAS WHERE IT CAME FROM

LAWRENCE WEINER American, born 1942
TAKEN FROM HERE TO WHERE IT CAME FROM AND TAKEN TO A PLACE AND USED IN SUCH A MANNER THAT IT CAN ONLY REMAIN AS A REPRESENTATION OF WHAT IT WAS WHERE IT CAME FROM, 1981
Vinyl letters on wall; dimensions variable
Gift of Coosje Van Bruggen and Claes Oldenburg, 1982.402

Lawrence Weiner established himself as one of the leading figures in the Conceptual Art movement during the late 1960s by creating works that challenge traditional assumptions about the nature of the art object. Using language as his medium, Weiner set out to question the conventional relationship between artist and viewer and to redefine standard systems of artistic display and distribution. In 1968 Weiner issued a statement of intent, outlining the three conditions in which his works could exist: they could be built by him; fabricated by someone else; or not constructed at all. His works have the potential for being realized in countless ways and contexts; they may be shown outdoors as a public project, published in a book, printed on a matchbook cover, or simply spoken. He is best known, however, for written phrases presented on gallery or museum walls, typically in stenciled or vinyl lettering. Weiner felt the permanence and integrity of a linguistic construction—presented as a title in the form of a simple descriptive phrase on the wall—was less vulnerable to change over time than an actual sculpture. This work, which describes a physical act of displacement as a metaphor for representation, and its title are one and the same.

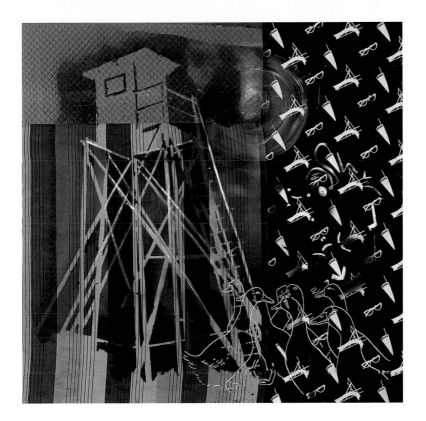

SIGMAR POLKE German, 1941–2010
Watchtower with Geese, 1987–88
Artificial resin and acrylic on various fabrics; 290 x 290 cm (114 ³/₁₆ x 114 ³/₁₆ in.)
Restricted gift in memory of Marshall Frankel; Wilson L. Mead Fund, 1990.81

Sigmar Polke was born in Silesia, which, after World War II, became part of East Germany. After moving to West Germany in the 1960s, he began to produce art in response to life in his bifurcated, psychologically damaged country. Between 1984 and 1988, Polke executed five paintings featuring the central image of a watchtower. The last in the series, the Art Institute's composition has a disjunctive quality, created partly by the superimposition of multiple images on a surface covered with diverse fabrics: a bright pink, quilted textile; striped awning material; and black cloth. The title of the work indicates an elevated seat frequently used in the German countryside as a lookout for hunting fowl, a reference underscored by a gaggle of geese in the painting's right-hand corner. The designs on the black fabric evoke the pleasures of leisure time at a beach and provide an association to another kind of raised chair, that of a lifeguard. More ominously, watchtowers are related to guard towers, prisons, concentration camps, and walled countries. Polke is one of a number of German artists who have confronted the collective trauma that characterizes the history of their nation in the twentieth century.

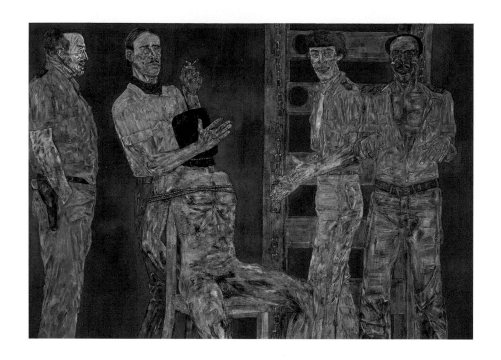

LEON GOLUB American, 1922–2004
Interrogation II, 1981
Acrylic on canvas; 305 x 427 cm (120 x 168 in.)
Gift of Society for Contemporary Art, 1983.264

Leon Golub's often harrowing paintings express his commitment to the possibility that art can effect social and political change. In the 1960s and early 1970s, Golub's political activism and his pursuit of a painterly, figurative style ran counter to the prevailing Pop Art and Minimalist movements. It was not until the 1980s that Golub's monumental canvases finally received widespread critical and popular attention. One of three depictions of brutal torture sessions that Golub painted in 1981, *Interrogation II* was inspired by human-rights violations in El Salvador and elsewhere in Central America. The work depicts four mercenaries and their naked, hooded victim, who is bound to a chair. A grayish black torture rack provides the only interruption to the intense, red-oxide color field, which creates a symbolically bloody backdrop for the heinous activity. The rawness of the action is reinforced by Golub's technique of scraping the applied paint down to the tooth of the canvas. An image of cruel intensity, *Interrogation II* is made even more disturbing by the torturers' grinning faces and the direct eye contact they make with the viewer, drawing us into uncomfortable complicity with their terrible acts.

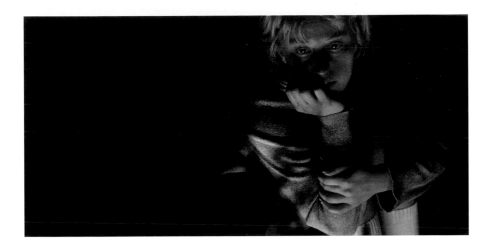

CINDY SHERMAN American, born 1954
Untitled #88, 1981
Chromogenic print; 61 x 121.9 cm (24 x 48 in.)
Gerald S. Elliott Fund in memory of Ann Elliott, 1988.118

Cindy Sherman is a major figure in the contemporary revival of directed or staged photography. Her work explores the pervasive effects that mass-media images have upon individual identities. Since the late 1970s, the artist has served as both photographer and model for a large cast of fictional personalities that she created through costume, hair (usually a wig), makeup, and lighting. Sherman first gained recognition for a series of black-and-white works that imitate the look and feel of stills from popular films of the 1950s and 1960s. In 1981 Sherman began a series of large color photographs that mimic the horizontal format of a magazine centerfold. Drawing a critical eye to these glossy spreads, Sherman's representations are fraught with anxiety, vulnerability, and longing. In *Untitled #88,* she depicted herself as a young, disheveled blonde in a large, frayed sweater and knee socks. The girl's fragility and isolation is underscored by her huddled body language and pensive stare. An imposing darkness surrounds her, except for the warm glow from what is most likely a fire, the only source of light in the picture. While the girl's specific situation remains ambiguous, the photograph illustrates that, for Sherman, gender is purely a performance.

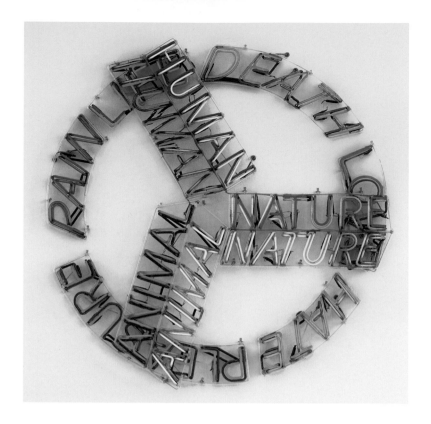

BRUCE NAUMAN American, born 1941
Human Nature/Life Death, 1983
Neon tubing with clear glass tubing suspension frames; 182.9 x 182.9 x 10.2 cm (72 x 72 x 4 in.)
Acquired from City of Chicago Public Art Program Collection; through prior gifts of Florence S.
McCormick and Emily Crane Chadbourne, 2004.151

Regarded as one of the most innovative artists of his generation, Bruce Nauman has
produced an oeuvre of stunning diversity, encompassing works of film, installation,
performance, photography, sculpture, and video. He is known for creating profoundly
aesthetic experiences that are often aimed at disrupting viewers' habits of perception.
In the mid-1960s, the artist adopted the medium of flashing neon in order to critically
examine the role of language in visual art. Inspired by its hypnotic aura and non-art
aesthetic, Nauman began using this quintessentially commercial medium in an ironic
way, as a vehicle for wordplay, puns, and jokes. The artist created this neon sign for
an invitational sculpture exhibition held in Chicago in 1985. Three pairs of words,
antithetical in their connotations, line the six-foot circumference: "life/death," "love/
hate," "pleasure/pain." In the center, the words "human," "animal," and "nature"
appear, repeated and stacked in sets of two. Each word blinks independently, ordered
so that over several minutes all possible permutations are displayed. The juxtapositions
of colors produce optical illusions that create a jarring, visceral effect for the viewer.
This work ultimately insists on language's inability to deliver a fixed or stable set
of meanings, conveying a deep suspicion about what constitutes truth, especially in
the public realm.

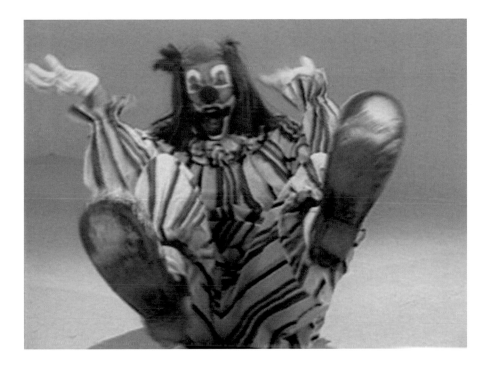

BRUCE NAUMAN American, born 1941

Clown Torture, 1987

Four-channel video (monitors, projection, and sound); 60-minute loop

Watson F. Blair Prize, Wilson L. Mead, and Twentieth-Century Purchase funds; through prior gift of Joseph Winterbotham; gift of Lannan Foundation, 1997.162

Bruce Nauman's wildly influential, relentlessly imitated work explores the poetics of confusion, anxiety, boredom, entrapment, and failure. One of the artist's most spectacular achievements to date, *Clown Torture* consists of two rectangular pedestals, each supporting two pairs of stacked color monitors; two large color-video projections on two facing walls; and sound from all six video displays. The monitors play four narrative sequences in perpetual loops, each chronicling an absurd misadventure of a clown (played to brilliant effect by the actor Walter Stevens). In "No, No, No, No (Walter)," the clown incessantly screams the word *no* while jumping, kicking, or lying down; in "Clown with Goldfish," the clown struggles to balance a fish bowl on the ceiling with the handle of a broom; in "Clown with Water Bucket," the clown repeatedly opens a door booby-trapped with a bucket of water that falls on his head; and finally, in "Pete and Repeat," the clown succumbs to the terror of a seemingly inescapable nursery rhyme. The simultaneous presentation and the relentless repetition creates an almost painful sensory overload. With both clown and viewer locked in an endless loop of failure and degradation, the humor soon turns to horror.

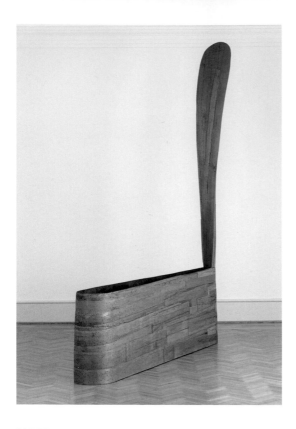

MARTIN PURYEAR American, born 1941
Lever #1, 1988–89

Red cedar, cypress, poplar, and ash; 429.3 x 340.4 x 45 cm (169 x 134 x 17 ³/₄ in.)

A. James Speyer Memorial, UNR Industries in honor of James W. Alsdorf, and Barbara Neff Smith and Solomon Byron Smith funds, 1989.385

Martin Puryear has produced an expertly handcrafted body of sculpture characterized by extreme elegance of form and organic simplicity. Influenced by his travels through Africa, Asia, Europe, and the United States, Puryear fuses modern traditions—his work pays homage to Constantin Brâncusi, Jean Arp, and Scandinavian furniture designers—with non-Western architecture, sculpture, and craft. Consisting of a tall, narrow, wood vessel and a dramatically arched top flap that seems poised to slam down upon it, *Lever #1* exemplifies the artist's ongoing exploration of the relationship between interior space, form, and volume. The sculpture suggests an array of possible associations, including a deep-hulled boat, a coffin, or sexual themes. It also reflects some of the most celebrated methods of avant-garde art, notably Constructivism and assemblage. While the sculpture alludes to recognizable forms and subjects, Puryear intended for it to remain independent of specific interpretations. The surface is alive with the remnants of glue, staples, and other marks of construction; these residual effects serve as a reminder that, above all else, the work is about the process of making sculpture.

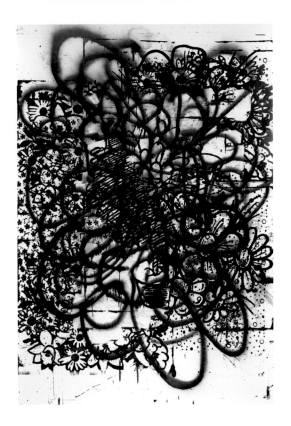

CHRISTOPHER WOOL American, born 1955
Maggie's Brain, 1995
Enamel on aluminum; 274.3 x 182.9 cm (108 x 72 in.)
Gift of Society for Contemporary Art, 1996.399

Equally concerned with process and picture-making, Christopher Wool's works explore points of intersection between signage and language, pattern and decoration—typically by altering found, mass-producible imagery through techniques of layering, overpainting, and variations in register. Since the late 1980s, Wool has produced black-and-white text paintings consisting of single words and pointed phrases in allover compositions of stenciled block letters. He has also executed paintings based on decorative motifs such as vines, flowers, and polka dots. In 1995 Wool began using a spray gun to apply black paint in a drawing-like manner onto both paper and aluminum surfaces. Later he employed the spray gun in conjunction with more conventional silkscreen and painting techniques. In *Maggie's Brain*, a silkscreened surface is overpainted with white, then silkscreened again and topped with an explosive, floral-like spray in the center. Here Wool's critical engagement with the history of painting has resulted in hybrid approaches that combine the emphasis on gesture and touch of Abstract Expressionism with the cool, mediated remove of Pop Art.

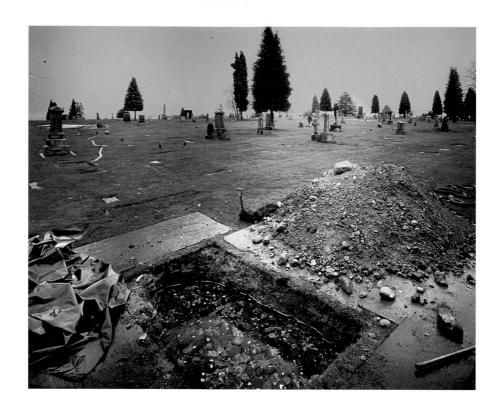

JEFF WALL Canadian, born 1946
The Flooded Grave, 1998–2000
Silver dye-bleach transparency, aluminum light box; 228.6 x 282 cm (89 ⁷/₈ x 111 in.)
Gift of Pamela J. and Michael N. Alper; Claire and Gordon Prussian Fund for Contemporary Art;
Harold L. Stuart Endowment; through prior acquisitions of the Mary and Leigh Block Collection,
2001.161

Jeff Wall uses state-of-the-art photographic and computer technology to create images
that evoke the composition, scale, and ambitions of the grandest history paintings.
His works frequently have the formal clarity of documentary photography or pho-
tojournalism, but he often relies on staged or constructed artifices. Unrivaled in its
technical complexity, this image is the result of two years of work, during which the
artist fused countless photographs of both documentary and fabricated scenes into
a single, surreal whole. After taking pictures in two Vancouver cemeteries over the
course of several months, Wall built an aquatic system in his studio, crafting the
tank from a plaster cast of an actual grave. With the aid of marine-life specialists,
the artist cultivated a living, underwater ecosystem identical to one found off the
coast of Vancouver. In the finished product, the two worlds are married through a
technical process that presents the illusion of a water-filled grave. *The Flooded
Grave* therefore challenges the notion of the photograph as the record of a single
moment in time; instead, it is an elaborate fantasy on the subconscious life of the
image it projects.

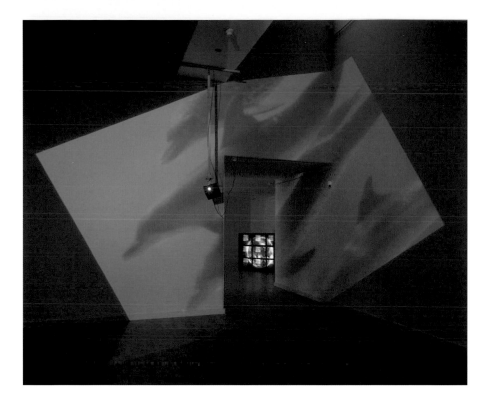

DIANA THATER American, born 1962
Delphine, 1999
Five-channel digital video (projection, sound) with nine-monitor wall cube; continuous loop
Howard and Donna Stone New Media Fund, 2005.93

Widely recognized as a pioneer of video art as installation, California-based artist
Diana Thater is best known for work featuring images of animals such as bees,
horses, and wolves. In *Delphine,* which takes as its primary subject wild dolphins
interacting with humans, the artist worked for the very first time with untrained
animals in their natural habitat. Complex spatial thinking is key to Thater's projects;
she understands installation art as a dialogue between sculpture and architecture.
Projected on a large scale—onto entire ceilings, walls, and floors—her work thoroughly
transforms the physical realities of the spaces it inhabits. This generic and spatial
fluidity blurs conventional boundaries between the work and the viewer. The artist
also insists on revealing how her images are made. Shot in both digital video and
film, *Delphine* was edited without regard for separating the different media. Clarity
and grain flow together as the immediacy and flatness of video gives way to the
depth of film. These self-conscious production methods are mirrored by Thater's
particular aesthetic of presentation: she always leaves her equipment in full view
inside the installation. This transparent approach, the artist insisted, "does not,
as some people might have us believe, preclude transcendence. This is ultimately my
point—that neither magic nor superficial beauty is required to approach the sublime."

FELIX GONZALEZ-TORRES American, born Cuba, 1957–1996
"Untitled," 1989

Paint on wall; dimensions variable

The Art Institute of Chicago: bequest of Carolyn Spiegel; Watson Blair Prize, Muriel Kallis Newman, Sara Szold, and Modern and Contemporary Discretionary funds; Samuel and Sarah Deson Fund, established by Marianne Deson-Herstein in their memory; Oscar Gerber Memorial endowments; and San Francisco Museum of Modern Art, Accessions Committee Fund Purchase: gift of Jean and James E. Douglas, Jr., Carla Emil and Rich Silverstein, Collectors Forum, Doris and Don Fisher, Niko and Steve Mayer, Elaine McKeon, and Danielle and Brooks Walker, Jr., 2002.80

Felix Gonzalez-Torres's work is consistently characterized by a sense of quiet elegy. One of the defining moments in his widely influential career, *"Untitled"* is a self-portrait in the form of painted words and dates. First realized in 1989, the work expanded with subsequent installations until the artist's premature death in 1996. The portrait joins historical events and enigmatic personal milestones into a running text placed close to the ceiling. Such an installation is reminiscent of traditional friezes carved on the faces of public architecture, including the facade of the Art Institute's 1893 Allerton Building, which includes artists' names chiseled into a horizontal band. By offering a personal history in a commemorative form normally dedicated to institutional use, Gonzalez-Torres undercuts the public and official in favor of the private and subjective, reminding us that an individual's identity is not always reducible to an image captured on canvas or etched in marble. *"Untitled"* changes each time it is installed and may be presented in an infinite variety of ways. Its owner is obliged to add (or subtract) events to ensure that it remains relevant and dynamic, thereby granting the work, and the artist himself, a form of perpetually renewable life.

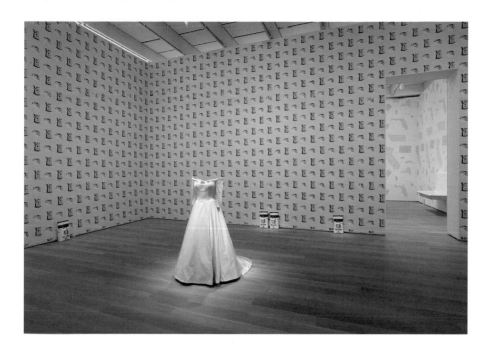

ROBERT GOBER American, born 1954
Untitled, 1989–96

Installation, including *Wedding Gown* (1989; silk satin, muslin, linen, tulle, and welded steel),
Hanging Man / Sleeping Man (1989; hand-printed silkscreen on paper), and *Untitled* (1996; cast
hydrostone plaster, vinyl acrylic paint, ink, and graphite); approx. 800 square feet installed
Restricted gift of Stefan T. Edlis and H. Gael Neeson Foundation; through prior gifts of Mr. and
Mrs. Joel Starrels, and Fowler McCormick, 2008.174

Robert Gober's insistently handmade, deceptively modest sculptures are re-creations
of familiar things—body parts and everyday objects such as children's furniture,
sinks, and urinals. As imitations of the originals, Gober's works have an uncanny
effect, triggering disquieting thoughts about the most commonplace aspects of
daily life. At the Paula Cooper Gallery in New York in 1989, Gober constructed two,
three-sided rooms defined by temporary sheetrock walls. The room seen here was
outfitted with wallpaper depicting alternating images of a sleeping white man and
a lynched black man hanging from a tree. At the literal center of the installation,
the figure of a bride is strongly conjured by a wedding dress supported by a welded
steel armature. The delicate dress stands rigid and empty, waiting to be filled. Gober
himself has speculated that the relationship between the bride and the sleeping man
in the wallpaper is that of husband and wife. Eight hand-painted plaster bags of
cat litter line the walls of the room. A material that absorbs or hides waste, the litter
serves as a symbolic remedy for the figurative mess of the bride, groom, and mur-
dered black man. More to the point, however, it speaks to the lasting obligations
and intimacy of committed love. On the whole, the room—and the veiled story of
the imaginary couple it contains—can be considered a meditation on gender, race,
romance, and terrible violence in contemporary American life.

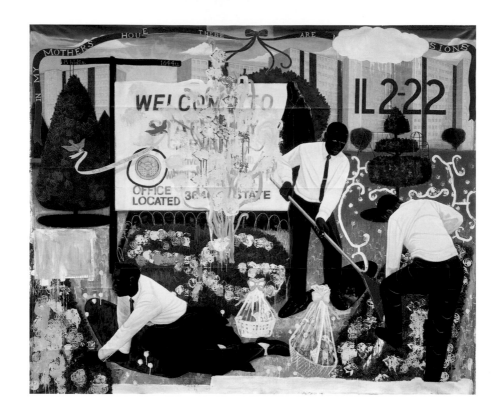

KERRY JAMES MARSHALL American, born 1955
Many Mansions, 1994
Acrylic on paper, mounted on canvas; 289.6 x 342.9 cm (114 x 135 in.)
Max V. Kohnstamm Fund, 1995.147

Inspired by the names of urban housing projects, Kerry James Marshall explored the triumphs and failures of these much-maligned developments in a series entitled *Garden Project*. With these works, the Chicago-based-artist—who once lived in public housing in Birmingham, Alabama, and in Los Angeles—hoped to expose and challenge stereotypes. "These pictures," Marshall remarked, "are meant to represent what is complicated about life in the projects. We think of projects as places of utter despair . . . but [there] is also a great deal of hopefulness, joy, pleasure, and fun." Set in Stateway Gardens, an immense Chicago development that has since been demolished, *Many Mansions* depicts three men tending a surprisingly elaborate garden. Negating misperceptions of the black male, the dark-skinned trio—attired in white dress shirts and ties—enterprisingly beautify their harsh surroundings. Two blue-birds on the left support a banner proclaiming "Bless Our Happy Home," while the sun seems ready to dispel an ominous cloud. The red ribbon in the background bears the message "In My Mother's House There Are Many Mansions"; this feminist gloss on a famous biblical phrase (John 14:2) expresses an inclusive understanding of the idea of home.

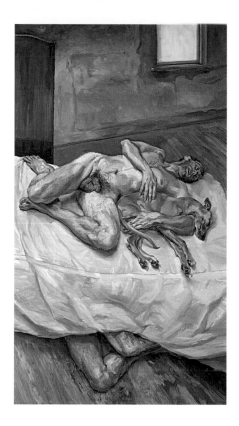

LUCIAN FREUD English, born Germany, 1922–2011
Sunny Morning—Eight Legs, 1997
Oil on canvas; 234 x 132.1 cm (92 1/8 x 52 in.)
Joseph Winterbotham Collection, 1997.561

Lucian Freud has subjected the human face and figure to uncompromising scrutiny
for over fifty years. The monumental *Sunny Morning—Eight Legs* confronts us
with three models arranged on top of and under a sheet-draped bed in the artist's
London studio. With his head thrown back, his upper torso twisted, and his bent
legs stretched awkwardly, the male nude is a study in tension and discomfort, in contrast
to the easy tenderness with which he holds a sleeping dog. The legs that emerge from
beneath the bed are the reverse of those of the reclining man; the inclusion of the
lower pair, without a body, imparts a tone of perversion or even violence. Employing
a mostly neutral palette, Freud used thick strokes of paint to create his forms, molding
his subject's flesh similar to the way a sculptor works with clay. The model's exposed
genitals and almost pleading expression; the downward angle of the floor, accentu-
ated by the second pair of legs; the heavy, falling linen; and the dog's delicate frame
as it nestles against the man combine to present a disturbing image of vulnerability.

VIJA CELMINS American, born Latvia 1938
Night Sky #2, 1991
Alkyd on canvas, mounted on aluminum; 45.7 x 54.6 cm (18 x 21 ½ in.)
Ada S. Garrett Fund, 1995.240

In the mid-1960s, Vija Celmins began using photographs from books, magazines, and newspapers that she found in secondhand stores and at yard sales as the point of departure for her paintings. While she produced work in the wake of Pop Art, her interest in the quotidian had nothing to do with issues of commerce or the media but rather with the illusionistic process of image making itself. Since the early 1970s, the artist has created exacting depictions of such expansive subjects as desert floors, ocean waves, the moon's surface, and star-studded night skies—the latter derived from satellite photographs. To create her smooth, velvety compositions, Celmins often applies multiple layers of pigment to her canvases, sanding each down before she adds the next. Each work is further modulated through the use of a wide range of black, white, and silvery gray tones. With its jewel-like imagery and suggestion of vastness, *Night Sky #2* is at once romantic and unsettling. Lacking the anchor of a horizon, a humanly scaled reference point, or a recognizable landmark, viewers may have difficulty determining their relationship to the image. The enormity of the subject presented on a relatively small scale (the work is less than two feet wide) furthers this sense of disorientation.

SOL LEWITT American, 1928–2007
Wall Drawing #821: A black square divided horizontally and vertically into four equal parts, each with a different direction of alternating flat and glossy bands, 1997
Acrylic paint; approx. 3.45 x 3.45 m (12 x 12 ft.)
Through prior gifts of Judith Neisser and Mary and Leigh Block; Norman Waite Harris Purchase Fund, 2006.168

Over nearly four decades, Sol LeWitt's work—equal parts conceptual and visual—introduced new ways of making and thinking about art. The artist posited his influential ideas most clearly in over 1,200 wall drawings, which he conceived between 1968 and his death in 2007. LeWitt shared the creation of his work with other makers—trained draftsman and, in most cases, assistants hired from local art schools or institutions—extending the collaborative possibilities of his artwork indefinitely. Through the 1980s, the artist used only traditional drawing media such as crayon, ink, and pencil. In the following decade, however, acrylic paint became his dominant medium. *Wall Drawing #821* depicts a signature motif with monumental solemnity. The work comprises a grid of horizontal, vertical, and opposing diagonal lines, which were LeWitt's most fundamental geometric and linear building blocks. The artist usually rendered this motif graphically; in this work, however, the figure-ground relationship is articulated solely through the juxtaposition of subtly differentiated matte and gloss paints.

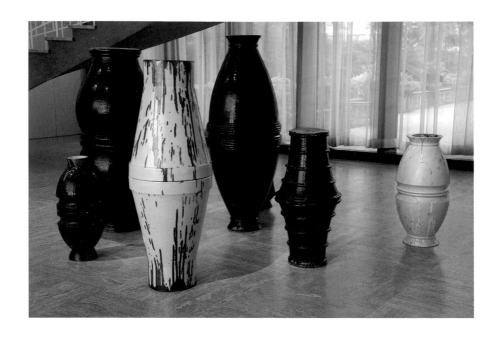

THOMAS SCHÜTTE German, born 1954
Urns (set of 8), 1999
Terracotta and porcelain; approx. 177.8 x 188 cm (70 x 74 in.) installed
Gift of Michael N. Alper in memory of Pamela J. Alper, 2004.247.1–8

Avoiding any signature style, Thomas Schütte has produced an oeuvre of perplexing diversity, including architectural models, photographs, sculpture, and watercolor drawings. His decidedly unimposing, antiheroic works explore the cultural, economic, historical, and social conditions of his native Germany with a detached, often humorous, sensibility. Much of Schütte's work addresses the almost existential difficulty postwar German artists encounter in attempting to create monuments and memorials. As such, it evidences an ongoing preoccupation with themes of death, mourning, and collective memory. This is true of *Urns*, an installation comprising eight ceramic vessels glazed in a palette of solid colors marked by streaks, drips, and other surface effects. Ranging from three to five feet in height, these fragile containers at once imply living bodies and oversize repositories for their ashes. The vessels are intended to be grouped together, like a family. Displayed closed, these mysterious containers prompt speculation about what might be contained inside. One of the urns, however, lacks a top and bottom; viewing the installation from above reveals that it is empty.

KATHARINA FRITSCH German, born 1956
Monk, 1997–99
Polyester and paint; 193 x 58.4 x 43.1 cm (76 x 23 x 17 in.)
Anstiss and Ronald Krueck Fund for Contemporary Art, 2000.49

Born in 1956 in the heart of Germany's industrial Ruhr district, Katharina Fritsch roots
her work in personal memories and folklore. Her iconic sculptures—meticulously
crafted transformations of recognizable objects—also engage broader aspects of German
history, drawing on both high art and mass culture. Through experimentation with
scale, surface, and color, Fritsch provides new forms for old symbols, creating a strange
tension between the familiar and the uncanny. *Monk* is a life-size representation of a
man in a monk's habit, whose stiff posture and closed eyes signal that he is engaged
in a moment of intense contemplation. With a uniform matte black surface, the loom-
ing figure seemingly absorbs light like a black hole in space. By painting the sculpture
black, a color associated with evil, Fritsch asks the viewer to reconsider the spiritual
purity and goodness associated with the religious figure. The work draws on the
artist's fascination with Christian rituals and the medieval towns, such as Nuremberg
and Bamberg, that she visited during her youth. It also recalls an important art-
historical antecedent, Caspar David Friedrich's *Monk by the Sea* (1809–10; National-
galerie, Berlin). This exemplar of German Romantic painting depicts the monk as
an embodiment of the sublime, standing on the shore, gazing at the unknowable void
before him.

STEVE MCQUEEN English, born 1969
Caribs' Leap/Western Deep, 2002
Color film transferred to three-channel digital video (projection, sound); *Caribs' Leap*: 8 mm and
35 mm film transferred to digital video, 28:53-minute loop and 12:06-minute loop; *Western Deep*:
Super 8 mm film transferred to digital video, 24:12-minute loop
Marilynn Alsdorf Discretionary, Annabelle Decker, Wilson L. Mead, and Modern and Contemporary
Discretionary funds; Robert and Marlene Baumgarten Endowment, 2003.86

English artist Steve McQueen's projected video and film installations are rich in
cinematic tradition and compelling in content. His earliest works—black-and-white
silent films—are indebted to 1960s structural filmmaking, wherein the mechanics of
shooting and projection become essential components of the film's subject. His more
recent work explores the relation between the medium and the spectator. At once
confrontational and seductive, these colossally scaled works transform a purely visual
experience into a visceral event. Presented as a single installation, *Caribs' Leap* and
Western Deep are linked by the theme of descent. The dual-screen projection *Caribs'
Leap* juxtaposes luminous scenes of the beachfront on the island of Grenada—
the birthplace of McQueen's parents—with irregular images of tiny figures falling
through a vast sky. The latter pay homage to the island's indigenous Caribs, who
in 1651 leapt to their death rather than surrender to the invading French. In *Western
Deep*, the viewer takes a nightmarish journey into the hot, noisy depths of a South
African goldmine. Presented and considered together, these two films suggestively
liken modern mining conditions to a historical act of genocide.

PETER DOIG Scottish, born 1959
Gasthof zur Muldentalsperre, 2000–02
Oil on canvas; 196 x 296 cm (77 1/8 x 116 1/2 in.)
Collection Nancy Lauter McDougal and Alfred L. McDougal, partial and promised gift to the Art
Institute of Chicago, 2003.433

Peter Doig creates dreamlike, psychologically charged landscapes that display a peculiar
blend of abstraction and representation. Combining a hallucinatory palette with
expressionist brushwork, his paintings have a mysterious, often melancholic air. Doig
works exclusively from found images, drawing inspiration from film stills, newspaper
clippings, personal photo albums, record album covers, and the work of earlier artists
such as Edvard Munch (see p. 304) and Ernst Ludwig Kirchner (see p. 308). The image
of the two men in *Gasthof zur Muldentalsperre* derives from a photograph taken when
the artist was working as a dresser at the London Coliseum. One night, after a production
of Igor Stravinsky's burlesque ballet *Petrouchka* (1911), Doig and a friend donned
costumes from the performance and comically posed for a snapshot. The artist initially
used the photo as the basis for a figure study; he then superimposed the two figures
on a landscape he borrowed from an antique postcard, which depicts the vista from
an old German tavern, Gasthof zur Muldentalsperre. In Doig's version, the view has
undergone strange chromatic shifts, resulting in a fantastical, nocturnal scene that
resembles a theatrical backdrop. The men at the gate are an otherworldly presence;
the winding path behind them seems to lead to another realm beyond the edge of
the painting.

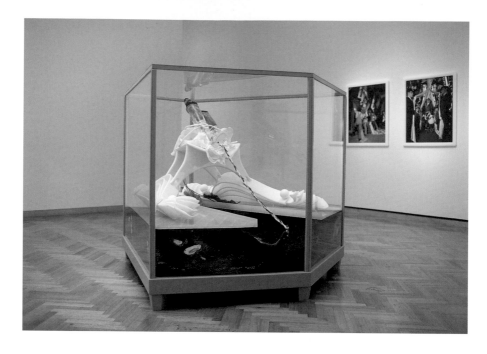

MATTHEW BARNEY American, born 1967
Oonagh MacCumhaill: The Case of the Entered Novitiate, 2002
Internally lubricated plastic, cast urethane, cast thermoplastic, prosthetic plastic, stainless steel,
acrylic, earth, and potatoes in polyethylene and acrylic vitrine; 152 x 185 x 201 cm (60 x 73 x 79 in.)
Claire and Gordon Prussian Fund for Contemporary Art, Charles H. and Mary F. S. Worcester, Mr. and
Mrs. Frank G. Logan Purchase Prize, and Alonzo C. Mather Prize funds; restricted gift of Barbara
Bluhm-Kaul and Don Kaul; through prior acquisitions of Mary and Leigh Block, 2003.180

Matthew Barney has gained international acclaim for his ambitious *Cremaster*
Cycle—a series of five visually extravagant, feature-length films that are an eccentric
mixture of autobiographical allusions, historical references, and private symbolism.
Named for the muscle that raises and lowers the human male's sexual glands, the
Cremaster series is rife with spectacular imagery of ascent and descent, birth and
death, creation and destruction. Barney purposely produced the films out of sequence
to discourage a linear analysis; *Cremaster 3*, which presents a mythical story of the
construction of the Chrysler Building, is the last and most elaborate installment in the
series. Replete with symbolism from Freemasonry and Celtic lore, the film depicts a
struggle between the Entered Apprentice, played by Barney, and the Architect, played
by the artist Richard Serra. This sculptural installation relates to two characters in
the film—Oonagh MacCumhaill, the wife of a giant, and the Entered Novitiate, the
feminine alter ego of the Entered Apprentice—both played by Paralympic athlete
and double amputee Aimee Mullins. The objects in the vitrine include the brass toe
of Oonagh's shoe, as well as the glass legs, white clothing, noose, and white sleigh
of the Novitiate. This vitrine makes explicit the affiliation between the two characters,
who in the film are more subtly linked. For Barney, the sculpture is not subsidiary
to the film; it is another vehicle for expressing his particular aesthetic.

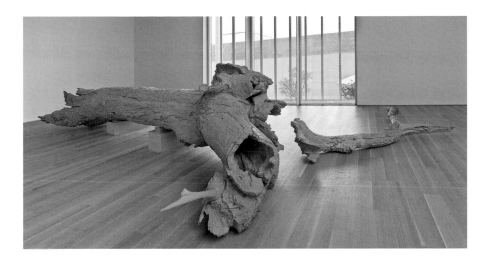

CHARLES RAY American, born 1953
Hinoki, 2007

Hinoki cypress; three elements: 172.7 x 762 x 233.7 cm (68 x 300 x 92 in.); 63.5 x 426.7 x 208.3 cm
(25 x 168 x 82 in.); and approx. 60.5 x 400 x 200 cm (25 x 150 x 78 in.)

Through prior gifts of Mary and Leigh Block, Mr. and Mrs. Joel Starrels, Mrs. Gilbert W. Chapman,
and Mr. and Mrs. Roy J. Friedman; restricted gift of Donna and Howard Stone, 2007.771

The work of Chicago-born sculptor Charles Ray is based on a complex interplay
between realism and artifice. Possessed by the idea to make a sculpture of a felled tree,
Ray spent several years searching for a model. In 1998, while walking in the woods
of central California, he encountered the source for *Hinoki,* a coastal oak that had
fallen decades earlier. The artist was drawn to the complexity of the tree's surfaces;
over time, gravity, weather, bugs, and the sun's rays had done considerable damage,
and it was partially sunken into the ground. Aided by several assistants, Ray trans-
ported the tree—hacked apart by a chainsaw—back to his Los Angeles studio. Silicone
molds were taken and a fiberglass version of the log was reconstructed. The fiber-
glass version was then cut into five sections and sent to Osaka, Japan, where master
woodcarvers, working by eye from the model, painstakingly rendered an actual-size
replica out of Japanese cypress (*hinoki*). The use of this pristine, sturdy wood to
create a sculpture of an already partially collapsed and rotted oak tree is pointed:
Ray both re-created and extended the tree's life cycle. Inevitably, *Hinoki* will change
over time; its patina will darken, it will begin to rot, and, in hundreds of years, it
will eventually decay, albeit more slowly than the original form.

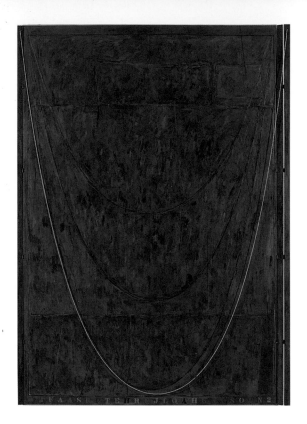

JASPER JOHNS American, born 1930
Near the Lagoon, 2002–03
Encaustic on canvas and wooden boards with objects; 300 x 198.1–214.6 (variable) x 10 cm
(118 x 78–84 ½ [variable] x 3 ¹⁵/₁₆ in.)
Through prior gift of Muriel Kallis Newman in memory of Albert Hardy Newman, 2004.146

In his artistic practice, Jasper Johns repeatedly revisits certain images, motifs, and themes, as he did in his *Catenary* series (1997–2003). The term *catenary* describes the curve assumed by a cord suspended freely from two fixed points. The artist has often affixed objects to the surfaces of his paintings in an ongoing search for non-illusionistic ways of mediating between the flat plane of the picture and a fully dimensional world. Johns formed his catenaries by tacking ordinary household string to the canvas or its supports. The string activates and engages the abstract, collaged field of multitonal gray behind it in several ways, both literally and figuratively. It casts an actual shadow on the canvas, in addition to painted ones that Johns rendered by hand; it also appears as a rut, where the artist embedded it in and later pulled it out of the encaustic. The catenaries are also Johns's playful attempt to show a work's front, side, and back from a single vantage point, as the cord strongly suggests a picture's hanging device. Epic and elegant, *Near the Lagoon* is the largest and last work to be completed in the *Catenary* series.

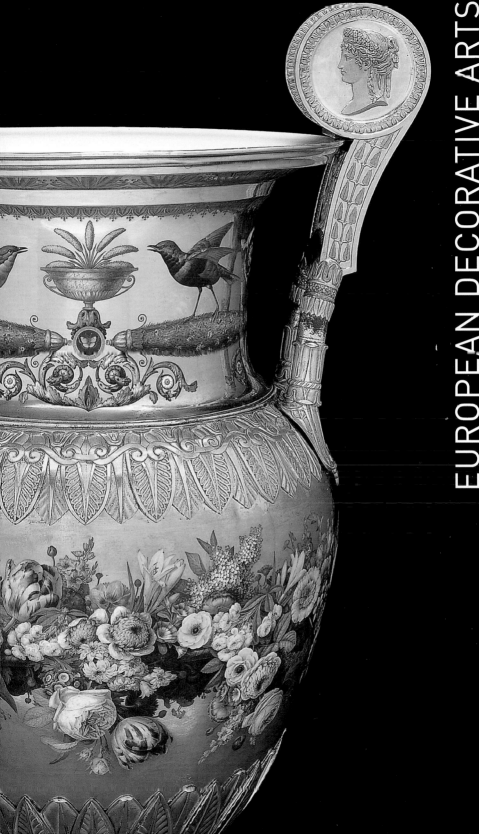

EUROPEAN DECORATIVE ARTS

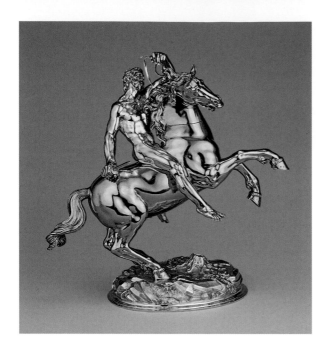

REARING HORSE AND RIDER

1630
Germany, Ulm
Hans Ludwig Kienle (German, 1591–1653)

Silver and silver gilt; h. 31.5 cm (12 ³/₈ in.)

Restricted gift of Mr. and Mrs. Stanford D. Marks, Mrs. Eric Oldberg, and Mrs. Edgar J. Uihlein; Albert
D. Lasker, Howard V. Shaw Memorial, and European Decorative Arts funds; James W. and Marilynn
Alsdorf, Pauline S. Armstrong, Harry and Maribel G. Blum, Michael A. Bradshaw and Kenneth
S. Harris, Tillie C. Cohn, Richard T. Crane, Jr., Memorial, Eloise W. Martin, Henry Horner Strauss,
Mr. and Mrs. Joseph Varley, and European Decorative Arts endowments; through prior acquisitions
of Kate S. Buckingham and the George F. Harding Collection in honor of Eloise W. Martin, 2003.114

This extraordinary sculptural group, which consists of a male nude astride a rearing
horse, is a rare example of the work of Hans Ludwig Kienle, a German silversmith
who specialized in depicting animals. Conceived as a drinking cup, this work was
destined for display on a buffet or sideboard. Kienle's work belongs to a larger body
of German Renaissance and Baroque sideboard silver that includes cups in the form of
fully three-dimensional horses, lions, stags, and other animals. Horse-and-rider figure
groups have their roots even earlier, in Greek and Roman sculpture. Renaissance
princes often had themselves depicted in monumental form, wearing Classical dress or
contemporary armor, and sitting atop prancing or rearing steeds. That Kienle based
this silver cup on an earlier sculptural model is suggested by the existence of a bronze
group of virtually identical subject, composition, and scale, made in northern Italy
during the second half of the sixteenth century. What makes Kienle's treatment of
this subject so exceptional, however, is his skill at rendering it in precious metals.
Working to suggest the differences between human and equine musculature, Kienle
contrasted silver and gilt-silver surfaces, thus animating the already dynamic subject.

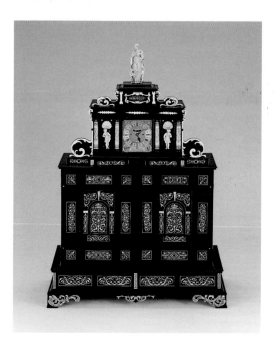

CABINET

c. 1630
Germany, Augsburg
Made by Philip Hainhofer (German, 1578–1647)
Ebony, carved and inlaid ivory, stained and carved wood relief, gilt bronze, and iron implements;
160 x 110.5 x 64.8 cm (63 x 43 ½ x 25 ½ in.)
Anonymous Purchase Fund, 1970.404

Cabinets made in the southern German town of Augsburg during the sixteenth and seventeenth centuries are famous for their showy decoration, which was typically executed in ebony veneer and ivory inlay. This exceptional example also includes lavish carved figures, bronze mounts, and narrative panels made from ivory and stained wood relief. The exquisite craftsmanship of this decoration is matched in inventiveness by the cabinet's interior structure, which is part display case, part tool chest, and part safe-deposit box. Hidden compartments to the right of a built-in clock (a 1715 replacement of an earlier timepiece) contain a set of five medicine canisters and at least twenty-two other utensils, including hammers, scissors, and a mortar and pestle. These and the other compartments in the cabinet would often have housed jewelry, gems, and important papers as well. Thematically, the cabinet's decoration ranges from pure patterns to hunting themes (especially related to the sport of falconry, which may have been a favorite pastime of the cabinet's owner) and from specific mythological tales to the allegorical figure of the Christian virtue Charity, who crowns the whole piece.

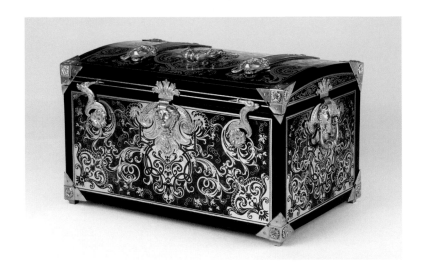

COFFER

1700/20
France, Paris
Attributed to André-Charles Boulle (French, 1642–1732)
Oak, tortoiseshell, brass, pewter, ebony, and gilt-bronze mounts;
44.5 x 73 x 48.3 cm (17 ½ x 28 ¾ x 19 in.)
Michael A. Bradshaw and Kenneth S. Harris, Eloise W. Martin, Richard T. Crane, Jr., Memorial,
and European Decorative Arts Purchase funds; through prior acquisitions of Mrs. C. H. Boissevain
in memory of Henry C. Dangler, Kate S. Buckingham Endowment, David Dangler, Harold T. Martin,
and Katherine Field-Rodman, 2001.54

The cabinetmaker André-Charles Boulle was responsible for some of the finest examples of French furniture made during the reign of Louis XIV (1643–1715). Boulle perfected the technique of veneering furniture with a rich marquetry of tortoiseshell, pewter, and gilt copper and further enriched his surfaces with sculptural gilt-bronze mounts. Acclaimed for his brilliant designs and superb execution, Boulle was commissioned by the most discerning and demanding patrons in France, among them members of the royal family, aristocrats, ministers, and financiers.

This rectangular casket is a visually powerful example of Boulle's work from the early eighteenth century. Such caskets served as containers for medals or jewels. This one is richly veneered with marquetry panels of scrolls, strapwork, and vines executed in engraved gilt copper on a ground of tortoiseshell. Framing the panels are strips of ebony and pewter. The casket also features gilt-bronze mounts in the form of male, female, and animal heads. The escutcheon in the center of the front panel may depict the head of Apollo, his long hair braided on either side of his face and gathered in a knot below his chin. The lid of the casket contains a grinning and bearded male face, perhaps that of a satyr, crowned with a radiating headdress, the whole of which supports a handle.

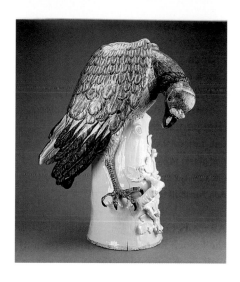

KING VULTURE
1734
Germany, Meissen
Meissen Porcelain Manufactory
(founded 1710)
Modeled by Johann Joachim Kändler
(German, 1706–1775)

Hard-paste porcelain and polychrome enamels; 58 x 43 cm (22 ⅞ x 16 ⅞ in.)

Gift of Harry A. Root, Doris and Stanford Marks, Fred and Kay Krehbiel, Maureen and Edward Byron Smith, Jr., Elizabeth Souder Louis, Ira and Barbara Eichner Charitable Foundation, Lori Gray Faversham, and the Women's Board of the Alliance Française; Lacy Armour Fund; Antiquarian Society; Kate S. Buckingham, Charles H. and Mary F. S. Worcester Collection, and Frederick W. Renshaw Acquisition funds; Robert Allerton Trust; Mary and Leigh Block Endowment and Northeast Auction Sales Proceeds funds; Kay and Frederick Krehbiel Endowment; Centennial Major Acquisitions Income, Ada Turnbull Hertle, Wirt D. Walker, Gladys N. Anderson, Robert Allerton Purchase Income, and Pauline Seipp Armstrong funds; Edward E. Ayer Fund in Memory of Charles L. Hutchinson; Marian and Samuel Klasstorner Fund; Helen A. Regenstein Endowment; Director's Fund; Maurice D. Galleher Endowment; Laura T. Magnuson Acquisition Fund; Samuel A. Marx Purchase Fund for Major Acquisitions; Edward Johnson Fund; Harry and Maribel G. Blum Endowment; Bessie Bennett Fund; Hugh Leander and Mary Trumbull Adams Memorial Endowment; Wentworth Greene Field Memorial and Elizabeth R. Vaughn funds; Capital Campaign General Acquisitions Endowment; European Decorative Arts Purchase, Samuel P. Avery, Mrs. Wendell Fentress Ott, Irving and June Seaman Endowment, Grant J. Pick Purchase, Betty Bell Spooner, and Charles U. Harris Endowed Acquisition funds, 2007.105

As Elector of Saxony and King of Poland, Augustus II (r. 1694/97–1733) presided over the ambitious transformation of his capital, Dresden, through advances in architecture, the arts, science, and technology. Produced beginning in 1710 thanks to the monarch's sponsorship and funding, Meissen porcelain was the most exclusive luxury good of its time. Around 1728 Augustus conceived of replicating the animal and bird kingdoms in porcelain for display in a Baroque palace that he was transforming into a showcase for his collections of Asian and Meissen ceramics. This porcelain zoo was intended for the long gallery on the principal floor of the palace. By 1733, the year the king died, more than thirty different models of birds and almost forty animals had been made, many by the sculptor Johann Joachim Kändler, who worked at Meissen from 1731 to 1775. Kändler drew this vulture from life, which allowed him to animate his work with the creature's quintessential spirit. Such porcelain animals remain the most vivid expression of Augustus's wish, as elector and king, to possess and rule over the natural world.

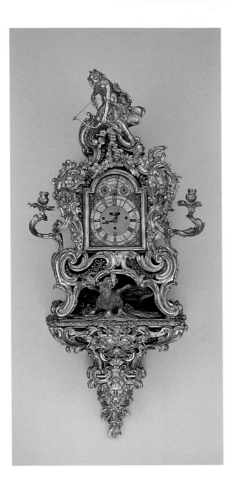

WALL CLOCK
1735/40
France
Clock case probably made by Jean-Pierre Latz (French, c. 1691–1754)
Clockwork made by Francis Bayley (Belgian, active 18th century)
Oak, tortoiseshell, kingwood, brass, gilt bronze, and glass; 147.3 x 64.8 x 53.3 cm
(58 x 25 ½ x 21 in.)
Ada Turnbull Hertle Fund, 1975.172

An exuberant and lavish example of the French Rococo style, this sculptural wall clock epitomizes the extravagant era of Louis XV (r. 1715–74). Costly and complicated, festooned with ormolu (gilt bronze) swirls and floral swags, the clock required the collaboration of numerous specialized artisans. Its case, candelabra, and wall bracket were created by the eminent Jean-Pierre Latz, who, in 1741, was appointed *ébéniste* (furniture maker) to the king. The clock's eight-day movement was manufactured in the Flemish city of Ghent by Francis Bayley, possibly a member of the large London dynasty of clockmakers of that name. Opulent clocks such as this did more than tell time; they delighted the ear with music (six melody titles are engraved in the dial's arch) and dazzled the eye with dramatic scenes. Here the Greek god Apollo is poised to slay the serpent Python. The space between the clock and the wall bracket was cleverly used to suggest the beast's home, the cave of Mount Parnassus in Greece. In the triangular base are the faces of Zeus, symbolizing time, and Hera, presiding over marriage and childbirth. They are surmounted by two small coats of arms belonging to the Flemish bride and groom whose union the clock was probably created to celebrate.

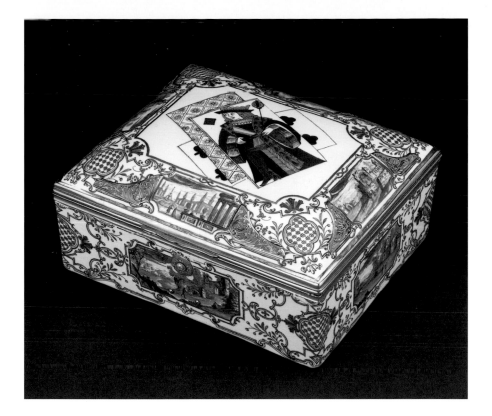

GAMING SET

1735/40

Austria, Vienna

Du Paquier Porcelain Manufactory (1718–44)

Hard-paste porcelain, polychrome enamels, and gilding; gold and diamond mounts;

16.8 x 14.8 cm (6 ⅝ x 5 ¹³/₁₆ in.)

Eloise W. Martin Fund; Richard T. Crane and Mrs. J. Ward Thorne endowments; through prior gift of the Antiquarian Society, 1993.349

This sumptuously decorated gaming box ranks among the most exceptional works of art produced by the Du Paquier Porcelain Manufactory during its short twenty-five-year existence. Mounted with gold plaques and painted with colored enamels and gilding, the box opens to reveal four small, similarly decorated porcelain containers. These smaller boxes are mounted with gold and set with diamonds; each, when opened, reveals two types of porcelain gambling chips. The boxes were painted according to a complex, tightly organized decorative scheme. The lid of the large box depicts three trompe l'oeil playing cards that appear to have been carelessly thrown down. Each of the corners of the box and lid is painted with a network of violet and gold ornaments characteristic of the factory's mature, late-Baroque style. There is a centuries-old tradition of exchanging diplomatic gifts between nations and ruling families, and the gaming box may have been conceived within this context. With its liberal use of gold and diamonds, this work was certainly among the most extravagant objects crafted at the Du Paquier manufactory. It has been suggested that the box may have been a gift from the Austrian Habsburgs to their Russian counterparts.

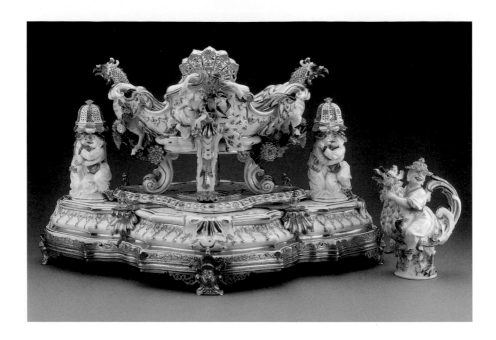

CENTERPIECE AND STAND WITH A PAIR OF SUGAR CASTERS AND AN OIL OR VINEGAR CRUET

c. 1737

Germany, Meissen

Meissen Porcelain Manufactory (founded 1710)

Modeled by Johann Joachim Kändler (German, 1706–1775)

Hard-paste porcelain, polychrome enameling, gilding, and ormolu mounts; bowl: 28 x 44.4 x 25.4 cm (11 x 17 ½ x 10 in.); stand: 15.2 x 66 x 50.8 cm (6 x 26 x 20 in.)

Tureen and stand: Atlan Ceramic Club, Buckingham Luster, and Decorative Arts Purchase funds, 1958.405a–f

Sugar casters: Louise D. Smith, Edward Byron Smith Charitable, Robert Allerton, Mrs. Edward I. Rothschild, and R. T. Crane, Jr., funds, 1984.1228a–b

Cruet: Gift of Mr. and Mrs. Samuel Grober in honor of Ian Wardropper and Ghenete Zelleke through the Antiquarian Society, 1998.504a–b

Typifying the resplendence of the Saxon court at Dresden during the eighteenth century, this porcelain centerpiece would have been part of an elaborate dinner service that graced ceremonial court banquet tables. Remarkable for its large size and luxurious decoration, the service was designed for Count Heinrich von Brühl, who was both administrator of the Royal Saxon Porcelain Manufactory at Meissen and prime minister to Augustus III (r. 1733–63), Elector of Saxony and King of Poland. The centerpiece consists of a large, flat plateau made in sections that are fitted together to support a tall, four-legged, open basket decorated with fanciful roosters and Chinese figures. At either end of the plateau are sugar casters in the form of Chinese figures embracing under a canopy. Established in 1710, the Meissen factory dominated porcelain production in Europe until the mideighteenth century and continues to operate to this day.

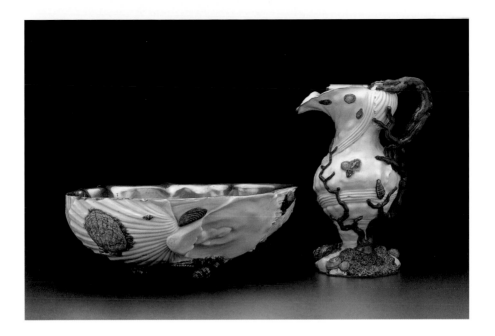

EWER AND BASIN

c. 1745
Italy, Capodimonte
Capodimonte Porcelain Factory (founded 1743)
Probably modeled by Giuseppe Gricci (Italian, active 1743–59)

Soft-paste porcelain with enameling and gilding; ewer: h. 30.5 cm (12 in.); basin: 16.5 x 38.7 x 34.3 cm (6 ½ x 15 ¼ x 13 ½ in.)

Gift of Mr. and Mrs. Robert Norman Chatain in memory of Professor Alfred Chatain, 1957.490a–b

Made during the earliest years of the royal porcelain factory in Capodimonte, this rare set is one of the great masterpieces of European porcelain. With its malleability and whiteness, porcelain was especially suited to the Rococo emphasis on invention, asymmetry, natural motifs, and a palette that was lucid and light. These soft-paste porcelain surfaces, probably designed by Capodimonte's master modeler, Giuseppe Gricci, conjure up the textures and luminescence of sea-washed shells and natural mother-of-pearl. The allusion to the marine world—so appropriate to these water-bearing vessels—is furthered by the use of shell-like forms for both the shape and decoration of the ewer and basin. The surfaces of the vessels are also encrusted with marine elements, and a trompe l'oeil coral branch cleverly serves as the ewer's handle. Swirling lines and irregular surfaces contribute to the ewer's sense of lightness and complete the allusion to the sea.

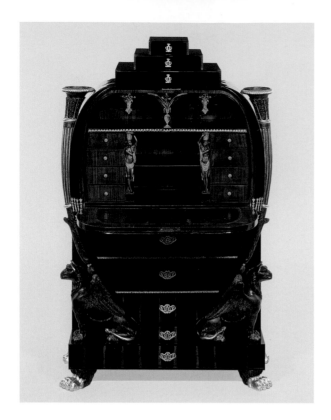

FALL-FRONT DESK

c. 1810

Austria, Vienna

Various woods and gilt-bronze mounts; 141 x 91.4 x 39.4 cm (55 ½ x 36 x 15 ½ in.)

Gift of the Centennial Fund; Mrs. Burton W. Hales, Mrs. William O. Hunt, Jessie Spaulding Landon, Mrs. Harold T. Martin, Adelaide Ryerson, Mrs. E. Hall Taylor, Mrs. Chester D. Tripp, and Mrs. Philip K. Wrigley funds, 1976.39

The inventive lyre shape of this secretary, surmounted by three stepped drawers and supported by griffins, identifies it as an elaborate, complex case form made in Vienna during the Napoleonic era. The upper half of the front falls forward to serve as a writing surface, revealing interior compartments, drawers, and shelves. The bold, severe forms of the Empire style in France brought a new rigor to the Neoclassical pursuit of the authority of ancient Greek and Roman art. Though craftsmen throughout Europe studied handbooks detailing such new designs, this secretary indicates that the models were by no means slavishly imitated. Rather, this example was made with materials and techniques typical of Viennese workshops, and its form has no direct source in antiquity. But its lyre shape and abundant decorative details—griffins, cornucopias, paw feet, and interior caryatid figures—are familiar Classical motifs. The variety of woods, selected to create contrasts between light areas and dark borders, matches the pastiche of decorative motifs. Vienna was a major European design center in the early nineteenth century, and this desk type enjoyed wide popularity. Production continued throughout the ensuing Biedermeier era, into the 1840s.

LONDONDERRY VASE

1813
France, Sèvres; Sèvres Porcelain Manufactory (founded 1740)
Designed by Charles Percier (French, 1764–1838); decoration designed by
Alexandre-Théodore Brongniart (French, 1739–1813)
Painted by Gilbert Drouet (French, 1785–1825) and Christophe-Ferdinand Caron
(French, active 1792–1815)
Hard-paste porcelain, gilding, and ormolu mounts; h. 137.2 cm (54 in.)
Gift of the Harry and Maribel G. Blum Fund; Harold L. Stuart Endowment, 1987.1

This vase epitomizes the great achievements of the royal porcelain factory at Sèvres
during the Napoleonic period. Sèvres was a chief beneficiary of Napoleon's policy of
resuscitating factories after the trauma of the French Revolution: demonstrating
the supremacy of French craftsmanship, the emperor used sumptuous porcelain in his
palaces as well as for state gifts. With its commanding contours, monumental size,
rigorous symmetry, and unabashed splendor, this vase is a superb example of the Empire
style, inspired by Greco-Roman art. It is a triumph of the collaborative practice of
the Sèvres porcelain factory; documents reveal the precise roles played by each artist
in its creation. Napoleon's chief architect, Charles Percier, created the Etruscan scroll-
handled design. Commissioned by Napoleon around 1805, the vase ironically cemented
a relationship that sealed the French emperor's defeat. Held by the factory until 1814,
after Napoleon's exile, it was used as a diplomatic gift from his successor, King
Louis XVIII, to Viscount Castlereagh, the English secretary for foreign affairs.

SIDEBOARD

c. 1876
England, London
Designed by Edward William Godwin (English, 1833–1886)
Made by William Watt (English, 1834–1885)

Ebonized mahogany with glass and silvered brass; 184.2 x 255.3 x 50.2 cm (72 $\frac{1}{2}$ x 100 $\frac{1}{2}$ x 19 $\frac{3}{4}$ in.) (with leaves extended)

Restricted gift of Robert Allerton, Harry and Maribel G. Blum, Mary and Leigh Block, Mary Waller Lang-horne, Mrs. Siegfried G. Schmidt, Tillie C. Cohn, Richard T. Crane, Jr., Memorial, Eugene A. Davidson, Harriott A. Fox, Florence L. Notter, Kay and Frederick Krehbiel, European Decorative Arts Purchase, and Irving and June Seaman endowments; through prior acquisition of the Reid Martin Estate, 2005.529

Celebrated as the "poet of architects and architect of all the arts," Edward William Godwin was a man of many accomplishments. In a career that spanned more than thirty-five years, he was an architect of civic, domestic, and ecclesiastic buildings; an innovative interior decorator and designer of furniture, textiles, and theater sets; and an articulate critic of art and architecture. Godwin first designed his ebonized sideboard, of which this is a variant model, for his own dining room in 1867, and he subsequently reconsidered the form over the next two decades. In its appearance, the sideboard represents a turning away from the weight of contemporary Gothic Revival aesthetics and a move toward a reductionist sensibility expressed through the balance of solids and voids. This spare style gained Godwin some notable contemporary clients, among them James McNeill Whistler and Oscar Wilde. In his 1904 study *The English House*, the perceptive critic Hermann Muthesius wrote that Godwin's furniture, including this sideboard, foreshadowed the more modern look that emerged at the turn of the twentieth century. While calling Godwin's creations "wildly picturesque," Muthesius concluded that the overall effect was "one of elegance."

MANXMAN PIANOFORTE

1897

England, London

Designed by Mackay Hugh Baillie Scott (English, 1865–1945)

Case made at Pyghtle Works, Bedford; piano mechanism made by John Broadwood and Sons

Oak and ebony, with marquetry decoration inlaid with ivory and mother-of-pearl; copper mounts, escutcheons, and candlesticks; 129.5 x 143.5 x 69.9 cm (51 x 56 ½ x 27 ½ in.)

Restricted gift of Robert Allerton, Mrs. Joseph Regenstein, Sr., Walter S. Brewster, Emily Crane Chadbourne, Richard T. Crane, Jr., Mr. and Mrs. Leopold Blumka, Henry Manaster, Jack Linsky, Margaret Day Blake, Mr. and Mrs. John Wilson, and Mrs. Henry C. Wood; through prior acquisition of the Florene May Schoenborn, Samuel A. Marx, and European Decorative Arts Purchase funds, 1985.99

A product of the Arts and Crafts movement in England, the *Manxman Pianoforte* represents an innovative solution to the somewhat awkward form of the upright piano. Motivated by the shoddy results of industrial mass production, the revolutionary movement stressed the recognition of furniture and decorative arts as works of art. Here the celebrated Scottish architect and designer Mackay Hugh Baillie Scott created an object that is both cleverly functional and aesthetically pleasing. When opened, the lid and doors of the strikingly decorated cabinet act as acoustical sounding boards. Revealed inside is the musical instrument itself, along with a profusion of exquisite handcrafted metalwork, including candleholders fixed to the sides of the case. The design, like the keyboard, is a study in contrasts of light and dark, especially the witty handling of the lower section's alternating pattern, which echoes the piano's keys. The name *Manxman* derives from Scott's early residence in the Isle of Man. This piano is one of several executed around 1900 with John Broadwood and Sons of London, who made the musical movements.

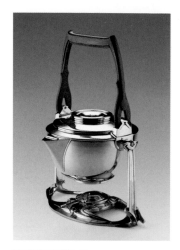

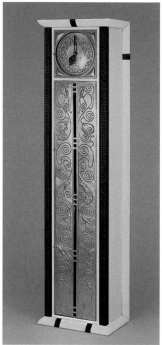

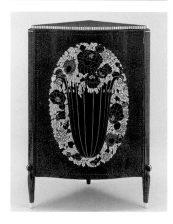

SAMOVAR
1897/1907
Germany, Weimar
Designed by Henry van de Velde
(Belgian, 1863–1957); made by the
workshop of Theodor Müller (German,
active late 18th/early 19th century)
Silvered brass and teak; h. 37.9 cm (14 7/8 in.)
Gift of the Historical Design Collection and an
anonymous donor; Mr. and Mrs. F. Lee Wendell
and the European Decorative Arts Purchase funds;
Edward E. Ayer Endowment in memory of Charles
L. Hutchinson; Bessie Bennett Endowment;
through prior gifts of Walter C. Clark, Mrs. Oscar
Klein, Mrs. R. W. Morris, and Mrs. I. Newton
Perry; through prior acquisition of the European
Decorative Arts Purchase funds, 1989.154

The Belgian architect and designer Henry
van de Velde was one of the primary
exponents of Art Nouveau, an inter-
national design style informed by the
English Arts and Crafts movement (see
p. 187) that was born in the 1880s and
flourished at the turn of the twentieth
century. This samovar, or Russian tea-
kettle, beautifully illustrates the adroit
mixture of taut lines and curvilinear
motifs that characterizes Van de Velde's
mature Art Nouveau style. The sinuous
organic lines of its base twist and snake
around upright brackets and pick up
again in the braided band motif of the
teak handle. The kettle itself is simple in
form, unornamented, and, with a promi-
nent hinge on the spout cover, appears
to be more engineered than crafted. This
example was made from silvered brass
and teak, in accord with Van de Velde's
philosophy that art should be accessible
and affordable to a broad public (though
other examples were made more costly
of silver). The kettle was designed at the
Weimar School of Applied Arts, where
Van de Velde became director in 1904.
That school later became the Bauhaus,
the bastion of modern design.

TALL-CASE CLOCK

c. 1906
Austria, Vienna
Case designed by Josef Hoffmann
(Austrian, 1870–1956); metalwork
by Carl Otto Czeschka (Austrian,
1878–1960); made by the Wiener
Werkstätte (1903–32)

Painted maple, ebony, mahogany, gilded brass,
glass, silver-plated copper, and clockworks;
179.5 x 46.5 x 30.5 cm (70 5/8 x 18 1/4 x 12 in.)
Laura Matthews and Mary Waller Langhorne
endowments, 1983.37

This tall-case clock represents a masterful collaboration between two major figures in the Vienna Secession movement: the architect Josef Hoffmann and the designer Carl Otto Czeschka. Like their English counterparts in the Arts and Crafts movement, the Secessionists initially supported the credo that art is for everyone and worked to create beautiful, simple objects for everyday use. A manifestation of this philosophy was the Wiener Werkstätte, or Vienna Workshop, of which Hoffmann was a founder and Czeschka a member. Produced by the Werkstätte's specialist craftsmen, this clock embodies the unexpected dichotomy that arose within the workshop: its early reformist ideals resulted in progressive, even avant-garde, products that appealed primarily to a privileged, sophisticated clientele. Hoffmann's design consists of simple, architectonic forms emphasized through the bold use of stark white-painted maple and an inlaid checkered pattern (a motif he favored). In striking contrast to the case's austere rectilinearity, Czeschka designed a luxurious, hand-wrought scheme for its dial and door. The door is fashioned from hand-embossed gilt brass, inset with cut-glass prisms. Its richly patterned surface decoration depicts a stylized Tree of Life motif.

CORNER CABINET

c. 1916
France
Designed by Jacques-Émile Ruhlmann
(French, 1869–1933)

Amboyna, ebony, and ivory veneer on oak
and mahogany carcass; replacement silver
escutcheon plate; 127.3 x 82.9 x 52.1 cm
(50 1/8 x 32 5/8 x 20 1/2 in.)
Restricted gift of Mrs. James W. Alsdorf, Mrs. T.
Stanton Armour, Mrs. DeWitt W. Buchanan, Jr.,
Mrs. Henry M. Buchbinder, Quinn E. Delaney,
Mrs. Harold T. Martin, Manfred Steinfeld, and
Mrs. Edgar J. Uihlein; Mrs. T. Stanton Armour,
Mr. and Mrs. Robert O. Delaney, Mr. and Mrs.
Fred Krehbiel, and Mrs. Eric Oldberg funds;
Pauline S. Armstrong, Harry and Maribel G.
Blum, Richard T. Crane, Jr., Memorial, Mr. and
Mrs. Fred Krehbiel, Mary Waller Langhorne,
and European Decorative Arts endowments;
through prior acquisitions of the Antiquarian
Society, European Decorative Arts Purchase
Fund, Howard Van Doren Shaw, and Mr. and Mrs.
Martin A. Ryerson, 1997.694

This sumptuously veneered corner cabinet is arguably a signature piece of the Art Deco era. This design term, used since the 1960s to refer to the high-style interiors of the years between World War I and World War II, is derived from the title of the 1925 Paris Exposition internationale des arts décoratifs et industriels modernes. This cabinet's monumental triangular form, with its serpentine door, is supported on short, fluted legs that are shod with ivory on the two front feet and terminate at the knees with a scroll flourish. Jacques-Émile Ruhlmann employed ebony and ivory to depict the large, fluted urn from which an abundance of stylized flowers and leaves cascades, overflowing the limits of the container to form a black-and-white oval that contrasts with the warm tone of the amboyna wood.

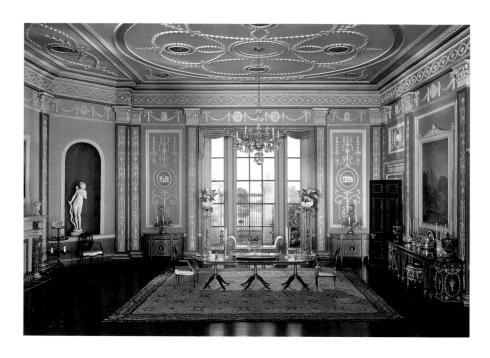

ENGLISH DINING ROOM OF THE GEORGIAN PERIOD, 1770–90
1937/40

Miniature room; 50.8 x 89.5 x 65.1 cm (20 x 35 ¼ x 25 ⅝ in.)

Gift of Mrs. James Ward Thorne, 1941.1195

The sixty-eight fascinating Thorne Miniature Rooms feature highlights from the history of interior design and decorative arts from the thirteenth century to 1940. These enchanting miniature stage sets were conceived by Mrs. James Ward Thorne of Chicago and constructed between 1937 and 1940 by master craftsmen according to her exacting specifications, on a scale of one inch to one foot. The harmonious elegance seen here is based on two dining rooms designed by Robert Adam, the successful eighteenth-century London architect whose precise and delicate interpretation of the antique (stimulated by then-recent excavations at Herculaneum and Pompeii) dictated English taste for a quarter of a century. To insure perfect conformity, Adam undertook the entire design of a house and every detail of its interior, hiring cabinetmakers to execute furniture that blended Neoclassical elements with current English forms. Instead of using wood and wallpaper, Adam carved low-relief ornament in plaster against painted panels in the style of Roman stuccos, as seen in this dining room. His furniture was often gilded in the continental fashion, as is the side table in this room. The landscape over the side table, painted by one of the many artists that Mrs. Thorne commissioned for the project, is in the style of Claude Lorrain (see p. 307).

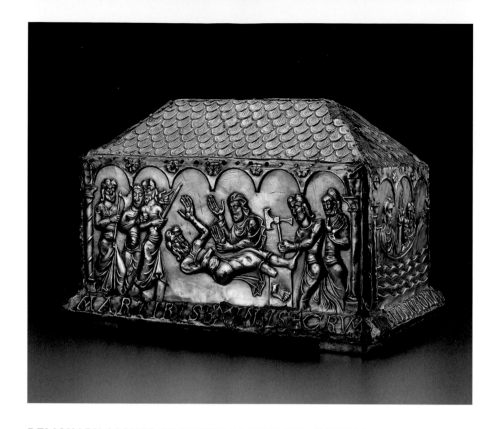

RELIQUARY CASKET OF SAINTS ADRIAN AND NATALIA

12th century
Northern Spain
Repoussé silver on oak core; 15.9 x 25.4 x 14.5 cm (6 3/8 x 10 x 5 3/4 in.)
Kate S. Buckingham Endowment, 1943.65

This rare casket was made to contain the sacred relics of Saint Adrian, and is fashioned like a miniature tomb, complete with a tiled roof and Romanesque columns. Saint Adrian was revered as the patron of soldiers and a protector against the plague. A Roman officer in charge of the persecution of Christians, Adrian so admired the virtues of those whom he oppressed that he converted to their faith. After declaring himself a Christian, Adrian was arrested and brutally martyred in the early fourth century. Unflinchingly illustrated on the sides of this reliquary (and reinforced by the inscription) is the story of Adrian's trial, his dismemberment, and the transport of his remains to a city near Constantinople by his devoted wife, Saint Natalia.

The casket's design was hammered out from the reverse on thin sheets of silver, a technique called repoussé. The figures were reduced to simple, monumental forms composed of convex bulges, reflecting the style of Romanesque relief sculpture and manuscript illumination in northern Spain.

HEAD OF AN APOSTLE

c. 1210
France, Paris
Limestone; h. 43.2 cm (17 in.)
Kate S. Buckingham Endowment, 1944.413

This imposing head probably comes from a full-length apostle that was one of the column or jamb figures flanking the portals of the west facade of Notre-Dame Cathedral in Paris. Showing the heritage of ancient and Byzantine models, it bears all the stylistic hallmarks of the beginning of the Gothic style in the region around Paris about the year 1200. The object's origin was the subject of heated scholarly debate for several decades. Recent scientific study—namely, neutron activation analysis, in which samples are taken and then bombarded in a nuclear reactor—has shown that the limestone came from a quarry that also supplied stone for other carvings on Notre-Dame. The discovery of sculptural fragments from the cathedral's Gallery of Kings above the west portals, dated to between 1220 and 1235 (and now in the Musée National du Moyen Âge, Paris), provided an important point of comparison. The Art Institute's head is said to have been found during excavations for the modernization of Paris in the mid-nineteenth century. Medieval sculpture from Notre-Dame was purposefully damaged in the 1790s during the French Revolution because of its presumed royal associations. Fragments of some of the sculpture removed at the order of the revolutionary tribunal were buried out of a lingering respect for its tradition and quality, to be rediscovered in later years.

TRIPTYCH WITH SCENES FROM THE LIFE OF CHRIST
1350/75
Probably Germany, Cologne
Ivory and gold; 25.7 x 17.5 cm (10 ⅛ x 6 ¹⁵/₁₆ in.)
Mr. and Mrs. Martin A. Ryerson Collection, 1937.827

Ivory was used to make highly prized devotional objects in the Gothic era. This triptych bears scenes from the Infancy and Passion of Christ, arranged in a chronological sequence from left to right, starting on the bottom with the Annunciation, the Adoration of the Magi, and the Presentation in the Temple. The narrative continues on the top of the triptych with the Road to Calvary and the Noli Me Tangere, and culminates in the central image of Christ on the Cross. Such small devotional objects might be kept on a stand or cabinet in a bedroom, ready to be used as a focus for prayer by the layperson who owned them, along with illuminated psalters and books of hours. The triptych's intimate scale and its moveable wings made it easy to store in a chest or to carry from one residence to another as needed. Although Paris has long been recognized as a great center for ivory carving in the Gothic era, recent scholarship has also emphasized the importance of workshops in England, Germany, and Italy—affirming the popularity of the medium throughout medieval Europe. This triptych was most likely made by a master artist and his atelier working in Germany, probably in Cologne.

JACQUES DE BAERZE Netherlandish, active before 1384–99
Christ Crucified, from *Altarpiece of the Crucifixion,* 1391–99
Walnut with traces of polychromy and gilding; h. 27.7 cm (11 in.)
Gift of Honoré Palmer, 1944.1370

Christ Crucified was originally the focal point of a large triptych combining painting
and sculpture that was commissioned in 1390 by Philip the Bold, duke of Burgundy,
for the newly founded Charterhouse of Champol outside Dijon. Philip founded
this monastery as a dynastic burial place, and it was richly endowed with artistic
treasures by him and by his successors. The triptych was a collaboration between
two important artists from the Flemish territories controlled by Philip the Bold: the
sculptor Jacques de Baerze and the painter Melchior Broederlam. When open, the
altarpiece showed carved reliefs of the Crucifixion, the Adoration of the Magi, and
the Entombment, together with standing figures of saints. The gilded center could
be covered by movable wings whose backs, painted with scenes from the Infancy
of Christ by Broederlam, were visible when the altarpiece was closed. Broederlam
was also responsible for painting and gilding the sculpted figures of the interior. The
triptych still survives in Dijon (Musée des Beaux-Arts), but the central figure of
the crucified Christ was removed during the French Revolution. Even separated
from its context within the altarpiece, however, the crucified Christ remains
a powerfully expressive work. Christ's tensed hands and feet and earthy features are
realistically observed, while the curving contour of his torso and the folds of his
loincloth reflect a more courtly ideal.

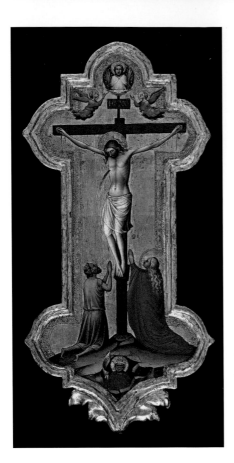

LORENZO MONACO
Italian, 1370/75–1425/30
The Crucifixion, 1390/95
Tempera on panel; panel: 57.3 x 28 cm (22 ½ x
11 ¹/₁₆ in.); painted surface: 51 x 23.3 cm (20 ⅛ x
9 ⅛ in.)
Mr. and Mrs. Martin A. Ryerson Collection,
1933.1032

Representative of the early work of
Lorenzo Monaco, a Camaldolese monk
and leading Florentine painter of the
end of the fourteenth century and the
beginning of the fifteenth century, the
delicate colors and simplified forms of
this Crucifixion are exceptionally well
preserved. The medallion above the
crucified Christ contains an image of
Christ in Glory, holding a palm in each
hand to symbolize his victory over death.
Below, the crowned figure of King David
holds an inscribed scroll. More often
in Crucifixion scenes of this period, a
pelican is shown at the top of the cross,
and the skull of Adam lies at the foot.
A penitential theme is suggested by the
figures kneeling under the cross: on
the right is a haloed Mary Magdalene
in a red robe; on the left, a man with
the incised rays of a *beatus,* or blessed
one, emanating from his head wears the
torn brown cloak of a hermit. He was
probably meant to represent a specific
hermit within the Camaldolese order.
The panel, which has a hole drilled at
its base for attaching a long pole, was
most likely used as a processional cross
in the monastic, Camaldolese commu-
nity of Santa Maria degli Angeli, where
Lorenzo lived and worked.

BERNAT MARTORELL Spanish, c. 1400–1452
Saint George Killing the Dragon, 1434/35
Tempera on panel; 155.6 x 98.1 cm (61 ¼ x 38 ⅝ in.)
Gift of Mrs. Richard E. Danielson and Mrs. Chauncey B. McCormick, 1933.786

Bernat Martorell was the greatest painter of the first half of the fifteenth century in
Catalonia in northeastern Spain. Depicted here is the most frequently represented epi-
sode from the popular legend of Saint George, in which the model Christian knight
saves a town and rescues a beautiful princess. Conceived in the elegant, decorative
International Gothic style, the painting was originally the center of an altarpiece
dedicated to Saint George that was apparently made for the chapel of the palace of
the Catalan government in Barcelona. This central scene was surrounded by four
smaller narrative panels, now in the Musée du Louvre, Paris, and was probably sur-
mounted by a lost image of Christ on the Cross. In the central panel, Saint George,
on his white steed, triumphs over the evil dragon. A wealth of precisely observed
details intensifies the drama. Dressed in an ermine-lined robe, the princess wears
a sumptuous gilt crown atop her wavy red-gold hair. Her parents and their subjects
watch the spectacle from the distant town walls. George's halo and armor and the
scaly body of the dragon are richly modeled with raised stucco decoration. Martorell
has also treated the ground, littered with bones and crawling with lizards, in a lively
manner, giving it a gritty texture.

GIOVANNI DI PAOLO Italian, c. 1399–1482
The Beheading of Saint John the Baptist, 1455/60
Tempera on panel; 68.6 x 39.1 cm (27 x 15 ³/₈ in.)
Mr. and Mrs. Martin A. Ryerson Collection, 1933.1014

Among the most impressive achievements of the Sienese master Giovanni di Paolo is his narrative series of twelve panels illustrating the life of Saint John the Baptist. With a wonderful feeling for detail and active silhouette, the artist depicted events from John the Baptist's life—from his birth, prophecy, and the baptism of Christ, through his beheading at the request of Salome. These scenes are enacted in complex settings that exploit the tall, slender proportions of the panels and set off the expressive poses of the figures. *The Beheading of Saint John the Baptist* depicts the henchmen of Queen Herodias placing his head on a golden platter. The execution has just occurred; blood spews profusely from the elongated neck of the saint. The rich patterning of the architecture, painted in a light, delicate palette, contrasts with the gruesome trails of blood falling to the ground and collecting beneath the decapitated corpse. The landscape was inspired by the hills around Siena. Throughout the series, Giovanni skillfully repeated colors, settings, and patterns to create a unified narrative. Eleven of the original twelve panels survive: six are in the Art Institute, and the remaining five are in various European and American collections. The panels were arranged in three rows to form two large, movable doors, possibly once enclosing a sculpture or relic.

SAINT MICHAEL AND THE DEVIL
1475/1500
Spain
Poplar; 52.4 x 22.9 x 21.3 cm (20 ⁵⁄₈ x 9 x 8 ³⁄₈ in.)
Chester Tripp Endowment, 2004.721

Saint Michael was one of the seven archangels of God in the Old Testament, and he led the heavenly host against God's enemies in the book of Revelation. This sculpture represents Michael's battle against Satan, who lies at his feet, pierced by the saint's lance. This subject would inevitably have been associated with the hope of salvation, since Saint Michael was often depicted weighing the souls of the blessed and the damned in images of the Last Judgment. This wood sculpture is a powerful example of the influence of trends from northern Europe on the art of Spain in the second half of the fifteenth century through the importation of works of art and craftsmen. The angular, dancing rhythm of the saint's pose and the tight, graphic quality of the details of his shield, hair, and wings may reflect sources in northern European prints, such as the engravings of Master E. S. These elements would originally have been enhanced by a painted and gilded surface, since stripped away.

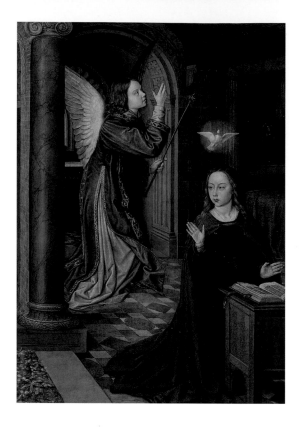

JEAN HEY (MASTER OF MOULINS) French, active c. 1475–c. 1505
The Annunciation, 1490/95
Oil on panel; 72 x 50.2 cm (28 ¹⁵/₁₆ x 19 ³/₄ in.)
Mr. and Mrs. Martin A. Ryerson Collection, 1933.1062

The archangel Gabriel's announcement to Mary that she will give birth to a son, and
her immediate acceptance of this news, represent the moment of Christ's Incarnation.
Though *The Annunciation* appears to be an independent painting, it is actually a
fragment that once formed the right side of an altarpiece; the left side, now in the
National Gallery, London, depicts the moment of Mary's own Immaculate Conception,
believed to have occurred when her parents, Joachim and Anne, greeted each other
at the Golden Gate. A central section, now lost, probably featured the enthroned
Virgin and Child, perhaps with Saint Anne. Jean Hey, known as the Master of Moulins,
was the leading painter working in France in the last decades of the fifteenth century.
He worked in Moulins in central France for Duke Pierre II of Bourbon and his wife,
Anne of France, who played a large role in the government of of the kingdom during
the minority of Anne's brother Charles VIII. As their court painter, Jean Hey, who
was probably of Netherlandish origin, fused the intense naturalism and preciousness
of Flemish and French painting and manuscript illumination with the emerging
Renaissance interest in antiquity, as is evident in this painting's Italianate architecture.

FRA BARTOLOMMEO (BACCIO DELLA PORTA) Italian, 1472–1517

The Nativity, 1504/07

Oil on panel; 34 x 24.5 cm (13 3/8 x 9 5/8 in.)

Ethel T. Scarborough Fund; L. L. and A. S. Coburn, Dr. and Mrs. William Gilligan, Mr. and Mrs. Lester King, John and Josephine Louis, Samuel A. Marx, Alexander McKay, Chester D. Tripp, and Murray Vale endowment funds; restricted gift of Marilynn Alsdorf, Anne Searle Bent, David and Celia Hilliard, Alexandra and John Nichols, Mrs. Harold T. Martin, Mrs. George B. Young in memory of her husband, and the Rhoades Foundation; gift of John Bross and members of the Old Masters Society in memory of Louise Smith Bross; through prior gift of the George F. Harding, Mr. and Mrs. W. W. Kimball, Mr. and Mrs. Martin A. Ryerson, and Charles H. and Mary F. S. Worcester collections, 2005.49

The young Baccio della Porta came under the spell of the charismatic Dominican friar Girolamo Savonarola, joining his monastic order as Fra (Friar) Bartolommeo in 1500 and forsaking his painting career for several years. Returning to painting in 1504, he looked to the most lyrical and harmonious recent works of Leonardo da Vinci, Raphael, and Michelangelo to form his own style, which was characterized by a new, quiet spirituality. The palette of saturated blue, red, and green announces the Holy Family, while the muted tones of the angels' garments establish an otherworldly presence. Here he treated the Nativity in a traditional, though especially intimate, manner. The Virgin kneels humbly as she gazes at the Christ Child, while Joseph assumes a pose of restrained wonderment, as if suddenly aware of the infant's divine nature. The family shelters in a rustic stall erected within the ruins of an edifice understood to be the palace of David at Bethlehem. This juxtaposition of architecture symbolizes Christ's establishment of his new church on the Old Testament order of the Jews. Reinforcing this device is a young tree springing from an outcropping of ancient rock directly above the infant.

CORREGGIO (ANTONIO ALLEGRI) Italian, c. 1489–1534
Virgin and Child with the Young Saint John the Baptist, c. 1515
Oil on panel; 64.2 x 50.2 cm (25 1/4 x 19 3/4 in.)
Clyde M. Carr Fund, 1965.688

Correggio spent most of his brief career in the northern Italian city of Parma. Removed from the great centers of Renaissance art, he was able to create a remarkably innovative body of work. This intimate devotional panel is a product of the artist's youth. In it Correggio revealed his own evolving style while assimilating lessons from other masters. The panel's pyramidal grouping of figures reflects the High Renaissance manner of Raphael, while their soft outlines and the Madonna's enigmatic smile recall Leonardo da Vinci. The evocative use of the distant landscape demonstrates the young artist's awareness of northern European precedents. The gentle sensuousness of the figures and the tenderness they show one another through glance are unique to Correggio. The artist used light, shadow, and color to bathe the panel in a gentle glow; skin and fabrics appear to take on a velvety texture. The expressive, idyllic quality of this painting presages the radiant ceiling frescoes of Correggio's maturity, especially those in Parma's Cathedral.

FRANCESCO DURANTINO Italian, active 1543–53
Wine Cistern, 1553
Tin-glazed earthenware (maiolica); 26 x 51.4 x 41.3 cm (10 ¼ x 20 ¼ x 16 ¼ in.)
Mary Waller Langhorne Endowment, 1966.395

Elaborately fashioned platters, vessels, and containers, often with decorative embellishments that indicated their specialized function or their owner's social status, were displayed on the banquet tables of Renaissance Italy. Cisterns such as this were filled with cold water and used to cool wine bottles at feasts. Skillfully decorated by the Italian ceramic painter Francesco Durantino, this work typifies the Renaissance interest in both Christian imagery and scenes from pagan antiquity. It is covered with depictions of two famous battle scenes, one on land and one at sea. Although the exterior, adapted from frescoes by Raphael's followers, represents a land battle culminating in the conversion of the Roman emperor Constantine to Christianity, the cistern's interior depicts a legendary naval disaster: the sinking of the Trojan hero Aeneas's ships by the jealous goddess Hera. At the cistern's center, the ships disappear beneath the waves, a playful conceit that was no doubt even more effective when the cistern was filled with water. The generously sized vessel displays all the characteristics that made maiolica, a tin-glazed earthenware, popular: brilliant colors, lively painting, and riveting narratives mixed with fanciful design. The term *maiolica* is probably a corruption of Majorca, referring to the port through which pottery from Moorish Spain was first exported to Italy.

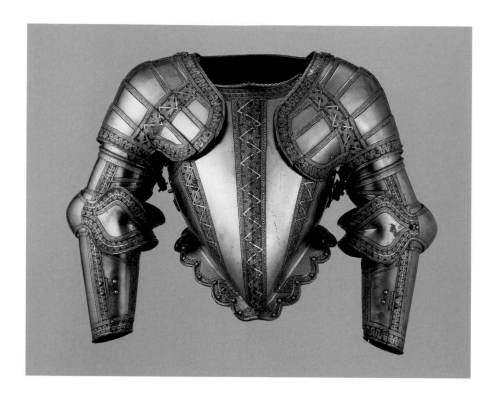

JACOB HALDER AND WORKSHOP German, active in England, 1576–1608
Portions of an Armor for Field and Tilt, c. 1590
Steel, etched and gilded; iron; brass; and leather; h. 61 cm (24 in.); wt. 17.7 kg (39 lb. 10 oz.)
George F. Harding Collection, 1982.2241a-h

Some of the finest armorers worked for royal patrons in workshops set up to meet the needs of a prince. The workshop established by Henry VIII of England at Greenwich Palace outside London produced outstanding armor for the English court over a period of more than one hundred years. It was staffed largely by Flemish and German craftsmen, among them Jacob Halder, who, originally from Landshut, headed the armory when this half-suit was produced about 1590. Made for the court and used for display and tournament competition more than for warfare, this and other examples of Greenwich armor feature crisply decorative bands of etching and gilding and a silhouette mimicking fashionable dress. Here the shape of the breastplate, tapering to a point that overhangs the natural waist, imitates the "peascod" cut of a gentleman's doublet of the same period.

ALESSANDRO VITTORIA Italian, 1525–1608

The Annunciation, c. 1583

Bronze; 97.8 x 61.6 cm (38 ½ x 24 ¼ in.)

Edward E. Ayer Endowment in memory of Charles L. Hutchinson, 1942.249

This masterpiece of Renaissance relief sculpture by the Venetian artist Alessandro Vittoria was commissioned in 1580 by Hans Fugger, a member of a noted Augsburg banking family, to decorate an altarpiece for the chapel of his family's castle in Kirchheim, Swabia. Here Vittoria translated into bronze the flickering light and colorful palette of the great Venetian painters of the period; his composition is specifically adapted from altarpieces by Titian. Working in wax (from which the finished relief was then cast in bronze), Vittoria manipulated the relief's form and edges to catch the light. The result is a highly animated surface in which everything—figures, drapery, clouds, and sky—seems to move with excitement, heightening the drama between the sharply turned, startled Virgin and the powerful figure of Gabriel, who has suddenly descended from heaven to announce the birth of Christ. Fully sculpted in the round, the archangel's arm points to the smallest feature in the scene: the dove, representing the Holy Ghost of the Christian Trinity. The plasticity and depth of the relief, the dramatic movement, and the handling of detail make this one of the artist's finest creations.

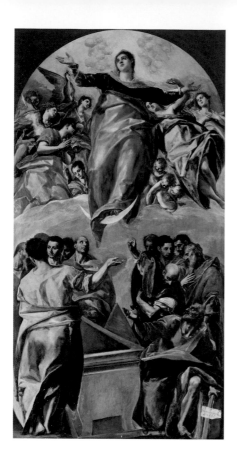

EL GRECO (DOMENICO THEOTOKÓPOULOS)

Spanish, born Crete (present-day Greece), 1541–1614

The Assumption of the Virgin, 1577–79

Oil on canvas; 403.2 x 211.8 cm (158 ³/₄ x 83 ³/₄ in.); original image approx. 396.4 x 202.5 cm (156 ¹/₁₆ x 79 ³/₄ in.)

Gift of Nancy Atwood Sprague in memory of Albert Arnold Sprague, 1906.99

This painting was the central element of the altarpiece that was El Greco's first major Spanish commission and first large public work. After living in Venice and Rome, where he absorbed the late Mannerist style, the Greek-born artist settled in the Spanish city of Toledo in 1577 to work on the high altar of the convent church of Santo Domingo el Antiguo. The church of this ancient Cistercian convent was being rebuilt as the funerary chapel of a pious widow, Doña Maria de Silva. In El Greco's grand design, the Assumption was surmounted by a representation of the Trinity and was flanked by two side altars decorated with paintings of the Adoration of the Shepherds and the Resurrection. The visionary imagery of the Assumption and the Trinity aptly expressed the patron's hope of salvation. Here the Virgin floats upward, supported on the crescent moon that is symbolic of her sinless nature, while the boldly modeled heads of the crowd of apostles gathered around her empty tomb express reactions of amazement and concern. The vigor of El Greco's broad brushstrokes proclaims the confident achievement of this early work, as does this artist's large signature in Greek, painted as though affixed to the surface of the picture at the lower right.

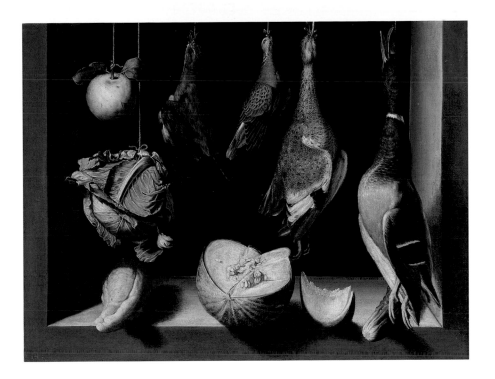

JUAN SÁNCHEZ COTÁN Spanish, 1560–1627
Still Life with Game Fowl, 1600/03
Oil on canvas; 67.8 x 88.7 cm (26 ¹¹/₁₆ x 34 ¹⁵/₁₆ in.)
Gift of Mr. and Mrs. Leigh B. Block, 1955.1203

This work, the earliest European still life in the Art Institute's collection, was painted
by a leading Spanish practitioner of this new genre. It employs Juan Sánchez Cotán's
signature format: commonplace edibles placed in a shallow, niche-like embrasure with
an impenetrable, dark background evoking the larders used in Spanish homes to keep
food fresh. Some of the artist's still lifes contain few objects, while in others, such as
this one, the recess is filled. The objects are painstakingly rendered, and their place-
ment seems mathematically exact. The hanging quince and game birds are arranged not
perpendicular to the bottom edge of the painting, but on a barely perceptible diagonal.
Further enlivening the composition is the strong light that sweeps over the still life and
creates a dramatic contrast of light and shade, of precise realism and abstract form.
After 1603 the artist stopped creating these austere and powerful images. Sánchez
Cotán left his successful artistic career in Toledo to join the Carthusian order as a
lay brother at the charterhouse of Granada. Thereafter, his work consisted solely of
idealized religious images.

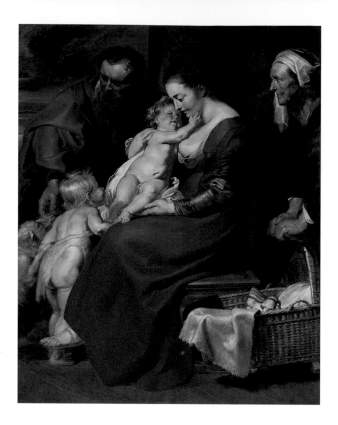

PETER PAUL RUBENS Flemish, 1577–1640
The Holy Family with Saints Elizabeth and John the Baptist, c. 1615
Oil on panel; 114.5 x 91.5 cm (45 1/8 x 36 in.)
Major Acquisitions Fund, 1967.229

This painting of the Holy Family is one of several completed in the decade after
Peter Paul Rubens returned to his native Antwerp, following an eight-year stay in Italy.
Fully immersed in Italian art, the prodigiously productive artist had acquired such
facility in handling brush, color, figures, and drapery, and in arranging large-scale
compositions, that he had no rival north of the Alps. Here he displayed these skills
not only by bringing a sacred subject to life, but also by bringing it down to earth.
Vital and believable Flemish figures fill the composition, which is dominated by the
Virgin clad in a brilliant red dress. The bold, diagonal movement of the playful infants
is an effective counterbalance to the full, rounded figure of Mary. Joseph (Mary's
husband) and Elizabeth (her cousin, and the mother of John the Baptist) frame the py-
ramidal group as aged and more passive protectors. The atmosphere of joyful solem-
nity—of light, color, and life—is typical of Rubens and made him the quintessential
Baroque artist, in demand as the designer of grand decorative schemes for churches
and palaces across Europe.

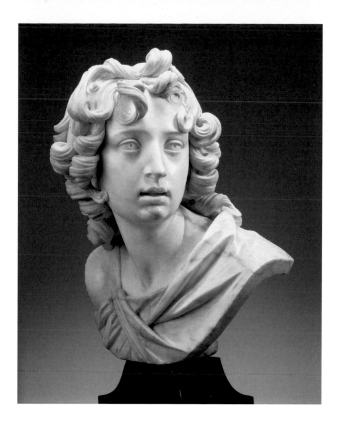

FRANCESCO MOCHI Italian, 1580–1654

Bust of a Youth, c. 1630

Marble; h. 40.5 cm (16 in.) (without base)

From the collection of the estate of Federico Gentili di Giuseppe; restricted gift of Mrs. Harold T. Martin through the Antiquarian Society; Major Acquisitions Centennial Endowment; through prior gift of Arthur Rubloff; European Decorative Arts Purchase Fund, 1989.1

One of the most individual sculptors of his age, Francesco Mochi possessed an astounding technical prowess. Although his output was relatively small, Mochi was one of the most original artists to emerge in seventeenth-century Italy. His art is distinguished by energetic lines, dramatic movement, and subtle psychology. Here a taut precision characterizes the youth's garment, and a carefully composed rhythm governs Mochi's virtuoso treatment of the hair, with its corkscrew curls. In contrast to the greater precision of the hair and drapery, the wistful expression of the youth, with his slightly parted lips, endows the sculpture with life. This work may have been conceived as a portrait, but it is more likely a biblical or mythological subject. The almost transcendent expression suggests that the sculpture may represent a religious figure, such as the youthful Saint John the Baptist. Its small scale suggests that the work was intended as an object for private contemplation.

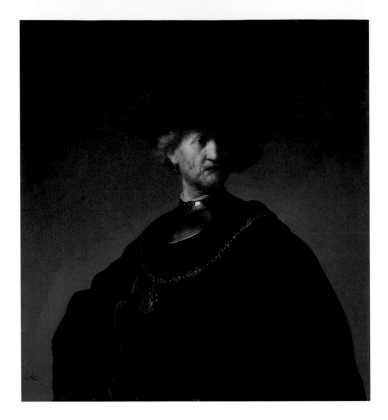

REMBRANDT HARMENSZ. VAN RIJN Dutch, 1606–1669
Old Man with a Gold Chain, c. 1631
Oil on panel; 83.1 x 75.7 cm (32 ¾ x 29 ¾ in.)
Mr. and Mrs. W. W. Kimball Collection, 1922.4467

This evocative character study is an early example of a type of subject that preoccupied the great Dutch master Rembrandt van Rijn throughout his long career. Although Rembrandt's large output included landscapes, genre paintings, and the occasional still life, he focused on biblical and historical paintings and on portraits. As an extension of these interests, he studied the effect of a single figure, made dramatic through the use of costume and rich, subtle lighting. Rembrandt collected costumes to transform his models into characters. Here the gold chain and steel gorget suggest an honored military career, while the plumed beret evokes an earlier time. The broad black mass of the old man's torso against a neutral background is a powerful foil for these trappings. The face is that of a real person, weathered and watchful, glowing with pride and humanity. The unidentified sitter, once thought to be Rembrandt's father, was a favorite model, appearing in many of the artist's early works. The confident execution suggests that the young Rembrandt completed this picture about 1631, when he left his native Leiden to pursue a career in the metropolis of Amsterdam; perhaps he wished to use this work to demonstrate his skill in a genre that combined history painting and portraiture.

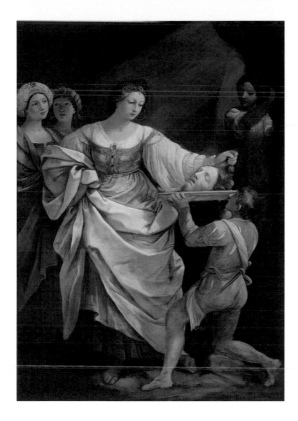

GUIDO RENI Italian, 1575–1642

Salome with the Head of Saint John the Baptist, 1639/42

Oil on canvas; 248.5 x 174 cm (97 ³/₄ x 68 ¹/₂ in.)

Louise B. and Frank H. Woods Purchase Fund, 1960.3

In this large canvas, Guido Reni, a leading seventeenth-century Bolognese painter, depicted one of the New Testament's more macabre stories. Salome, the daughter of Herodias, so pleased her stepfather, Herod Antipas, by dancing at his birthday feast that he promised to grant her any wish. Prompted by her vengeful mother, Salome asked for the head of the prophet John the Baptist, whom Herod had imprisoned for denouncing his marriage. The painting illustrates the moment when the head of the saint is presented to the beautiful young woman. Highly selective in his palette, Reni depicted this gory event with rhythmic grace, soft modeling, and elegant remove. No blood drips from John's head, and the color and illumination are cool; indeed, there is no specific setting, nor are any strong emotions depicted. In this late work, the handling of the figures is broad, especially in the legs of the young page and the feet of Salome, which are only summarily brushed in. This raises the central, unresolved question of much of Reni's late work: whether or not this picture should be considered finished.

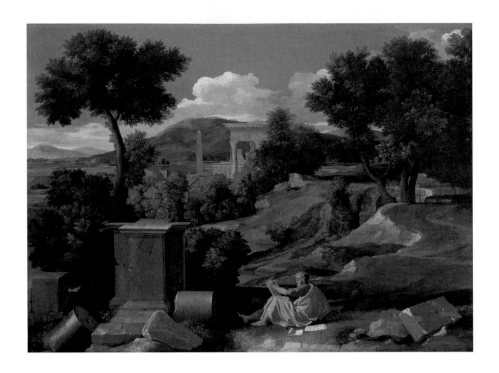

NICOLAS POUSSIN French, 1594–1665
Landscape with Saint John on Patmos, 1640
Oil on canvas; 100.3 x 136.4 cm (39 ½ x 53 ⅝ in.)
A. A. Munger Collection, 1930.500

Although French by birth and training, Nicolas Poussin spent most of his career in Rome, immersed in the study of ancient art, where he painted classically inspired works for an educated elite. His art has long been considered the embodiment of the ideals of seventeenth-century classicism. In this painting, Saint John, one of the four evangelists who wrote the Gospels of the New Testament, reclines beside his symbol, an eagle. He is here depicted as a powerful old man, presumably after he retired to the Greek island of Patmos to write his Gospel and the Book of Revelation at the end of his life. To suggest the vanished glory of the ancient world, Poussin carefully constructed an idealized setting for the saint, complete with an obelisk, a temple, and column fragments. Man-made and natural forms are adjusted according to principles of geometry and logic to convey the measured order of the scene. Even the profile view of Saint John is in harmony with the classical landscape surrounding him. This painting may have been part of a projected series on the four evangelists. Only this work and its companion, *Landscape with Saint Matthew* (1640; Gemäldegalerie, Berlin), appear to have been executed.

JACOB VAN RUISDAEL Dutch, 1628/29–1682
Landscape with the Ruins of the Castle of Egmond, 1650/55
Oil on canvas; 98 x 130 cm (38 9/16 x 51 1/4 in.)
Potter Palmer Collection, 1947.475

The heroic but ephemeral constructions of humankind and the enduring power and grandeur of nature are evocatively expressed in this work by the landscape painter Jacob van Ruisdael. A shepherd and his flock are dwarfed by the ruins of Egmond castle, the massive hill behind it, and the dark, swollen clouds gathering above. Ruisdael's skillful use of color also enhances the painting's poetic effect. Other than the glowing terracotta of the ruins and the restrained use of creamy whites, his palette consists mostly of the greens and browns of nature. There is only one small point of bright color in the entire painting: the shepherd's red jacket. Although Ruisdael's choice of ruins as his subject followed an established pictorial tradition in the Netherlands, he was not concerned with overall topographical accuracy; indeed, the prominent hill behind the structure was a product of his imagination. The castle, once the seat of the counts of Egmond, had powerful associations. It was destroyed at the command of the Prince of Orange to prevent the Spanish army from occupying it during the Dutch struggle for independence from Spanish rule in the late sixteenth century.

GIOVANNI BATTISTA TIEPOLO Italian, 1696–1770
Armida Encounters the Sleeping Rinaldo, 1742/45
Oil on canvas; 187.5 x 216.8 cm (73 7/8 x 85 3/8 in.)
Bequest of James Deering, 1925.700

Giovanni Battista Tiepolo's monumental ceiling and wall decorations epitomize
the brilliant exuberance of the late Baroque style. Tiepolo enjoyed an international
career and was called upon to use his mastery of light, color, and illusion to trans-
form palaces and monasteries in his native Venice and elsewhere in Italy, as well as
in Germany and Spain. This painting and three others at the Art Institute, together
with smaller decorative panels and a ceiling painting, once graced the cabinet of
mirrors, a richly decorated room in the Venetian palace of the powerful Cornaro
family. The suite illustrates Torquato Tasso's popular sixteenth-century epic romance
Gerusalemme liberata, which is set in the eleventh century, during the First Crusade,
when Western knights sought to take Jerusalem from the Muslims. The canvas captures
the moment of Rinaldo's seduction: the beautiful sorceress Armida has just arrived
to divert the sleeping hero from his crusade. Accompanied by her attendant nymph
and a cupid figure, she appears like a beautiful mirage, enthroned on a billowing
cloud, her drapery and shawl wafting gently behind her. Altough Tasso's story sym-
bolizes the conflict between love and duty, Tiepolo's depiction of a magical bucolic
world—enhanced by effervescent colors, luminous atmosphere, and dense, creamy
paint—seems to evoke only love's enchantment.

SIR JOSHUA REYNOLDS English, 1723–1792
Lady Sarah Bunbury Sacrificing to the Graces, 1763–65
Oil on canvas; 242.6 x 151.5 cm (95 ½ x 59 ¾ in.)
Mr. and Mrs. W. W. Kimball Collection, 1922.4468

Lady Sarah Bunbury was famous for being the society beauty who attracted the atten-
tion of the future king George III when she was only fifteen. George was persuaded
to marry a German princess instead of her, and a year after the royal marriage, Lady
Sarah wed Sir Charles Bunbury in a match that did not survive for long. In this por-
trait, Sir Joshua Reynolds—the first president of the Royal Academy and a champion
of the importance of Classical artistic models—conferred upon her a flattering honorary
citizenship in the ancient world. Dressed in a loose, vaguely Roman costume and
surrounded by the art and artifacts of antiquity, Lady Sarah is cast as a devotee of the
Three Graces, symbols of generosity and the mythical companions of Venus, the
Roman goddess of love and beauty. Lady Sarah pours a libation into a smoking tripod,
and one of the Graces seems to offer her a wreath, as if inviting the aristocratic
beauty to join their number. As an academician, Reynolds valued historical subjects,
but as a practicing painter, he made his living largely through portraiture. In this and
other grand portraits, he found a way of combining the requirements of his patrons
with the prestige of the Classical tradition.

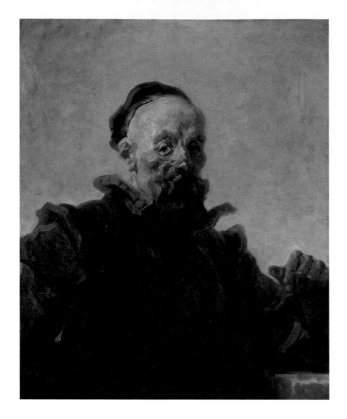

JEAN-HONORÉ FRAGONARD French, 1732–1806
Portrait of a Man, 1768/70
Oil on canvas; 80.3 x 64.7 cm (31 ⅝ x 25 ½ in.)
Gift of Mary and Leigh Block in honor of John Maxon, 1977.123

Jean-Honoré Fragonard is perhaps best known for his light-hearted, amorous sub-
jects. This work, painted in lively brushstrokes, represents another important aspect
of Fragonard's genius—in a series of fantasy portraits, he used references to earlier
artists to enliven his own characterizations of his patrons and artistic friends. Here
the identity of the sitter is unknown; but the half-length format, the rapid, virtuoso
handling of the paint, and the use of seventeenth-century costume link this work to
the fantasy portraits. In this instance, Fragonard took as his starting point a painting
of an actor by the Italian Baroque artist Domenico Fetti, then in a leading Parisian
collection; in other related portraits, the French painter was inspired by the bravura
style of the Flemish artists Peter Paul Rubens and Anthony van Dyck. Two paint-
ings from this series bear inscriptions stating that they were painted in one hour.
Whether or not this is literally true, the direct, personal quality that results from
Fragonard's command of the medium makes this series particularly appealing to a
modern sensibility.

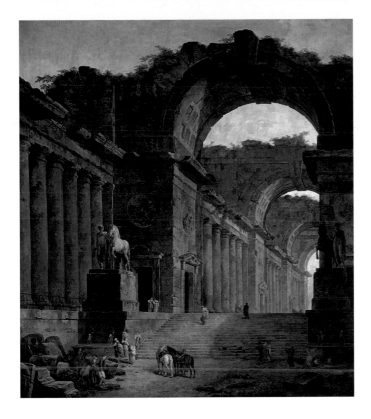

HUBERT ROBERT French, 1733–1808
The Fountains, 1787/88
Oil on canvas; 255.3 x 221.2 cm (100 ½ x 88 ⅛ in.)
Gift of William G. Hibbard, 1900.385

The painting of Classical ruins had reached the zenith of its popularity when Hubert
Robert, the leading French practitioner of this specialty, was commissioned in 1787
to paint a suite of four canvases for a wealthy financier's château at Méréville, near
Paris. *The Fountains* and its companion pieces were set into the paneled walls of a salon
in the château, creating an alternate space that played off of the elegant, Neoclassical
decor of the room. Robert had gleaned his artistic vocabulary from more than a de-
cade's study in Rome from 1754 to 1765. Like the other three large paintings from the
group painted for Méréville, all in the Art Institute, *The Fountains* exploits Robert's
typical vocabulary of fictive niches, arches, coffered vaults, colonnades, majestic stair-
wells, and Roman statuary to create a fantasy of expansive space. The four paintings
are inhabited by tiny figures in the foreground; these serve only to set the scale and
animate the scene, for the ruins themselves are the true subject of the pictures. In his
use of ruins, Robert embodied the notion of the relationship of man and his works
to nature that was expressed by the French philosopher and encyclopedist Denis
Diderot: "Everything vanishes, everything dies, only time endures."

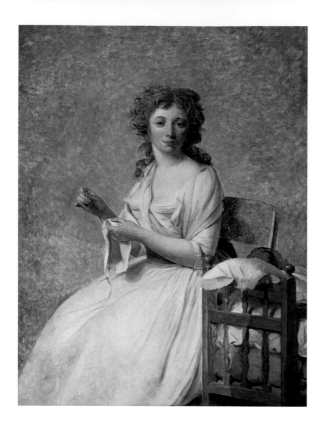

JACQUES-LOUIS DAVID French, 1748–1825

Madame de Pastoret and Her Son, 1791–92

Oil on canvas; 129.8 x 96.6 cm (51 ⅛ x 38 in.)

Clyde M. Carr Fund; Major Acquisitions Endowment, 1967.228

The volatile events leading to the French Revolution make the date of Jacques-Louis David's warm, fresh portrait of Adélaïde de Pastoret impossible to determine with certainty. They also probably account for the portrait's unfinished state. David, a renowned Neoclassical painter, was at the time an ardent revolutionary; Madame de Pastoret was the wife of a staunch royalist. The sittings must have occurred after the birth, early in 1791, of her son, who is portrayed asleep by her side, and before her brief imprisonment during the Reign of Terror in 1792. Here David completed the stippled, almost monochromatic underpainting but did not create the stark, enamel-smooth surface that is characteristic of his finished paintings. He did not even get far enough to place a needle and thread in Madame de Pastoret's hand. Nevertheless, this large portrait of unaffected domesticity captures the youthful mother with charm as well as dignity and displays David's skill as a portraitist. Objecting to David's revolutionary ideals, Madame de Pastoret (who became the marquise de Pastoret in 1817) refused the painting during the artist's lifetime. After David's death, she had her son, by then an adult (see p. 221), purchase the portrait from the artist's estate.

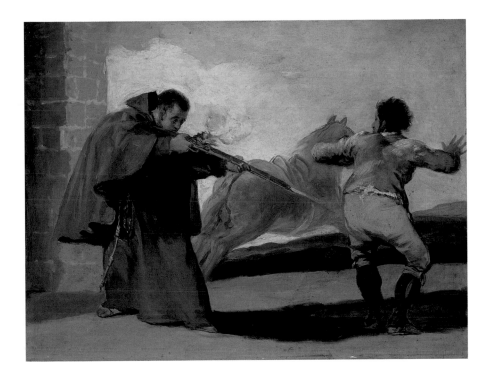

FRANCISCO DE GOYA Y LUCIENTES Spanish, 1746–1828
Monk Pedro de Zaldivia Shoots the Bandit Maragato, 1806/07
Oil on panel; 29.2 x 38.5 cm (11 ½ x 15 ⅝ in.)
Mr. and Mrs. Martin A. Ryerson Collection, 1933.1075

When the dreaded bandit Maragato was seized in 1806 by the humble monk Pedro de Zaldivia, a lay brother of a Franciscan barefoot order, the story swept through Spain. Not only did daily newspapers and pamphlets publicize it, but songs, ballads, and popular prints also praised the heroic deed. Although at the time Francisco de Goya was chief painter to the Spanish king, he was interested in the whole range of human experience, including contemporary Spanish events. The tale of Zaldivia and Maragato evidently captured his imagination. This small, lively painting belongs to a series of six in the Art Institute, which, like a modern-day comic strip, dramatically illustrates the event. This is the climactic scene, presenting the bandit's degrading and not unhumorous downfall at the hands of the brave monk. Here, as in all the panels, Goya's broad, quick brushwork dispenses with unnecessary detail to pinpoint the essential drama of the event. Goya probably made these paintings for his own interest rather than for a commission, since they were still listed among his possessions in an 1812 inventory.

ANTONIO CANOVA Italian, 1757–1822
Bust of Paris, 1809
Marble; h. 66 cm (26 in.)
Harold Stuart Endowment; restricted gift of Mrs. Harold T. Martin, 1984.530

The enormously popular Neoclassical sculptor Antonio Canova frequently made
replicas or variants of his major works to satisfy the demand for his art. While
executing a commission from Empress Josephine of France for a full-length statue
of Paris (State Hermitage Museum, St. Petersburg), Canova carved this bust for
his friend Antoine Quatremère de Quincy, a French Neoclassical theorist and critic
who greatly influenced the sculptor's artistic ideals. It depicts the moment in Greek
mythology when the shepherd Paris, called upon by Zeus to judge who was the
most beautiful among Hera, Athena, and Aphrodite, turns to gaze at the three
goddesses. Canova exploited the subject to create an ideal head, balancing the
geometry of pure forms with the sensuousness of Paris's expression. Upon receipt
of the gift, Quatremère stated: "There is in [the bust] a mixture of the heroic and
the voluptuous, the noble and the amorous. I do not believe that in any other
work you have ever combined such life, softness, and chaste purity." Documents
indicate that Canova made four full-length marble statues and at least seven busts
of Paris, a clear indication of the sculpture's public success.

JEAN-AUGUSTE-DOMINIQUE INGRES French, 1780–1867

Amédée-David, Comte de Pastoret, 1823–26

Oil on canvas; 103 x 83.5 cm (40 ½ x 32 ¾ in.)

Bequest of Dorothy Eckhart Williams; Robert Allerton, Bertha E. Brown, and Major Acquisitions endowments, 1971.452

Jean-Auguste-Dominique Ingres, who championed Classical ideals throughout his long and productive career, began this portrait in 1823, the same year that the thirty-two-year-old count helped him become a full member of the French Academy. Ingres astutely captured the character of the suave young nobleman, from the refined line of his silhouette to his elegant costume, long fingers, and slightly swaggering pose. The artist's fastidious, impeccable technique is particularly evident in the precisely rendered details of the sword hilt and the badge of the Order of the Legion of Honor, which the count received in 1824. Ingres studied in the prestigious atelier of Jacques-Louis David; although he considered himself a history painter, portraits such as this paid his bills for many years and earned him considerable praise. This work was in progress at about the same time that the count acquired a painting of his mother by David at the artist's posthumous sale (see p. 218). In 1897 *Amédée-David, Comte de Pastoret* was purchased by the painter Edgar Degas, an avid art collector and admirer of Ingres who succeeded the older artist as the greatest French portrait painter of his generation.

EUGÈNE DELACROIX French, 1798–1863

The Combat of the Giaour and Hassan, 1826

Oil on canvas; 59.6 x 73.4 cm (23 ½ x 28 ⅞ in.)

Gift of Bertha Palmer Thorne, Rose Movius Palmer, Mr. and Mrs. Arthur M. Wood, and Mr. and Mrs. Gordon Palmer, 1962.966

The Combat of the Giaour and Hassan is among Eugène Delacroix's finest early representations of battle. The painting was inspired by "The Giaour," a lengthy poem by England's most famous Romantic poet, Lord Byron. Written in 1813 and translated into French in 1824, the poem presents a subject and setting—passion avenged on an exotic battlefield in Greece—that perfectly suited the artist's Romantic imagination. The painting depicts the poem's dramatic climax, when the Venetian giaour (a Christian infidel), his eyes bloodshot, avenges his lover's death at the hands of a Turk called Hassan. Weapons poised, the two enemies face off in mirroring poses: the giaour in swirling white, and Hassan with his face hidden. With its exotic costumes, intense drama, and forceful colors and forms, this painting is the most revered of the six known versions Delacroix made based on Byron's poem. Begun in 1824, the year Byron died in the struggle for Greek independence from the Turks, Delacroix finished the painting two years later, just in time for it to be included in a Parisian exhibition benefiting the popular Greek cause.

CARL BLECHEN German, 1798–1840
The Interior of the Palm House on the Pfaueninsel near Potsdam, 1834
Oil on canvas; 135 x 126 cm (52 ½ x 50 in.)
Through prior acquisitions of the George F. Harding Collection; L. L. and A. S. Coburn and Alexander
A. McKay endowments; through prior gift of William Wood Prince; through prior acquisitions of
the Charles H. and Mary F. S. Worcester Collection, 1996.388

Carl Blechen is regarded as a pivotal figure in nineteenth-century German painting; his short career marks the transition from Romanticism to a more realistic view of nature. Although he is best known for scenes in which a carefully observed Italian landscape served as the backdrop for mysterious or nostalgic figures, *The Palm House* represents an important detour in his work. In 1832 Blechen was commissioned by Friedrich Wilhelm III of Prussia (r. 1797–1840) to paint two views of an exotic pleasure building recently constructed near Potsdam. The architect Karl Friedrich Schinkel designed the Palm House to contain the king's collection of palms. It was situated on the Pfaueninsel, or Peacock Island, a favorite royal retreat dotted with whimsical buildings such as a tiny castle and a Gothic dairy. Blechen's painting is both a record of the appearance of the building, with its lush palms and fragments of an Indian temple, and an evocation of a fantasy world peopled by beautiful Asiatic women, purposefully playing to the viewer's imagination. After completing two exquisite, small paintings for the king, Blechen made this grand version for public viewing. *The Palm House* was one of the artist's most ambitious statements, for he soon succumbed to melancholy and madness.

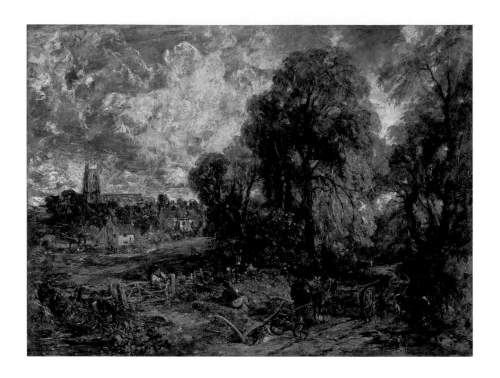

JOHN CONSTABLE English, 1776–1837
Stoke-by-Nayland, 1836
Oil on canvas; 126 x 169 cm (49 ⁵/₈ x 66 ¹/₂ in.)
Mr. and Mrs. W. W. Kimball Collection, 1922.4453

Stoke-by-Nayland depicts the subject matter that the landscape painter John Constable explored throughout his life: the Suffolk countryside of his youth. Constable based his landscapes on countless studies and sketches that he often took back to his London studio to expand and then finish. Of *Stoke-by-Nayland,* he wrote to a friend: "What say you to a summer morning? July or August, at eight or nine o'clock, after a slight shower during the night." To achieve the effect of sparkling wetness and a freshness of earth and air, Constable painted as much with a palette knife as with a brush, flecking the surface with white highlights and sketching and scraping the picture into existence. The deliberate ruggedness of his style echoes nature's rough spontaneity. The unpolished execution is reminiscent of the full-scale sketches in oil that Constable made for earlier exhibition paintings; however, no more fully treated version is known, and the rich color suggests that this is a finished work, done in the artist's late style. Constable's emphasis on surface brushwork and texture in his effort to record the constantly shifting effects of natural light on land and sky exerted enormous influence on French artists like Eugène Delacroix and a younger generation of French painters, the Impressionists.

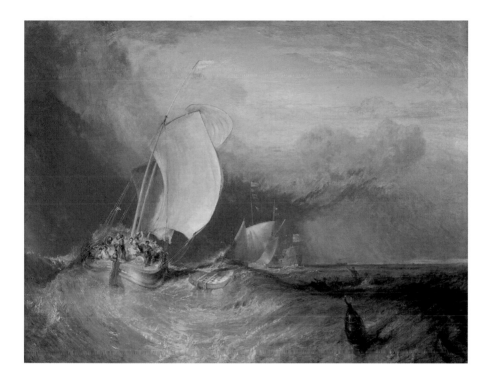

JOSEPH MALLORD WILLIAM TURNER English, 1775–1851
Fishing Boats with Hucksters Bargaining for Fish, 1837/38
Oil on canvas; 174.5 x 224.9 cm (68 ³/₄ x 88 ¹/₂ in.)
Mr. and Mrs. W. W. Kimball Collection, 1922.4472

In *Fishing Boats with Hucksters Bargaining for Fish,* Joseph Mallord William Turner translated his enduring preoccupation with the sea into a dramatic vision. The subject itself and the painting's low horizon line derive directly from seventeenth-century Dutch sea painting. But where the boats in the seascapes of the period are almost reconstructible in their exactness, Turner's minimal and more impressionistic depiction of vessels is secondary to the drama of roiling seas, billowing sails, and a threatening sky. With just a few figurative details, Turner roughly sketched in the standing, gesturing figure on the right, who is negotiating to buy fish from the larger, crowded fishing boat on the left. Between them is a mythical golden boat that seems to spring from the artist's imagination, and on the distant horizon is the suggestion of progress, a steam-driven vessel. With his manipulation of translucent and opaque pigments to create a sense of atmosphere and light, Turner alluded to the insignificance of man in the face of nature's mysterious and sublime power.

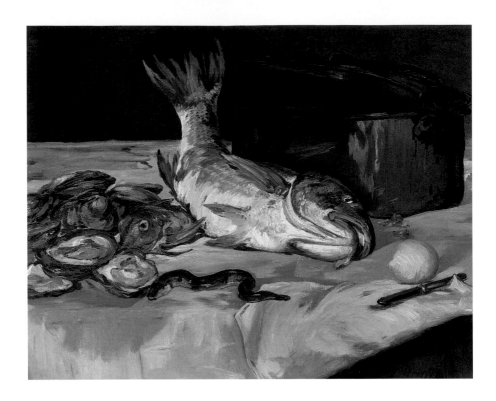

ÉDOUARD MANET French, 1832–1883
Fish (Still Life), 1864
Oil on canvas; 73.4 x 92.1 cm (28 ⅞ x 36 ¼ in.)
Mr. and Mrs. Lewis Larned Coburn Memorial Collection, 1942.311

Although still-life ensembles were an important element in many of the major paintings of the avant-garde artist Édouard Manet, his most sustained interest in the genre itself was from 1864 to 1865, when *Fish* was painted. Manet's focus on still lifes coincided with the gradual reacceptance of the genre during the nineteenth century, due in part to the growth of the middle class, whose tastes ran to intimate, moderately priced works. This painting, like many of Manet's still-life compositions, recalls seventeenth-century Dutch models. The directness of execution, bold brushwork, and immediacy of vision displayed in the canvas, however, suggest why the public found Manet's work so unorthodox and confrontational. While *Fish* is indeed an image of "dead nature" (*nature morte* is the French term for still life), there is nothing still about the work: the produce seems fresh and the handling of paint vigorous. Further enlivening the composition is the placement of the carp, which offsets the strong diagonal of the other elements. Manet never submitted his still lifes to the official French Salon, but rather sold them through the burgeoning network of art galleries in Paris and gave them to friends.

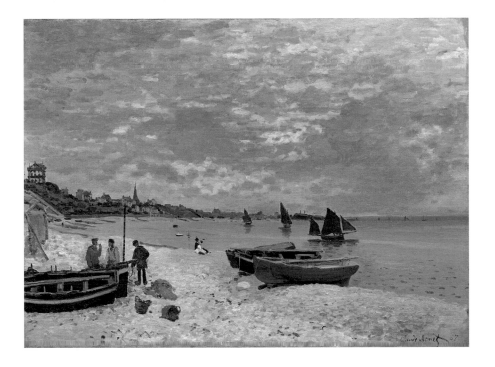

CLAUDE MONET French, 1840–1926
The Beach at Sainte-Adresse, 1867
Oil on canvas; 75.8 x 102.5 cm (29 ¹³/₁₆ x 40 ¹⁵/₁₆ in.)
Mr. and Mrs. Lewis Larned Coburn Memorial Collection, 1933.439

In the summer of 1867, Claude Monet stayed with his aunt at Sainte-Adresse, an affluent suburb of the port city of Le Havre, near his father's home. The paintings he produced that summer, few of which survive, reveal the beginnings of the young artist's development of the revolutionary style that would come to be known as Impressionism. In his quest to capture the effects of shifts in weather and light, Monet painted *The Beach at Sainte-Adresse* out-of-doors on an overcast day. He devoted the majority of the composition to the sea, sky, and beach. These he depicted with broad sheets of color, animated by short brushstrokes that articulate gentle azure waves, soft white clouds, and pebbled ivory sand. While fishermen go about their chores, a tiny couple relaxes at the water's edge. Monet did not exhibit this work publicly for almost ten years after he completed it. In 1874 he banded together with a diverse group of like-minded, avant-garde artists to mount the first of what would be eight independent exhibitions. He included *Sainte-Adresse* in the second of these Impressionist shows, in 1876.

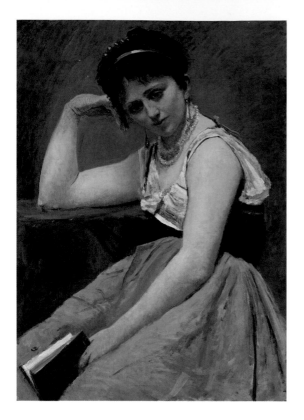

JEAN-BAPTISTE-CAMILLE COROT French, 1796–1875
Interrupted Reading, c. 1870
Oil on canvas, mounted on board; 92.5 x 65.1 cm (36 ³/₈ x 25 ⁵/₈ in.)
Potter Palmer Collection, 1922.410

Interrupted Reading is among the most compelling of Camille Corot's late figure paintings. Corot almost never exhibited these studies of the human form, preferring instead to publicize the idyllic landscapes that were his specialty. To emphasize the private nature of *Interrupted Reading*, Corot enclosed his model within the protective environment of the artist's studio. The mood of the painting is introspective and somewhat melancholic, the very essence of the Romantic sensibility. The muselike image of a woman reading a book was a popular one in nineteenth-century art, but Corot chose to show his model pausing, looking up from this activity. Having spent a number of years in Italy, and being a lover of everything Italian, the artist often furnished his models with Italianate costumes such as the one worn here. Whereas Corot's subject matter is traditional, his technique is not. With direct and bold brushwork, he explored the human form as a construction of masses that support and balance one another. This broad handling is complemented by the artist's obvious delight in detail—the ribbon in the model's hair, the delicate earrings, the deep folds in the skirt. Here he combined a profound sense of formal structure with the dreamy softness and intimacy that characterize his most famous landscapes.

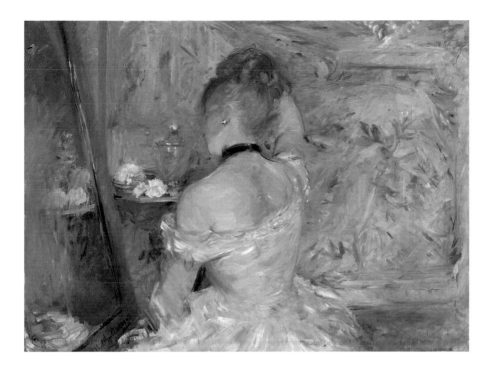

BERTHE MORISOT French, 1841–1895
Woman at Her Toilette, 1875/80
Oil on canvas; 60.3 x 80.4 cm (23 ¾ x 31 ⅝ in.)
Stickney Fund, 1924.127

Consistent with the Impressionist aesthetic that Berthe Morisot fervently espoused, *Woman at Her Toilette* attempts to capture the essence of modern life in summary, understated terms. The painting also moves discreetly into the realm of female eroticism explored by Edgar Degas, Édouard Manet, and Pierre-Auguste Renoir but seldom broached at this time by women artists. Rendered with soft, feathery brushstrokes in nuanced shades of lavender, pink, blue, white, and gray, the composition resembles a visual tone poem, orchestrated with such perfumed and rarified motifs as brushed blonde hair, satins, powder puffs, and flower petals. The artist even signed her name along the bottom of the mirror, as if to suggest that the image in her painting is as ephemeral as a silvery reflection. Morisot exhibited in seven of the eight Impressionist group shows; this painting was included in the fifth exhibition, in 1880, where her work received high acclaim. She was a particularly close friend of and frequent model for Manet, and she married his younger brother Eugène the year before she completed this painting. In addition to domestic interiors such as this one, Morisot's pictorial realm included studies of women and children, gardens, fields, and vacation homes by the sea.

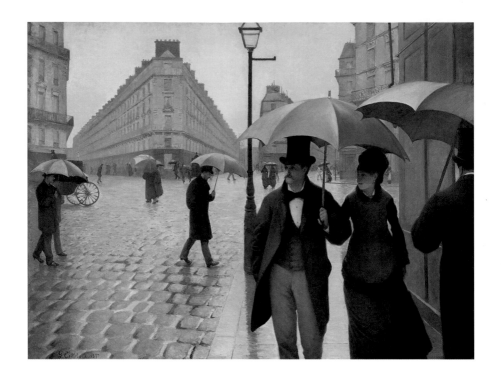

GUSTAVE CAILLEBOTTE French, 1848–1894
Paris Street; Rainy Day, 1877
Oil on canvas; 212.2 x 276.2 cm (83 ¹/₂ x 108 ³/₄ in.)
Charles H. and Mary F. S. Worcester Collection, 1964.336

This complex intersection, just minutes away from the Saint-Lazare train station, represents in microcosm the changing urban milieu of late-nineteenth-century Paris. Gustave Caillebotte grew up near this district when it was a relatively unsettled hill with narrow, crooked streets. As part of a new city plan designed by Baron Georges-Eugène Haussmann, these streets were relaid and their buildings razed during the artist's lifetime. In this monumental urban view, which measures almost seven by ten feet and is considered the artist's masterpiece, Caillebotte strikingly captured a vast, stark modernity, complete with life-size figures strolling in the foreground and wearing the latest fashions. The painting's highly crafted surface, rigorous perspective, and grand scale pleased Parisian audiences accustomed to the academic aesthetic of the official Salon. On the other hand, its asymmetrical composition, unusually cropped forms, rain-washed mood, and candidly contemporary subject stimulated a more radical sensibility. For these reasons, the painting dominated the celebrated Impressionist exhibition of 1877, largely organized by the artist himself. In many ways, Caillebotte's frozen poetry of the Parisian bourgeoisie prefigures Georges Seurat's luminous *Sunday on La Grande Jatte—1884* (see p. 236), painted less than a decade later.

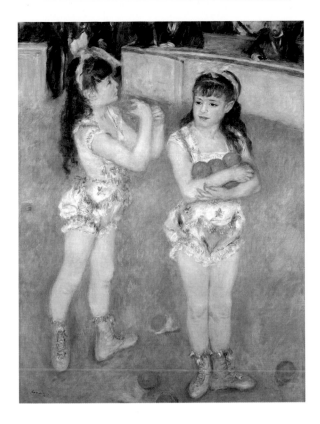

PIERRE-AUGUSTE RENOIR French, 1841–1919
Acrobats at the Cirque Fernando (Francisca and Angelina Wartenberg), 1879
Oil on canvas; 131.5 x 99.5 cm (51 ¾ x 39 ⅛ in.)
Potter Palmer Collection, 1922.440

The two little circus girls in this painting are Francisca and Angelina Wartenberg, who performed as acrobats in the famed Cirque Fernando in Paris. Although they were depicted in the center of a circus ring, the sisters actually posed in costume in Pierre-Auguste Renoir's studio, enabling him to paint them in daylight. Here he portrayed them just as they have finished their act and are taking their bows. One sister turns to the crowd, acknowledging its approval, while the other faces the viewer with an armful of oranges, a rare treat that the audience has tossed in tribute. Although *Acrobats at the Cirque Fernando* reflects the artist's enchantment with the innocence of childhood—he has enveloped the girls in a virtual halo of pinks, oranges, yellows, and whites—the partially visible, darkly clothed (mainly male) spectators allude to the less wholesome, nocturnal demimonde of the nineteenth-century circus in which these two young performers grew up. The famed Chicago collector Mrs. Potter Palmer purchased *Acrobats at the Cirque Fernando* in 1892 and was so enamored of the picture that she kept it with her at all times, even on her travels abroad.

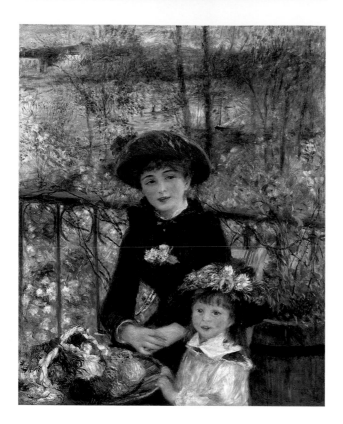

PIERRE-AUGUSTE RENOIR French, 1841–1919
Two Sisters (On the Terrace), 1881
Oil on canvas; 100.5 x 81 cm (39 ⁹/₁₆ x 31 ⁷/₈ in.)
Mr. and Mrs. Lewis Larned Coburn Memorial Collection, 1933.455

"He loves everything that is joyous, brilliant, and consoling in life," an anonymous
interviewer once wrote about Pierre-Auguste Renoir. This may explain why *Two Sisters
(On the Terrace)* is one of the most popular paintings in the Art Institute. Here Renoir
depicted the radiance of lovely young women on a warm and beautiful day. The older
girl, wearing the female boater's blue flannel, is posed in the center of the evocative
landscape backdrop of Chatou, a suburban town where the artist spent much of the
spring of 1881. She gazes absently beyond her younger companion, who seems, in a
charming visual conceit, to have just dashed into the picture. Technically, the painting
is a tour de force: Renoir juxtaposed solid, almost life-size figures against a land-
scape that—like a stage set—seems a realm of pure vision and fantasy. The sewing
basket in the left foreground evokes a palette, holding the bright, pure pigments that
the artist mixed, diluted, and altered to create the rest of the painting. Although the
girls were not actually sisters, Renoir's dealer showed the work with this title, along
with *Acrobats at the Cirque Fernando* (see p. 231) and others, at the seventh Impres-
sionist exhibition, in 1882.

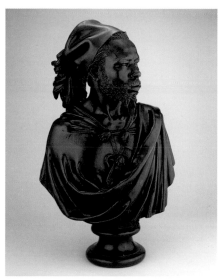

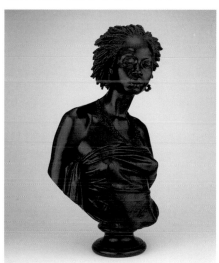

CHARLES HENRI JOSEPH CORDIER

French, 1827–1905

Bust of Said Abdullah of the Darfour People, 1848

Bronze; h. 82.5 cm (32 ½ in.) (with socle)

Bust of an African Woman, 1851

Bronze; h. 71.7 cm (31 in.) (with socle)

Ada Turnbull Hertle Endowment, 1963.839–40

Charles Henri Joseph Cordier was still a student of French sculptor François Rude when his plaster-cast version of the clay portrait he had modeled of a Sudanese man was accepted to the Paris Salon. Exhibited in the same year that France extended full emancipation to all residents, including those in its African colonies and territories, Cordier's sculpture was seen as embodying the Romantic ideals of individual liberty. Its detailed realism (including the individual strands of tassels and hair) appealed to the public's growing interest in ethnographic accuracy, while its strong features and dignified expression matched the European tradition for expressing moral and physical purity. Two years later, Cordier created a female portrait that was equally acclaimed as a blend of realism (the model wears a patterned wrap, heavy earrings, and coral necklace, all associated with East Africa) and idealism (in the sitter's regal and aristocratic bearing). In 1851 casts of both sculptures were commissioned for the anthropological gallery of the National History Museum in Paris, and for the International Exhibition in London, sealing their fate as companion pendants. While Cordier came to specialize in ethnographic sculpture and made several trips to North Africa during his lifetime, it is by these two works that he is best remembered.

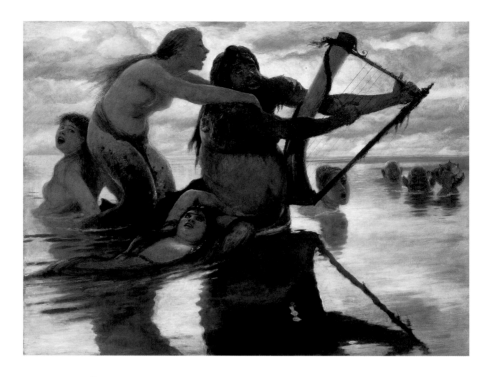

ARNOLD BÖCKLIN Swiss, 1827–1901
In the Sea, 1883
Oil on panel; 86.5 x 115 cm (34 ¼ x 45 ½ in.)
Joseph Winterbotham Collection, 1990.443

Arnold Böcklin's art had little in common with Impressionism or the academic art of his time. Instead, his depictions of demigods in naturalistic settings interpret themes from Classical mythology in an idiosyncratic, often sensual manner. *In the Sea*, part of a series of paintings of mythological subjects, displays an unsettling, earthy realism. Mermaids and tritons frolic in the water with a lusty energy and abandon verging on coarseness. Occupying the center of the composition is a harp-playing triton. Three mermaids have attached themselves to his huge frame as if it were a raft; the one near his shoulder seems to thrust herself upon him. The work's sense of boisterousness is tempered by the ominously shaped reflection of the triton and mermaids in the sea and by the oddness of the large-eared heads that emerge from the water at the right. In addition to imaginative, bizarre interpretations of the Classical world, Böcklin painted mysterious landscapes punctuated by an occasional lone figure. These haunting later works made him an important contributor to the international Symbolist movement. They also appealed to some Surrealist artists, particularly Giorgio di Chirico (see p. 257), who declared, "Each of [Böcklin's] works is a shock."

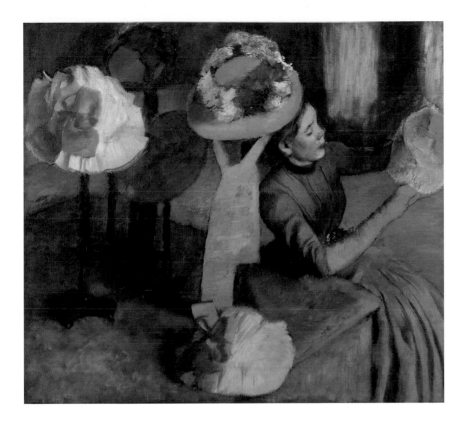

HILAIRE-GERMAIN-EDGAR DEGAS French, 1834–1917
The Millinery Shop, 1879/86
Oil on canvas; 100 x 110.7 cm (39 3/8 x 43 9/16 in.)
Mr. and Mrs. Lewis Larned Coburn Memorial Collection, 1933.428

Of at least fifteen pastels, drawings, and paintings that Edgar Degas created on this
subject during the 1880s, *The Millinery Shop* is the largest and perhaps the most
ambitious. As a result of its unusual cropping and tilted perspective, it seems to capture
an unedited glimpse of the interior of a small nineteenth-century millinery shop. The
identity of the young woman in the painting remains unclear: she may be a shop girl
or a customer. In an early version of the composition, the woman is clearly intended
to be a customer; she wears a fashionable dress, though her hat—a prerequisite token
of bourgeois culture—is absent. In the final painting, however, the woman appears
with her mouth pursed, as if around a pin, and her hands gloved, possibly to protect
the delicate fabric of the hat she holds. Degas seems to have deliberately left her role
as a creator or consumer ambiguous. She is totally absorbed in her activity and, like
most of the women in Degas's paintings, seems unaware of being watched. The
bonnets that are displayed on the table next to her like a still life present an analogy
to the artist's creative process: where they are unfinished, so too is the painting.

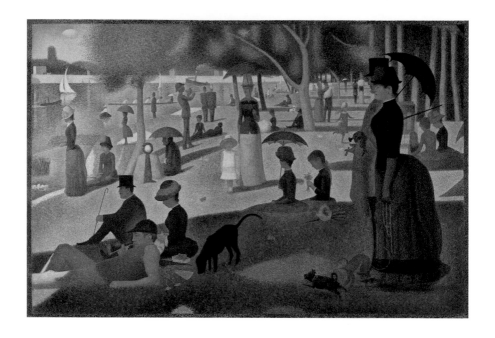

GEORGES SEURAT French, 1859–1891
A Sunday on La Grande Jatte—1884, 1884–86
Oil on canvas; 207.5 x 308.1 cm (81 $^3/_4$ x 121 $^1/_4$ in.)
Helen Birch Bartlett Memorial Collection, 1926.224

"Bedlam," "scandal," and "hilarity" were among the epithets used to describe what
is now considered Georges Seurat's greatest work, and one of the most remarkable
paintings of the nineteenth century, when it was first exhibited in Paris. Seurat labored
extensively over *A Sunday on La Grande Jatte—1884,* reworking the original as well
as completing numerous preliminary drawings and oil sketches (the Art Institute has
one such sketch and two drawings). With what resembles scientific precision, the
artist tackled the issues of color, light, and form. Inspired by research in optical and
color theory, he juxtaposed tiny dabs of colors that, through optical blending, form a
single and, he believed, more brilliantly luminous hue. To make the experience of the
painting even more intense, he surrounded the canvas with a frame of painted dashes
and dots, which he, in turn, enclosed with a pure white wood frame, similar to the one
with which the painting is exhibited today. The very immobility of the figures and
the shadows they cast makes them forever silent and enigmatic. Like all great master-
pieces, *La Grande Jatte* continues to fascinate and elude.

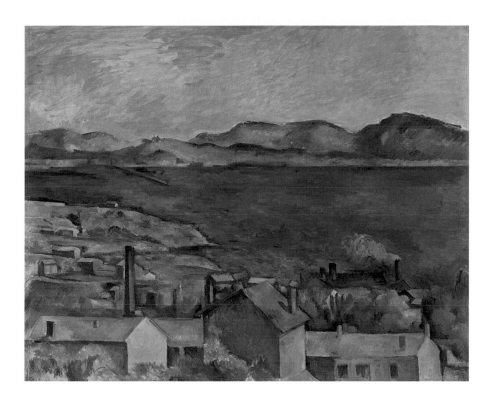

PAUL CÉZANNE French, 1839–1906
The Bay of Marseilles, Seen from L'Estaque, c. 1885
Oil on canvas; 80.2 x 100.6 cm (31 ⅝ x 39 ⅝ in.)
Mr. and Mrs. Martin A. Ryerson Collection, 1933.1116

In a letter to his friend and teacher Camille Pissarro, Paul Cézanne compared the view of the sea from L'Estaque to a playing card, with its simple shapes and colors. The landscape's configuration and color fascinated him. This painting is one of more than a dozen such vistas created by the artist during the 1880s. Cézanne divided the canvas into four zones—architecture, water, mountain, and sky. Although these four elements are seen repeatedly in Impressionist paintings, Cézanne's work is very different from that of his fellow artists. Whereas their primary purpose was to record the transient effects of light, Cézanne was interested in the underlying structure and composition of the views he painted. Filling the canvas with shapes defined by strong, contrasting colors and a complex grid of horizontal, vertical, and diagonal lines, he created a highly compact, dynamic pattern of water, sky, land, and village that at once refers back to traditionally structured landscape paintings and looks forward to the innovations of Cubism. Using blocklike brushstrokes to build the space, Cézanne created a composition that seems both two- and three-dimensional. Not locked tightly in place, his forms appear to touch and shift continually, creating a sense of volume and space that strengthens the composition and brings it to life.

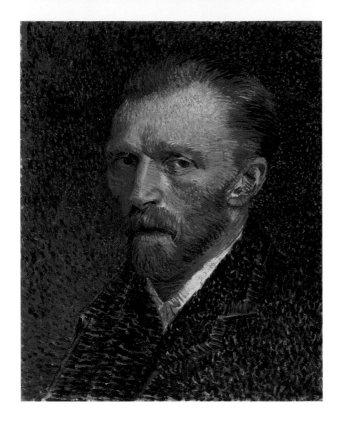

VINCENT VAN GOGH Dutch, 1853–1890
Self-Portrait, 1887
Oil on artist's board, mounted on cradled panel; 41 x 32.5 cm (16 ⅛ x 13 ¼ in.)
Joseph Winterbotham Collection, 1954.326

In 1886 Vincent van Gogh left his native Holland and settled in Paris, where his beloved brother, Theo, was a dealer in paintings. Van Gogh created at least twenty-four self-portraits during his two-year stay in the energetic French capital. This early example is modest in size and was painted on prepared artist's board rather than canvas. Its densely dabbed brushwork, which became a hallmark of Van Gogh's style, reflects the artist's response to Georges Seurat's revolutionary pointillist technique in *A Sunday on La Grande Jatte—1884* (see p. 236). But what was for Seurat a method based on the cool objectivity of science became in Van Gogh's hands an intense emotional language. The surface of the painting dances with particles of color—intense greens, blues, reds, and oranges. Dominating this dazzling array of staccato dots and dashes are the artist's deep green eyes and the intensity of their gaze. "I prefer painting people's eyes to cathedrals," Van Gogh once wrote to Theo. "However solemn and imposing the latter may be—a human soul, be it that of a poor streetwalker, is more interesting to me." From Paris, Van Gogh traveled to the southern town of Arles for fifteen months (see p. 240). At the time of his death, in 1890, he had actively pursued his art for only five years.

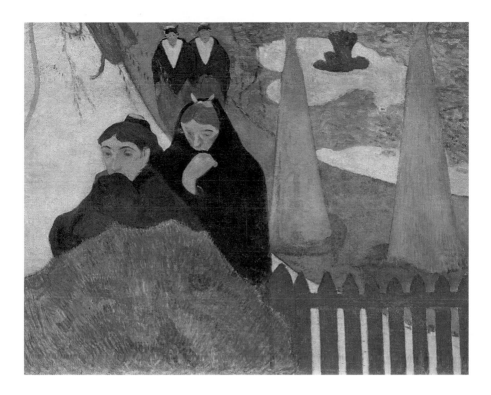

PAUL GAUGUIN French, 1848–1903
Arlésiennes (Mistral), 1888
Oil on jute; 73 x 92 cm (28 ³/₄ x 36 ³/₁₆ in.)
Mr. and Mrs. Lewis Larned Coburn Memorial Collection, 1934.391

One of seventeen canvases that Paul Gauguin completed during a brief and tumultuous visit with Vincent van Gogh in Arles (see p. 240), this powerful and enigmatic painting depicts the public garden directly across from Van Gogh's residence, the Yellow House. Not only is the careful planning of the composition in marked contrast to the spontaneity seen in Van Gogh's depiction of the same scene (State Hermitage Museum, St. Petersburg), but everything about the painting—its large, flat areas of color; arbitrary handling of space; and enigmatic silhouettes—also exemplifies the deliberateness with which Gauguin sought pictorial harmony and symbolic content in his work. Here four women wrapped in shawls slowly stroll through the garden. The two closest to the viewer avert their gazes and curiously cover their mouths. Their somber outlines echo the two orange cones, which probably represent shrubs wrapped against the frost. The bench along the upper-left path rises steeply, defying logical perspective. Equally puzzling is the mysterious bush on the left, in which Gauguin consciously embedded forms that suggest eyes and a nose, creating the impression of a strange, watchful presence. With its aura of repressed emotion and elusive meaning, *Arlésiennes (Mistral)* explores the ambiguities, mysteries, and emotions that Gauguin believed underlie appearances.

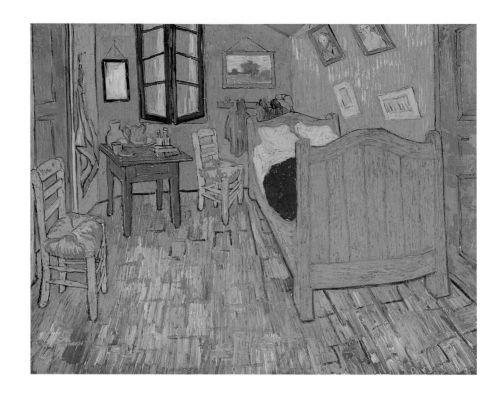

VINCENT VAN GOGH Dutch, 1853–1890
The Bedroom, 1889
Oil on canvas; 73.6 x 92.3 cm (29 x 36 ⅝ in.)
Helen Birch Bartlett Memorial Collection, 1926.417

"Looking at the picture ought to rest the brain, or rather the imagination," Vincent van
Gogh wrote to his brother, Theo, before painting this bedroom scene. The work
was part of a decorating scheme for his new house in Arles, which Van Gogh dubbed
the "Studio of the South" with the hope that friends and artists would join him there.
He produced a considerable number of paintings during his fifteen months in Arles
(from February 1888 to May 1889), including *The Bedroom*. But, with the exception
of Paul Gauguin's two-month visit, the artists' colony he envisioned never materialized.
 The vivid palette, dramatic perspective, and dynamic brushwork of this painting
hardly express the "absolute restfulness" of which Van Gogh spoke. Pictures tilt off
the wall, and a blood red quilt covers the looming bed. The sun-drenched space
seems ready to burst with an overwhelming sense of intense, nervous vitality. Van Gogh
liked this image so much that he painted three versions. He executed the first (Van
Gogh Museum, Amsterdam) in October 1888, right before Gauguin's visit, and the
second, the Art Institute's work, in September 1889, during a year of voluntary
confinement at the asylum of Saint Paul in Saint-Rémy. At the same time, Van Gogh
also painted a smaller copy for his mother and two sisters (Musée d'Orsay, Paris).

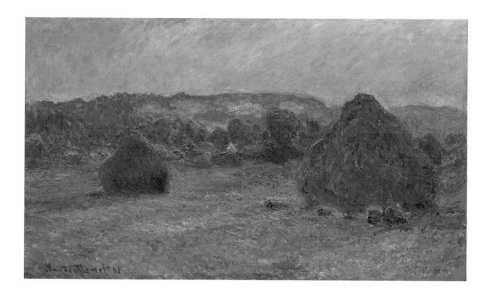

CLAUDE MONET French, 1840–1926
Stacks of Wheat (End of Summer), 1890/91
Oil on canvas; 60 x 100 cm (23 ⅝ x 39 ⅜ in.)
Gift of Arthur M. Wood, Sr., in memory of Pauline Palmer Wood, 1985.1103

The monumental stacks that Claude Monet depicted in his series *Stacks of Wheat* rose fifteen to twenty feet and stood just outside the artist's farmhouse at Giverny. Through 1890 and 1891, he worked on this series both in the field, painting simultaneously at several easels, and in the studio, refining pictorial harmonies. In May 1891, Monet hung fifteen of these canvases next to each other in one small room in the Galerie Durand-Ruel in Paris. An unprecedented critical and financial success, the exhibition marked a breakthrough in Monet's career, as well as in the history of French art. In this view, and in nearly all of the autumn views in the series, the conical tops of the stacks break the horizon and push into the sky. But in most of the winter views, which constitute the core of the series, the stacks seem wrapped by bands of hill and field, as if bedded down for the season. For Monet, the stack was a resonant symbol of sustenance and survival. He followed this group with further series depicting poplars, the facade of Rouen Cathedral, and, later, his own garden at Giverny (see p. 246). The Art Institute has the largest group of Monet's *Stacks of Wheat* in the world.

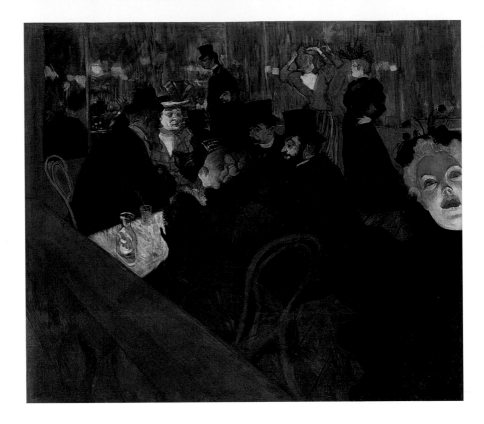

HENRI DE TOULOUSE-LAUTREC French, 1864–1901
At the Moulin Rouge, 1892/95
Oil on canvas; 123 x 141 cm (48 ⁷⁄₁₆ x 55 ¹⁄₂ in.)
Helen Birch Bartlett Memorial Collection, 1928.610

Henri de Toulouse-Lautrec memorialized Parisian nightlife at the end of the nine-
teenth century in his masterpiece *At the Moulin Rouge.* The painting is noted for its
daring composition, dramatic cropping, and flat planes of strident color. A regular
patron of the Moulin Rouge, one of the most famous cabarets of the Montmartre
district, Toulouse-Lautrec here turned his acute powers of observation on the club's
other habitués. The flaming red-orange hair of the entertainer Jane Avril is the focal
point of the central seated group. Preening in the greenish mirror in the background
is the dancer La Goulue. The stunted figure of the aristocratic artist appears, as it
often did in life, next to his devoted, much taller cousin, Dr. Gabriel Tapié de Céleyran.
But it is the frozen, acid green face of the dancer May Milton that dominates the
canvas and haunts the action. The painting comprises two joined parts: a small main
canvas and an L-shaped panel to the lower and right edges. The canvas was severed
after the artist's death, perhaps by his dealer (to make the composition less radical
and more saleable), and restored sometime before 1914.

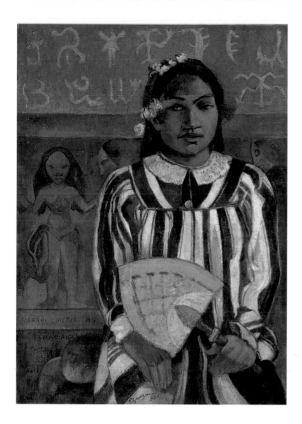

PAUL GAUGUIN French, 1848–1903
The Ancestors of Tehamana, or *Tehamana Has Many Parents (Merahi metua no Tehamana)*, 1893
Oil on canvas; 76.3 x 54.3 cm (30 ⅛ x 21 ⅜ in.)
Gift of Mr. and Mrs. Charles Deering McCormick, 1980.613

The nomadic Paul Gauguin yearned for the exotic and primitive, for cultures more spiritually pure than he believed his native France to be. This search took the former stockbroker to the French regions of Brittany and Provence, to Panama and Martinique, and finally to Tahiti and the Marquesas, where he spent all but two of the remaining years of his life. This stately portrait of Gauguin's young Tahitian "wife," Tehamana, is perhaps a farewell, since it was painted shortly before the artist made a two-year trip back to France. Elaborately dressed, her hair decorated with flowers, Tehamana is seated in front of a mysterious painted background reminiscent of a frieze on the wall of an ancient palace or temple. Two ripe mangoes—perhaps an offering or symbol of fertility—rest beside her hip. She points a fan, an emblem of beauty, toward the similarly frontal figure of a goddess, who also wears a red flower in her hair. The fan, flowers, fruit, and even Tehamana's glance suggest not only the strong, enigmatic bond between these two figures but also the connections between the present and the past, the corporeal and the spiritual, and the living and the dead.

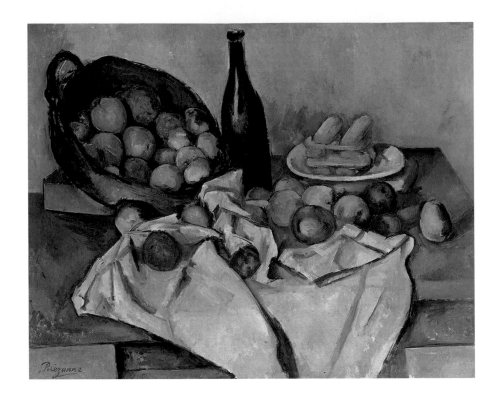

PAUL CÉZANNE French, 1839–1906
The Basket of Apples, c. 1893
Oil on canvas; 65 x 80 cm (25 ⁷/₁₆ x 31 ½ in.)
Helen Birch Bartlett Memorial Collection, 1926.252

Art, Paul Cézanne once claimed, is "a harmony running parallel to nature," not an imitation of nature. In his quest for underlying structure and composition, he recognized that the artist is not bound to represent real objects in real space. Thus, *The Basket of Apples* contains one of his signature tilted tables, an impossible rectangle with no right angles. On it, a basket of apples pitches forward from a slablike base, seemingly balanced by the bottle and the tablecloth's thick, sculptural folds. The heavy modeling, solid brushstrokes, and glowing colors give the composition a density and dynamism that a more realistic still life could never possess. This painting, one of Cézanne's rare signed works, was part of an important exhibition urged on the artist by the Parisian art dealer Ambroise Vollard in 1895. Since Cézanne had spent the majority of his career painting in isolation in his native Provence, this was the first opportunity in nearly twenty years for the public to see the work of the artist who is now hailed as the father of modern painting.

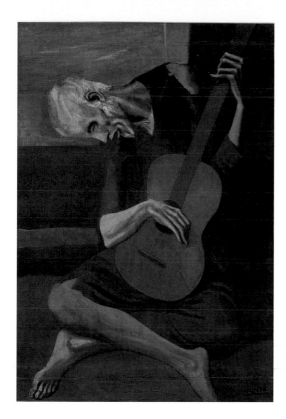

PABLO PICASSO Spanish, 1881–1973
The Old Guitarist, 1903–04
Oil on panel; 122.9 x 82.6 cm (48 ³/₈ x 32 ¹/₂ in.)
Helen Birch Bartlett Memorial Collection, 1926.253

Pablo Picasso produced *The Old Guitarist*, one of his most haunting images, while working in Barcelona. In the paintings of his Blue Period (1901–04), of which this is a prime example, Picasso restricted himself to a cold, monochromatic blue palette; flattened forms; and the emotional, psychological themes of human misery and alienation, which are related to the Symbolist movement and the work of such artists as Edvard Munch.

Picasso presented *The Old Guitarist* as a timeless expression of human suffering. The bent and sightless man holds his large, round guitar close to him; its brown body is the painting's only shift in color. The elongated, angular figure of the blind musician relates to Picasso's interest in the history of Spanish art and, in particular, the great sixteenth-century artist El Greco. Most personally, however, the image reflects the struggling twenty-two-year-old Picasso's sympathy for the plight of the downtrodden; he knew what it was like to be poor, having been nearly penniless during all of 1902. His works from this time depict the miseries of the destitute, the ill, and the outcasts of society.

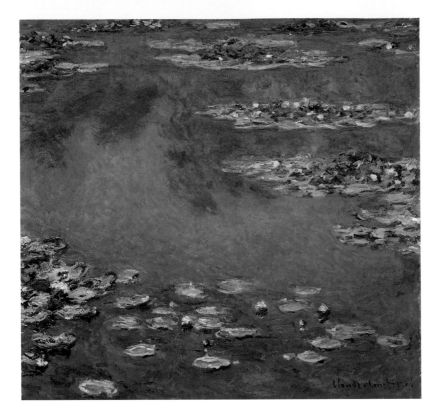

CLAUDE MONET French, 1840–1926
Water Lilies, 1906
Oil on canvas; 87.6 x 92.7 cm (34 ½ x 36 ½ in.)
Mr. and Mrs. Martin A. Ryerson Collection, 1933.1157

"One instant, one aspect of nature contains it all," said Claude Monet, referring to his late masterpieces, the water landscapes that he produced at his home in Giverny between 1897 and his death in 1926. These works replaced the varied contemporary subjects he had painted from the 1870s through the 1890s (see p. 241) with a single, timeless motif—water lilies. The focal point of these paintings was the artist's beloved flower garden, which featured a water garden and a smaller pond spanned by a Japanese footbridge. In his first water-lily series (1897–99), Monet painted the pond environment, with its water lilies, bridge, and trees neatly divided by a fixed horizon. Over time, the artist became less and less concerned with conventional pictorial space. By the time he painted *Water Lilies,* which comes from his third group of these works, he had dispensed with the horizon line altogether. In this spatially ambiguous canvas, the artist looked down, focusing solely on the surface of the pond, with its cluster of plants floating amidst the reflection of sky and trees. Monet thus created the image of a horizontal surface on a vertical one. Four years later, he further transcended the conventional boundaries of easel painting and began to make immense, unified compositions whose complex and densely painted surfaces seem to merge with the water.

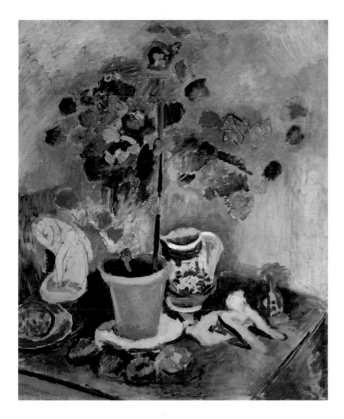

HENRI MATISSE French, 1869–1954
The Geranium, 1906
Oil on canvas; 100.3 x 81.5 cm (39 ½ x 32 ¹/₁₆ in.)
Joseph Winterbotham Collection, 1932.1342

Like his artistic hero, Paul Cézanne, Henri Matisse merged the traditional and the avant-garde. In *The Geranium*, he transformed a simple still life into a populated Arcadian landscape painting, rendered in the brilliant color, thick paint, and rapid brushwork characteristic of the group of painters known as the Fauves (wild beasts). Matisse was recognized by critics as the leader of this group.

This composition is one of contrasts the pale palette and light brushwork in the upper half of the picture are juxtaposed with the darker colored, heavily painted lower half; the firmly planted pose of the female figure is contraposed with the almost-fleeing figure of the male; and the red vegetables grown near Paris are set near ceramic objects from exotic, faraway places. One of many still-life paintings in which Matisse incorporated his own figurative sculptures, here the artist challenged his viewers' expectations by rendering his modeled figures with minimal color and simple lines. Probably represented as plaster casts, these figures would later be made in bronze editions by the artist; versions of *Woman Leaning on Her Hands* (on the right of the geranium) and *The Thorn Extractor* (on the left) are in the collection of the Art Institute.

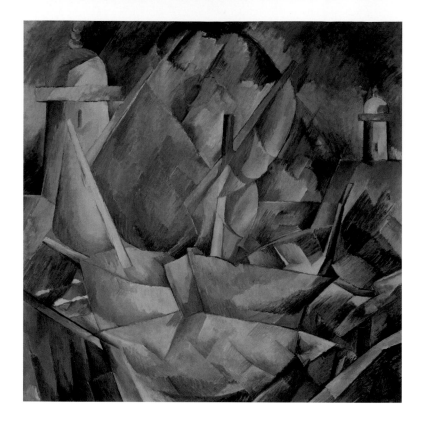

GEORGES BRAQUE French, 1882–1963
Little Harbor in Normandy, 1909
Oil on canvas; 81.1 x 80.5 cm (31 ¹⁵/₁₆ x 31 ¹¹/₁₆ in.)
Samuel A. Marx Purchase Fund, 1970.98

In early 1908, Georges Braque began an artistic collaboration with Pablo Picasso.
From 1909 until Braque was mobilized for World War I, they worked in creative
dialogue, breaking down and reformulating the representation of objects and their
structure. In doing so, they pioneered one of the most radical artistic revolutions
of the twentieth century, Cubism.

 Little Harbor in Normandy is the first fully realized example of Braque's early
Cubist style. He described the channel coast in severe geometries and a sober palette,
reduced in range and intensity to pale shades of color. His compressed treatment
of space and use of a shifting perspective seems to propel the two sailboats forward
to the front edges of the picture. To further energize the scene, Braque added a fringe
of whitecaps to the sea and dashes of clouds across the sky. His repetitive, striated
modeling of form, inspired by his study of the art of Paul Cézanne, increased the
rigid tension of this canvas. Documentation suggests that *Little Harbor in Normandy*
was exhibited in Paris in March 1909 at the Salon des Indépendants, making this
painting the first major Cubist work to be shown in such a prominent venue.

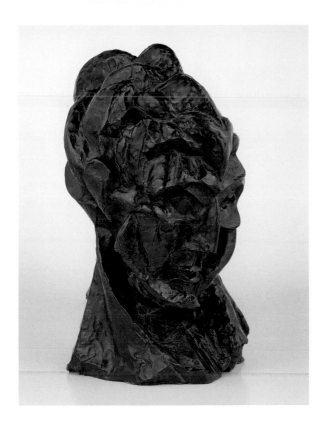

PABLO PICASSO Spanish, 1881–1973
Head of a Woman (Fernande), 1909
Bronze; 41 x 20.1 x 26.9 cm (16 1/8 x 9 7/8 x 10 9/16 in.)
Alfred Stieglitz Collection, 1949.584

This work is Pablo Picasso's first large Cubist sculpture and represents the distinctive physiognomy of Fernande Olivier, who was the artist's model and mistress from 1905 until 1912. Before making the bust, Picasso produced countless drawings and gouaches to explore the specific form and structure of his subject's facial features—her dark almond-shaped eyes, sharp nose, peaked upper lip, fleshy chin, and braided topknot. He also looked to African and ancient Iberian sculpture to guide his translation of Fernande's profile into the geometric language of Cubism. Converting his studies to three dimensions, Picasso simultaneously built up and cut away the clay as he worked, giving the surface a unifying rhythm of light and shadow. The resulting bronze retains the basic shape of Fernande's head, though the surface and structure are broken up into faceted, fragmented forms.

The Art Institute's bronze is one of a small edition produced by the Parisian art dealer Ambroise Vollard in 1910. It was sold in 1912 to the photographer and dealer Alfred Stieglitz, who published his own photographs of the work in his journal *Camera Work*. A year later, he loaned it to the landmark Armory Show, for which the Art Institute was the only museum venue.

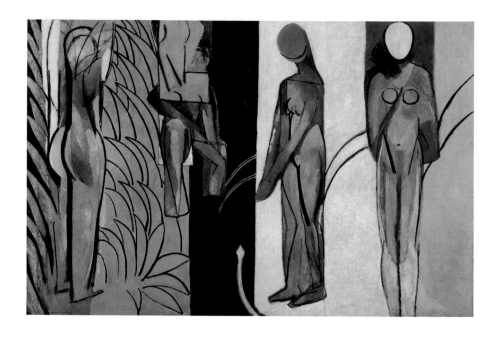

HENRI MATISSE French, 1869–1954
Bathers by a River, 1909–10, 1913, and 1916–17
Oil on canvas; 259.7 x 389.9 cm (102 ¼ x 153 ½ in.)
Charles H. and Mary F. S. Worcester Collection, 1953.158

Henri Matisse considered *Bathers by a River* to be one of the five most "pivotal" works of his career, and with good reason: it facilitated the evolution of the artist's style over the course of nearly a decade. Originally, the work was related to a 1909 commission by the Russian collector Sergei Shchukin, who wanted two large canvases to decorate the staircase of his Moscow home. Matisse proposed three pastoral images, though Shchukin decided to purchase only two works, *Dance II* and *Music* (State Hermitage Museum, St. Petersburg).

Four years later, Matisse returned to this canvas, the rejected third image, altering the idyllic scene and changing the pastel palette to reflect his new interest in Cubism. He reordered the composition, making the figures more columnar, with faceless, ovoid heads. Over the next years, Matisse transformed the background into four vertical bands and turned the formerly blue river into a thick black vertical band. With its restricted palette and severely abstracted forms, *Bathers by a River* is far removed from *Dance II* and *Music*, which convey a graceful lyricism. The sobriety and hint of danger in *Bathers by a River* may in part reflect the artist's concerns during the terrible, war-torn period during which he completed it.

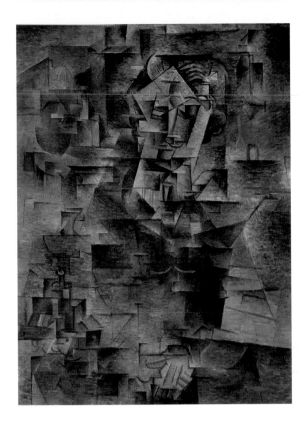

PABLO PICASSO Spanish, 1881–1973
Daniel-Henry Kahnweiler, 1910
Oil on canvas; 101.1 x 73.3 cm (39 $^{13}/_{16}$ x 28 $^{7}/_{8}$ in.)
Gift of Mrs. Gilbert W. Chapman in memory of Charles B. Goodspeed, 1948.561

The subject of this portrait is Daniel-Henry Kahnweiler (1884–1979), a German-born art dealer, writer, and publisher. Kahnweiler opened an art gallery in Paris in 1907 and in 1908 began representing Pablo Picasso, whom he introduced to Georges Braque. Kahnweiler was a great champion of the artists' revolutionary experiment with Cubism and purchased the majority of their paintings between 1908 and 1915. He also wrote an important book, *The Rise of Cubism*, in 1920, which offered a theoretical framework for the movement.

Kahnweiler sat as many as thirty times for this portrait. No longer seeking to create the illusion of true appearances, Picasso broke down and recombined the forms he saw. He described Kahnweiler with a network of shimmering, semitransparent surfaces that merge with the atmosphere around him. Forms are fractured into various planes and faceted shapes and presented from several points of view. Despite the portrait's highly abstract character, however, Picasso added attributes to direct the eye and focus the mind: a wave of hair, the knot of a tie, a watch chain. Out of the flickering passages of brown, gray, black, and white emerges a rather traditional portrait pose of a seated man, his hands clasped in his lap.

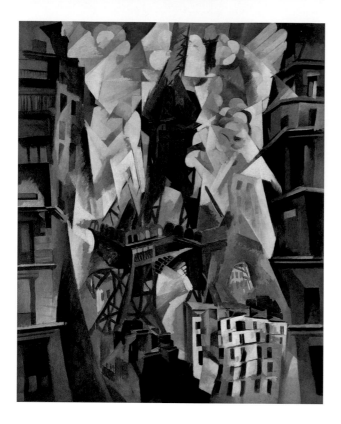

ROBERT DELAUNAY French, 1885–1941
Champs de Mars: The Red Tower, 1911/23
Oil on canvas; 160.7 x 128.6 cm (63 ¼ x 50 ⅝ in.)
Joseph Winterbotham Collection, 1959.1

Robert Delaunay was four years old when the Eiffel Tower was erected in Paris in the public green space known as the Champ de Mars. One of many artists to depict the landmark, Delaunay did a series of Eiffel Tower paintings, of which the Art Institute's example is among the best known. The artist infused the dynamism of modern life into this image by employing multiple viewpoints, rhythmic fragmentation of form, and strong color contrasts. Delaunay accented the structure's towering presence by framing it with tall buildings and placing smaller, shorter buildings, seen from above, at its base. The top of the tower seems to soar, its massive structure augmented by winglike clouds and patches of light-filled sky.

The artist first showed this painting in the winter of 1912, at the Galerie Barbazanges in Paris, where Guillaume Apollinaire described the work in a review as "unfinished, whether by design or accident." Although Delaunay's intent is not recorded, it is certain that by 1923, when this work was illustrated in the pages of the *Bulletin de l'effort moderne*, it looked as it does today: the artist had repainted portions of the canvas and filled areas of reserve with paint.

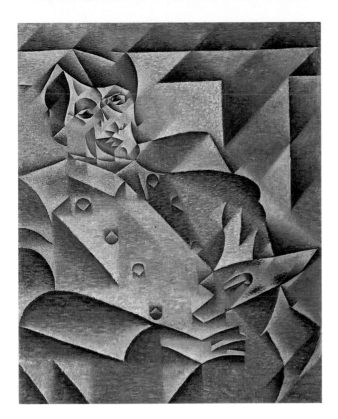

JUAN GRIS Spanish, 1887–1927
Portrait of Pablo Picasso, 1912
Oil on canvas; 93.3 x 74.4 cm (36 ¾ x 29 ⁵/₁₆ in.)
Gift of Leigh B. Block, 1958.525

In 1906 Juan Gris traveled to Paris, where he met Pablo Picasso and Georges Braque and participated in the development of Cubism. Just six years later, Gris too was known as a Cubist and identified by at least one critic as "Picasso's disciple." Gris's style draws upon Analytic Cubism—with its deconstruction and simultaneous viewpoints of objects—but is distinguished by a more systematic geometry and crystalline structure. Here he fractured his sitter's head, neck, and torso into various planes and simple, geometric shapes but organized them within a regulated, compositional structure of diagonals. The artist further ordered the composition of this portrait by limiting his palette to cool blue, brown, and gray tones that, in juxtaposition, appear luminous and produce a gentle undulating rhythm across the surface of the painting.

Gris depicted Picasso as a painter, palette in hand. The inscription, "Hommage à Pablo Picasso," at the bottom right of the painting demonstrates Gris's respect for Picasso as a leader of the artistic circles of Paris and as an innovator of Cubism. At the same time, the inscription helped Gris solidify his own place within the Paris art world when he exhibited the portrait at the Salon des Indépendants in the spring of 1912.

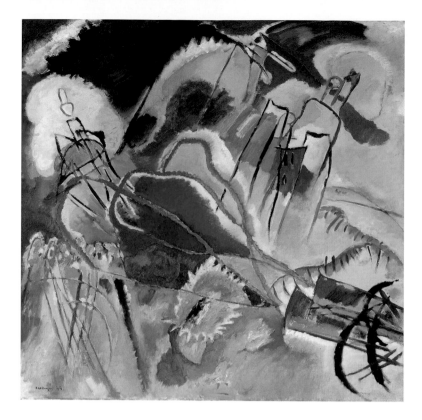

VASILY KANDINSKY French, born Russia, 1866–1944
Improvisation No. 30 (Cannons), 1913
Oil on canvas; 109.2 x 110.5 cm (43 ¼ x 43 ¾ in.)
Arthur Jerome Eddy Memorial Collection, 1931.511

In his seminal 1912 publication *Concerning the Spiritual in Art,* Vasily Kandinsky advocated an art that could move beyond imitation of the physical world, inspiring, as he put it, "vibrations in the soul." Pioneering abstraction as the richest, most musical form of artistic expression, Kandinsky believed that the physical properties of artworks could stir emotions, and he produced a revolutionary group of increasingly abstract canvases—with titles such as *Fugue, Impression,* and *Improvisation*—hoping to bring painting closer to music making.

Kandinsky's paintings are, in his words, "largely unconscious, spontaneous expressions of inner character, nonmaterial in nature." Although *Improvisation No. 30 (Cannons)* at first appears to be an almost random assortment of brilliant colors, shapes, and lines, the artist also included leaning buildings, a crowd of people, and a wheeled, smoking cannon. In a letter to the Chicago lawyer Arthur Jerome Eddy, who purchased the painting in 1913 and later bequeathed it to the Art Institute, Kandinsky explained that "the presence of the cannons in the picture could probably be explained by the constant war talk that has been going on throughout the year." Eventually, Kandinsky ceased making these references to the material world in his work and wholly devoted himself to pure abstraction.

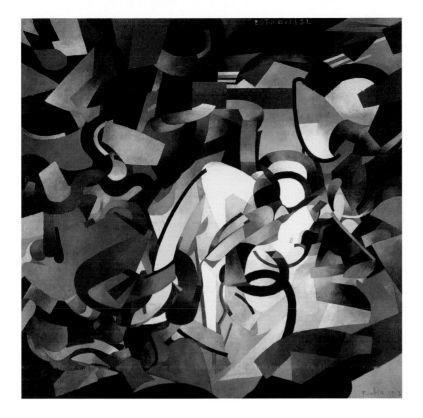

FRANCIS PICABIA French, 1879–1953
Edtaonisl (Ecclesiastic), 1913
Oil on canvas; 300.4 x 300.7 cm (118 ¼ x 118 ¾ in.)
Gift of Mr. and Mrs. Armand Bartos, 1953.622

In 1911 Francis Picabia met Marcel Duchamp, who had devised a unique style of
painting that combined Cubist elements with pseudodiagrams in humorous composi-
tions. Stimulated by Duchamp's example, Picabia pioneered a new, colorful, and
intellectual visual language, of which *Edtaonisl* is a prime example.

This picture relates to Picabia's experience aboard a transatlantic ship in 1913,
on his way to the opening of the Armory Show, North America's first major exhibition
of modern art. Picabia was amused by two fellow passengers—an exotic Polish
dancer named Stasia Napierskowska and a Dominican priest who could not resist the
temptation of watching her rehearse with her troupe. While the tumultuous shapes
in this work suggest fragments of bodies and nautical architecture, the depiction of
specific forms is less important than the effective expression of contrast and rocking
motion, which evokes the sensations of dance and a ship moving through rolling seas.
On the top right of the canvas, Picabia painted the word *Edtaonisl*—an acronym
made by alternating the letters of the French words *étoile* (star) and *dans[e]* (dance), a
process analogous to the artist's shattering and recombining of forms. He subtitled
the work *Ecclesiastic*, hinting at the juxtaposition of the spiritual and the sensual.

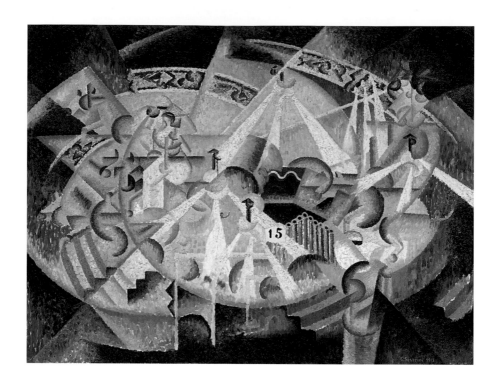

GINO SEVERINI Italian, 1883–1966
Festival in Montmartre, 1913
Oil on canvas; 89 x 117 cm (35 x 46 in.)
Bequest of Richard S. Zeisler, 2007.281

Gino Severini was a member of the Futurists, a group of Italian artists that announced its existence with a manifesto published in 1909 on the front page of *Le Figaro*. The Futurists urged others to ignore the past and focus on the aesthetic power of modern life. Their paintings celebrate modernity—the speed, thrill, and especially danger of factories, airplanes, automobiles, locomotives, and steamships. Their style blended Divisionism and Cubism to render "dynamic sensation" and the interpenetration of objects and their environment by superimposing different chromatic planes and lines of force.

Severini's work focused on Parisian entertainments, nightlife, and street activities. In *Festival in Montmartre*, he depicted the centrifugal motion of a carousel and the liberating, yet destabilizing, effects of color, speed, and sound. The artist presented this work in his first solo exhibition in 1913, writing in the catalogue, "My object has been to convey the sensation of a body, lighted by electric lamps and gyrating in the darkness of the Boulevard. The shapes of the pink pigs and of the women seated on them are the subordinate factors to the whole, whose rotary movement they follow while undergoing displacement from head to foot and vice-versa."

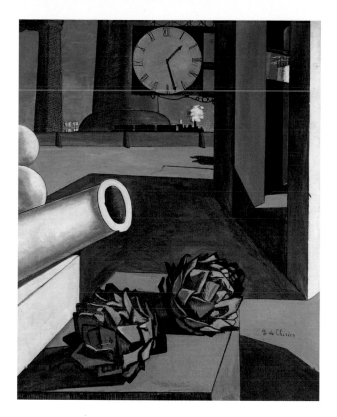

GIORGIO DE CHIRICO Italian, 1888–1978
The Philosopher's Conquest, 1913–14
Oil on canvas; 125.1 x 99.1 cm (49 ¼ x 39 in.)
Joseph Winterbotham Collection, 1939.405

The work of Giorgio de Chirico represents an unexpected form of classicism in early avant-garde painting. This canvas, one of six in a series, combines a Mediterranean cityscape with still-life objects. Familiar elements appear in many of de Chirico's paintings like pieces of a mysterious puzzle: a classical arcade, oddly oversize artichokes, a cannon and cannonballs, a clock, an industrial brick chimney, a monumental tower, a running train, and a square-rigged sailing ship. Here the stage set for this extraordinary juxtaposition of objects is an Italian piazza, virtually deserted except for the menacing shadowy figures outside the edge of the scene.

De Chirico represented objects with a matter-of-fact, though intentionally crude, precision. He painted his scenes flatly, in bright colors, and illuminated them with a cold white light. Rendered in this clear style, works like *The Philosopher's Conquest* seem rife with meaning, though they remain resolutely enigmatic. Indeed, by juxtaposing incongruous objects, the artist sought to produce a metaphysical quality, what he called "art that in certain aspects resembles . . . the restlessness of myth." De Chirico's works would profoundly affect the Surrealists, who in the 1920s and 1930s attempted to portray dreams and images of the subconscious in their work.

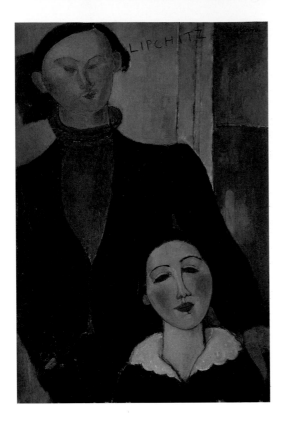

AMEDEO MODIGLIANI Italian, 1884–1920
Jacques and Berthe Lipchitz, 1916
Oil on canvas; 81 x 54 cm (31 ⅞ x 21 ⅜ in.)
Helen Birch Bartlett Memorial Collection, 1926.221

After receiving his artistic training in Italy, the sculptor and painter Amedeo Modigliani moved to Paris in 1906. Three years later, he helped pioneer a general migration of artists to the neighborhood of Montparnasse, which remained the center of avant-garde activity in the city until World War II. Scores of artists lived there, and many of them shared a Jewish heritage—including Modigliani and his friend the Lithuanian-born sculptor Jacques Lipchitz.

Lipchitz commissioned Modigliani to paint this portrait on the occasion of his marriage to the Russian poet Berthe Kitrosser, as a way of helping his troubled friend financially. The double portrait is one of only three in the artist's oeuvre and, according to Lipchitz, took two days to paint. Modigliani made about twenty drawings on the first day; the next day, he declared the picture finished. At the modest price of what Lipchitz remembered as "ten francs per sitting and a little alcohol," however, he persuaded Modigliani to work on the portrait for another two weeks in an effort to provide more financial assistance to his friend. Despite Modigliani's exceptional talent, his work found a market only after his death in 1920, which was hastened by tuberculosis and his legendary bohemian lifestyle.

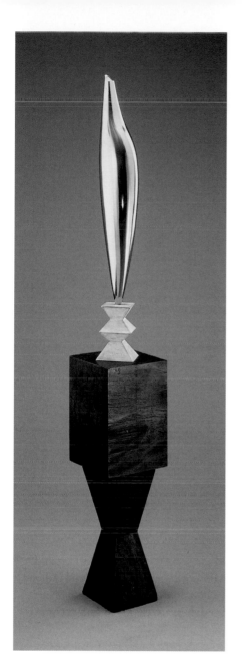

CONSTANTIN BRÂNCUSI

French, born Romania, 1876–1957

Golden Bird, 1919/20 (base c. 1922)

Bronze, stone, and wood; 217.8 x 29.9 x 29.9 cm (86 x 11 ³/₄ x 11 ³/₄ in.)

Partial gift of the Arts Club of Chicago; restricted gift of various donors; through prior bequest of Arthur Rubloff; through prior restricted gift of William Hartmann; through prior gifts of Mr. and Mrs. Carter H. Harrison, Mr. and Mrs. Arnold H. Maremont through the Kate Maremont Foundation, Woodruff J. Parker, Mrs. Clive Runnells, Mr. and Mrs. Martin A. Ryerson, and various donors, 1990.88

Trained in both folk and academic traditions, Constantin Brâncusi sought his own path for sculpture around 1907. Breaking with the currents of the time, he adopted direct carving, combined different materials for single works, and simplified form in his search for his subjects' essential characters. His works have profoundly influenced the development of twentieth-century abstraction.

More than any other theme, Brâncusi's series *Bird* summarizes his quest for a self-sufficient form. "All my life, I have sought to render the essence of flight," the artist once said. He began the first of twenty-seven *Bird* sculptures around 1910 and completed the last in the 1940s. He called the earliest variations *Maiastra*, referring to a bird in Romanian folklore that leads a prince to his princess. In the Art Institute's *Golden Bird*, details such as feet, a tail, and an upturned crowing beak are only suggested in an elegant, streamlined silhouette. Brâncusi perched this refined shape on a rough-hewn, geometric base, contrasting the disembodied, light-reflective surface with an earthbound mass. The central polyhedron was cut from the middle of a tree trunk, and its circles (indicating the tree's age) rotate like a sun, as if radiating light over the bird.

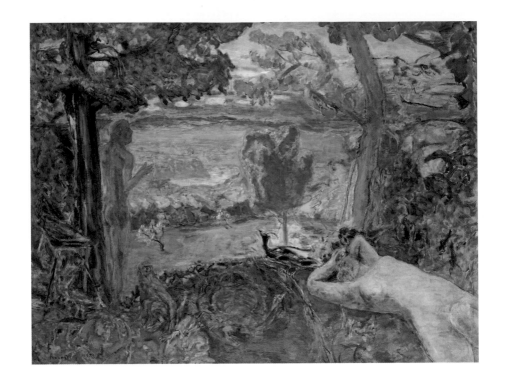

PIERRE BONNARD French, 1867–1947

Earthly Paradise, 1916–20

Oil on canvas; 130 x 160 cm (51 3/16 x 63 in.)

Estate of Joanne Toor Cummings; Bette and Neison Harris and Searle Family Trust endowments; through prior gifts of Mrs. Henry Woods, 1996.47

Following a period spent producing Parisian scenes in the style of Édouard Vuillard and Henri de Toulouse-Lautrec, Pierre Bonnard virtually reinvented his art around 1905. The artist's new emphasis on large-scale compositions, bold forms, and brilliant colors shows his awareness of the work of his contemporaries Henri Matisse and Pablo Picasso, as does his focus on Arcadian landscapes, a theme he had not previously explored.

Part of a series of four canvases painted for his dealers, Josse and Gaston Bernheim, between 1916 and 1920, *Earthly Paradise* demonstrates Bonnard's new, daring investigations of light, color, and space. Here the artist used foliage to create a proscenium-like arch for a drama involving a brooding Adam and recumbent Eve. The contrast Bonnard established between the figures seems to follow a tradition in which the female, presented as essentially sexual, is connected with nature, while the male, essentially intellectual, is able to transcend the earthly. Heightening the image's ambiguity is an array of animals, including birds, a monkey, rabbits, and a serpent (here reduced to a garden snake). This less-than-Edenic paradise may reflect the artist's response to the destruction of Europe during World War I, which was still raging when he began the painting.

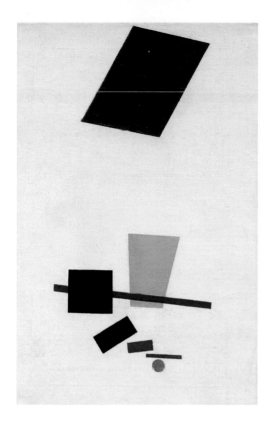

KAZIMIR MALEVICH Russian, born Ukraine, 1878–1935

Painterly Realism of a Football Player—Color Masses in the 4th Dimension, 1915

Oil on canvas; 70.2 x 44.1 cm (27 ⅝ x 17 ⁵⁄₁₆ in.)

Through prior gifts of Charles H. and Mary F. S. Worcester Collection; Mrs. Albert D. Lasker in memory of her husband, Albert D. Lasker; and Mr. and Mrs. Lewis Larned Coburn Memorial Collection, 2011.1

During the summer and fall of 1915, Kazimir Malevich secluded himself in his Moscow studio in order to prepare for the groundbreaking exhibition *0.10 (Zero-Ten) The Last Futurist Exhibition of Paintings*. Seeking to push the formal discoveries of Cubism and Futurism to their limits, to find the most essential core—the "zero"—of painting, Malevich produced a series of completely abstract works that he declared constituted an entirely new system of art. Suprematism, as he called the new style, eradicated all references to the natural world and focused instead on the inherent relationships between colored geometric shapes against the void of a subtly textured white background. In the catalogue to the exhibition, Malevich warned, "In naming some of the paintings I do not wish to point out what form to seek in them, but I wish to indicate that real forms were approached in many cases as the ground for formless painterly masses from which a painterly picture was created, quite unrelated to nature." *Painterly Realism of a Football Player—Color Masses in the 4th Dimension* belongs to this very first group of Suprematist works. The second part of its title refers to the mathematical theory of fourth dimensional space, a concept appropriated by many early-twentieth-century artists to justify their representation of truths beyond immediate sensory perception.

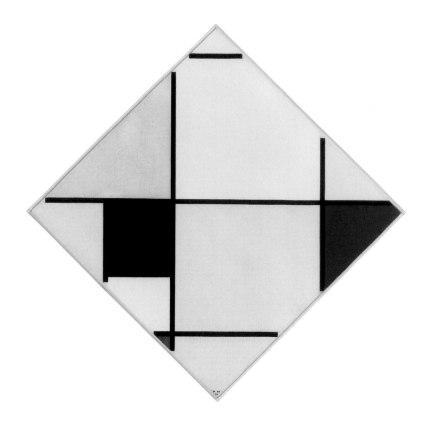

PIET MONDRIAN (PIETER CORNELIS MONDRIAAN) Dutch, 1872–1944
Lozenge Composition with Yellow, Black, Blue, Red, and Gray, 1921
Oil on canvas; 60 x 60 cm (23 ⅝ x 23 ⅝ in.)
Gift of Edgar Kaufmann, Jr., 1957.307 © 2012 Mondrian/Holtzman Trust c/o HCR International USA

Although Piet Mondrian's abstractions may seem far removed from nature, his basic vision was rooted in landscape, especially the flat geography of his native Holland. Beginning with his earliest naturalistic landscapes, he reduced natural forms to their simplest linear and colored equivalents in order to suggest their unity and order. Eventually he eliminated such forms altogether, developing a pure visual language of verticals, horizontals, and primary colors that he believed expressed universal forces.

In *Lozenge Composition with Yellow, Black, Blue, Red, and Gray*, Mondrian rotated a square canvas to create a dynamic relationship between the rectilinear composition and the diagonal lines of the edges of the canvas. Deceptively simple, his works are the result of constant adjustment to achieve absolute balance and harmony, and they reveal an exacting attention to the subtle relations between lines, shapes, and colors. The artist hoped that his paintings would point the way to a utopian future. This goal was first formulated in Holland around 1916–17 by Mondrian and a small group of like-minded artists and architects who collectively referred to their aesthetic as De Stijl (The Style). Their ideas have been extraordinarily influential for all aspects of modern design, from architecture and fashion to household objects.

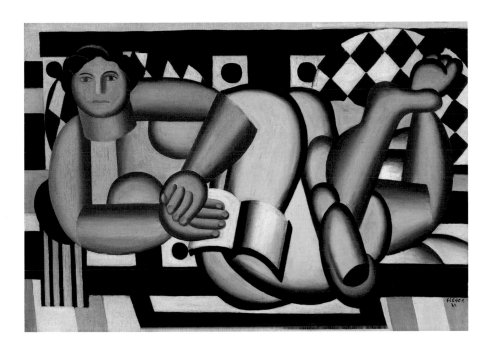

FERNAND LÉGER French, 1881–1955
Reclining Woman, 1922
Oil on canvas; 64.5 x 92 cm (25 ½ x 36 ¼ in.)
A Millennium Gift of Sara Lee Corporation, 1999.369

Fernand Léger first saw the work of the Cubists Georges Braque and Pablo Picasso at the Paris gallery of Daniel-Henry Kahnweiler. Around 1909 Léger began to experiment with geometric shapes, complementary colors, and strong outlines, although his paintings remained largely nonrepresentational until after World War I. His involvement in the war had a profound impact on his work. In the years following, he introduced volumetric forms that resembled pistons and pipes into his compositions, joining others in the Parisian vanguard in charting a more sober, conservative course that placed renewed emphasis on objective observation. Substituting hard metallic tubes for pliant flesh and flat patterned disks for soft and dense pillows, the artist updated the classical figure of the odalisque (a female slave or concubine often pictured in the history of art as a reclining nude) with his particular blend of Cubism and machine aesthetics. *Reclining Woman* demonstrates Léger's interest in producing "everyday poetic images": paintings in which the manufactured object is the "principal personage," shown as precisely as possible to reveal an absolute sculptural value rather than sentimental associations. This work exemplifies the Purist style, a kind of industrial classicism that focused on utilitarian objects. Léger hoped that through such paintings, art would become accessible to the whole of modern society, and not just a privileged few.

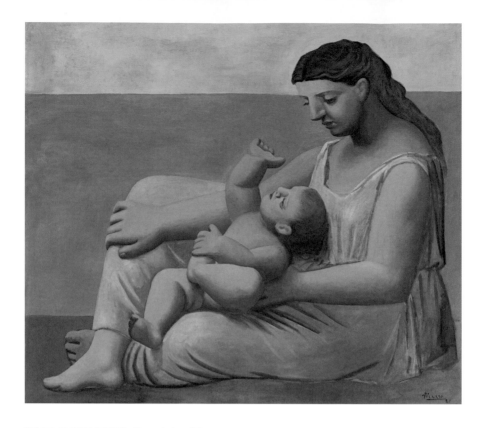

PABLO PICASSO Spanish, 1881–1973
Mother and Child, 1921
Oil on canvas; 142.9 x 172.7 cm (56 ¼ x 68 in.)
Restricted gift of Maymar Corporation, Mrs. Maurice L. Rothschild, and Mr. and Mrs. Chauncey
McCormick; Mary and Leigh Block Fund; Ada Turnbull Hertle Endowment; through prior gift of Mr.
and Mrs. Edwin E. Hokin, 1954.270

In 1917 Picasso traveled to Rome to design sets and costumes for Sergei Diaghilev's famed Ballets Russes. Deeply impressed by the ancient and Renaissance art of that city, he began painting monumental figures inspired by antiquity. His new classical style was influenced by the finely modeled odalisques of Jean-Auguste-Dominique Ingres and the late, oddly proportioned female nudes of Pierre-Auguste Renoir. This paint-ing was also inspired by Picasso's own life. Just three years earlier, he had married Olga Koklova, a Russian dancer, with whom he fathered his first child, Paolo, in 1921.
A new father, Picasso made many images of mothers with children: between 1921 and 1923, he produced at least twelve works on this subject, returning to a theme that he had explored during his Blue Period. But whereas those figures are frail and an-guished, his classical-period figures, with their sculptural modeling and solidity, are majestic in proportion and feeling. Here an infant sits on its mother's lap and reaches up to touch her. The mother, dressed in a Grecian gown, gazes intently at her child. Behind them stretches a simplified background of sand, water, and sky. Picasso's treat-ment of the mother and child is not sentimental, but the relationship between the figures expresses a serenity and stability that characterized his own life at this time.

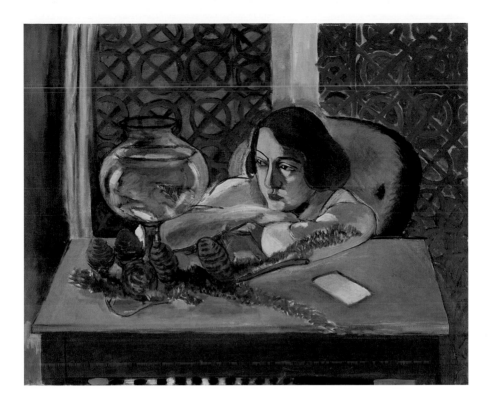

HENRI MATISSE French, 1869–1954
Woman before an Aquarium, 1921–23
Oil on canvas; 80.7 x 100 cm (31 3/4 x 39 3/8 in.)
Helen Birch Bartlett Memorial Collection, 1926.220

Henri Matisse was fascinated by the cultures of North Africa and the Middle East. In 1903 he visited an Islamic art exhibition at the Musée des Arts Décoratifs, Paris; in 1910 he traveled to Munich for a major display of Islamic objects and then to Spain to see Moorish architecture. He also collected brilliantly colored and richly ornamented textiles, pottery, and tiles. It was, however, the physical experience of these lands that proved to have the greatest impact on Matisse's vision and creativity. In May 1906 and for long periods between January 1912 and February 1913, he visited North Africa. There, he came to understand the unique quality of light and its effect on the perception of color and space.

Even a decade later, while Matisse lived in the southern French city of Nice, these experiences would continue to transform his work. In *Woman before an Aquarium,* the paneled screen and goldfish are pictorial elements drawn from Matisse's Moroccan journeys. Moreover, the artist's own transformation—the "new rhythm" of his inner vision that resulted from his travels—was responsible for the particular luminosity, cool palette, and intimate effect of this canvas. Matisse was entranced by the golden light and sea-soaked atmosphere of Nice, and his paintings from this period demonstrate his newfound interest in an impressionistic naturalism that was not a rejection of his earlier work, but rather an effort to infuse his previous style with a "human element."

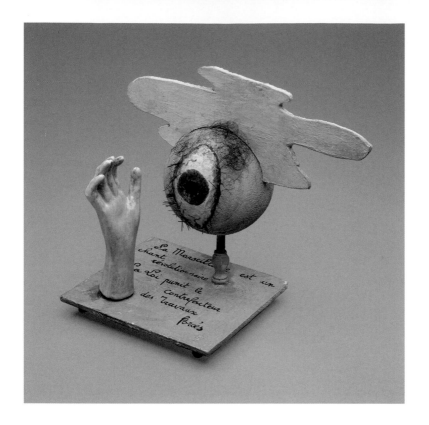

CLAUDE CAHUN French, 1894–1954
Object, 1936
Wood, paint, and hair; 13.7 x 16.2 x 10.2 cm (5 ³⁄₈ x 6 ³⁄₈ x 4 in.)
Through prior gift of Mrs. Gilbert W. Chapman, 2007.30

Claude Cahun, born Lucy Schwob, was closely associated with the Paris Surreal-
ists of the 1930s. Attracted to the group's desire to transform society through the
exploration of the unconscious, she challenged traditional ideas about gender and
sexuality through her intimate photographic self-portraits, collages, and sculptures.
For *Object,* Cahun altered a number of seemingly unrelated components—a doll's
hand, a cloud-shaped piece of wood, and a tennis ball painted with a wide-open
eye—to produce a startling psychological resonance. The eye, in particular, a key
Surrealist symbol of inner perception, also suggests female anatomy. On the base of
the work, Cahun added the French phrase, "The Marseillaise is a revolutionary song,
the law punishes counterfeiters with forced labor." Much like the rest of the work,
the inscription is a juxtaposition of disparate elements: the first, a well-known slogan
from France's antifascist coalition, the left-wing Popular Front, and the other, a line
from Belgian currency. In combining these phrases, Cahun seems to point an accusa-
tory finger at the supposed "revolutionary" leaders of France—a rare direct reference
to politics in a Surrealist artwork. Cahun's assemblages were typically ephemeral and
made to be photographed; *Object* is the only sculptural work by the artist known to
still exist in its original form.

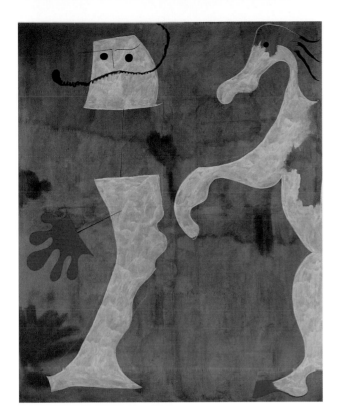

JOAN MIRÓ Spanish, 1893–1983
The Policeman, 1925
Oil on canvas; 248 x 194.9 cm (97 ⅝ x 76 ¹¹/₁₆ in.)
Bequest of Claire Zeisler, 1991.1499

Soon after the artist Joan Miró moved to Paris from his native Barcelona in 1920, he met a group of avant-garde painters and writers who advocated merging the everyday rational world with that of dreams and the unconscious in order to produce an absolute reality, or surreality. To release images of this higher realm, the Surrealists embraced automatism, a spontaneous working method much like free association. Miró experimented with automatism: "Even a few casual wipes in cleaning my brush," he said, "may suggest the beginning of a picture." Between 1925 and 1927, his experiments unleashed a revolutionary series of works called the "dream paintings," which straddle abstraction and representation in freely moving, calligraphic compositions. In *The Policeman,* a large canvas from this group, two biomorphic shapes spring to life as a policeman and a horse, their forms defined by thinly applied white paint against a neutral ocher ground. The form on the left has sprouted five buds that act as fingers, and both forms extrude curves that suggest torsos or mouths. With graffiti-like dots and squiggles added to their heads to make eyes and a mustache, Miró's shapes come to life in a liquid space as animated equivalents of a policeman and his horse.

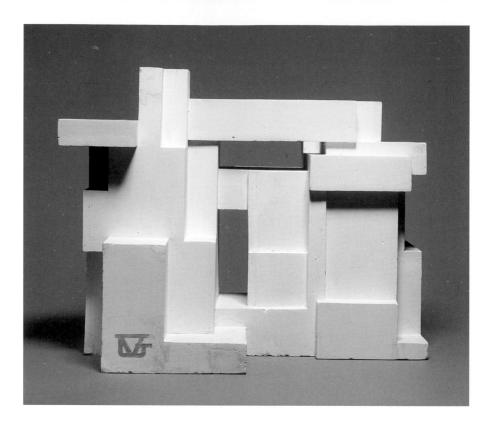

GEORGES VANTONGERLOO Belgian, 1886–1965
Interrelation of Volumes from the Ellipsoid, 1926
Plaster; 40 x 47 x 26 cm (15 $\frac{3}{4}$ x 18 $\frac{1}{2}$ x 10 $\frac{1}{4}$ in.)
Through prior gift of Lucille E. and Joseph L. Block; partial gift in memory of Lillian Florsheim,
2004.245

Near the end of World War I, Georges Vantongerloo felt the need to break with the past. He came in contact with a group of artists, including Theo van Doesburg and Piet Mondrian, who saw abstraction as an almost spiritual vehicle to reconstruct art and society. Their approach, known as De Stijl, was marked by fundamentals: geometry combined with asymmetry; pure primary colors with black and white; and positive and negative elements. Motivated by his belief in this utopian aesthetic, Vantongerloo joined the De Stijl group in 1917, its founding year.

 In 1919 he embarked on a series of sculptures based on the interrelation of masses. *Interrelation of Volumes from the Ellipsoid,* the fifth in the group, explores the inter-sections of a parallel-faced polyhedron within an ovoid volume. To produce this work, the artist mapped the intersecting volumes of forms from different views in order to reveal core geometric units and planes. While this sculpture was inspired by mathemati-cal principles, it is not a sterile, scientific object but, in its realized form, suggests an element of human invention in the mold marks and alterations that Vantongerloo considered part of the artistic process.

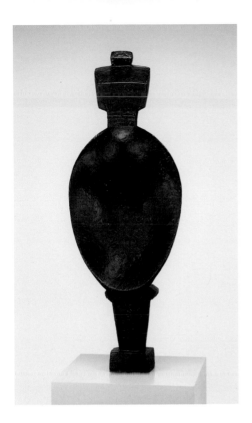

ALBERTO GIACOMETTI Swiss, 1901–1966
Spoon Woman, 1926–27
Bronze; 146 x 52 x 25.4 cm (57 ½ x 20 ½ x 10 in.)
Gift of Florene May Schoenborn, 1971.880

After studying at the École des Beaux-Arts and the École d'Arts et Métiers in Geneva, Alberto Giacometti traveled throughout Italy. He finally settled in Paris in 1923. Two years later, despite his formal training in drawing and painting, he began to focus solely on sculpture. During these early years, he forged a path based on a variety of influences, including the formal simplicity of Constantin Brâncusi's sculpture, aspects of Cubism, and the totemic quality of African art. *Spoon Woman* was inspired by a type of anthropomorphic spoon carved by the Dan people of West Africa; such works were exhibited frequently in Paris during the 1920s and were the subject of great fascination for artists, including Giacometti. Drawing on the frontality and cultural significance of these implements, he presented his female figure as a symbol of fertility. Topped by a set of simple blocks to suggest her torso and head, the woman's wide, curving womb is represented by the concave section of the spoon. Giacometti's interest in female totems extended beyond the art of the Dan; in the 1920s, he studied and sketched prehistoric female figures—symbols of fertility and mystery—that were in the collections of many museums.

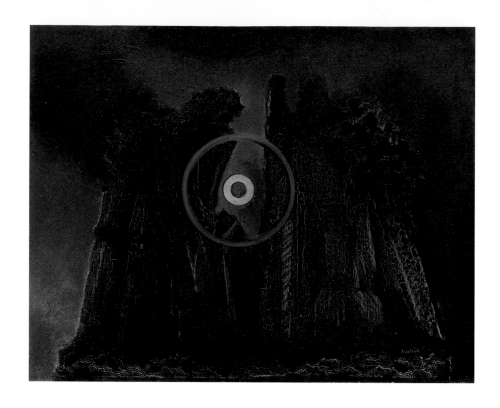

MAX ERNST French, born Germany, 1891–1976
Forest and Sun, 1927
Oil on canvas; 66 x 82.5 cm (26 x 32 ½ in.)
Bequest of Richard S. Zeisler, 2007.276

Among his many recollections of childhood, Max Ernst often recounted his fear and fascination with a forest that surrounded his home. He wrote of feeling "delight and oppression and what the Romantics called 'emotion in the face of Nature.'" By expressing his thoughts in these terms, Ernst linked himself with the spiritual landscape tradition of Romanticism, which conceived of an invisible realm at work in the natural world.

This dark and mysterious forest scene dates to one of the most creative periods of Ernst's career. Spurred by the Surrealist leader André Breton's proclamation of "pure psychic automatism" as an artistic ideal, he developed the innovative technique of frottage, his term for the method of reproducing a relief design (like the surface of a piece of wood) by laying paper or canvas over it and rubbing it with a pencil, charcoal, or another medium. In *Forest and Sun,* Ernst used this technique to create a petrified forest, which he imbued with a sense of primordial otherworldliness. By scraping away almost-dry paint on the canvas (a process he called grattage), the artist produced the encircled sun at the center of the composition. This painting is one of six variations of the forest and sun theme by Ernst. As in the other five canvases, the tree trunks suggest a letter in the artist's name: in this case, a capital *M*.

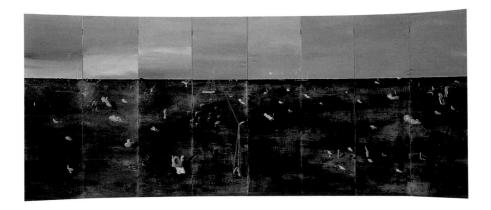

YVES TANGUY French, 1900–1955
Untitled, 1928
Hinged unfolding screen in eight panels; oil on wood; each panel: 200 x 59.7 cm (78 ³/₄ x 23 ¹/₂ in.);
overall: 200 x 477.6 cm (78 ³/₄ x 188 in.)
Joseph Winterbotham Collection, 1988.434

The largely self-taught Yves Tanguy decided to become an artist around 1923, when he was inspired by a painting by Giorgio de Chirico that he saw in a shop window. Tanguy became interested in Surrealism a year later, after reading the periodical *La Révolution surréaliste*. André Breton welcomed him into the Surrealist group in 1925. Inspired by the metaphysical qualities of de Chirico's work, as well as the biomorphic forms of Jean Arp, Max Ernst, and Joan Miró, Tanguy quickly developed his own fantastic vocabulary of organic, amoeba-like shapes that populate mysterious, dream-like settings.

Tanguy painted this primordial landscape on a hinged wooden screen. Little information exists about the circumstances of the work's making, but the artist probably intended it to be for a patron's home, since many Surrealists were interested in the decorative arts and produced folding screens, furniture, and other domestic objects. In this unusual example, although the screen retains the potential to close off the private sphere, it simultaneously opens up more intimate dreams and fantasies to the outside world.

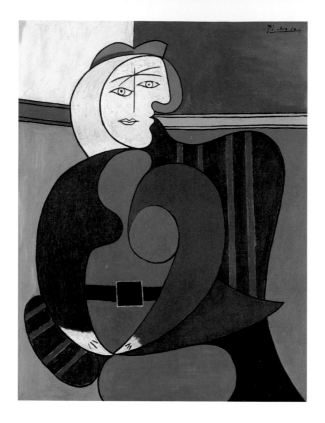

PABLO PICASSO Spanish, 1881–1973
The Red Armchair, 1931
Oil and Ripolin on panel; 131.1 x 98.7 cm (51 ⅝ x 38 ⅞ in.)
Gift of Mr. and Mrs. Daniel Saidenberg, 1957.72

Pablo Picasso painted numerous portraits of the many women in his life. Often the circumstances surrounding his relationships or the distinct personalities of his sitters seem to have precipitated stylistic changes in his work. Marie-Thérèse Walter came into the artist's life around 1925. Though twenty-eight years her senior, Picasso was smitten and began making furtive references to her blond hair, broad features, and voluptuous body in his work. Perhaps acknowledging the double life he and she were leading, he devised a new motif: a face that encompasses both frontal and profile views.

Picasso experimented beyond form and style, exploring different materials—including found objects such as newspaper, wallpaper, and even studio scraps—in his work. *The Red Armchair* demonstrates the artist's innovative use of Ripolin, an industrial house paint that he first employed as early as 1912 for its brilliant colors, as well as its ability to provide an almost brushless finish if used straight from the can. In preparation for an exhibition of his work at the Galeries Georges Petit in 1931, Picasso began a series of large paintings of Marie-Thérèse, of which *The Red Armchair* was the first. Here he mixed Ripolin with oil to produce a wide range of surface effects—from the crisp brushmarks in the yellow background, to the thick but leveled look of the white face and the smooth black outlines of the figure.

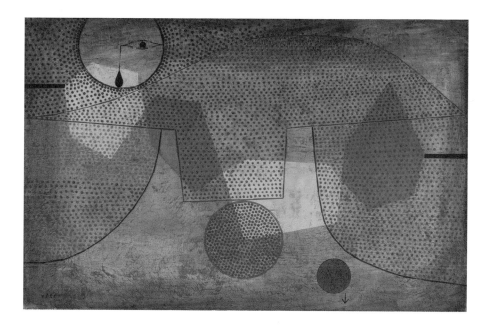

PAUL KLEE German, born Switzerland, 1879–1940
Sunset, 1930
Oil on canvas; 46.1 x 70.5 cm (18 ³/₁₆ x 27 ³/₄ in.)
Gift of Mary and Leigh B. Block, 1981.13

Paul Klee was an artist and teacher at the Bauhaus for most of that famed school's existence. Initially head of the bookbinding department, Klee made his greatest contribution as a lecturer on the theory of form in art for the basic design course. There, he developed his ideas about the "polyphony" of painting—the simultaneous effect of formal elements that produces "a transformed beholder of art."

Klee was also a trained musician and shared with many artists of the early twentieth century the idea that music was the key to producing a new, abstract form of art. He was interested in the temporal character of music and its possible translation into art. Works like *Sunset* reflect the principles of rhythm: linear structures, forms, and tonal values are orchestrated into a measured, vibrating image. To produce such a harmonious effect, Klee layered an intricate pattern of dots over a neutral background. Abstract, geometric, and overlapping shapes balance with recognizable forms, such as the schematic face in the upper left and the red sun and arrow in the lower right. The resulting composition—balancing stillness and movement, shallowness and depth—relates to Klee's larger project of looking to music to produce an art that "does not reproduce the visible, but makes visible."

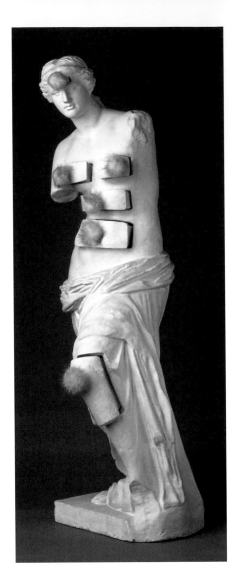

SALVADOR DALÍ

Spanish, 1904–1989

Venus de Milo with Drawers, 1936

Painted plaster, metal drawer pulls, and mink pompons; 98 x 32.5 x 34 cm (38 ⁵/₈ x 12 ³/₄ x 13 ³/₈ in.)

Through prior gift of Mrs. Gilbert W. Chapman, 2005.424

Among Salvador Dalí's many memorable works, perhaps none is more deeply embedded in the popular imagination than *Venus de Milo with Drawers*, a half-size plaster reproduction of the famous marble statue (130/120 B.C.; Musée du Louvre, Paris), altered with pompon-decorated drawers in the figure's forehead, breasts, stomach, abdomen, and left knee. The combination of cool painted plaster and silky mink tufts illustrates the Surrealist interest in uniting different elements to spark a new reality. For the Surrealists, the best means of provoking this revolution of consciousness was a special kind of sculpture that, as Dalí explained in a 1931 essay, was "absolutely useless . . . and created wholly for the purpose of materializing in a fetishistic way, with maximum tangible reality, ideas and fantasies of a delirious character." Dalí's essay, which drew upon the ideas of Marcel Duchamp's readymades, inaugurated object making as an integral part of Surrealist activities.

Influenced by the work of Sigmund Freud, Dalí envisioned the idea of a cabinet transformed into a female figure, which he called an "anthropomorphic cabinet." *Venus de Milo with Drawers* is the culmination of Dalí's explorations into the deep, psychological mysteries of sexual desire, which are symbolized in the figure of the ancient goddess of love.

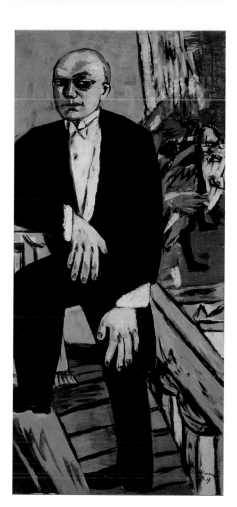

MAX BECKMANN
German, 1884–1950
Self-Portrait, 1937
Oil on canvas; 192.5 x 89 cm (75 ¹³/₁₆ x 35 in.)
Gift of Lotta Hess Ackerman and Philip E.
Ringer, 1955.822

Max Beckmann was one of the Weimar Republic's most honored artists, and he was one of those most vilified by the Nazis. This was perhaps the last painting the artist completed in Berlin before he and his wife fled to the Netherlands on July 20, 1937. Their flight occurred just two days after Adolf Hitler delivered a speech condemning modern art and one day after the opening of the "Degenerate Art" exhibition, the Nazis' official denigration of the avant-garde, which included twenty-two of Beckmann's works. The artist departed Germany just in time: in 1937 more than five hundred of his works were confiscated from public collections.

The most brilliantly colored and aggressive of all of Beckmann's self-portraits (he painted over eighty), this powerful work depicts the artist, near life-size, on the staircase of a hotel lobby, separated from two figures in the background on the right. Beckmann steps to the left, while his dark-rimmed gaze and the entire picture plane—curtains, flowers, staircase, and banisters—seem to slide off to the right. His large hands hang down, limp, against his black tuxedo.

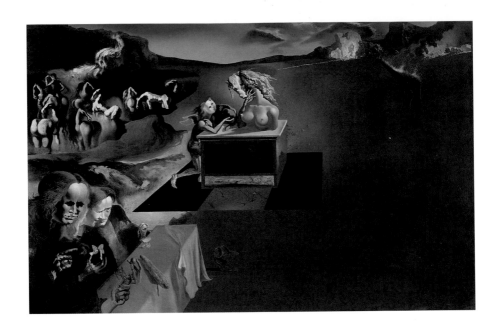

SALVADOR DALÍ Spanish, 1904–1989
Inventions of the Monsters, 1937
Oil on canvas; 51.4 x 78.4 cm (20 ¼ x 30 ⅞ in.)
Joseph Winterbotham Collection, 1943.798

Salvador Dalí, Surrealism's most publicized practitioner, created monstrous visions of a world turned inside out, which he made even more compelling through his extraordinary technical skills. In 1943, when the Art Institute acquired *Inventions of the Monsters*, Dalí wrote his congratulations and explained:

> According to Nostradamus the apparition of monsters presages the outbreak of war. The canvas was painted in the Semmering mountains near Vienna a few months before the Anschluss [the 1938 political union of Austria and Germany] and has a prophetic character. Horse women equal maternal river monsters. Flaming giraffe equals masculine apocalyptic monster. Cat angel equals divine heterosexual monster. Hourglass equals metaphysical monster. Gala and Dalí equal sentimental monster. The little blue dog is not a true monster.

Dalí's painting has an ominous mood. It is rife with threats of danger, from the menacing fire in the distance to the sibylline figure in the foreground with an hourglass and a butterfly, both symbols of the inevitability of death. Next to this figure sit Dalí and his wife and muse, Gala. With his native Catalonia embroiled in the Spanish Civil War, the artist surely felt great anxiety over a world without a safe haven, a world that indeed had allowed for the invention of monsters.

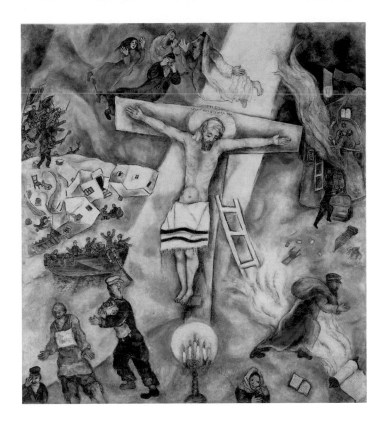

MARC CHAGALL French, born Russia, 1887–1985
White Crucifixion, 1938
Oil on canvas; 155 x 140 cm (61 x 55 in.)
Gift of Alfred S. Alschuler, 1946.925

The 1938 painting *White Crucifixion* represents a critical turning point for the artist Marc Chagall: it was the first of an important series of compositions that feature the image of Christ as a Jewish martyr and dramatically call attention to the persecution and suffering of European Jews in the 1930s.

In *White Crucifixion*, his first and largest work on the subject, Chagall stressed the Jewish identity of Jesus in several ways: he replaced his traditional loincloth with a prayer shawl, his crown of thorns with a headcloth, and the mourning angels that customarily surround him with three biblical patriarchs and a matriarch, clad in traditional Jewish garments. At either side of the cross, Chagall illustrated the devastation of pogroms: On the left, a village is pillaged and burned, forcing refugees to flee by boat and the three bearded figures below them—one of whom clutches the Torah—to escape on foot. On the right, a synagogue and its Torah ark go up in flames, while below a mother comforts her child. By linking the martyred Jesus with the persecuted Jews and the Crucifixion with contemporary events, Chagall's painting passionately identifies the Nazis with Christ's tormentors and warns of the moral implications of their actions.

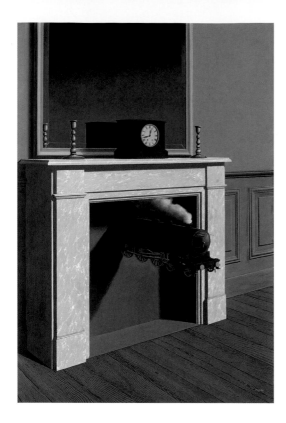

RENÉ MAGRITTE Belgian, 1898–1967
Time Transfixed, 1938
Oil on canvas; 147 x 98.7 cm (57 $^7/_8$ x 38 $^7/_8$ in.)
Joseph Winterbotham Collection, 1970.426

Impressed by René Magritte's submissions to the 1936 International Surrealist Exhibition, the collector Edward James invited the artist to paint canvases for the ballroom of his London home. In response, Magritte conceived *On the Threshold of Liberty* (in the collection of the Art Institute) and his now-famous *Time Transfixed*. The artist later explained this picture: "I decided to paint the image of a locomotive. . . . In order for its mystery to be evoked, another *immediately* familiar image without mystery—the image of a dining room fireplace—was joined." The surprising juxtaposition and scale of unrelated elements, heightened by Magritte's precise realism, gives the picture its perplexity and allure. The artist transformed the stovepipe of a coal-burning stove into a charging locomotive, situating the train in a fireplace vent so that it appears to be emerging from a railway tunnel. Magritte was unhappy with the English translation of the original French, *La Durée poignardé*, which literally means "ongoing time stabbed by a dagger." He hoped that the painting would be installed at the bottom of the collector's staircase so that the train would "stab" guests on their way up to the ballroom. Ironically, James installed it over his fireplace instead.

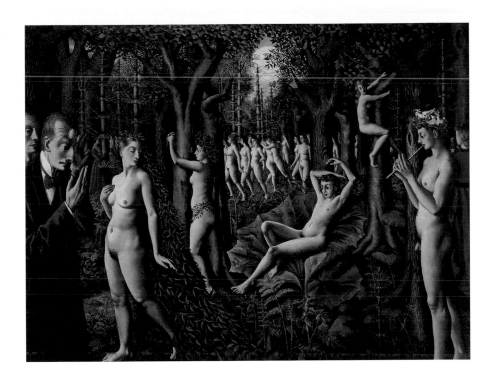

PAUL DELVAUX Belgian, 1897–1994
The Awakening of the Forest, 1939
Oil on canvas; 170.2 x 225.4 cm (67 x 88 ³/₄ in.)
Joseph Winterbotham Collection, 1991.290

Paul Delvaux painted *The Awakening of the Forest* in the late 1930s, when he adopted Surrealism as a visual language to give form to his inner world—one populated with childhood memories and fantasy. For this monumental painting, the artist transformed an episode from Jules Verne's *Journey to the Center of the Earth* (1864), in which Professor Otto Lidenbrock and his nephew Axel discover a prehistoric forest deep inside the earth. Delvaux showed the professor at left, examining a rock or fossil; behind him stands Axel, who bears a striking resemblance to the artist himself. Under a full moon, women appear like automatons in the background. In the foreground, several figures combine human and vegetal elements; these ambiguous figures seem to embody a primordial, as yet undifferentiated, state. A woman in the right foreground and another in the left middle ground, both in Victorian dress, hold lamps and try in a vain to shed light on the unyielding mystery of the scene. Despite the multitude of naked figures and their detailed description, *The Awakening of the Forest* retains a detached emotional quality that adds to its strange and mysterious effect.

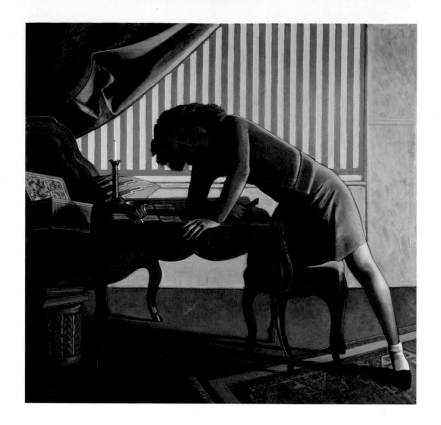

BALTHUS (BALTUSZ KLOSSOWSKI DE ROLA) French, 1908–2001
Solitaire, 1943
Oil on canvas; 161.3 x 163.5 cm (63 ¹/₂ x 64 ³/₈ in.)
Joseph Winterbotham Collection, 1964.177

Balthus was born into an educated and artistic, but impoverished, family of Polish aristocrats who had fled political and economic turmoil to settle in Paris. As a young man, he traveled to Italy to study such Old Masters as Piero della Francesca. Aside from this direct experience, Balthus received little formal schooling; this permitted him to develop his own unique artistic vision. In 1933 Balthus began painting the erotically charged images for which he is best known—enigmatic scenes of young girls lost in reveries that often place the viewer in the position of voyeur.

Balthus spent most of World War II in Switzerland, where in 1943 he painted *Solitaire.* The striking posture of the girl, deep in thought as she considers the cards on the table, is one the artist used in a number of earlier works. The insistent verticals of the patterned wallpaper create a counterpoint to the diagonal of the girl's back; the mysterious expression of her shadowed face contrasts with the strong, raking light that defines her delicate, long fingers. These details suggest how carefully Balthus orchestrated the painting's unsettling emotional tenor.

PHOTOGRAPHY

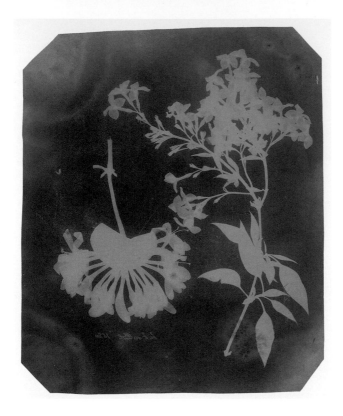

WILLIAM HENRY FOX TALBOT English, 1800–1877
Two Plant Specimens, 1839
Photogenic drawing; 22.1 x 18 cm (8 ¹¹/₁₆ x 7 ⅛ in.)
Edward E. Ayer Endowment in memory of Charles L. Hutchinson, 1972.325

Contained within this haunting and poetic image is the seed of photography: the possibility of creating a negative from which an unlimited number of positives can be made. William Henry Fox Talbot produced this image by placing botanical specimens on sensitized paper and exposing them to light. He made this groundbreaking discovery after his 1833 honeymoon on the shores of Lake Como, in Lombardy, Italy. Frustrated by his inability to draw his Italian surroundings accurately, Talbot recalled the fleeting images of external objects that appeared within a camera lucida (an optical prism that creates a superimposed image on an artist's drawing surface) and wondered how he could make them "imprint themselves durably, and remain fixed upon the paper." What resulted, two years later, were the first camera negatives. Unveiled in 1839 and called photogenic drawing, Talbot's process was perfected two years later into the calotype (from the Greek word *kalos*, meaning "beautiful"). By the end of his life, Talbot—whose far-ranging interests included mathematics, botany, etymology, and ancient Assyria—had also discovered the basis of halftone printing, obtained twelve patents, and authored seven books, including one of the first photographically illustrated books, *The Pencil of Nature* (1844).

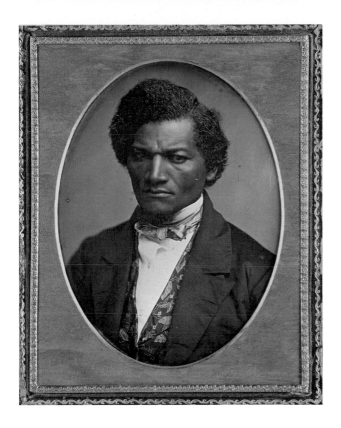

SAMUEL J. MILLER American, 1822–1888
Frederick Douglass, 1847–52

Daguerreotype; plate: 14 x 10.6 cm (5 ½ x 4 ⅛ in.); mat opening: 12.1 x 8.8 cm (4 ¾ x 3 ½ in.); plate in closed case: 15.2 x 12 x 1.4 cm (6 x 4 ¾ x ½ in.); plate in open case: 15.2 x 24 x 2 cm (6 x 9 ½ x ¾ in.)
Major Acquisitions Centennial Endowment, 1996.433

In 1839 Louis-Jacques-Mandé Daguerre announced the perfection of the daguerreotype, a photographic process that employed a silver-coated copperplate sensitive to light. This new artistic process was celebrated for its remarkably sharp detail and praised as a "democratic art" that brought portraiture into reach for the masses. Within a few years, thousands of daguerrean portrait studios had sprung up all over the United States, among them the one that Samuel J. Miller owned in Akron, Ohio. Although most of the likenesses made in commercial studios were formulaic and not very revealing of the subject's character, this portrait of Frederick Douglass—an escaped slave who had become a lauded speaker, writer, and Abolitionist agitator— is a striking exception. Northeastern Ohio was a center of Abolitionism prior to the Civil War, and Douglass knew that this picture, one of an astonishing number that he commissioned or posed for, would be seen by ardent supporters of his campaign to end slavery. Douglass was an intelligent manager of his public image and likely guided Miller in projecting his intensity and sheer force of character. As a result, this portrait demonstrates that Douglass truly appeared "majestic in his wrath," as the nineteenth-century feminist Elizabeth Cady Stanton observed.

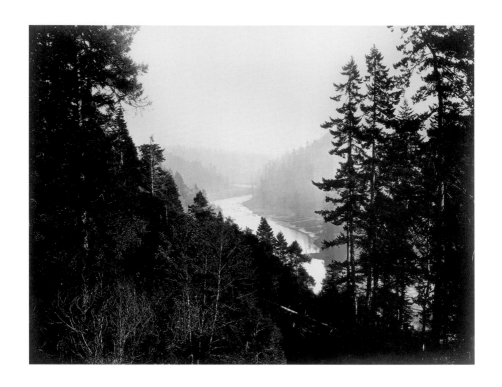

CARLETON WATKINS American, 1829–1916
Big River from the Rancherie, Mendocino, California, 1863
Albumen print; 40 x 52.5 cm (15 3/4 x 20 11/16 in.)
Gift of the Auxiliary Board, 1981.649

Like the vast and untapped landscape of the American West, Carleton Watkins's photographic images are grand in spirit and in size. Using a giant wet-plate camera whose thick glass negatives—coated with a sensitized emulsion called collodion and exposed while still wet—were often as large as the average easel painting of the time, Watkins here fused a sense of the picturesque with a Romantic expression of nature's timelessness, immensity, and silence. The trees are sharply defined, still, and majestic. Depicted with equal clarity is the river, which winds into the receding hills. This technical and aesthetic perfection was all the more remarkable considering the difficulty of the wet-plate process for a frontier photographer. In the field, Watkins had to transport (with the aid of several pack mules) mammoth cameras, dark tents, chemicals, and as many as four hundred glass plates. He also had to contend with constant packing and unpacking, the lack of pure water, and the tendency of dust to adhere to the sticky collodion. Photographs such as *Big River* and Watkins's famous views of Yosemite (which helped persuade the United States Congress to pass legislation protecting the valley's wilderness) provided the world with some of the first glimpses of the American West.

JULIA MARGARET CAMERON English, 1815–1879
Mrs. Herbert Duckworth, 1867
Albumen print; 34.2 x 26.3 cm (13 ½ x 10 ⅜ in.)
Mary L. and Leigh B. Block Endowment, 2001.59

Julia Margaret Cameron began photographing at age forty-eight, when her daughter and son-in-law gave her a camera. She soon became obsessed with photography, reveling in its messy magic and focusing more on the overall effects of her pictures than on technical perfection. Although she made portraits of some of the most important men of her day, Cameron's female subjects helped her to explore the realm of mythology and imagination in highly allegorical and literary pictures. She delighted in dressing and posing friends, relatives, and servants as the Virgin Mary, Queen Esther, or Shakespeare's faithful Cordelia. Julia Jackson, Cameron's niece, was one of the few female sitters who posed for the photographer as herself. Known as a great beauty throughout her life, she was a favorite subject for Cameron, who took dozens of photographs of her over the course of ten years. In April 1867, shortly before Jackson's wedding to her first husband, Herbert Duckworth, Cameron made a series of head-on portraits of the young bride-to-be that alternately reveal Jackson as noble, tender, and vulnerable. In this photograph, made after the wedding, Cameron captured Jackson's mature beauty and her extraordinary strength.

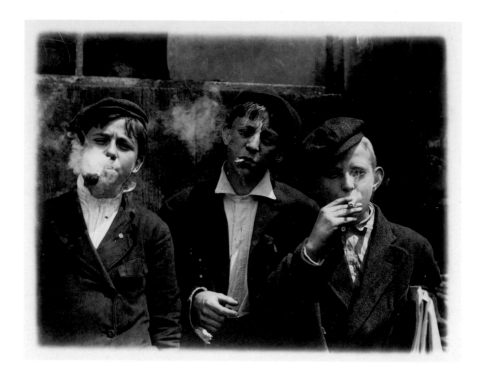

LEWIS WICKES HINE American, 1874–1940
Newsies at Skeeter Branch, St. Louis, Missouri, 11:00 a.m., May 9, 1910, 1910
Gelatin silver print; 8.9 x 11.5 cm (3 ½ x 4 ⁹⁄₁₆ in.)
Restricted gift of Charles and Ruth Levy Foundation, 1974.216

Beginning in 1906, Lewis Hine was employed by the National Child Labor Committee (NCLC) to photograph and investigate scenes of child labor across the country. He produced some five thousand images of deplorable working and living conditions for children—some just four or five years old—in coal mines, cotton mills, canneries, and farms, sometimes posing as a fire inspector or postcard salesman to gain access to underage workers. Hine composed his images to elicit sympathy from viewers, adding captions noting his subjects' ages, heights, or work histories. Interested in art as a means to enhance persuasion and critical thinking rather than to create things of rarefied beauty, Hine distributed his photographs in reformist or popular magazines; they were also made into graphic posters and employed as lantern slides in lectures. It was relatively hard to inspire compassion for those in the "street trades," especially newspaper delivery boys (newsies), whom contemporary literature both valorized and sentimentalized. The NCLC, however, demonstrated that in no other occupation were children so unsupervised, and the harsh city environment exposed them to physical danger and adult vices. The young boys seen here, smoking like their elders, seem prematurely hardened to life on the street.

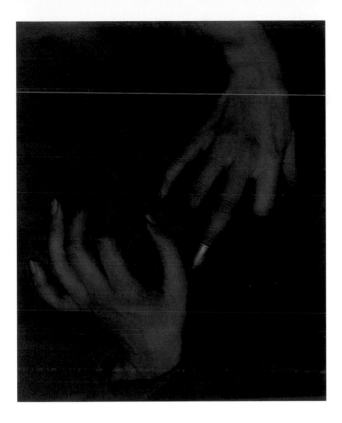

ALFRED STIEGLITZ American, 1864–1946
Georgia O'Keeffe, 1919
Palladium print, solarized; 25.1 x 20.2 cm (9 7/8 x 7 15/16 in.)
Alfred Stieglitz Collection, 1949.745

Alfred Stieglitz campaigned throughout the first half of the twentieth century to legitimize photography and modern art. He founded first an exhibiting organization, the Photo-Secession, then the periodical *Camera Work*, and finally a series of galleries. The most influential of these, the gallery known simply as 291, operative from 1908 until 1917, introduced in America the work of such leaders of the European avant-garde as Paul Cézanne, Henri Matisse, and Pablo Picasso. Georgia O'Keeffe, who became Stieglitz's wife in 1924, was among the progressive American artists whose work he also exhibited at 291. In a search for objective truth and pure form, the innovative photographer took some five hundred photographs of O'Keeffe between 1917 and 1937. The essence of O'Keeffe, he felt, was not confined to her head and face alone; equally expressive were her torso, feet, and especially her hands, as seen here. What resulted is a "composite portrait" of the painter, in which each photograph, revealing her intrinsic nature at a particular moment, can stand alone as an independently expressive form. When these serial images are viewed as a whole, they portray the essence of O'Keeffe's many different "selves."

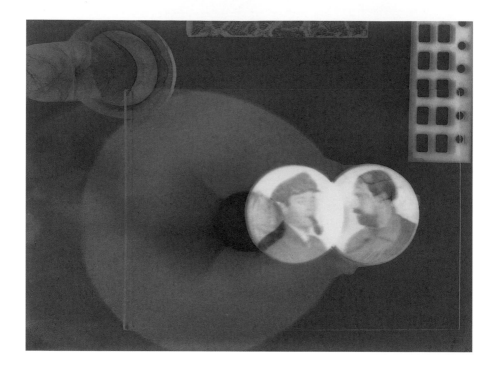

EL LISSITZKY Russian, 1890–1941
Untitled, 1923
Gelatin silver photogram; 17.6 x 23.7 cm (6 ¹⁵/₁₆ x 9 ⁵/₁₆ in.)
Mary L. and Leigh B. Block Collection, 1992.100

A painter, architect, and designer, as well as a photographer, El Lissitzky believed that avant-garde art could transform daily life. One of the key figures to integrate artistic developments in Russia with those in Western Europe, he began experimenting with photography seriously in Germany in 1923. Lissitzky was fascinated by the possibilities of photograms, multiple exposures, and what he called *fotopis*—loosely translatable as "photo-writing"—and he eventually abandoned painting to focus on combined photographic and architectural projects.

Photograms (images made without a camera by placing objects directly on photographic paper and exposing them to light) were taken up in Dada and Constructivist circles in different countries between 1919 and 1923. The primitive technology, which dispensed with lenses, permitted a merger of touch and sight that Lissitzky thematizes in this picture by having himself (at left) and fellow painter and designer Vilmos Huszár appear to be the twinned pupil of a ghostly eyeball—at once pictured and the embodied agent of picturing.

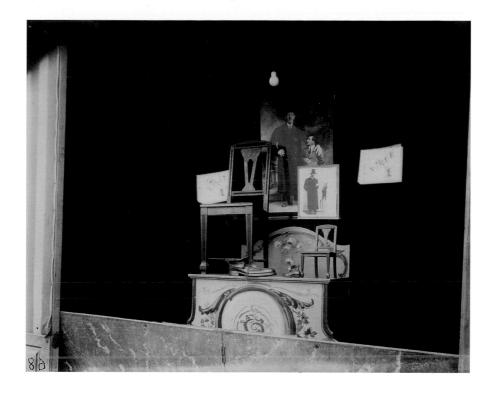

JEAN-EUGÈNE-AUGUSTE ATGET French, 1857–1927
Fête du Trône, 1925
Gelatin silver printing out print; 19.9 x 22.5 cm (7 ¹³/₁₆ x 8 ⁷/₈ in.)
Julien Levy Collection; Special Photography Acquisition Fund, 1979.56

For almost three decades, Eugène Atget, an actor turned documentary photographer, organized views of Paris into an elaborately ordered archive that mapped the city in its details and registered a broad complaint against its transformation from a world of artisans and individuals into a capital of spectacle. Usually early in the morning, Atget hauled a large view camera, a wooden tripod, and heavy glass plates around the city to do his work. In *Fête du Trône,* the photographer captured a curious window display featuring articles associated with a giant and a midget, a sort of ready-made Surrealism. In 1925, the year this photograph was taken, Atget was discovered by the expatriate American artist and photographer Man Ray, who was part of the Surrealist circle of poets and artists in Paris. With Man Ray's support, Atget's work began to be published and recognized as more than just a visual history of Paris. Upon Atget's death, Man Ray's assistant, the photographer Berenice Abbott, acquired the more than eight thousand prints found in his studio and devoted decades to promoting his vast and remarkable oeuvre. The funds for Abbott's purchase were supplied by Julien Levy, a prominent dealer of photography and Surrealism, the core of whose photographic collection is held at the Art Institute.

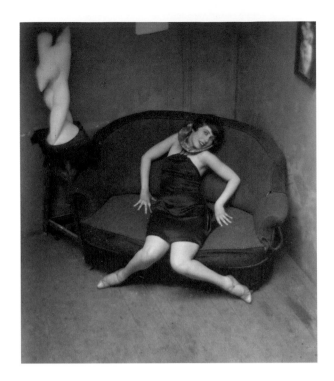

ANDRÉ KERTÉSZ American, born Hungary, 1894–1985
Satyric Dancer, Paris, 1926
Gelatin silver print; 9 x 7.8 cm (3 ½ x 3 ¹/₁₆ in.)
Gift of Nicholas and Susan Pritzker, 2009.646

In 1915 André Kertész began submitting pictures to newspaper and exhibition competitions in his native Hungary. He arrived in Paris one decade later greatly attuned to the possibilities of photographs as both unique display objects and mass-media images. This gorgeously printed view of the dancer Magda Förstner posing in the Montparnasse studio of sculptor Étienne Beöthy (who, like the photographer and dancer, was also a Hungarian émigré) is a variant of one published by the Berlin leisure magazine *Die Dame* in 1927 to illustrate a parable of marital infidelity. Clad in a short halter dress with a ruff around her neck, Förstner perches alluringly on a couch, her lower legs swiveled outward as if in imitation of a Charleston step. Beöthy was pursuing an abstracted figural language in sculpture, just as Kertész was in photography, and his statue *Direct Action*, which appears in a corner next to the sofa, serves as a foil for the latter's camera work. Interestingly, the published photograph became an icon, and possibly gained its current title, only in the 1960s, when Kertész recovered the negative and reprinted it many times. The Art Institute's version, meanwhile, is believed to be unique.

LÁSZLÓ MOHOLY-NAGY American, born Hungary, 1895–1946
Berlin Radio Tower, 1928
Gelatin silver print; 36 x 25.5 cm (14 3/16 x 10 in.)
Julien Levy Collection, Special Photography Acquisition Fund, 1979.84

Over the winter and spring of 1927–28, Bauhaus professor László Moholy-Nagy
took a series of perhaps nine views looking down from the Berlin Radio Tower,
one of the most exciting new constructions in the German capital. Moholy had
already photographed the Eiffel Tower in Paris, looking up through the tower's
soaring girders. In Berlin, however, Moholy turned his camera around and pointed
it straight down at the ground. This plunging perspective showed off the spectacu-
lar narrowness of the Radio Tower, finished in 1926, which rose vertiginously to a
height of 450 feet from a base seven times smaller than that of its Parisian prede-
cessor (which opened in 1889). Moholy attached exceptional importance to this,
his boldest image: he hung it just above his name in a room devoted to his work at
the Berlin showing of *Film and Foto*, a mammoth traveling exhibition that he had
helped to prepare. Moholy also chose this view and one other to offer Julien Levy,
the pioneering art dealer, when Levy visited him in Berlin in 1930. The following
year the pictures went on view at the Levy Gallery in New York, in Moholy's first
solo exhibition of photographs.

MANUEL ALVAREZ BRAVO Mexican, 1902–2002
Wineskins, 1932
Gelatin silver print; 15.9 x 23.9 cm (6 ¼ x 9 ⅜ in.)
Julien Levy Collection, gift of Jean Levy and the Estate of Julien Levy, 1988.157.9

During and following the Mexican Revolution (1910–20), art entered politics, and the handicrafts of indigenous peoples were celebrated as expressions of a new national culture and identity. Manuel Alvarez Bravo, who embraced nativist iconography from a distinctly modernist vantage beginning in the later 1920s, flourished in this Mexican Renaissance. He fostered relationships with Mexican muralists as well as with European and American artists who traveled to Mexico, including such figures as Surrealist leader André Breton and photographers Henri Cartier-Bresson and Edward Weston. Julien Levy exhibited this print and other photographs by Bravo alongside works by Cartier-Bresson and Walker Evans in the 1935 show *Documentary and Anti-Graphic Photographs*. In his press release for the show, Levy explained "anti-graphic" as something that defies or eschews generally accepted criteria for good photography and remains "in many ways the more dynamic, startling, and inimitable" on that account. Bravo's image of Mexican goatskin vessels—a traditional means of transporting wine—suggests an intoxicating ambiguity between inanimate and animal creations, in the spirit of the Surrealist movement.

WALKER EVANS
American, 1903–1975
Citizen in Downtown Havana, Cuba, 1933
Gelatin silver print; 22.2 x 11.7 cm (8 ³/₄ x 4 ⁵/₈ in.)
Gift of Mrs. James Ward Thorne, 1962.162

Walker Evans is perhaps best known for his dispassionate photographs of the American South during the Depression. It was during a 1933 assignment in Havana, Cuba, however, that he truly honed his eye as a social documentarian. Evans was hired by Carlton Beals to illustrate his book *The Crime of Cuba*, a polemical work that criticized American capitalists for their contribution to the economic and political collapse of Cuba. In the three weeks Evans spent in Havana, he was dismayed by the cultural crisis and police repression but visually delighted by the urban crowds, street grids, advertisements, and cinema posters. "It's still a frontier town, and half savage, forgetful and unsafe," he noted. "I have been drunk with this new city for days." This photograph of a Cuban man—nonchalantly dapper in his white suit and skimmer hat, calling to mind the "dandy" figure praised by nineteenth-century critic and poet Charles Baudelaire—suggests Havana streets that were overwhelmingly male but racially diverse. Although omitted from Beals's book, this image became one of Evans's favorites, and he featured it in his landmark 1938 Museum of Modern Art exhibition and book, *American Photographs*.

JOHN HEARTFIELD German, 1891–1968

All Fists Clenched as One, 1934

Cover for *AIZ* (*Arbeiter-Illustrierte-Zeitung*), edited by Wieland Herzfelde, October 4, 1934

Photolithograph of photomontage; 38.1 x 28 cm (15 x 11 in.)

Wirt D. Walker Trust, 2009.488

In 1929, following ten years of activity in photomontage and publishing, John Heartfield began working for the left-wing periodical *Arbeiter-Illustrierte-Zeitung* (*AIZ*, or Workers' Illustrated Magazine). The weekly magazine, founded to popularize news and images from a working-class viewpoint, served from the first as a major organ of opposition to the rising National Socialist party. When Hitler took power in early 1933, Heartfield and the *AIZ* editorial office fled to Prague; many of Heartfield's best-known covers for the magazine were made in the Czech capital. Among them is this iconic picture of a monumental fist that contains a multitude of arms raised in solidarity. The composition, exceptional for Heartfield in that it shows a picture of inspiration rather than acerbic critique, was undoubtedly influenced by the work of Soviet photomontage artist Gustav Klutsis, particularly a 1932 election poster for which Klutsis repeated the image of his own raised palm numerous times to evoke a crowd acting as one. In 2009 the Art Institute acquired a premier collection of Central and Eastern European photography in print that includes 163 issues of *AIZ*—one of the largest such holdings in the country—and many other books, periodicals, and posters by both Heartfield and Klutsis.

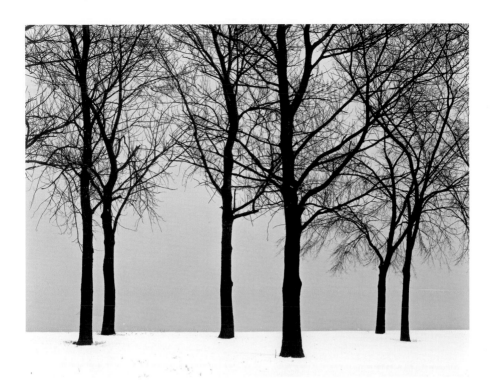

HARRY CALLAHAN American, 1912–1999
Chicago, 1950
Gelatin silver print; 19.2 x 24.2 cm (7 ⁹/₁₆ x 9 ½ in.)
Mary L. and Leigh B. Block Endowment, 1983.65

One of the most important figures in modern American photography, Harry Callahan was a humble and intuitive artist. He was largely self-taught, and as a teacher at Chicago's Institute of Design (1946–61), he continued to learn by assigning photographic problems to students and then solving them himself. Influenced by both the classicism of Ansel Adams and the experimentalism of László Moholy-Nagy, Callahan fused formal precision and exploration with personal subjectivity. He photographed a wide range of subjects—female pedestrians lost in thought on Chicago's streets; architectural facades; his wife, Eleanor; and weeds and grasses in snow. *Chicago*, one of his best-known pictures, shows trees covered in snow along Chicago's Lake Shore Drive. Although Callahan captured all of the detail available in the bark and snow in his negative, he purposely printed this image in high contrast to emphasize the black-and-white forms of the trees against the stark backdrop. With a graphic sensibility typical of the Institute of Design, Callahan reminds the viewer that a photograph is first and foremost an arrangement of tones and shapes on a piece of paper.

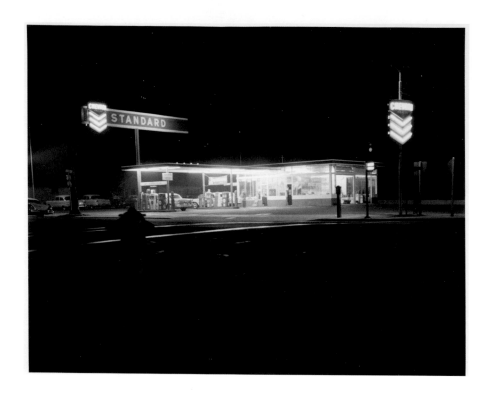

ED RUSCHA American, born 1937
Standard—Figueroa St., 1962
Gelatin silver print; 19 x 24 cm (7 ½ x 9 ⁷⁄₁₆ in.)
Photography Gala Fund and restricted gift of Martin and Danielle Zimmerman and the Comer Foundation, 2012.118

Ed Ruscha radically changed the basis for art with his photobooks, the earliest of which appeared in 1963 with the matter-of-fact title *Twentysix Gasoline Stations*. Photographed on Route 66 between Los Angeles, where Ruscha still lives and works, and his hometown of Oklahoma City, the book heralded fundamentally influential turns in contemporary art: to vernacular corporate architecture and the branding of public space; to critical and creative possibilities found on the interstate highway; and to the impersonal, banal, and random as sources of inspiration. Ruscha interspersed pictures of industry giants such as Standard, Shell, or Texaco with others of mom-and-pop stations. He never showed the photographs but instead presented the coolly designed books (eighteen in all, recently acquired by the Art Institute along with a selection of the original photographs) in galleries, where the asking price of a few dollars apiece confounded purchasers of his paintings and drawings; and at bookstores, where they failed equally to attract buyers for many years. Yet, by equating an artist's book with a dime novel, Ruscha achieved his desire to "be the Henry Ford of book making."

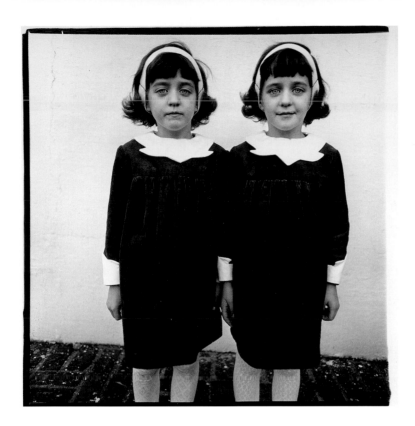

DIANE ARBUS American, 1923–1971
Identical Twins, Roselle, New Jersey, 1967
Gelatin silver print; 37.8 x 37 cm (14 ⁷/₈ x 14 ⁹/₁₆ in.)
Gift of Richard Avedon, 1986.2976

Two years before she received her first camera, Diane Arbus wrote: "There are and
have been and will be an infinite number of things on Earth. Individuals all different,
all wanting different things, all knowing different things, all loving different things, all
looking different. . . . That is what I love: the differentness." Arbus's appreciation for
the unusual, eccentric, and extraordinary led her to photograph a range of subjects
over the thirty years of her career—transvestites, giants, art philanthropists, nudists,
and, as here, identical twins. No one knows how Arbus learned about a small-town
Christmas party in 1967 being held for local twins and triplets, but it is in keeping
with her interest in how people are who they are. Isolating these seven-year-old girls
against the wall of the Knights of Columbus hall in Roselle, New Jersey, and photo-
graphing them in her typically straightforward manner, Arbus ensured close attention
would be paid to the details: the matching homemade dresses (which were green but
appear black), the lace stockings bunched below the knees, and the barely discernible
difference in each girl's presentation before the camera. Such details variously belie and
reinforce the uncanny suggestion of two thoroughly identical individuals.

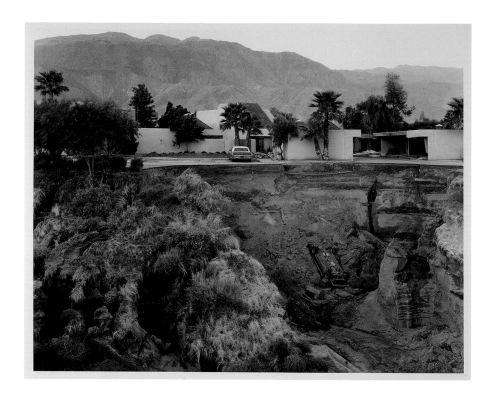

JOEL STERNFELD American, born 1944
After a Flash Flood, Rancho Mirage, California, July 1979, 1979
Chromogenic print; 40.5 x 50.8 cm (15 ¹⁵/₁₆ x 20 in.)
Gift of Ralph and Nancy Segall, 1993.410

Just as color photography was coming into its own as a medium for art, Joel
Sternfeld started his career dedicated to using color film. In the late 1960s he made a
major aesthetic shift by transitioning from images of life on the streets captured with
a handheld camera to studies of the American landscape taken with a large-format
view camera. In 1978 a Guggenheim grant allowed Sternfeld to embark on a nearly
decade-long project that began as a drive across the United States. His photographic
Wanderjahr, which echoed those of Walker Evans in the 1930s and Robert Frank in
the 1950s, yielded the 1987 publication *American Prospects*, the contents of which
the Art Institute owns complete. *After a Flash Flood* is typical of photographs in that
book, many replete with details that take time to register fully, such as the compari-
son between a more visible car that sits calmly parked and another, destroyed, that
lies overturned and embedded in the underside of a largely beige to brown landscape.
Sternfeld uses color here and often to add layers of emotional complexity to seemingly
straightforward images.

RICHARD PRINCE American, born 1949
Untitled (fashion helmet), 1982
Chromogenic print; 59.5 x 40.7 cm (23 $^7/_{16}$ x 16 in.)
Gift of Boardroom, Inc., 1992.708

Around the time he made this piece, Richard Prince was spending a lot of time watching movies rented from a World of Video store. Asked by a store employee what he did for a living, Prince answered that he was a thief, a statement whose possible truth belied its apparent irony. From 1977 until 1984, Prince presented as his own work rephotographed advertisements from magazines. Liberated from their initial context, the images, or details of images, took on a fantastic quality, one that kept in play the aura of desire, money, and power fuelling all consumer culture, while adding dimensions of instability and true freedom that consumerism is designed to repress. In this photograph fashion sheaths its wearer like a condom, making a man-part out of a woman while cloaking manliness in a feminine accoutrement. Copyright infringement, an act of thievery in legal terms, is the most obvious but not the greatest transgression accomplished by Prince's appropriation of publicly circulating photographs, an interest he retains to this day.

THOMAS STRUTH German, born 1954
Art Institute of Chicago II, Chicago, 1990
Chromogenic print mounted on acrylic; 184.1 x 219 cm (72 ⁷/₁₆ x 86 ³/₁₆ in.)
Restricted gift of Susan and Lewis Manilow, 1991.28

As a student of the renowned photographers Bernd and Hilla Becher at the Kunst-
akademie Düsseldorf in the 1970s, Thomas Struth absorbed their objective, methodical
style of making pictures, often emphasizing the camera's single-point perspective.
To his varied subject matter—city streets, rainforests, family portraits—Struth brings
an acute awareness of the act of observation. His use of relatively great depth of field
allows him to lead the viewer's eye to certain details and gloss over other ones.

Struth's celebrated *Museum Photographs* series is composed of monumental images
of museum visitors in various stages of observation, captivation, and even distraction.
As part of this series, *Art Institute of Chicago II* depicts a woman pushing a stroller
facing Gustave Caillebotte's famous *Paris Street; Rainy Day* (see p. 216), while another
woman reads the label. The women's clothing harmonizes remarkably with the palette
of the painting, and the gallery's marble floor seems transformed into a continuation
of the wet cobblestones rendered so believably by Caillebotte's paintbrush. As historian
Hans Belting concluded of this work, "One no longer knows what is inside the painting
and what is in front of it. . . . We feel like rubbing our eyes when the space in front of
the painting transforms itself into a picture that is not separated from the painting."

DAWOUD BEY American, born 1953
Candida and Her Mother, Celia, II, 1994
Internal dye diffusion transfer prints; each: 76.5 x 56 cm (30 ⅛ x 22 ¹⁄₁₆ in.)
Gladys N. Anderson Endowment, 2002.554.1–6

In the dispiriting years just after World War I, the Irish poet William Butler Yeats wrote the famous line: "Things fall apart; the centre cannot hold." We have since gotten used to living with pieces—pieces of time, heritage, even morality. Although Dawoud Bey sometimes seeks a solitary moment or a single point of view in his photographs, he knows that the essence of what lives before the camera often eludes such an approach. Thus, in *Candida and Her Mother, Celia, II,* he emphasized the complexities of mother-daughter relationships. The grid format of his composition includes frames in which the mother and daughter's faces and hands are captured together, as well as separate frames in which they gaze back at the artist. In the wholesome beauty of this loving family bond, Bey constructed a cohesive sanctuary apart from the horrors and ambiguities of our time.

NAN GOLDIN American, born 1953
The Ballad of Sexual Dependency, 1979–2001
Multimedia installation of 720 color slides and a programmed soundtrack; running time: 45 minutes
Through prior bequest of Marguerita Ritman; restricted gift of Dorie Sternberg, Photography Associ-
ates, Mary L. and Leigh B. Block Endowment, Robert and Joan Feitler, Anstiss and Ronald Krueck,
Karen and Jim Frank, and Martin and Danielle Zimmerman, 2006.158

For thirty-five years Nan Goldin has obsessively recorded her life experiences, and
her slide installation *The Ballad of Sexual Dependency* represents the zenith of this
endeavor. A hybrid of photography, film, and installation art, the work projects hun-
dreds of Goldin's photographs in a unique sequence, accompanied by a specified
soundtrack. Images representing couples, gender roles, dependency, and alienation
are paired with evocative songs such as Dean Martin's "Memories Are Made of This."
It is appropriate that Goldin's images of her subjects' fantasies and sorrows should be
realized as short-lived projections. The slide projector was adopted as an artistic vehicle
in the 1960s and 1970s for public performance-based work, and *The Ballad* codifies
more performative presentations by Goldin in the clubs and cinemas of 1980s New
York's artistic demimonde.

Goldin's pictures, like images of family vacations or holidays, embrace photography's
potential for immediacy, emotion, and anecdote. Unlike such snapshots, however,
they capture Goldin, her friends, and her family in moments of intimacy—lovemaking,
violence, addiction, hospitalization—and depict the rollercoaster of human emotions
that accompanies these moments. In this way, *The Ballad* offers a more exposed, and
potentially more honest, version of the traditional domestic slideshow.

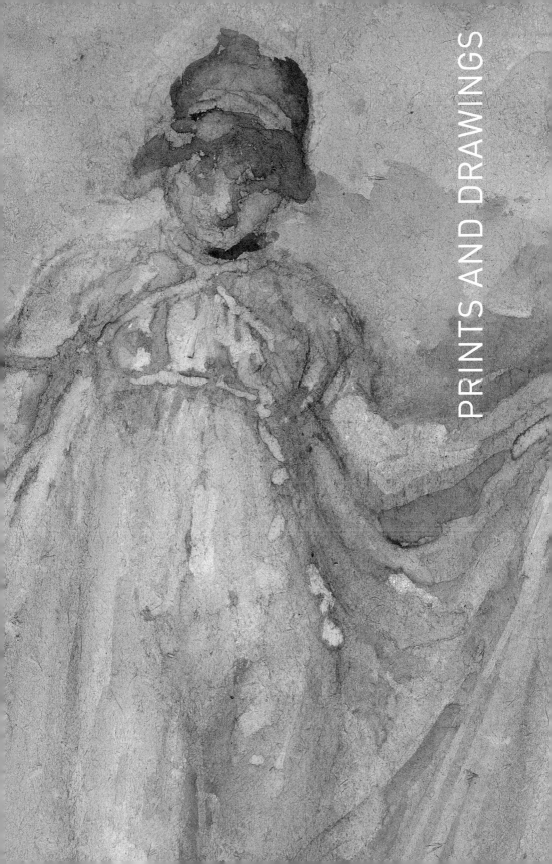

PRINTS AND DRAWINGS

MASTER OF THE AMSTERDAM CABINET (ALSO KNOWN AS THE HOUSEBOOK MASTER) German or Flemish, active c. 1465–1500
The Road to Calvary, 1475/80
Drypoint on ivory laid paper; 13 x 19.4 cm (5 ⅛ x 7 ⅝ in.)
Clarence Buckingham Collection, 1958.299

This dramatic depiction of Christ's suffering on his way to the Crucifixion is one of the first examples of drypoint by the anonymous master who invented this method of engraving. In drypoint the image is drawn directly on a metal plate with a sharp instrument, a process that preserves the artist's personal "handwriting" and imparts to the print a characteristically velvety line. Here the printmaker skillfully exploited the soft, atmospheric effects, silvery shadows, and sense of delicate, luminous distances that are attainable in drypoint. The forest of lances that juts up behind the hills in the background also creates the illusion of depth. The central motif is Christ's ordeal at the hands of three soldiers who force him and Simon of Cyrene, an innocent bystander, onward to the Mount of Calvary. On the left, the grieving figure of Mary, supported by the apostle John, is strikingly juxtaposed with the utterly indifferent soldier on the right, who has turned his back on the whole scene. This impression of *The Road to Calvary* is one of only three versions of this print. The artist is called the Master of the Amsterdam Cabinet because the Rijksprentenkabinet in Amsterdam owns eighty of the approximately ninety surviving prints by his hand.

ALBRECHT DÜRER German, 1471–1528
Young Steer, c. 1493
Pen and black ink on ivory laid paper; 17.5 x 14 cm (6 7/8 x 5 1/2 in.)
Clarence Buckingham Collection, 1965.408

From an early age, Albrecht Dürer displayed an inquisitive mind and exceptional talent as a draftsman. He was born in Nuremberg and first trained as a goldsmith in his father's shop before apprenticing with the painter Michael Wolgemut. One of his earliest animal drawings, *Young Steer* shows its subject grazing in an unseen field. The artist's sure strokes and adept cross-hatching delineate the steer's sculptural form, with taut skin stretched over a strong yet bony frame. Dürer's precise draftsmanship recalls the drawings and prints of the celebrated German master Martin Schongauer, whom he greatly admired. This work was probably a study from nature; sketchy lines around the animal's right hind foot, back, muzzle, and horns reveal that the artist originally drew the steer in a slightly different position, with his mouth open. A masterful engraver who would elevate printmaking to an expressive art form over the course of his career, Dürer employed the steer's hindquarters for the barnyard scene in his engraving *The Prodigal Son amid the Swine* (1494/96; The Art Institute of Chicago).

GIOVANNI BENEDETTO CASTIGLIONE Italian, 1609–1664
The Creation of Adam, c. 1642
Monotype on ivory laid paper; 30.3 x 20.3 cm (11 $^{15}/_{16}$ x 8 in.)
Gift of an anonymous donor; restricted gift of Dr. William D. and Sara R. Shorey and Mr. and Mrs.
George B. Young, 1985.1113

Considered one of the most original and innovative Italian artists of the Baroque
period, Giovanni Benedetto Castiglione literally separated light from darkness, creating
form out of chaos in this work, his earliest known monotype. In a perfect match of
medium and message, Castiglione, the Genoese artist credited with inventing the tech-
nique, used this new method to portray the central act of Genesis: the creation of
man. He produced this electrifying image by subtracting the design from the inked
surface of a copperplate with a blunt instrument, such as a stick or paintbrush
handle, and then printing directly on a sheet of paper. Broad, angular strokes of white
depict God emerging from a cloud, while thin, fluid lines extract the languid body
of Adam from velvety blackness. Castiglione's monotypes employ both this dark-
ground technique, which naturally lends itself to dramatic and mysterious imagery,
and the light-ground manner, in which the design is drawn in ink directly on a clean
plate. Both processes yield only one fine impression. It was not until the nineteenth
century that such versatile artists as Edgar Degas explored the monotype's full potential
(see p. 316).

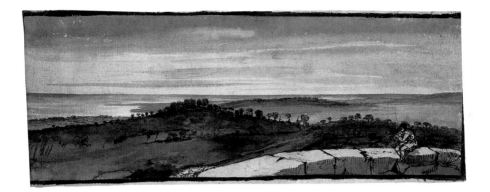

CLAUDE LORRAIN (CLAUDE GELLÉE) French, 1600–1682
Panorama from the Sasso, 1649/55

Pen and brown ink, with brush and brown wash, heightened with white gouache and traces of white chalk, over black chalk and traces of graphite, on cream laid paper; 16.2 x 40.2 cm (6 3/8 x 15 7/8 in.)
Helen Regenstein Collection, 1980.190

For Claude Lorrain, one of the most important aspects of his adopted city of Rome was its surrounding countryside, the Campagna, which the artist studied, sketched, and painted all his life. His evocative classical landscapes were sought after by papal patrons, as well as by aristocrats and royalty throughout Europe. For nearly a century after his death, travelers on the Grand Tour of European capitals judged real scenery according to his standards. In Claude's landscapes, as in this superb drawing, order and tranquility prevail; men perform no labor but rather exist peacefully in beautiful pastoral settings blessed by the warm Roman light. Depicted here is the region around the Sasso, a large rock ten miles south of Civitavecchia, Rome's modern seaport. Evidently made at the site of the rock itself, the drawing is remarkable in its mastery of subtle ink washes that evocatively suggest, rather than describe, the landscape and sea. Individual trees stand out as nearly geometric forms against the unifying light. The drawing's horizontal format enhances the idyllic landscape's panoramic sweep, which the viewer savors along with the solitary shepherd.

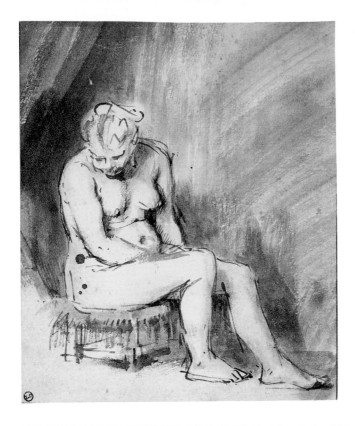

REMBRANDT HARMENSZ. VAN RIJN Dutch, 1606–1669
Nude Woman Seated on a Stool, 1654/56

Pen and brown ink, and brush and brown wash, on ivory laid paper; laid down on cream laid card;
21.2 x 17.4 cm (8 ¼ x 6 ⅞ in.)
Clarence Buckingham Collection, 1953.38

For Rembrandt van Rijn, simple honesty of vision and sureness of line were far more important than the classical glorification of the nude. He focused on this subject only during certain phases of his career, and very few of the resulting studies, which he used to prepare biblical or mythological representations, survive today. This strong form is a late work, and one of only four extant drawings of the female nude attributed to Rembrandt with certainty. Unlike the almost scientific realism of his earlier nudes, his late studies are less detailed and more painterly. He attained a maximum of expression with a minimum of means. Rendered with a swift treatment by brush and the blunt reed pen favored by the artist in his late years, this ample figure projects a forceful presence. Her face is generalized, and her feelings are suggested through her contemplative pose. Her simple shape and external immobility seem to increase the viewer's sense of her inner vitality. In *Nude Woman Seated on a Stool*, Rembrandt's penstrokes and brushwork are integrated with the utmost lightness and perfection; the pen stresses structural features, while the brush provides a transparent, atmospheric tone linking figure and space.

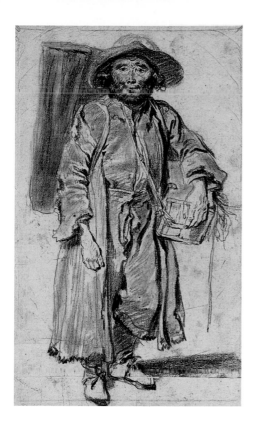

JEAN-ANTOINE WATTEAU French, 1684–1721

The Old Savoyard, c. 1715

Red and black chalk, with stumping, on buff laid paper, laid down on cream wove card, laid down on cream board; 35.9 x 22.1 cm (14 ⅛ x 8 ¹¹/₁₆ in.)

Helen Regenstein Collection, 1964.74

The Flemish-born artist Jean-Antoine Watteau deviated from his acclaimed scenes of courtly figures in parklike settings (called *fêtes galantes*) with this arresting and naturalistic chalk drawing of a humble Savoyard. This elderly vagabond from the Savoy region of France was one of many peasants who, around the turn of the eighteenth century, flocked to Paris, where they tried to eke out livings as chimney sweeps, scavengers, or street entertainers. This old entertainer's props accompany him: a large box of curiosities is on his back, and under his arm is a smaller case probably containing his constant companion and co-performer, a furry marmot. Using only two colors of chalk, Watteau depicted the Savoyard's shrewd, humorous face, his tattered clothing, and his bulky paraphernalia with remarkable precision, sensitivity, and humanity. Of the ten extant studies of Savoyards by Watteau, four appear to portray the same salty character seen here. The drawing's broad, free execution points to the accomplished late works of this gifted artist.

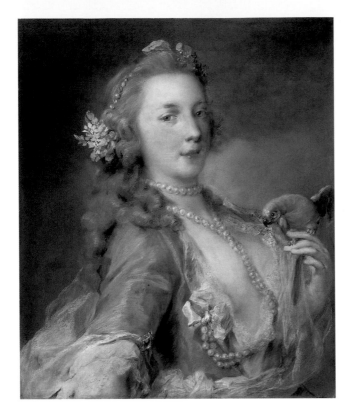

ROSALBA CARRIERA Italian, 1675–1757

A Young Lady with a Parrot, c. 1730

Pastel on blue laid paper, mounted on laminated paperboard; 60 x 50 cm (23 ⅝ x 19 ⅝ in.)

Regenstein Collection, 1985.40

Rosalba Carriera is renowned for the distinction she brought to pastel portraiture in Italy and France during the first half of the eighteenth century. No female artist enjoyed greater success or exerted more influence on the art of her era than Rosalba, as she is known. The artist's work in pastel divides itself into two categories: portraits and allegories. A shrewd judge of character, she enhanced but never obscured the actual appearance of the sitters in her portraits. In contrast, her allegorical types are often so generalized that they can seem repetitive, bland, and undistinguished. *A Young Lady with a Parrot* is an intriguing combination of both genres. The colorful parrot is a witty conceit that subtly transfers the provocative gesture of baring one's breast from the young woman to a mischievous bird, whose beak pulls back the gauzy fabric that edges the sitter's bodice. With its rich colorism and vaporous effects, *A Young Lady with a Parrot* is a fully mature work, exhibiting the assurance of Rosalba's finest and most famous portraits. The pastel may depict a young Englishwoman, perhaps one of the daughters of Lord Manchester. Whoever the model, this image's aura of grace and seduction was to characterize the arts of much of the century, marking Rosalba as one of the originators of the Rococo style in Italy and France.

JOSEPH WRIGHT OF DERBY English, 1734–1797
Self-Portrait in a Fur Cap, 1765/68
Monochrome pastel (grisaille) on blue-gray laid paper; 42.5 x 29.5 cm (16 ³/₄ x 11 ⁵/₈ in.)
Clarence Buckingham Collection, 1990.141

Joseph Wright, a leading artist of the eighteenth century, spent most of his life in the
central Midlands town of Derby, where he ran a successful portrait-painting practice.
His best work in this vein portrays solid middle-class citizens, much like himself, with
a keen perceptiveness of both character and physical appearance. Throughout his
career, Wright was preoccupied with the evocative effects of light, specifically those
produced by a single light source such as a candle, and the resulting play of shadows.
Influenced by the powerful chiaroscuro of the superb mezzotints of Thomas Frye, a
contemporary printmaker, Wright produced a number of dramatically lit self-portraits
in oil, charcoal, and black-and-white pastel during the mid-1760s. Depicting himself
in nocturnal lighting, wearing an exotic black hat, the artist evoked a time-honored
tradition in portraiture: the deeply pensive artist who confronts himself and the
viewer with a quiet challenge. Wright later ventured into landscape and genre subjects,
the most original of which are concerned with the exploration of light phenomena.
Portrait commissions continued to be a reliable source of income throughout his career.

JEAN-SIMÉON CHARDIN French, 1699–1779
Self-Portrait with a Visor, c. 1776
Pastel on blue laid paper, mounted on canvas; 45.7 x 37.4 cm (18 x 14 ¹³/₁₆ in.)
Clarence Buckingham Collection; Harold Joachim Memorial Fund, 1984.61

Over a century after its creation, the French novelist Marcel Proust said of Jean-Siméon Chardin's audacious self-portrait, "This old oddity is so intelligent, so crazy . . . above all, so much of an artist." In a fitting finale to a long, successful career as a painter of still lifes and genre scenes, Chardin turned in his last decade to a new medium, pastel, and to a new subject matter, portraits (primarily self-portraits). Eye problems arising from lead-based oil paint poisoning were the partial cause of this dramatic change. Of the thirteen pastel self-portraits by Chardin known today, the most famous are versions of the example seen here, with the casually dressed, aging artist in his studio. A virtuoso colorist, the septuagenarian here revealed a joyously free stroke and palette. Nonetheless, the construction of the figure is solid and rigorous, adding to Chardin's powerful presence. This composition was created at the same time as a portrait of the artist's wife for the 1775 Salon (Musée du Louvre, Paris). A year later, Chardin—with greater daring—replicated the pair. These later portraits were separated for almost two hundred years, until they were reunited in the collection of the Art Institute.

JEAN-HONORÉ FRAGONARD French, 1732–1806
The Letter, or *The Spanish Conversation,* c. 1778
Brush and brown ink, with brush and brown wash, with graphite, on ivory laid paper; 39.9 x 29 cm
(15 ¹¹/₁₆ x 11 ⁷/₁₆ in.)
Margaret Day Blake Collection, 1945.32

Jean-Honoré Fragonard's highly personal, powerful style emerged after periods of
study with both François Boucher and Jean-Siméon Chardin, and over five years at
the Académie de France in Rome. Entitled *The Letter,* or *The Spanish Conversation*
(because of the man's elegant attire—with a doublet of full sleeves and a wide, stiff
neck ruff—a costume that was "in the Spanish mode"), this lively sheet depicts with
wit and teasing ambiguity an intimate incident in an upper-class drawing room. The
artist's rapid, virtuoso draftsmanship evokes forms with what seems like a minimum
of effort, and his powerful handling of brush and wash reflects his ability to capture
the effects of light. The interplay between the drawing's broad, free underdrawing and
its shimmering veils of wash lend this work its charm and vivacity. The woman in
this drawing is said to be Fragonard's sister-in-law, the artist Marguerite Gérard.

CASPAR DAVID FRIEDRICH German, 1774–1840
Statue of the Madonna in the Mountains, 1804
Brush and black ink and gray wash, with graphite, on cream wove paper; 24.4 x 38.2 cm (9 ⅝ x 15 ¹/₁₆ in.)
Margaret Day Blake Collection, 1976.22

This vast landscape by one of the central figures of German Romanticism dates from
Caspar David Friedrich's early years in Dresden, where he settled after studying in
Copenhagen (then considered the artistic center of northern Europe). Subtly graded
shades of gray wash evoke the gloomy, overcast days so common in Germany in
November, when this image was created. The drawing also conveys, in the artist's
words, "Not only what he sees before him, but also what he sees within him." In the
center of the landscape, atop the highest peak, a tiny pilgrim kneels in prayer at the
base of a statue of the Madonna. Nature—with its sheer, blank sky, stark hills, and
mute firs—is depicted almost religiously. In this deeply spiritual image, humankind's
experience of nature seems as overwhelming as the unfathomable mystery of our ex-
istence. Just as the infinitesimal pilgrim wanders in this faraway, expansive landscape,
so too did the artist embark upon his own Romantic quest, a search for meaning
in the natural world that reveals the sacred.

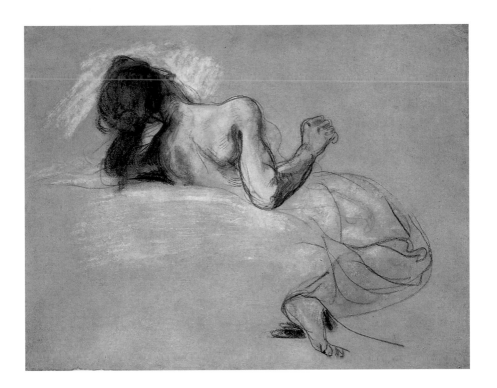

EUGÈNE DELACROIX French, 1798–1863

Crouching Woman, 1827

Black and red chalk, with pastel, heightened with white chalk, over wash, on tan wove paper; 24.6 x 31.4 cm (9 ¹¹/₁₆ x 12 ³/₈ in.)

Through prior bequest of Mr. and Mrs. Martin A. Ryerson Collection, 1990.226

Crouching Woman is one of five pastel studies for Eugène Delacroix's monumental painting *The Death of Sardanapalus* (Musée du Louvre, Paris), which helped establish the artist's reputation as the leader of the French Romantic movement. Of the few pastels that Delacroix produced, this is the only group that can be related to a single painting. Inspired by an 1821 play by the English Romantic poet Lord Byron, the canvas dramatically depicts the last king of the Assyrians. Reclining on his bed moments before his own suicide, the king gazes passively at his wives, concubines, and livestock as they are slain by his order to prevent their slaughter by the enemy army that has just defeated them. In this expressive image of one of the concubines, Delacroix convincingly captured the horror of the moment. With a sure, sweeping line, he described the rhythmic, taut posture of a figure recoiling from a blow or the stab of a knife. Although this powerful figure is significantly truncated in the final painting, the pastel provides insight into Delacroix's creative process, and its sensual drama is representative of the Romantic period.

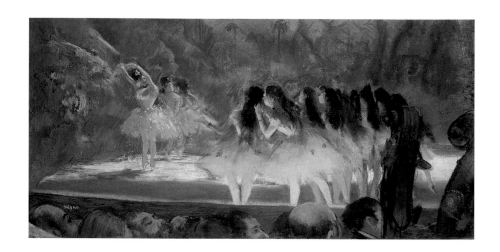

HILAIRE-GERMAIN-EDGAR DEGAS French, 1834–1917
Ballet at the Paris Opéra, 1877
Pastel over monotype on cream laid paper; 35.9 x 71.9 cm (14 ⅛ x 28 ¼ in.)
Gift of Mary and Leigh Block, 1981.12

One of the nineteenth century's most innovative artists, Edgar Degas often combined traditional techniques in unorthodox ways. In *Ballet at the Paris Opéra,* the artist creatively joined the monotype technique, rarely used in his time, with the fragile medium of pastel. Described as "the powder of butterfly wings," pastel was the perfect medium to illustrate the onstage metamorphosis of spindly young dancers into visions of beauty as perfect and short-lived as butterflies. This work, executed on one of the widest monotype plates ever used by the artist, bears Degas's characteristically cropped forms and odd vantage points, which effectively convey the immediacy of the scene. The view is from the orchestra pit, with the necks of the double basses intruding into the dancers' zone. The central dancer is in fifth position, *en pointe,* but the random placement of the corps de ballet, with the dancers' free-flowing hair, suggests a rehearsal rather than a performance. The Paris Opéra was the official school of the first state-supported ballet, the Académie Royale de Danse, created in 1661.

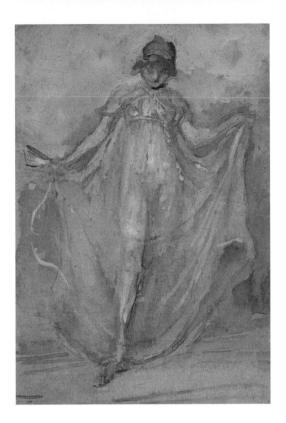

JAMES MCNEILL WHISTLER American, 1834–1903
Green and Blue: The Dancer, c. 1893
Transparent and opaque watercolor, over traces of black chalk, on brown wove paper, laid down
on card; 27.5 x 18.3 cm (10 $^{13}/_{16}$ x 7 $^{3}/_{16}$ in.)
Restricted gift of Dr. William D. Shorey, through prior acquisitions of the Charles Deering Collection;
through prior bequest of Mrs. Gordon Palmer, 1988.219

Inspired by Greek sculpture and Japanese prints, James McNeill Whistler became
entranced with portraying the female form clad in diaphanous drapery in the 1890s.
He developed this theme in all the media in which he worked, including transfer
lithography, oil, pastel, and watercolor. Whistler usually provided garments for his
models to wear, often classical gossamer gowns with high waists and crossed bodices
paired with brightly colored kerchiefs. His models needed a certain degree of strength
and agility, as he sometimes asked them to dance about his studio until he found a
suitable pose. In *Green and Blue: The Dancer,* Whistler employed thin watercolor
washes to distill the graceful movements of his lissome young model. The brown
paper on which he painted lends opacity to the washes, thereby adding subtle weight
to the thin veils of fabric draping the model.

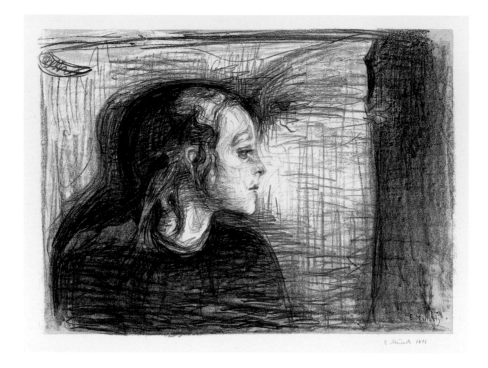

EDVARD MUNCH Norwegian, 1863–1944
Printed by Auguste Clot (French, 1858–1936)
The Sick Child I, 1896
Transfer lithograph printed from two stones in pale blue and black ink on ivory wove paper;
48.3 x 63.5 cm (19 x 25 in.)
Major Acquisitions Fund, 2003.1

When Edvard Munch was thirteen years old, his sister Sophie died of tuberculosis.
Nine years later, he created the first of five painted versions of *The Sick Child,* all
representing Sophie just prior to her death. Munch later described the process of
painting these works as a form of technical and personal catharsis.

Due to the great success of the paintings and his own psychological preoccupations, from 1894 to 1896, Munch made three prints based on the motif, of which
The Sick Child I was the last. In 1896 the artist traveled to Paris to experiment with
new printmaking processes and work with respected printers such as Auguste Clot,
hoping to gain the commercial success that had previously eluded him in the French
capital. There he made this, his first color lithograph, which features Sophie's head
silhouetted against a pillow. Munch printed the lithograph with several different stones
and a variety of color combinations: he made the keystone either black or red and
added up to four other color stones in combinations of blue, gray, red, yellow, reddish
brown, and purple-blue. Munch was keenly aware of the symbolic associations of various colors, and the icy blue and stark black of this impression suggest the haunting
pallor of death.

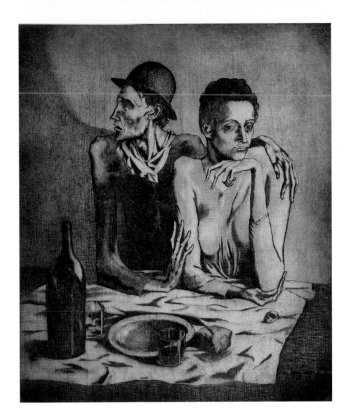

PABLO PICASSO Spanish, 1881–1973
Printed by Eugène Delâtre (French, 1864–1938)
The Frugal Meal, 1904
Etching on zinc in blue-green on ivory laid paper (discolored to cream); 48 x 38 cm (18 7/8 x 15 in.)
Clarence Buckingham Collection, 1963.825

The remarkable artistic career of Pablo Picasso spanned more than seven decades and
influenced nearly every major trend in the first half of the twentieth century. One of
the last works of Picasso's Blue Period (1901–04), this large, hauntingly expressive
etching was completed just after the artist settled permanently in France and moved
into a dilapidated Montmartre tenement nicknamed the Bateau-Lavoir (washerwoman's
boat). During this time, the struggling artist's palette and the mood of his particular
cast of characters—the poor, ill, and outcast—were dominated by the color blue, then
symbolically associated with melancholy. In this austere etching, two subjects that
fascinated Picasso—couples in cafés and the solitude of the blind—are brought to
refinement. The man's emaciated face is in profile, while the woman stares directly
at the viewer, emphasizing the blindness of her companion. Their angular bodies and
elongated fingers and the chalky, cold light recall works by El Greco. *The Frugal
Meal,* which was only Picasso's second attempt at printmaking, reveals the artist's
extraordinary gift for draftsmanship and his remarkable facility with new mediums
and techniques.

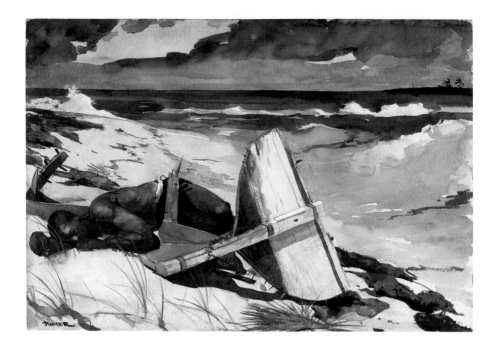

WINSLOW HOMER American, 1836–1910
After the Hurricane, Bahamas, 1899
Transparent watercolor, with touches of opaque watercolor, rewetting, blotting, and scraping,
over graphite, on moderately thick, moderately textured (twill texture on verso) ivory wove paper;
38 x 54.3 cm (14 ¹⁵/₁₆ x 21 ³/₈ in.)
Mr. and Mrs. Martin A. Ryerson Collection, 1933.1235

Revered as America's master of watercolor, Winslow Homer did not begin working
in the medium until the mature age of thirty-seven. As a watercolorist, Homer adapted
his practice to the diverse locales he visited. His sojourns in the tropics took him to
the Bahamas, Bermuda, Cuba, and various locations in Florida. In each new environ-
ment, the self-taught artist pushed the flexible medium in new directions as he applied
his increasingly sophisticated understanding of color and light to a new set of atmos-
pheric conditions. This compelling watercolor was painted during Homer's second
trip to the Bahamas in the winter of 1898–99. Depicting a luckless man washed up
on the beach, surrounded by fragments of his shattered craft, the work demonstrates
the artist's fascination with the rapid and dangerous weather changes of the tropics.
Here sunlight glints through gradually thinning storm clouds. Homer employed
thickly applied opaque red and yellow pigments for the seaweed tossed on the sand,
creating a contrast with the thin washes and fluid brushstrokes that he used to
render the receding waves.

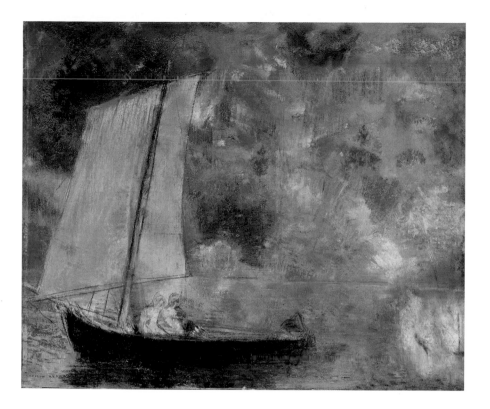

ODILON REDON French, 1840–1916
Flower Clouds, c. 1903
Pastel, with touches of stumping, incising, and brushwork, on blue-gray wove paper with multi-colored fibers altered to tan; perimeter mounted to cardboard; 44.7 x 54.2 cm (17 ⁹/₁₆ x 21 ⁵/₁₆ in.)
Through prior bequest of the Mr. and Mrs. Martin A. Ryerson Collection, 1990.165

The evocative, symbolic art of Odilon Redon drew its inspiration from the internal world of his imagination. For years this student of Rodolphe Bresdin worked only in black and white, producing powerful and haunting charcoal drawings, lithographs, and etchings. Just as these black works, or *Noirs*, began to receive critical and public acclaim in the 1890s, Redon discovered the marvels of color through the use of pastel. His immersion in color and this new technique brought about a change in the artist's approach to his subject matter as well. *Flower Clouds* is one of a number of pastels executed around 1905 that are dominated by spiritual overtones. Here a sailboat bears two figures, perhaps two saintly women, on a timeless journey through a fantastic, phosphorescent sea and sky. The dreamlike skiff may reflect Redon's internal voyage, replacing the nocturnal turmoil of the earlier *Noirs* with a more hopeful vision. The luminous intensity of the pastels echoes the ardent spirituality of the theme.

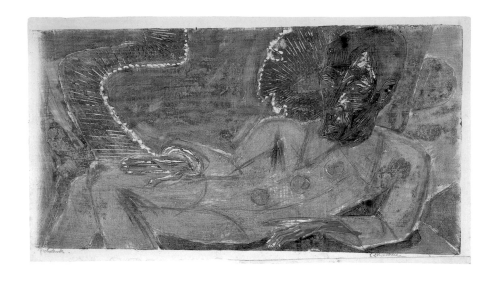

ERNST LUDWIG KIRCHNER German, 1880–1938
Portrait of Otto Müller, 1915
Color woodcut with charcoal on cream wove paper; 27.3 x 54.6 cm (10 ³/₄ x 21 ¹/₂ in.)
Gift of Dr. Eugene Solow in honor of Paulette Solow, Judy Solow Kleckner, Bryan Kleckner, and
Gabrielle Kleckner, 1988.433

Ernst Ludwig Kirchner's *Portrait of Otto Müller*—with its vibrant, modulated color
and penetrating psychological force—is emblematic of the artist's innovative approach
to technique and imagery. A pivotal figure of the German Expressionist movement,
Kirchner first met Otto Müller, also a painter-printmaker, in 1910. Müller then joined
Die Brücke (The Bridge), the group Kirchner had helped found in 1905, which was
instrumental in promoting Expressionism. The period between 1915 and 1919 marked
Kirchner's most concentrated and productive phase of work with portrait prints,
which he made primarily as large-format woodcuts. In this depiction of Müller, Kirchner
used a spare, planar composition and broad areas of undifferentiated color to depict
his subject's sharp features. He painted on a single block with a brush and varying
colors; thus, each print is unique. The cobalt blue striated forms that emanate from
Müller's right and from the side of his head in this print are abstract representations
of the painted bands that decorated Kirchner's studio wall, against which Müller
posed. These bands, which Kirchner painted himself, exemplify his adoption of motifs
and styles from Palauan art of the South Pacific and resonate with Müller's own
fondness for African-inspired furniture and wall paintings. Indeed, Müller's hieratic,
frontal position may suggest his interest in Egyptian art.

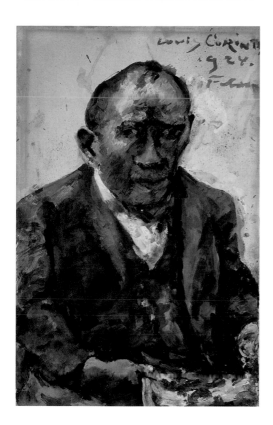

LOVIS CORINTH German, 1858–1925
Self-Portrait, 1924
Gouache, with possible additions in oil, on ivory wove paper; 48.6 x 30.5 cm (19 ⅛ x 12 in.)
Clarence Buckingham Collection, 1987.280

"The times are not the same for us old folk anymore," reads a 1923 diary entry by Lovis Corinth, who suffered a stroke in 1911 and never quite recovered. "We have lost our way . . . so sad, so very sad." The following year, the artist created this tortured self-image; he was sixty-five, with one year left to live. An inveterate self-portraitist, Corinth produced more images of himself than almost any other artist except Rembrandt van Rijn. In this haunting gouache, he gazes at the viewer in anguish. The brooding palette portrays a deeply shadowed face—contorted, haggard, and sunk into hunched shoulders. The pain that both the diary entry and this portrait convey is curiously at odds with Corinth's professional life, which had, in fact, been successful. Challenging traditional approaches to art, his early figure compositions, with their overt sexuality and theatrical movements, made his reputation. Later he executed intensely colored, windswept landscapes that became his most popular works. But Corinth was a deeply patriotic man, and his personal accomplishments failed to assuage the torment he experienced after Germany's humiliation in World War I and his despair over the values of the ensuing Weimar Republic.

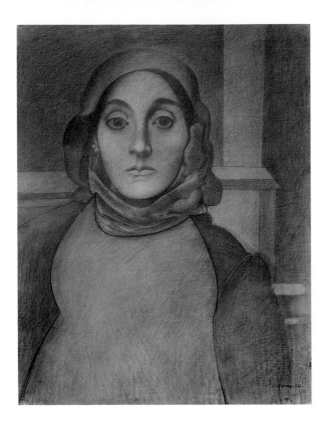

ARSHILE GORKY American, born Turkish Armenia (present-day Turkey), 1904–1948
The Artist's Mother, 1926 or 1936
Charcoal on ivory laid paper; 63 x 48.5 cm (24 7/8 x 19 3/16 in.)
The Worcester Sketch Fund, 1965.510

"The eyes of the Armenian speak before the lips move and long after they cease to," Arshile Gorky once wrote. These words aptly describe this heroic portrait of the artist's mother, Shushan der Marderosian. Although of noble lineage, Shushan and her family were peasants who faced poverty and Turkish persecution and massacre; in 1919 she died from starvation. The following year, Gorky and one of his sisters immigrated to the United States. This tender, haunting image is based on a photograph of the artist with his mother taken in 1912. Clad in simple country clothes, Shushan is a gaunt, distant figure with remarkable and piercing eyes. Gorky depicted his mother with careful, classical simplicity, transforming her dark beauty into the perfect features of an Eastern European church icon. The same photograph served as the inspiration for two canvases entitled *The Artist and His Mother* (Whitney Museum of American Art, New York; and National Gallery of Art, Washington, D.C.), as well as numerous notebook sketches and other drawings, of which this is the most finished. From this early representational mode, Gorky's art underwent a complex evolution that led, in the 1940s, to his dynamic, biomorphic abstractions. Tragically, the artist did not escape hardship. After a series of personal disasters in the 1940s, Gorky took his own life.

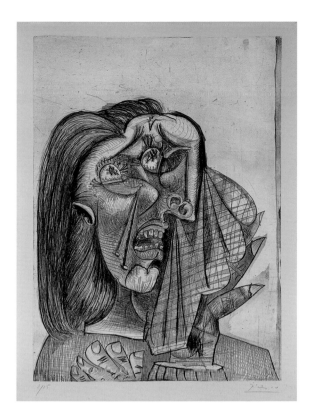

PABLO PICASSO Spanish, 1881–1973
Printed by Roger Lacourière (French, 1892–1966)
Weeping Woman I, 1937
Drypoint, aquatint, and etching, with scraping on copper in black on ivory wove paper;
77.4 x 56.8 cm (30 ½ x 22 ⅜ in.)
Through prior acquisition of the Martin A. Ryerson Collection with the assistance of the Noel and Florence Rothman Family and the Margaret Fisher Endowment, 1994.707

A ferocious image of grief, *Weeping Woman I* is one of the most powerful works that Pablo Picasso undertook in the wake of his seminal *Guernica* (1937; Museo del Prado, Madrid). After completing *Guernica*, an expression of the horrors of war and a critique of fascist tyranny, Picasso continued to be drawn to the subject of agonized grief. Between June and December 1937, he undertook a series of drawings, paintings, and prints known as *The Weeping Women,* in which he focused and elaborated on two figures first presented in *Guernica.* The figure in this print may also represent the artist's lover, the Surrealist photographer Dora Maar. In *Weeping Woman I*, Picasso drew inspiration from contemporary events and sixteenth- and seventeenth-century religious imagery. He modernized the traditional theme of the Virgin Mary lamenting the death of her son. The importance Picasso accorded this etching is suggested not only by its size—it was the largest plate he had yet attempted—but also by the energy he invested in it. He developed the finished print through seven independent states. It seems that he felt the need to work and rework this image, perhaps in an effort to exorcise the demons of war and his difficult relationship with Maar.

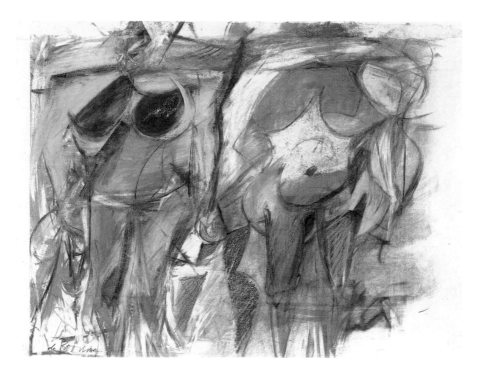

WILLEM DE KOONING American, born Netherlands, 1904–1997
Two Women's Torsos, 1952
Pastel and charcoal on ivory wove paper; 47.9 x 61 cm (18 ⁷/₈ x 24 in.)
John H. Wrenn Memorial Collection, 1955.637

A pioneer of Abstract Expressionism, Willem de Kooning experimented with the human form throughout his career, which reached its apex in the early 1950s with his celebrated *Woman* series. *Two Women's Torsos* was created during an intense campaign in which the artist focused on drawings related to his *Woman* paintings, which were exhibited together with this and other drawings at the Sidney Janis Gallery, New York, in 1953.

De Kooning's drawings are admired for their number and variety, as well as for the artist's expressive technique, exemplified here by his gestural use of pastel in concert with charcoal. This drawing's velvety texture and almost violently animated surface are characteristic of the approximately one hundred sheets that remain from his intense work on the *Woman* theme in 1952 and 1953. Also typical of de Kooning's art is the way in which *Two Women's Torsos* references aspects of related paintings but stands alone as an independent work. As the artist tried to jettison traditional modes of composition, he used drawing as a primary vehicle for the sequential development of his most important early body of work.

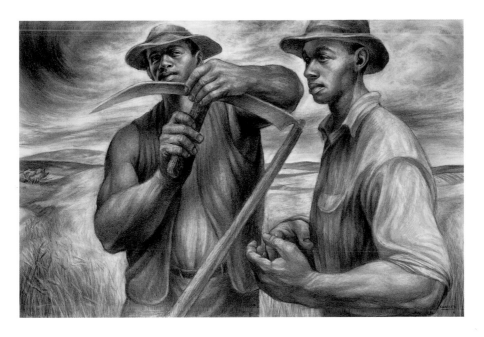

CHARLES WHITE American, 1918–1979
Harvest Talk, 1953
Charcoal, Wolff's carbon drawing pencil, and graphite, with stumping and erasing, on ivory wood-pulp laminate board; 66.1 x 99.2 cm (26 x 39 in.)
Restricted gift of Mr. and Mrs. Robert S. Hartman, 1991.126

Charles White is recognized for the richness of his graphic work and his paintings, which typically depict aspects of the history, culture, and life of African Americans. A native of Chicago, White attended the School of the Art Institute, the Art Students League of New York, and later the Taller de Gráfica Popular in Mexico. Beginning in 1939, he was employed by the Federal Art Project of the Works Progress Administration.

White's father was a railroad and steel worker and his mother was a domestic worker; thus, he had a deep respect for labor. *Harvest Talk*, one of six charcoal and carbon pencil drawings originally exhibited at ACA Galleries in New York in 1953, exemplifies the artist's mature drawing style. Here his strong, assured manner, coupled with the heroic proportions of the figures and the emphasis on the large scythe (an emblem often associated with the Soviet Union)—as well as the social realist sensibilities that prevail throughout his oeuvre, his travels to the U.S.S.R., and his writings for and affiliation with left-wing publications such as *Masses & Mainstream*, *Freedomways*, and the *Daily Worker*—suggest that *Harvest Talk* was inspired by socialist ideals. Like many of White's works on paper, it conveys the power of a mural, despite its relatively small format.

LEE KRASNER American, 1908–1984
Black and White, 1953
Oil paint, gouache, and cut and torn painted paper with adhesive residue, on cream laid paper;
76.6 x 57.1 cm (30 ⅛ x 22 ½ in.)
Margaret Fisher Endowment, 1994.245

Lee Krasner's pictures from the 1940s on are informed by her understanding of the
Abstract Expressionist ideal: to infuse abstract, painterly forms with mysterious and
significant content. The substantial body of work she created shows her sustained
development toward a refined expression of this concept. *Black and White* is one of
Krasner's first and most important works in a group of early paper collages. The
drawings that she disassembled to create these collages echo the work of her husband,
Jackson Pollock, from the same period. According to the art historian Ellen Landau,
however, it is difficult to determine who originated the strategy of cannibalizing
previous works to create new ones. Throughout her career, Krasner employed the
technique more consistently than Pollock.

In *Black and White,* Krasner not only appropriated her own discarded markings
but also referred to Pollock's early-1940s tactic of quoting Pablo Picasso's studio
subjects. She reversed the gender implications of Picasso's prototypes by showing,
at right, a female figure who may be a painter contemplating her works of art, or
perhaps a woman looking in a mirror. The artist's redeployment of studio scraps in
a new context helped her, paradoxically, to mark out new aesthetic territory.

ROY LICHTENSTEIN American, 1923–1997
Alka Seltzer, 1966
Graphite and lithographic rubbing crayon pochoir, with scraping, on cream wove paper; 76.2 x 55.9 cm
(30 x 22 in.)
Margaret Fisher Endowment, 1993.176

Roy Lichtenstein had been exhibiting in galleries for nearly ten years when, in 1961, he dramatically changed the course of his work. Prompted by the comic strips on his children's gum wrappers, he began to create paintings based on cartoon images. The reductive style that soon emerged became his particular contribution to the idiom known as Pop Art. From around 1961 until 1968, the artist created a group of highly finished black-and-white drawings that demonstrate his subversive use of commercial illustration techniques. In *Alka Seltzer*, Lichtenstein exploited everyday practices of visual representation and magnified them, indicating the gas bubbles rising over the glass by meticulously scraping away extra spaces from a field of imitation hand-stenciled Benday dots. To signify the reflective surface of the glass, he drew flat black graphite shapes—a parody, like the dots, of the reductive, linecut effect of pulp advertising. The artist's use of mechanical reproduction conventions served to unify his composition and produce movement and volume on a two-dimensional surface. *Alka Seltzer* is one of Lichtenstein's watershed works because it shows the artist summing up his early graphic techniques and introducing what would become his most significant formal preoccupations in the years that followed.

JASPER JOHNS American, born 1930
Perilous Night, 1982
Ink on frosted Mylar; 100.4 x 240 cm (39 9/16 x 94 7/16 in.)
Through prior gift of Mary and Leigh Block; Harold L. Stuart Endowment, 1989.82

Jasper Johns, one of the greatest artists of our era, began his career in the mid-1950s by re-creating, with great precision, such familiar images as targets, letters, numbers, and flags. Although his subject matter has become less commonplace, he continues to "borrow" from the public domain. *Perilous Night,* for instance, owes its title to a pivotal and expressive piece of music written by the American composer John Cage (1912–1992) in 1945. Both score and cover sheet are rendered on the right-hand side of the drawing with Johns's characteristically fluid handling of ink. On the sheet's left side is a freehand rendition—abstracted, reversed, and turned ninety degrees—of a single, terror-stricken soldier from the Resurrection panel of Matthias Grünewald's sixteenth-century masterwork the *Isenheim Altarpiece* (Unterlinden Museum, Colmar). Between the soldier and the musical score is a black imprint of Johns's right arm, evidence perhaps of the creative power that can merge two disparate images into a cogent statement. The overcome soldier witnessing the Resurrection of Christ and a piece of music marking a key transition in a composer's career both point to "perilous nights" that can change the course of a human life. Characteristically, Johns also explored the same subject in different media. This somberly colored drawing derives from a painting of the same name (1982; private collection).

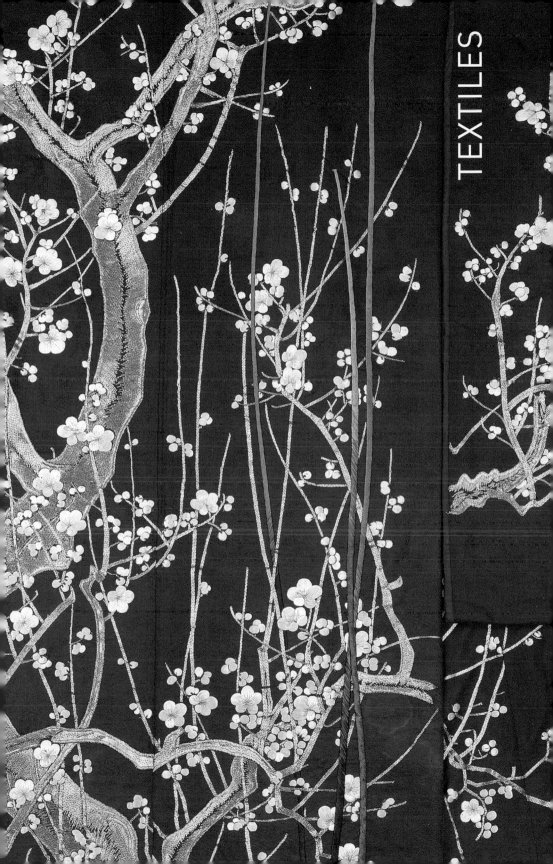

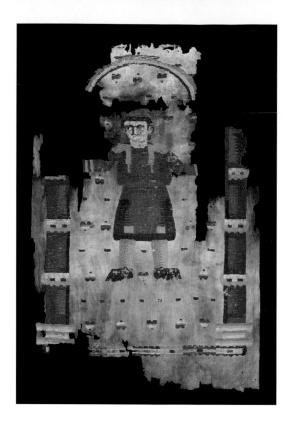

PORTION OF HANGING WITH WARRIOR
5th/6th century
Coptic; Egypt

Linen and wool, plain weave with supplementary wefts forming uncut pile and embroidered linen pile formed by variations of back and stem stitches; 136.5 x 88.3 cm (53 $^3/_4$ x 34 $^3/_4$ in.)
Grace R. Smith Textile Endowment, 1982.1578

Because many textiles made by early Christian Egyptians, called Copts, were preserved in arid tombs, a substantial number of these fabrics have survived in remarkably good condition. This striking portion of a wall hanging depicts a warrior standing beneath a colonnaded, arched opening. With raised arms, which perhaps once held a weapon, he wears a traditional tunic with clavic bands (the narrow strips extending down from the shoulders, on the front and back, to the waist or hem). This woven piece is distinguished by its large size, imposing composition, and brilliant, unfaded shades of red, green, blue, brown, and yellow. The figure's commanding frontality, solemn expression, and animated side glance, together with the composition's bold lines and vivid colors, relate this fragment to the Copts' hauntingly realistic portrait icons. Also suggestive of icons is the three-dimensional appearance of the warrior's face and legs and the columns—an effect much easier to achieve in painting than in weaving. Woven of indigenous materials, this hanging is composed of linen warps and wool and linen wefts that create an uncut pile against a plain-weave foundation, a fabric surface less common in Coptic textiles than the tapestry weave.

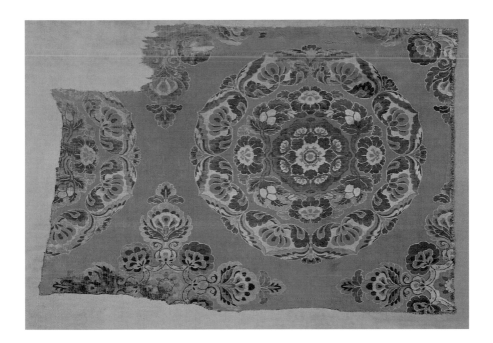

FLORAL MEDALLIONS AND BOUQUETS
Tang dynasty (618–906), late 8th/early 9th century
China
Silk, weft-float faced 1:2 'S' twill weave of complementary wefts and inner warps (samite); 61.6 x 90.2 cm
(24 ¼ x 35 ½ in.)
Robert Allerton Endowment, 1998.3

This textile reflects the cosmopolitan richness and inventiveness of the Tang dynasty. During this period, caravans of merchants and Buddhist clerics traversed the vast network that modern scholars call the Silk Road, transporting China's luxurious silks westward across Asia and returning with exotic goods from empires extending to the Mediterranean Sea.

In this textile's jewel-like floral medallion and quatrefoil floral scrolls, symmetrically curled and piled tendrils derived from the Classical half-palmette were adopted and refined by Chinese weavers from foreign sources. The stylized floral head seen from above, the blossoming stems in three-quarter view, and the half-palmettes in profile merge naturalism and geometry by subtly varying perspective and color. This design pervaded East Asian decorative arts; similar floral medallions and scrolls embellish wall paintings, stone carvings, and vessels of ceramic and silver that Tang aristocrats commissioned for their tombs, Buddhist temples, and private treasuries. Architectural tiles from palace sites in Korea and, most notably, exquisite silk fabrics and carpets preserved in the Shosoin repository in Nara, Japan, attest to the transmission of these patterns throughout eighth-century East Asia.

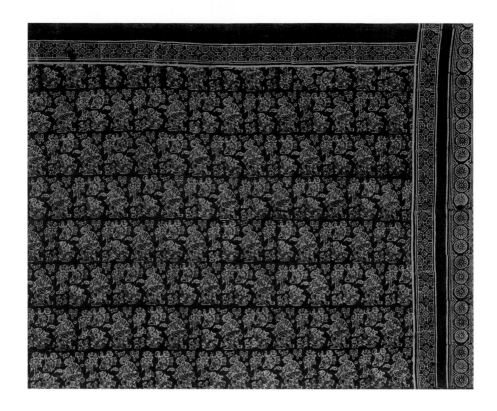

FRAGMENT OF A HEIRLOOM TEXTILE

Late 14th or 15th century

India, Gujarat; traded to Sulawesi, eastern Indonesia

Cotton; block printed, resist and mordant dyed; 94 x 120 cm (37 x 47 in.)

Belle M. Borland Estate; Marie Walters Endowment Fund; Christa C. Mayer Thurman Textile Endowment Fund, 2011.271

Textiles were the primary Indian goods employed in the trade for Southeast Asian spices destined for the Indian Ocean, Red Sea, and European markets. This fragmentary textile is among the oldest Indian textiles to have survived in Southeast Asia. Made in Gujarat for the Indonesian market, it has been radiocarbon-dated to between 1382 and 1502. The pattern derives from a block-printed image that was arranged horizontally along the textile's length, repeated without regard for vertical alignment in seven and a half rows. The image consists of a seated male figure facing three attendant figures of lesser scale, the group complemented by small geese and vegetal and perhaps architectural elements. It has been suggested that the main figure may be a Jain sage, and indeed the representation of a three-quarter profile view and the so-called protruding eye do provide a link to the Jain painting tradition seen in Gujarati manuscripts dating from the fourteenth and fifteenth centuries.

Trade cloths such as this have not survived in India, where they may have originally functioned as ceremonial hangings or backdrops. In Indonesia, such cloths were treasured as heirlooms, preserved and handed down within societies to be displayed as banners and architectural decoration during thanksgiving ceremonies.

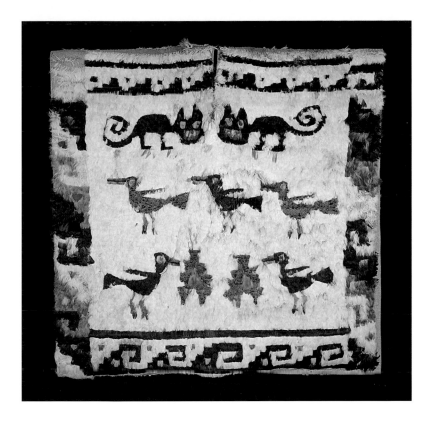

FEATHERED TUNIC WITH FELINES, BIRDS, AND FISH
1470/1532
Chimú; possibly Nazca Valley, south coast, Peru
Cotton, plain weave; embellished with feathers knotted and attached with cotton yarns in overcast stitches; 85.1 x 86 cm (33 ½ x 33 ⅞ in.)
Kate S. Buckingham Endowment, 1955.1789

One of the most extraordinary pieces in the Art Institute's archaeological textile collection, this feathered tunic was created by Chimú weavers in northern Peru in 1470/1532. The knee-length, sleeveless garment is composed of a plain-weave cotton cloth completely concealed by thousands of brightly colored feathers. These exotic plumes were taken from macaws, parrots, toucans, cotingas, and tanagers from the tropical forests of South America. Because they were transported across the treacherous peaks of the Andes, the feathers were extremely rare and valuable and would only have been available to the most elite members of pre-Hispanic society. Thus, the feathered tunic—with its stylized felines, birds, and fish—would have been a sumptuous emblem of power, wealth, and prestige. Like many other pre-Hispanic textiles, it would have been buried with its owner in a subterranean tomb on the southern coast of Peru. The dark and arid conditions in these tombs protected the tunic, thereby allowing its vibrant colors and bold motifs to be appreciated by modern audiences.

FRAGMENT (detail)
Nasrid dynasty (1232–1492), late 15th century
Probably Granada, Spain

Silk, warp-float faced 4:1 satin weave with plain interlacings of secondary binding warps and patterning and self-patterning wefts; 60.8 x 30.5 cm (23 7/8 x 12 in.)

Restricted gift of the Textile Society; Mrs. Julian Armstrong, Jr.; Franke Family Charitable Foundation; Nicole S. Williams Fund, 2007.17

Highly sought after in Islamic Spain, silk textiles such as this one are remarkable for their wide variety of designs and vivid color combinations. The design of this fragment is vibrant and sophisticated, setting an intricate geometric pattern against a rich satin-weave ground. The pattern joins white trilobed arches with a repeat design of green hop blossoms, stylized vegetal motifs, and yellow arabesque ornaments that recall the lush interior settings of the Alhambra, an extensive royal complex overlooking the city of Granada. Known as *ataurique*, these elements are closely connected to architectural decoration—especially stuccowork and wall tiles—and they were shared by potters, stucco carvers, and weavers. In impressive condition, this textile presents a clear sense of the luxury and splendor of Nasrid palace interiors. Indeed, weaving establishments were often attached to palaces and formed an important part of royal households.

COPE
Late 15th/early 16th century
England

Silk, warp-float faced 3:1 broken warp chevron twill weave with supplementary pile warps forming cut voided velvet; appliquéd with linen, plain weave; couching; embroidered with silk and gilt-metal-strip-wrapped silk in satin and split stitches; laid work, couching, and padded couching; spangles; 144 x 291.1 cm (56 ³/₄ x 114 ⁵/₈ in.)
Grace R. Smith Textile Endowment, 1971.312a

The production of textiles for the church—hangings, altar frontals, and liturgical vestments—was a thriving industry in Europe from the twelfth century through the eighteenth century. Unlike secular fabrics, these glorious works of art were preserved in church treasuries, and many survive today. Among the finest ecclesiastical vestments is this resplendent velvet cope, a semicircular cloak worn as an outer garment in processions or during special ceremonies by a priest or bishop. The elegant needlework was called *opus anglicanum* (English work). Surrounding the cope's central image of the Assumption of the Virgin, rendered in silk and gold threads, are seraphim standing on wheels, thistles, fleurs-de-lis, and double-headed eagles—all connected by tendrils animated by spangles. Old Testament prophets and New Testament saints with their attributes alternate on the orphrey band, which runs the full width of the work. Saint Paul is depicted on the hood, which rests on the back of the cope, while an image of God holding an orb decorates the morse, or closure. The brown velvet ground is an unusual color for vestments of this style; it may have faded from purple or crimson.

CRAVAT END WITH MONOGRAM OF LOUIS XIV
1700/15
Brussels, Flanders
Linen, bobbin part-lace of a type known as "Brussels" with a Drochel mesh ground; 32.1 x 41.7 cm
(12 5/8 x 16 3/8 in.)
Restricted gift of Mr. and Mrs. John V. Farwell III, 1987.334

When the heavily Baroque fashions originating at the court of Louis XIV (r. 1643–1715) were simplified during the late 1660s, accessories underwent similar changes. Once belonging to a set of two, this splendid piece of Brussels lace was made for the Sun King himself, shortly before his death. This type of bobbin part-lace, initially produced in Brussels during the eighteenth century, consists of individual motifs made separately but joined together so skillfully that the seams are almost imperceptible. Worn, with its mate, slightly gathered at the neck, this rectangular piece of fabric is replete with symbols signifying the elevated status of its wearer. At center are a rooster and trophies, beneath which is the king's monogram of double Ls. Surmounting this image and supported by two trumpeting angels is a baldachin, a canopy carried over important personages during processions. Armed female warriors appear to the right and left, and gracing the upper corners are the Maltese cross and the sun, the emblem of Louis.

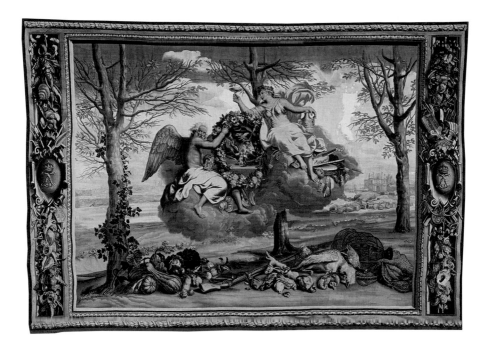

WINTER, FROM THE SEASONS

1700/20
After a design by Charles Le Brun (French, 1619–1690)
Produced at the workshop of Étienne Le Blond (French, 1652–1727) and
Jean de La Croix (French, 1628–1712) at the Manufacture Royale des Gobelins
Wool and silk, slit and double interlocking tapestry weave; 540.1 x 384.8 cm (212 5/8 x 151 1/2 in.)
Gift of the Hearst Foundation in memory of William Randolph Hearst, 1954.261

Winter presents a barren landscape, above which Saturn (the god of agriculture and time) and Juventas (the cupbearer to the gods on Mount Olympus) repose on a large cloud. The musical instruments and the mask at Juventas's feet allude to ballet performances and masked balls—the favorite pastimes of the French court—while Saturn holds a floral wreath that features a ballet scene. In the foreground, a variety of winter vegetables are visible, along with a cage, nets, a gun, and game of various kinds: the results of a successful hunt. The buildings on the right of the tapestry are identified as the Palais du Louvre in Paris. The border imitates a gilt wood frame and contains interlocking *L*s, the cipher of the French king Louis XIV (r. 1643–1715). It is supplemented by additional devices of armor above and below, juxtaposed and intertwined with floral garlands at both ends. The tapestry is from a series based on the four seasons (*Autumn* is also in the Art Institute's collection), after a design by Charles Le Brun, who was appointed director of the Gobelins Manufactory in 1663.

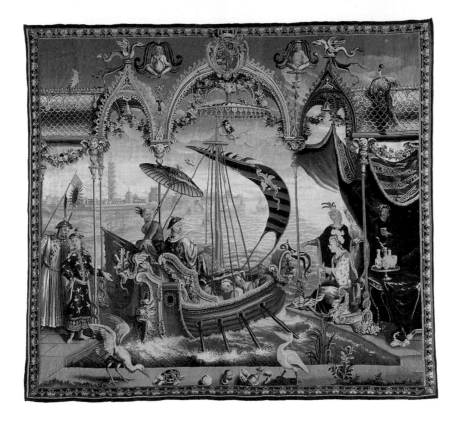

THE EMPEROR SAILING, FROM THE STORY OF THE EMPEROR
OF CHINA

1716/22
After a design by Guy-Louis Vernansal (French, 1648–1729)
Produced at the Manufacture Royale de Beauvais under the direction
of Pierre and Etienne Filleul (codirectors, 1711–22)
Wool, silk, and silvered-and-gilt-metal-strip-wrapped silk, slit and double interlocking tapestry
weave with some areas of 2:2 plain interlacings of silvered-and-gilt-metal-strip-wrapped-silk wefts;
385.8 x 355 cm (151 $^3/_4$ x 139 $^3/_4$ in.)
Charles H. and Mary F. S. Worcester Fund, 2007.22

This tapestry originally formed part of a suite that portrays scenes from the lives of the
Shunzhi emperor (r. 1644–61) and his son, the Kangxi emperor (r. 1661–1722). This
innovative and highly influential tapestry series was ordered by Philippe Behagle, the
director of the Beauvais Manufactory, in response to the French court's growing
interest in the Far East. Drawing upon observations made by missionaries to China and
information published in travelers' reports, the series represents the two emperors dutifully
fulfilling a range of responsibilities. *The Emperor Sailing* shows the elder emperor seated
in a ceremonial dragon boat as it pulls away from a quay. Members of the imperial family
and their attendants watch the launch from an arcaded trellis, in close proximity to a crane
and a tortoise that together symbolize their well-wishes for the monarch. As an allegory
of good governance, the series makes manifest the perceived parallels, first propounded
by French Jesuit missionaries in China, between Louis XIV and the Kangxi emperor.

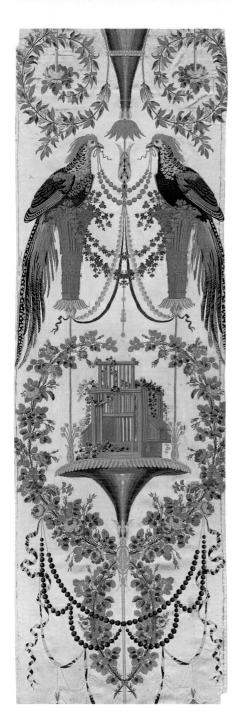

THE PHEASANTS, FROM VERDURES DU VATICAN

1783/89
Designed by Jean-Démosthène
Dugourc (French, 1749–1825)
Woven by Camille Pernon et Cie,
Lyon, France

Silk, warp-float faced 7:1 satin weave with plain interlacings of secondary binding warps and supplementary brocading wefts; embroidered with silk in chain (tambour work) and satin stitches; 242.5 x 44.5 cm (95 ½ x 17 ½ in.)
Restricted gift of Mrs. Chauncey B. Borland, 1945.12

Perhaps the last great name connected with the French silk industry in the late eighteenth and early nineteenth centuries is that of Jean-Démosthène Dugourc. A designer of costumes and stage decorations for the French opera, he was also the superintendent of buildings and designer of Garde-Meuble for the Duc d'Orléans. Dugourc was the most outstanding interior decorator of his time, and from 1774 to 1790, he produced designs for the silk manufacturer Camille Pernon of Lyon. Educated in Italy for a time, Dugourc was familiar with the antique motifs that Raphael had revived in his fresco decorations for the Vatican Loggie, part of the papal palace in Rome. In fact, the French designer titled a group of textile patterns *Verdures du Vatican*. *The Pheasants*, which was designed for the Spanish royal palace in Madrid, is part of this series. The elaborate composition encompasses a lavish, symmetrical interplay of birds, baskets, strings of pearls, garlands, and ribbons—all realized with the excellence of workmanship that made French silks so desirable.

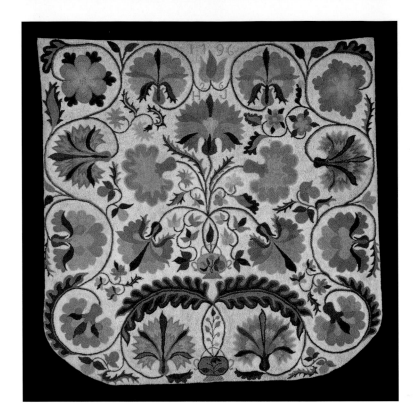

BEDCOVER ("BED RUGG")
1796
Made by Hannah Johnson (American, 1770–1848), Bozrah, Connecticut
Wool, plain weave; embroidered with wool yarns in looped running stitches, cut to form pile;
249.4 x 246.1 cm (98 ¼ x 97 in.)
Restricted gift of the Needlework and Textile Guild, 1944.27

It is not surprising that early American textiles reflect the strong influence of European, especially English, designs and techniques. Materials were scarce and making utilitarian objects such as bedcoverings depended entirely on raw products that could be raised by a family or community. Yet typical and indigenous forms of American needlework did develop, as can be seen in this masterful bed rug. Although the coiling tendrils of its design are reminiscent of motifs that appear in sixteenth- and seventeenth-century English textiles, their application to an item of bedcovering and the technique of looped running stitches embroidered through a wool support fabric are typically American. The term *rugge* or *rugg* appears in colonial inventories, where it refers to a woven yardage fabric used to make bedcovers. Such pieces were unique to the Connecticut River valley. The information provided by the needlework contributes to the rarity of this piece: the initials *H. J.* refer to its maker, Hannah Johnson, the daughter of Ebenezer and Anna Johnson. It is dated 1796 and carries the number 26, which indicates that Johnson was twenty-six years old when she made it.

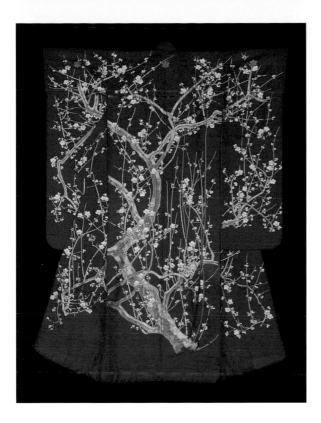

FURISODE
Late Edo period (1789–1868), 19th century
Japan

Silk, 4:1 satin damask weave (*rinzu*); embroidered with silk and gold-leaf-over-lacquered-paper-strip-wrapped silk in satin stitches; laid work, couching, and padded couching; lined with silk, plain weave; 183.8 x 128.8 cm (72 ¼ x 50 ¾ in.)

Gift of Gaylord Donnelley in memory of Frances Gaylord Smith, 1991.637

This *furisode*, a long-sleeved garment worn by children and unmarried women on special occasions, belonged to a family whose crest was the *tachibana*, the flower of the Mandarin orange. Made of *rinzu* (a soft, lustrous silk), it was probably used as an *uchikake*, an outer coat worn without an *obi*, which would have interrupted the flow of the patterning. A blossoming plum tree embroidered with gold and white silk thread spreads its branches from hem to shoulder. The red fabric is woven in a *sayagata* pattern of key-fret lozenges, over which individual orchids or chrysanthemums are scattered. The carefully delineated picture of a tree shows the influence of Western art on Japanese design. Needlework typical of this period was used to realistically portray the contours of the tree trunk. First the edges of the trunk were padded with a heavy thread; then, over this padding, gold-wrapped thread was couched with red silk thread.

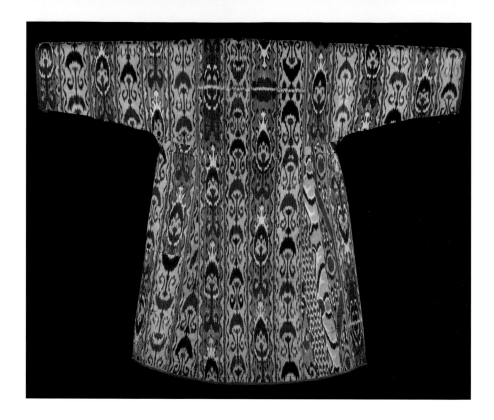

WOMAN'S ROBE
1840s/60s
Bukhara, Uzbekistan

Silk and cotton, warp-resist-dyed (warp ikat) plain weave; pieced; main lining: cotton, plain weave; printed; center opening lining: silk and cotton, warp-faced plain weave; bottom edge lining: cotton, plain weave; cuff lining: cotton, 2:1 Z twill weave; edging: silk, warp twining; 134 x 137.2 cm (52 13/16 x 54 in.)
Gift of Guido Goldman, 2005.606

This woman's robe exemplifies the long tradition of ikat production in Central Asia, specifically in the region now known as Uzbekistan, in the city of Bukhara, once an active center along the ancient Silk Road. Among the many uses of ikats was their role as a component of a woman's dowry. A woman would have worn this robe at weddings and other special occasions, and at her funeral, it would have been draped over her bier. The choice of fabric was determined by a woman's age and status. In general, young women wore bright colors and large patterns, while older women dressed in more sober hues. Most women wore garments made of inexpensive native cotton fabrics, but wealthy women owned robes made of silk and cotton-wefted ikat fabric. Ikat is an ancient technique involving precise and repeated tying (binding) and dyeing of threads or yarns before they are woven. The warp threads are dyed while the weft threads remain plain in color. These threads intersect at right angles during the weaving process; the results are complex patterns in dazzling color combinations that produce a slightly blurred visual effect known by the Persian word *abr* (cloud).

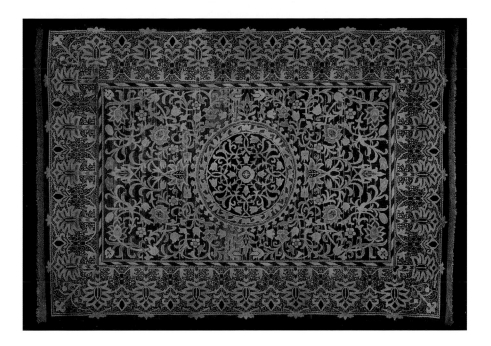

CARPET

1887

Designed by William Morris (English, 1834–1896); produced by Morris & Company; woven at Merton Abbey Works, England, Surrey, Wimbledon

Cotton and wool, plain weave with supplementary wrapping wefts forming "Ghiordes knots" cut pile; 472.3 x 333.4 cm (186 x 131 1/4 in.)

Gift of Mrs. Charles F. Batchelder, 1974.524

This carpet was among the original furnishings of the John J. Glessner House on Prairie Avenue in Chicago, which was designed by the architect Henry Hobson Richardson (1838–1886) and completed in 1887. The carpet was located in the hall of the house and was one of the many furnishing textiles designed by Morris and other eminent Arts and Crafts textile designers and producers of the period.

The design and craftsmanship of Morris's textiles were of the upmost importance; he considered color, composition, and technique from design to finished product. His artistic talent and ingenuity made him one of the most celebrated textile producers in British history. In the 1870s, Morris began designing hand-knotted and machine-made carpets. He had long been interested in historical carpets, and many could be found in his personal collection. Although he did not copy such types directly, his works were strongly influenced by them. Here, while looking to Turkish and Middle Eastern examples for inspiration, he chose a classical Persian arrangement of a central medallion and a quartered symmetrical layout, with a composition of stylized flowers and foliage surrounding the large-scaled medallion with continuous palmettes in the borders.

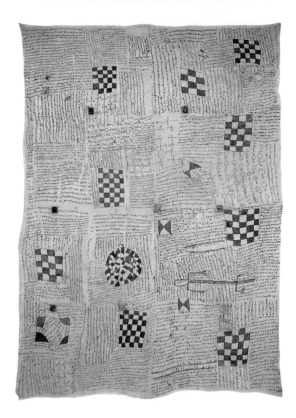

TALISMANIC TEXTILE
Late 19th/early 20th century
Probably Senegal

Four panels joined: cotton, plain weave; painted; amulets of animal hide and felt attached by knotted strips of leather; 255.2 x 178.8 cm (100 ½ x 70 ⅜ in.)

African and Amerindian Purchase Endowment, 2000.326

In Sufism, a form of Islamic mysticism that is widely practiced in Senegal, the repetition of verses from the Qur'an and even of individual letters or words is a transcendent form of devotion. This textile is covered with Qur'anic verses that were likely recited as they were inscribed in tightly composed Arabic script, thereby forging a link between the written word and its sound. The calligraphy is arranged in a fluid checkerboard pattern and organized around a series of painted shapes. The checkered motifs evoke magic squares, arrangements of numbers that, when added together in any direction, always amount to the same sum. Sufis view such numerological devices as a powerful reflection of divine mystery. Like words, they are filled with sacred blessings, or *baraka*. The elongated quadruped figure may be read in multiple ways, including as a lizard, a spirit, and a stylized rendering of the name Muhammad. Attached amulets further punctuate the textile. These commonly encase small squares of folded paper bearing sacred writing. Across Senegal, learned Sufi practitioners apply their esoteric knowledge of sacred writing to the therapeutic practices of divination, healing, and spiritual protection. This textile was likely prepared by a practitioner who lent or rented it to clients as needed.

POPPYHEADS (*MOHNKÖPFE*) (detail)
1900
Designed by Koloman Moser (Austrian, 1868–1918)
Produced by Johann Backhausen und Söhne, Vienna, Austria
Silk, wild silk, and cotton; warp-float faced 15:1 satin weave, self-patterned by ground weft floats;
woven on a loom with Jacquard attachment; 182.9 x 113 cm (72 x 44 ½ in.)
Restricted gift of Mrs. Julian Armstrong, Jr., 1986.963

Koloman Moser, a prominent Viennese designer, is best remembered for his work
with the Wiener Werkstätte (1903–32), of which he was a founder. Prior to 1903,
however, he was an influential member of the modern movement in Vienna. Moser
was also a founder of the Vienna Secession, the association of young artists who
had broken away from the Wiener Künstlerhaus, the accepted artistic forum of the
time. Although *Poppyheads* (Mohnköpfe) was designed by Moser three years before
the Wiener Werkstätte was formed, it foreshadows the kind of elegant textile designs
he would produce at the Werkstätte. With the fluidity of its organic forms and its
combination of oranges and gold, this textile's pattern strongly reflects the influence
of the French Art Nouveau movement. It was produced in various colors by the
Viennese firm of Johann Backhausen und Söhne, which was closely linked to the Werk-
stätte and is still in business today. The textile was intended for upholstery or curtain
fabric, ideally for rooms whose design and furnishings would be produced as total
environments by Werkstätte artists.

WATERS ABOVE THE FIRMAMENT
1976
Lenore Tawney (American, 1907–2007)

Linen, warp-faced weft-ribbed plain weave with discontinuous wefts; 18th-/19th-century manuscript pages cut into strips, attached, and painted with Liquitex acrylic paint; braided, knotted, and cut warp fringe; 397.6 x 369 cm (156 ½ x 145 ¼ in.)

H. L. and Mary T. Adams, Harriott A. Fox, and Mrs. Siegfried G. Schmidt endowments; restricted gift of Laurance H. Armour, Jr., and Margot G. Armour Family Foundation, Mrs. William G. Swartchild, Jr., Joan Rosenberg, Joseph W. Fell, and the Textile Society, 1983.203

Lenore Tawney's *Waters above the Firmament* owes its striking character to the simplicity of its basic concept: a large circle set into a square. The piece's mystical quality is enhanced by the weight given to the upper half of the composition through the use of laminated strips of writing—not intended to be read—covered by an intense blue Liquitex paint. Here Tawney, known for her pioneering exposure of the warp, provided a variant on that theme: she wove the circle in a warp-faced, weft-ribbed plain weave, with slits that open at regular half-inch intervals, creating a third dimension, a device Tawney utilized in most of her weavings. Trained in sculpture at the Institute of Design in Chicago and an alumna of the School of the Art Institute, Tawney moved to New York in 1957. She is also known for her laminated boxes and collages, as well as for constructions composed of such materials as eggshells and chairs. *Waters above the Firmament* is the last and largest of Tawney's major weavings.

Unless otherwise noted, all photographs of the works in the catalogue were made by the Department of Imaging of the Art Institute of Chicago, Christopher Gallagher, Associate Director, and are copyrighted by the Art Institute of Chicago. Every effort has been made to contact and acknowledge copyright holders for all reproductions; additional rights holders are encouraged to contact the Art Institute of Chicago. The following credits apply to all images in this catalogue for which separate acknowledgment is due.

pp. 44, 80: © 2012 Frank Lloyd Wright Foundation / Artists Rights Society (ARS), NY. p. 51: © 2012 Artists Rights Society (ARS), New York / SOMAAP, Mexico City. p. 52: Permission by Paulette Frankl. p. 54: © 2012 Georgia O'Keeffe Museum / Artist Rights Society (ARS), NY. pp. 55–57: © The Art Institute of Chicago. p. 59: © Valerie Gerrard-Browne, courtesy of the Chicago History Museum. p. 60: Art © The Educational Alliance, Inc. / Estate of Peter Blume / Licensed by VAGA, New York, NY. p. 83: Courtesy, The Estate of R. Buckminster Fuller. p. 85: © 1978 Stanley Tigerman. p. 87: © Tokujin Yoshioka Design. p. 88: Courtesy of Maharam. p. 89: © Hernan Díaz Alonso. p. 126: Art © The Joseph and Robert Cornell Memorial Foundation / Licensed by VAGA, New York, NY. pp. 127, 324: © 2012 The Arshile Gorky Foundation / Artists Rights Society (ARS), NY. p. 128: © 2012 The Barnett Newman Foundation / Artists Rights Society (ARS), NY. p. 129: © 2012 The Estate of Robert Rauschenberg/Licensed by VAGA, New York, NY. pp. 130, 326. © 2012 The Willem de Kooning Foundation / Artists Rights Society (ARS), New York. pp. 131, 328: © 2012 The Pollock-Krasner Foundation / Artists Rights Society (ARS), New York. p. 132: © Ellsworth Kelly, courtesy Matthew Marks Gallery, New York. p. 133: © 1998 Kate Rothko Prizel & Christopher Rothko / Artists Rights Society (ARS), New York. p. 134: © The Estate of Joan Mitchell. p. 135: © The Clyfford Still Estate. p. 136: © 2012 The Estate of Francis Bacon. All Rights Reserved. / ARS, New York / DACS, London. p. 137: © Gerhard Richter. p. 138: Art © Estate of David Smith/Licensed by VAGA, New York, NY. p. 139: © Marisa Merz, courtesy of Gladstone Gallery. p. 140: © Cy Twombly Foundation. p. 141: © The Estate of Eva Hesse. Hauser & Wirth, Zürich, London. p. 142: © Jim Nutt. p. 143: © 1974 Ed Paschke. p. 144: © Georg Baselitz. p. 145: © David Hockney. pp. 146, 329: © Estate of Roy Lichtenstein. p. 147: © 2012 Brice Marden / Artists Rights Society (ARS), New York. p. 148: Art © Estate of Robert Smithson / Licensed by VAGA, New York, NY. p. 149: Art © Judd Foundation. Licensed by VAGA, New York, NY. p. 150: © 2012 The Andy Warhol Foundation for the Visual Arts, Inc. /Artists Rights Society (ARS), New York. pp. 151, 158, 166: Courtesy McKee Gallery, New York. p. 152: © Lawrence Weiner. pp. 153, 168–69, 273, 275, 288, 291, 294: © 2012 Artist Rights Society (ARS), New York / VG Bild-Kunst, Bonn. p. 154: Art © The Estate of Leon Golub / Licensed by VAGA, New York, NY. Courtesy Ronald Feldman Fine Arts. p. 155: Courtesy of the artist and Metro Pictures. pp. 156–57: © 2012 Bruce Nauman / Artists Rights Society (ARS), New York. pp. 159, 298: Courtesy of the artist and Luhring Augustine, New York. p. 161: Courtesy David Zwirner, New York. p. 162: © The Felix Gonzalez-Torres Foundation. p. 163: © Robert Gober, courtesy of Matthew Marks Gallery, New York. p. 164: Courtesy the artist and Jack Shainman Gallery, New York. p. 165: © The Lucian Freud Archive. p. 167: © The Estate of Sol LeWitt. p. 171: © Peter Doig, courtesy Victoria Miro Gallery, London. p. 172: © Matthew Barney, courtesy of Gladstone Gallery. p. 173: © Charles Ray. p. 174, 330: Art © Jasper Johns/Licensed by VAGA, New York, NY. pp. 245, 249, 251, 264, 272, 319, 325: © 2012 Estate of Pablo Picasso / Artists Rights Society (ARS), New York. pp. 247, 250, 265: © 2012 Succession H. Matisse / Artists

Rights Society (ARS), New York. pp. 248, 254, 255, 256, 259, 260, 263, 267, 269, 270, 277, 292: © 2012 Artists Rights Society (ARS), New York / ADAGP, Paris. p. 257: © 2012 Artists Rights Society (ARS), New York / SIAE, Rome. p. 262: © 2012 Mondrian/Holtzman Trust c/o HCR International USA. p. 268: © 2012 Artists Rights Society (ARS), New York / ProLitteris, Zürich. p. 269: © 2012 Succession Giacometti/ Artists Rights Society (ARS), New York / ADAGP, Paris. p. 271: © 2012 Estate of Yves Tanguy / Artists Rights Society (ARS), New York. pp. 274, 276: © 2012 Salvador Dali, Fundació Gala-Salvador Dali Foundation / Artists Rights Society (ARS), New York. p. 278: © 2012 C. Herscovici, London / Artists Rights Society (ARS), New York. p. 279: © 2012 Artists Rights Society (ARS), New York / SABAM, Brussels. p. 280: © Balthus. p. 290: © Estate of André Kertész/Higher Pictures. p. 293: © Walker Evans Archive, The Metropolitan Museum of Art, New York. p. 295: © The Estate of Harry Callahan. Courtesy Pace/MacGill Gallery, New York. p. 296: © Ed Ruscha, courtesy of the artist. p. 297: © 1980 The Estate of Diane Arbus, LLC. p. 299: © Richard Prince. p. 300: © 2012 Thomas Struth. p. 301: © 2012 by Dawoud Bey, courtesy of the artist. p. 302: © Nan Goldin, courtesy of the artist and Matthew Marks Gallery, New York. p. 318: © 2009 The Munch Museum / The Munch-Ellingsen Group / Artists Rights Society (ARS), New York. p. 348: Courtesy of the Estate of Lenore Tawney.